# Arts of India: 1550 -1900

# The Nehru Gallery of Indian Art

◀**Endpapers: Page from the Gentil Album [160] illustrating jewellery and weapons**
Watercolour on paper
Faizabad, *c.*1770
38.2 × 55.5cm
IS 25–1980

Edited by John Guy and Deborah Swallow

# Arts of India:
# 1550-1900

Rosemary Crill, John Guy, Veronica Murphy,
Susan Stronge and Deborah Swallow

**Victoria & Albert Museum**

Published by the Victoria and Albert Museum, London SW7 2RL

© Text: The Trustees of the Victoria and Albert Museum, 1990

© Illustrations: The Trustees of the Victoria and Albert Museum
unless otherwise acknowledged

British Library Cataloguing in Publication Data

Arts of India: 1550–1900.
  1. Indian visual arts, history
  I. Guy, J. (John 1949–)  II. Swallow D. (Deborah 1948–)
  III. Victoria and Albert Museum
  709.54
  ISBN 1-85177-022-4

Maps by Chapman, Bounford & Associates

Set in Linotron Bembo Medium and Folio by
Rowland Phototypesetting Ltd, Bury St Edmunds, Suffolk

Printed in Italy by Amilcare Pizzi

Designed by Paul McAlinden

# Contents

# Acknowledgements

# Photographic credits

The authors wish to record their profound debt to Robert Skelton, Keeper of the Indian Department from 1978 until 1988. Since retirement Robert has continued to contribute to the life of the Department, offering advice and a sharp eye when requested. The content of this book is central to Robert's interests and much that is contained here has been built on past research undertaken by him, a debt we happily acknowledge.

This book is greatly enhanced by the quality of photography it contains and we wish to thank the Museum photographers for their contribution, particularly Mike Kitcatt who has carried the lion's share of this task. In the preparation of objects for photography, the staff of the Museum's Conservation Department have helped enormously in cleaning and conserving objects to their usual exacting standards.

Within the Indian and South-East Asian Section the authors were greatly assisted by Graham Parlett, John Clarke, Caroline Bacon and Ben Curran. The secretarial support of Ann Bonney was inestimable. Individual authors have benefited from discussions with colleagues elsewhere: Susan Stronge wishes to thank Carol Altman Bromberg, Dr A.S.Melikian-Chirvani, and Mrs P. Kattenhorn of the India Office Library. Deborah Swallow wishes particularly to thank Dr Anil Seal for his invaluable help.

## Note on Transliteration

In the transliteration of names and terms, diacritical marks have not been included. It is hoped that scholarly readers will excuse this omission in the interests of popular accessibility.

Measurements are in centimetres, with height followed by width and depth
**Abbreviations:**
Ht. Height
L. Length
Diam. Diameter
f. Folio

**Dating system:**
AH *Anno hejirae* (the Islamic calendar, commencing with the flight (*hijra*) of Muhammad from Mecca to Medina in AD 622).

# Prefaces

The Victoria and Albert Museum, which possesses the largest collection of the arts of India outside the Indian sub-continent, has recently put a major part of the collection on display in a new gallery to be known as The Nehru Gallery of Indian Art. Pandit Jawaharlal Nehru, the Indian statesman and patriot, born and brought up in India and educated in England, represented a fusion of the traditions of both cultures. Nehru led India into independence and established her as a sovereign republic, and his vision and statesmanship were central in the formation of the Commonwealth. In creating the new gallery the Museum has been supported and encouraged by the British and Indian Governments, and is deeply grateful to the many sponsors and donors, in India as well as in Britain, whose generosity has made it possible to realise this long-sustained dream.

The gallery and the selection of exhibits displayed in it are part of an ambitious project, of which this book is another, designed to increase public understanding and appreciation of Indian arts and culture. They show the many ways in which the arts of India have influenced, and been influenced by, Western arts and culture as a result of the close connection between Europe and India over the last three centuries and more.

This book, written and edited by members of the curatorial staff of the Indian and South-East Asian Section at the Victorian and Albert Museum, provides the historical and cultural background to the collection displayed in the Nehru Gallery, and I hope that it will help to increase the enjoyment and improve the understanding of visitors who come to see the displays. But it is more than just the book of the gallery – it stands on its own as an introduction to the arts and culture of India during the period of its closest involvement with Britain. Its illustrations show the vitality of the products of Indian art and culture during this period and the technical skill and aesthetic genius of the artists who made them. It will have a strong interest and appeal to all those who are drawn to the beauty and power of Indian art and wish to understand more about the society and the civilisation which produced it.

The vitality of a great museum depends on the scholarship of its curators. The Trustees commend this book and are proud of the project of which it is part, as an example of the way in which the skills and resources of a national museum can be brought together in the fulfilment of its task of enlarging public understanding, appreciation and enjoyment of all that is best in art and design.

**Lord Armstrong of Ilminster**
Chairman of the Board of Trustees of the
Victoria and Albert Museum

This publication marks an important milestone in the history of the Victoria and Albert Museum, for it records not only the opening of The Nehru Gallery of Indian Art, but also the beginning of a major programme of educational activities and events centred on the new gallery. It is the aim of the Museum to establish the Nehru Gallery and the large reference collections which support it, as the major national centre for public education on Indian culture and art.

From Persia to the Chinese Sea, from the icy regions of Siberia to the islands of Java and Borneo, from Oceania to Socotra, India has propogated her beliefs, her tales and her civilisation. She has left indelible imprints on one-fourth of the human race in the course of a large succession of centuries. She has the right to reclaim in universal history the rank that ignorance has refused her for a long time and to hold her place amongst the great nations summarising and symbolising the spirit of Humanity. ( Jawaharlal Nehru, *The Discovery of India*, 1946)

The Victoria and Albert Musuem holds the oldest and most comprehensive collection of Indian art outside that continent. It has held the collection in trust for present and future generations for many years, but now, with a community of nearly one million people of South Asian origin living in Britain, it is not only time to display more of that collection, but actively to use it to explain the richness and diversity of our multi-cultural heritage.

The Nehru Gallery opened as a result of an Appeal which captured the imagination of hundreds of people both in Britain and in India. Many individuals, businesses, foundations and communities have contributed to raising the sum needed to display this most magnificent and varied collection of Indian art. Help will still be needed in the years to come to realise the ideals embodied in this book and in the gallery. To the many people who assisted us to make this dream come true, I offer my heart-felt gratitude.

In order to become truly one nation and one people we need to understand the rich strands of our culture. History has made Indian art and culture one of those strands. In learning about India we shall come to understand ourselves so much the better.

**Elizabeth Esteve-Coll**
Director of the Victoria and Albert Museum

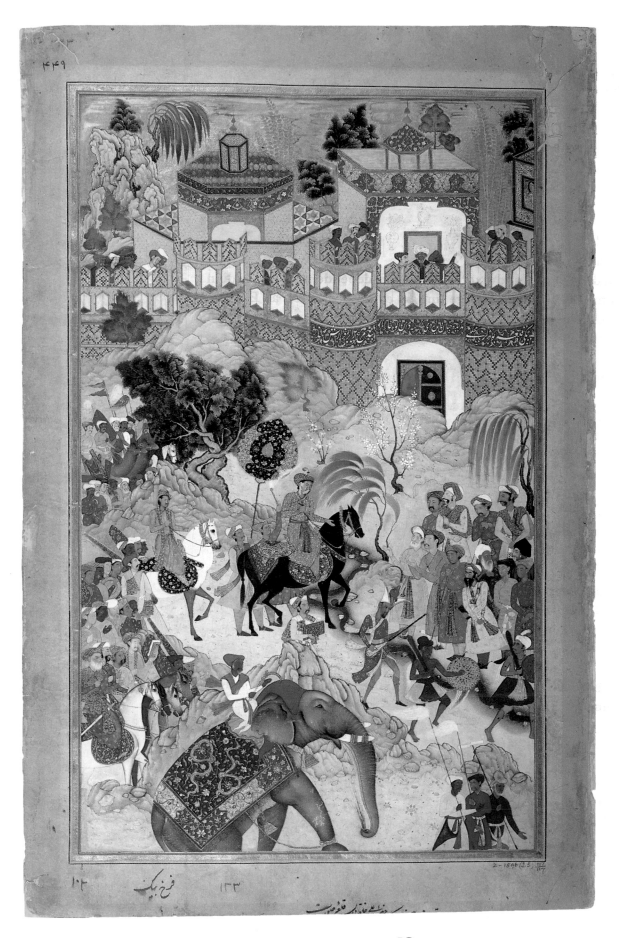

# 1.
# Introduction

The arts of India are among the greatest aesthetic achievements of mankind, but the recognition of their importance only gained full acceptance in the West this century as the regions of South Asia struggled for, won and exercised their independence. The Indian subcontinent, an area as large and as culturally varied as Europe, has produced through its village artisans, its centres of specialist production and its imperial workshops an immense range and wealth of works of art. As rulers and patrons of foreign origin have come and gone, its artists have readily accepted outside influences, but the deeper roots of indigenous traditions have persisted too, and the dialogue continues to enrich this still-vital art.

The British, by virtue of their imperial past, have the privilege of holding in their care magnificent collections of the arts of India, the most comprehensive of which is in the Victoria and Albert Museum. This Museum, the world's first and greatest collection of the decorative arts, owes its inception to the mid-nineteenth century's concerns with the affects of industialisation on the arts. Its Indian collections,[1] however, date back to the latter half of the eighteenth century, to the period of Britain's colonial expansion in India, when the English East India Company became *de facto* ruler of Bengal. It was at this time that India's religious and philosophical traditions began to be systematically explored – a product of the Enlightenment and a pragmatic response by a few Company officials, who recognised the need to understand the social and cultural practices of those over whom they ruled. In 1784, with the blessing of Warren Hastings, then Governor General, William Jones founded the Asiatic Society of Bengal, and by 1801 the Company's Court of Directors in London had been persuaded to establish a Repository for Oriental writings at East India House, their headquarters in Leadenhall Street.

The Repository, although initiated as a library, immediately took on the character of a museum and started to acquire a wide range of 'productions of nature and Art' [2]. By mid-century marble busts of distinguished soldiers and statesmen, pictures, mineral products, jewellery, textiles, agricultural models, stuffed birds and animals, ethnological specimens and a distinguished collection of sculpture adorned the galleries which had almost taken over East India House. With the transfer of India's government to the Crown in 1858,

**1. Akbar's triumphant entry into Surat in 1573**
Gouache on paper
Mughal c.1590
By Farrukh Beg
33 x 20cm
IS 2–1896 (f.117/117)
From an Imperial copy of the *Akbarnama*

the collections became part of the India Office. They were moved first to Fife House in Whitehall [3], then in 1869 to the new India Office buildings. After 1858 there was a growing interest in archaeology and photography, but the focus of attention was mainly on India's 'economic products'. The Secretary of State for India, keen to offset the costs of the Museum (which fell on the Indian taxpayer) urged that it become a trade museum and that parts irrelevant to that purpose be disposed of. To exacerbate the situation the India Office premises proved inadequate for the ever-growing collection of objects, and in 1874 it was moved to some former exhibition buildings in South Kensington. Meanwhile the nearby Victoria and Albert Museum,[2] founded on the profits of the Great Exhibition of 1851, was acquiring its own Indian collection – in order to inspire students with an understanding of 'good' design. In 1879, after protracted

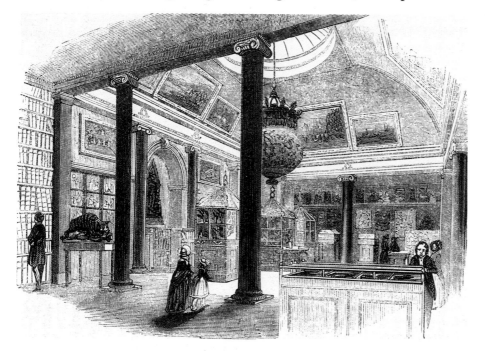

**2. Indian Museum, East India House, *c.*1843**

After C. Knight, *London Pictorial Illustrated*, vol. 5, 1843

Objects from the India Museum on display in the Library, East India House, showing the Museum's most celebrated possession, then and now – 'Tippoo's Musical Tiger' (see 162), a trophy of Britain's recent military success against Tipu Sultan of Mysore.

negotiations, the main part of the East India Company Museum's collections was brought under the aegis of the Victoria and Albert Museum, whose own collection was moved to join it.

Indian art had always met with mixed responses in the West. During the nineteenth century appreciation of Indian artistic achievements was almost totally confined to the applied arts, and most writers dismissed Indian sculpture and painting as unworthy of inclusion among the fine arts. But early in the twentieth century India's standing in relation to the art of other great cultural traditions began to be revalued – largely through the missionary zeal of E.B.Havell, a former principal of the Madras and the Calcutta Schools of Art, and the work of the great Sinhalese scholar, Ananda Coomaraswamy.[3] This reappraisal affected the Museum's collecting and display policies and greater attention was paid to sculpture and painting, resulting in a collection with a range unequalled outside India.

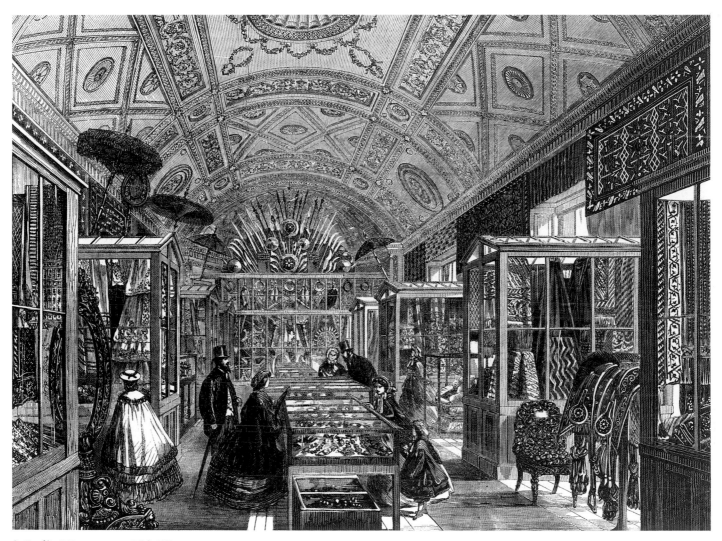

**3. India Museum at Fife House, Whitehall**

After *The Illustrated London News*, 3 August, 1861.

The Indian collection remained housed in its own off-site galleries until, in 1955, these buildings were demolished to make way for the expansion of Imperial College. Despite a plethora of proposals for the future, the Victoria and Albert Museum in the end was faced with the immediate impossible task of finding space in its own galleries. Displays were mounted, but the bulk of the collection was relegated to store. A series of attempts to solve the problem were aborted and with each proposal costs escalated.

Meanwhile the study of Indian art, released from its craft bias, moved gradually from the analysis of style in the fine arts to a more comprehensive examination of the arts as a whole in relation to their historical, social and religious contexts. It is this approach that has informed the choice of content, the groupings of material and the design of the new suite of galleries of Indian art, that the Museum was finally able to start planning in 1987. A new gallery showing the arts of India from 200 BC to AD 1500 was opened in March 1988; and a second gallery exploring the expansion of Hindu and Buddhist artistic traditions into the Himalayan region and South-East Asia opened in June 1989. The opening of *The Nehru Gallery of Indian Art 1550–1900* represents the culmination of this first stage of the Museum's plan to give the Indian collections the prominence they so richly deserve.

The 350-year period covered by the Nehru Gallery experienced what appear to be major sea changes in Indian political, social and cultural life. The coming of the Mughals (a Muslim dynasty of Central Asian origin) and their establishment of an empire in India in the sixteenth century not only brought new unities and new forms of government but also gave rise to the most extraordinary transformation of the arts of the lands they conquered. By the eighteenth century, however, this empire was collapsing. As it declined regional kingdoms emerged only to be broken by the growing power of European trading companies, one of which led to a new and even more extensive empire, that of the British. Like the Mughals, the British made major changes in government and in the economy and they too brought dramatic new artistic influences, once again infusing indigenous artistic traditions with new styles. But, as all students of Indian society and history know, the continuities are as strong as these apparent changes. The Mughal emperors, despite their visible successes, were kings of the high roads and plains only. They, like the British after them, were foreign rulers, and were severely limited in their ability to redraw the political, social and religious map of India. Again and again they had to show tolerance in their dealings with the indigenous population and to make strategic alliances with both Hindu and Muslim rulers. These limitations explain too the syncretic character of their culture, even at the centres of high culture in their cities, courts and camps. At the local level indigenous artistic traditions retained their vitality. The Mughals introduced new archi-

**14**

tectural styles and techniques, new types of weaponry, and influences from Iran and Central Asia. But the extent to which the forms that resulted represented the synthesis of alien and indigenous artistic influence is a reflection both of the Mughals' inability to impose absolute changes and their wise recognition that success lay in creative collaboration.

Similarly, British imperialism in India hovered above Indian society, never penetrating its surface. Like the Mughals, the British faced limitations and made accommodations. Their new cities of Calcutta and Madras, Bombay and Karachi might have seemed to herald change, but under the British umbrella myriad communities made these cities their own. The architecture the British left throughout the subcontinent is a testimony to their presence, but their cultural impact remained limited. A layer of western influence lay over Indian urban and elite culture, but it was soon transformed by powerful indigenous traditions.

In the analysis of the cultural impact of the Mughals and then the British on India, one feature stands out. Both empires in their heyday created a central cultural focus; both, up to a point, were political unifiers. At the height of their power a common cultural model began to emerge and there were fewer independent concentrations of regional patronage. But no empire is independent of the regions under its 'control', and its attempts to maintain the balance between different regions can, indirectly, either cause a powerful regional revival or destroy a regional culture.

This volume aims, through its various contributions, to show that an understanding of artistic dynamics in India depends not only on the examination of the centres of high culture but also on the analysis of regional solidarities, and the patterns by which relationships between local, regional and central cultures are refined and developed. It therefore begins with a review of the various aspects of India's artistic heritage and the resources of skill that were available to the Mughals on their arrival in India in the sixteenth century (chapter 2). Northern India had been ruled since the late twelfth century by a series of Muslim dynasties of Turkic and Afghan descent (the Delhi Sultanates). The northern Deccan, ruled by the Muslim Bahmani kings since the fourteenth century, was soon to give way to five new kingdoms. South India, however, and large parts of western and north-eastern India remained under the rule of Hindu kings, and even in those parts ruled by Muslims much of the population was still Hindu. Buddhism as a separate religion had disappeared from its land of birth, its teaching in part absorbed into Hinduism, its institutions destroyed and its traditions transported to the Himalayas, South-East Asia and further east. Jainism, an ascetic and non-violent religion founded like Buddhism in the sixth century BC in opposition to 'orthodox' Hinduism's priestly ritualism, was still the religion of some of India's trading communities. Both the

Delhi and the Deccani Sultans, and Jain merchants were active patrons of the arts, and though the great period of large scale Hindu temple building was drawing to a close, rulers and merchants alike continued to patronise other religious arts. A sophisticated and rich tradition of specialist artisan production serviced India's élite and, through its part in internal and international long-distance trade, brought wealth to her rulers.

Chapter 3 introduces the great Mughals themselves, tracing the rich artistic developments under each of the emperors in turn, from Babur's first raids into northern India at the beginning of the sixteenth century until the death of Aurangzeb in 1707. It analyses the Mughals' dynamic role as patrons, and the ways in which new and vibrant artistic styles developed, as they encouraged experimentation and the combined use of foreign and indigenous techniques, styles and materials.

Chapter 4 turns to the northern Deccan, a region that remained politically independent until the seventeenth century. Here artistic styles reflected close links with the Safavid dynasty of Iran until its conquest by the Mughals in 1636, after which Mughal aesthetic influence became pronounced. But local traditions and influences also persisted. Some of the most successful industries had had a long history and were based on skills that pre-dated even the arrival of the Muslims in India.

In dealing with the Hindu rulers of Rajasthan (chapter 5) the Mughals encountered formidable opposition. The Rajput kingdoms were already highly developed in cultural terms by the time the Mughals finally imposed their authority on them in the late sixteenth and early seventeenth centuries. Just as the Rajputs took from the Mughals whatever privilege or position they could use, so they adopted those aspects of Mughal cultural and courtly life which appealed to them. At the same time many important aspects of Rajput culture were sustained through the popular rather than the courtly tradition.

By the eighteenth century the Mughal empire was in decline and a series of regional kingdoms emerged, to flourish for a while until broken by the growing power of the European trading companies that had been operating on its shores since the sixteenth century. Chapter 6 examines the nature of the trade – first in spices and later in textiles – that brought the Portuguese, the Dutch, the French, the Danes and then the British into the region. By the mid-eighteenth century the need to protect trading monopolies and to control production led the British into direct conflict both with their main trading rivals, the French, and with the regional rulers of the Gangetic plain, Murshidabad and Oudh (Awadh). The outbreak of war between Britain and France in the 1790s provided justification for the British to take the French allied state of Mysore. In western India the exaggerated danger posed by the confederacy of Maratha

rulers led to further territorial expansion, and the political confusion following the death of the great Sikh ruler of the Punjab, Ranjit Singh, in 1839 led to its annexation. Chapter 7 examines the artistic traditions of some of these regional kingdoms which, though short-lived and operating increasingly within a European sphere of influence, for a short time achieved a stature and a splendour that impressed even their foes.

By the middle of the nineteenth century British territorial expansion came to an end (chapter 8). The Indian colony was secured, and attention was focused on its role as the linchpin of Britain's wider trading empire. Once again political changes at the centre had to accommodate to regional forces. The British, unlike the Mughals, never settled in India. Most maintained as British a lifestyle as possible. Their cultural impact, even more than that of the Mughals, was syncretic; often it was superficial, and always it was limited. Regional courtly patronage declined, princely tastes became part-Europeanised and market changes began to affect craft production. By the end of the nineteenth century, however, there had been no major economic or social revolution, and the local roots of regional tradition lived on, awaiting new impetuses and new patronage.

1. For the full history of these collections see Skelton, 1978, and Desmond, 1982.

2. The Museum was given its present name only in 1899. It was first called the Museum of Science and Art, and then the South Kensington Museum. A brief history of the Museum and its collections is to be found in Somers Cocks, 1980.

3. For an account of changing European reactions to Indian art see Mitter, 1977.

# 2.
# The Arts of Pre-Mughal India

### India in the Ancient World

The India which the Mughals inherited in the mid-sixteenth century was a rich and complex society marked more by a continuity of tradition than by dramatic breaks from that tradition. The Mughal rulers brought a new courtly culture to the subcontinent, but a cosmopolitan outlook was not new to India; indeed there was a well established system of international trade and prosperous urban centres supported an extensive network of internal trade. Contemporary descriptions give a vivid impression of the splendour of the great cities of India, much of whose wealth was based on maritime trade.

The *Shilappadikaram* (*The Ankle Bracelet*), a Tamil romance probably written in the late second century AD, provides a vivid glimpse of the splendour of the cosmopolitan cities of South India. The story is set in the prosperous port city of Puhar (Kaveripattanam), where the ship owners are described as having riches 'the envy of foreign kings'. It is an entrepôt city, with enclaves populated by foreign merchants and traders, where trade was well regulated: 'The city of Puhar possessed a spacious forum for storing bales of merchandise, with markings showing the quantity, weight, and name of the owner.' The markets are described as overflowing with the exotic products of the ancient world. The *Shilappadikaram* gives the flavour of the city and of the luxury nature of its trade:

> The sunshine lighted up . . . the harbour docks. . . . In various quarters of the city the homes of wealthy Greeks [*Yavanas*, foreigners from the West] were seen. Near the harbour seamen from far-off lands appeared at home. In the streets hawkers were selling unguents, bath powders, cooling oils, flowers, perfumes, incense. Weavers brought their fine silks and all kinds of fabric made from wool or cotton. There were special streets for merchants of coral, sandalwood, myrrh, jewellery, faultless pearls, pure gold, and precious gems.[1]

The major Indian trade ports are described by a number of early writers, including the Alexandrian Ptolemy (*c*.AD 150) in his *Geography* and the anonymous first-century AD Greek author of *The Periplus of the Erythrean Sea*. The most notable ports were Barbaricon, at the mouth of the Indus; Barygaza, near modern Broach in Gujarat;

**4. Jain *yantra*** (detail)
Gouache, ink and gold on cotton
Gujarat, dated 1447
137 x 110.5cm
IM 89–1936

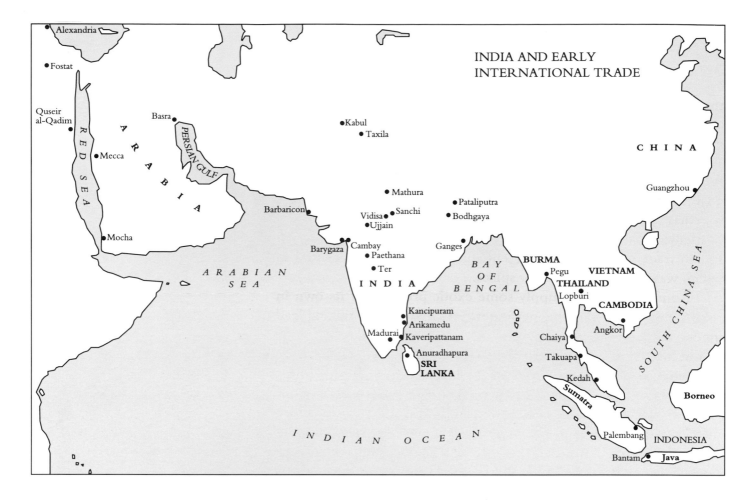

Ganges at the mouth of the River Ganges in Bengal; and several ports in South India. The exotic products of China and South-East Asia, together with those of India, were assembled in these entrepôts for supply to the markets of the Arab world and the West. In this way the trading activity of India served to link imperial Rome and Han China. The archaeological evidence indicates that trade with the Roman world, although widespread, was a particular feature of the commerical activity of the South. Coral from the western Mediterranean and amphora of glazed pottery decorate the homes of the wealthy in the *Shilappadikaram*. An excavation conducted at the site of Arikamedu, near Pondicherry, in 1945 revealed the remains of a harbour with waterfront warehouse facilities dating from the first century AD.[2] Finds included cut and uncut gems, some carved with intaglio designs in a Roman style. Bead-making appears also to have been practised there. Roman lamps and glassware were found, together with fragments of amphora vessels characteristic of the Mediterranean wine trade and red-glazed Arretine pottery. The impression given by the finds at Arikamedu is of a trading settlement frequented by foreigners, including traders from the Roman world, of the type described by early Mediterranean writers as an *emporium*.

Indian trade with the West may extend as far back as the early centuries BC, concentrated in the hands of the Arabs who sought

**20**

Indian teak for ship-building from an early period. It was not until the Roman capture of the great Mediterranean port of Alexandria that the trade with the West grew significantly. The first recorded Indian embassy to Rome occurs only in the late third century AD, in the reign of Augustus, well after trade between India and Rome was an established reality. Indian sources are almost silent on this trade apart from occasional glimpses provided by contemporary literature. Western sources however, describe the contents of this trade in remarkable detail: the Greek *Periplus* informs us that India supplied a variety of spices and aromatics (especially pepper and cinnamon), together with textiles (notably muslins and cottons of varying grades of quality), ivory, exotic animals, high quality iron, and gems. The Indian trade with Rome was essentially in luxury goods, central to which was the vast demand for spices.

Rome was able to supply some exotic products of its own in return, notably coral, wine, perfumes, papyrus, copper, tin and lead ingots, cut-gems and jewellery. While much of this reciprocal trade was in high-quality manufactures, it in no way matched the cost of supplying Rome with a seemingly limitless supply of Asian spices and quality textiles. The balance of payments had to be met in precious metals, principally gold and silver coinage. After precious metals, red coral appears to have been Rome's most valuable asset in its trade with India. Evidence of India's trade with the Roman Mediterranean is to be seen in the large quantity of engraved gems which have been found in the Indian world. Many examples of cut and mounted gems in circulation in ancient India were probably the products of Roman workshops: Roman craftsmen were famed for their skill in producing such items. Yet it was the Indian subcontinent which was the original source of many of the stones they used. The *Periplus* tells us that the precious stones, onyx and agate essential to the trade were brought to the port of Barygaza (Broach) from a number of sources in the western Deccan. Intaglio seals collected around Taxila, the early capital of the Gandharan region of north-western India (which historically has served as the gateway between India and the West since at least the campaigns of Alexander the Great in 327–6 BC) illustrate the variety of stones and engraved designs used. A carnelian seal engraved with a winged horse in the Greek tradition [5] displays workmanship of an extremely high standard and must be an import from the West. A bloodstone seal engraved with a humped Indian bull, by contrast [5], reveals the hand of a craftsman less experienced in the art of gem engraving. It was most probably engraved in India. The humped bull appears on a number of Kushan coins, both with and without the Hindu god Shiva, with whom the bull is already clearly identified by the first century AD.

Little of the Roman gold coinage which flowed into India, much of which was expressly minted for the purpose of trade, survived as

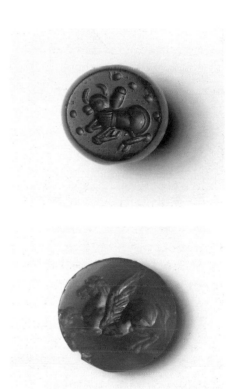

**5. Seals**
North-west of Indian subcontinent, 2nd century BC–2nd century AD
(i) Carnelian with seated bull
Diam. 1.4cm
IS 39–1948
(ii) Bloodstone with winged horse
Diam. 1.7cm
IS 36–1948

coins. Gold was in great demand for jewellery and for precious utensils and containers, such as reliquaries. A remarkable gold repoussé medallion [6] and a gold figure holding a mirror [7], illustrates the achievement of Indian jewellers of the Kushan period (first – second century AD). The use of cut gems and pearls in raised gold settings foreshadows developments of this technique in later Indian jewellery. Relatively little gold jewellery survives from this period. Pendant gold earrings, believed to be from the Taxila region of Gandhara, display a delicate use of applied wire and granules on thin sheet gold [8]. They are of a fairly standard construction: a flower medallion with applied wire and granulation decoration beneath which hangs a miniature vase in cut stone.

Indian exports to the Roman world included two crafts for which India was famed in the ancient world, the weaving of fine muslins (known in Roman literature as 'woven air') and the art of ivory carving. The Roman writer Pliny complained of the cost of these and other luxury commodities. The finest muslins were, according to the *Periplus*, produced in the Bengal market town of Ganges near to the river of the same name, and were known in the Western trade as 'Gangetic'.[3] Barygaza (Broach), the great port of western India, was an important staging post for this Roman trade. Inland trade routes connected this entrepôt with the great commercial cities of Ozene (Ujjain) and Ter (Tagara).

An Indian ivory female figure [9], probably a mirror handle, was excavated from the ruins of Pompeii (destroyed by volcanic eruption in AD 79). The style of the figure, the jewellery and the elaborate coiffure all find close parallels in the female nature-spirits (*yaksis*) to be seen adorning the ceremonial gateways (*toranas*) at the great *stupa* mound at Sanchi. Close to Sanchi is the ancient city of Vidisa (Bilsa), which is known to have had ivory carvers' guilds in the first century BC. The workshops of Vidisa or some other centre in Malwa were most probably the source of this ivory figure. From Vidisa it would have been transported to Ozene for despatch to the port of Barygaza and then traded west to find its way into a wealthy Roman's villa. The luxury element of India's early trade with the West is vividly illustrated by this remarkable find. Ivory, as a high value commodity, was no doubt also widely traded within the Indian world. A comb decorated with reclining figures in a plantain grove may come from a similar workshop [10]. The depiction of lovers (*mithuna*) on a comb is a reminder of the rich secular tradition in the arts of early India, a fact often obscured by the preponderance of religious imagery which survives from this period.

## Indian Trade in the Medieval Period

After the final collapse of the late Roman world marked by the Arab conquest of the eastern empire in the sixth century, trade with India largely reverted to Arab control. That this remained the case for the

### 6. Pendant with the goddess Hariti

Gold repoussé, with garnets and pearls
Taxila (?), Punjab, Pakistan
Kushan period, *c.*2nd century AD
Diam. 4.8cm
IS 9–1948

A mother-goddess worshipped in both a Hindu and Buddhist context, represented wearing a Hellenistic tunic and diadem. The cult of Hariti was particularly popular in the Gandharan region, the most probable source of this medallion.

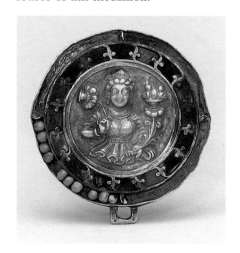

## 7. Goddess holding a mirror

Gold, with lac-filled base
Taxila (?), Punjab, Pakistan
Kushan period, c.1st century AD
Ht. 5cm
IS 13–1948

This figurine, Hellenistic in her attire, stands on a lotus base betraying its Indian origin. It may have served as the decorative finial to a mirror handle or a costume pin.

## 9. Female figure

Ivory
Probably Malwa, Central India, 1st century AD
Ht. 24cm
Museo Nazionale, Naples

This figurine, probably a mirror handle, was exported to Italy prior to 79 AD, the year it was buried in the ruins of Pompeii.

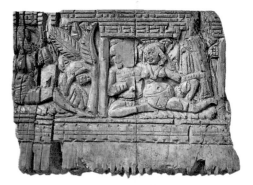

## 10. Fragment of a comb

Ivory
Probably Malwa, Central India, c.2nd century AD
5.1 x 6.4cm
IM 21–1937

## 8. Earring

Gold with turquoise
Taxila (?), Panjab, Pakistan
Kushan period, c.1st–2nd century AD
Ht. 4.4cm
IS 16–1948

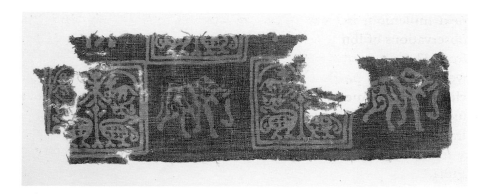

## ◄ 11. Textile fragment

Resist–dyed cotton
India, probably Gujarat, c.15th century
51 x 31cm
IS 72–1972

A large lotus petal design, possibly
forming part of a canopy or tomb
cover, recovered from Fostat, Egypt.
Such textiles formed part of an exten-
sive Indian trade with the Arab world.

## 12. Textile fragment

Resist–dyed cotton
India, probably Gujarat, c.15th century
15 x 45cm
T 253–1958

Indigo resist–dyed panel with alternat-
ing elephant and flowering tree with
geese and deer design. These motifs
also appear in western Indian manu-
script paintings of this period. From
Fostat, Egypt.

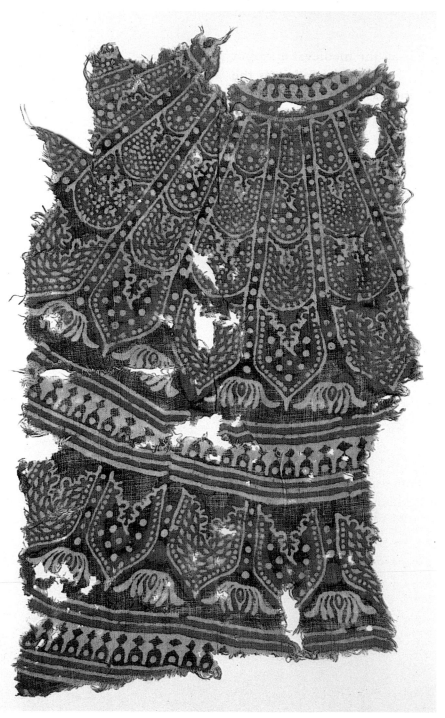

next millenium is clear from a number of sources, including the observations of Ibn Battuta, an Arab commentator who visited India from 1333–46, that the majority of inhabitants of Cambay, the great western Indian port of the fourteenth century, were foreign merchants.[4] The immense wealth of a prominent twelfth century Muslim merchant, Ramisht of Siraf, illustrates the profitability of the Indian trade.[5] The commercial integration of the Indian Ocean region was a reality throughout the period leading up to the Mughal era in India.[6]

Although there is evidence of Gujarati and Tamil ship owners active in the trade, Indian merchants were increasingly willing to conduct their overseas trade through foreign middlemen. The western extremity of the Indian trade was Fostat, the medieval entrepôt controlled by the Mamluks, which grew to rival Alexandria as the commercial nexus between the Western and Eastern markets. Extensive finds of Indian painted and printed resist-dyed cotton textiles made in the course of excavations in the city, and more recently at the Red Sea port of Quseir al-Qadim, record this otherwise undocumented aspect of India's textile trade.[7] The antiquity of this trade is clear from the first century source *Periplus*, which describes the Gujarati port of Barygaza (Broach) as exporting a variety of textiles, including a coarse dyed cotton.[8] The thirteenth-century Chinese traveller Chau Ju-kua describes 'Guzerat' as producing 'cotton stuffs of every colour . . . every year these goods are transported to the Ta-shi [Arab] countries for sale'.[9] The discovery at Broach of a hoard of gold and silver coins, mostly fourteenth-century and belonging to the Mamluk kingdom of Egypt and Syria, suggests the maintenance of the advantageous trading system recorded since Roman times whereby Indian textiles and other renewable resources were traded for precious metals.[10] Coarse cloths simply dyed with a single colour are the most typical of these modest textiles [11 and 12]. More elaborate, and almost certainly later, examples of Gujarati trade textiles have recently been noted in South-East Asia, particularly in the 'spice islands' of eastern Indonesia.[11]

The Indian textile trade to South-East Asia almost certainly has a comparable antiquity to that conducted with the West, although literary evidence is lacking for this early period. The development of this trade in all probability accompanied the spread of Indian cultural influence in South-East Asia. Textile patterns on sculptures of Indian deities in central Java and elsewhere in the region very probably reflect the prestige cloths in circulation in the late first millennium. Chou Ta-kuan, the Chinese observer of life at the Khmer capital of Angkor at the end of the thirteenth century, wrote that 'preference . . . [was] given to the Indian weaving for its skill and delicacy'.[12] The Portuguese traveller Tomé Pires observed, during his visit to Malacca in 1512, that '. . . if Cambay [Gujarat] ever cut off from trading with Malacca, it would not live for it would have no

outlet for its merchandise'.[13] The Coromandel coast of South India also maintained an active textile trade with Malacca, Pires recording over thirty varieties of cloth in cargoes arriving from Pulicat.

Asian trade in the period leading up to the Mughal period had been dominated by Muslim merchants, particularly Arabs and Gujaratis. They came to South-East Asia to trade for the spices and forest products of the region, particularly the pepper of Sumatra and Java and the cloves, nutmeg and mace of eastern Indonesia, which were in great demand both in India and the West. Central to this commerce was the exchange of Indian textiles. Gujarat, Bengal and the Coromandel coast were the regions which serviced this trade, contributing their cottons, silks and muslins. The staple of the trade was, however, painted and printed cottons, resist-dyed, some with mordants (dye fixatives), often of a coarse weave. The majority were of the Gujarati type known from the Fostat trade. In the records of the European trading companies these cloths were referred to as *sarassa*. The composition of a double-cloth collected in Indonesia [13] resembles the large ceremonial cloths (*dodot*) much prized in Javanese court circles and probably represents a prestige import from India. Of particular interest is the 'patchwork' centrefield which provides a remarkable index of designs found on the Indian trade cloths of the period. Amongst these is the geometric pattern recognisable as *patola*.

*Patola* are produced by the labour-intensive process of double *ikat* and consequently have always been regarded as high-prestige items. They formed an important part of the Indian textile trade to South-East Asia from at least the sixteenth century, when European sources first began reporting this trade. Their origins probably date much earlier; the Gujarati merchants who controlled this trade for much of its history were well established in the port cities of Java by at least the early fifteenth century.[14] The Dutch sources refer to 'patola zouratta'– that is, *patola* Surat – identifying this port-city in Gujarat as the major source for export *patola* intended for the South-East Asian spice trade. *Patola* production was closely associated with Patan and Ahmedabad and the reference to Surat probably reflects its importance as a distribution centre for the western Indian textile trade.

The right to wear *patola* was widely claimed as a prerogative of the nobility in Indonesia, a practice encouraged by the Dutch East India Company (VOC) who distributed *patola* to local rulers as part of the incentives offered to win local trading concessions and co-operation. The elephant-and-tiger design [14] appears to have been made almost exclusively for export to South-East Asia and is known to have been accorded very high status in Java [15]. The export of such cloths to South-East Asia continued well into the nineteenth century. The production of *patola* in Gujarat continues to this day and remains highly expensive.

**13. Ceremonial garment** (detail) ▶
Resist-dyed cotton
India, probably Gujarat, late 18th century
238 x 316cm
IS 41–1988

An exceptionally large cloth produced for the Indonesian market, combining a central medallion with a 'patchwork' (*tambal*) design and borders decorated with fabulous animals including the Chinese *kylin* (dragon-headed horse) and Indian *gajasimha* (elephant-lion).

**14. Patolu** (detail)
Resist-dyed (double ikat) silk
Gujarat, late 19th century
100 x 392cm
IS 5–1989

The elephant-and-tiger design appears to have been produced almost exclusively for the South-East Asian market, most recorded examples having been found in Indonesia.

**15. Prince of Surakarta and his family**
Central Java, Indonesia, *c.*1924
Photo courtesy of Mangkaunagaran palace, Surakarta

Prince Adipati Ario Prabu Prangwadono and family with an imported Indian elephant-and-tiger *patolu* as a ceremonial backdrop, reflecting the high status of such cloths.

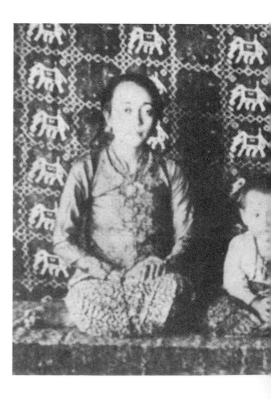

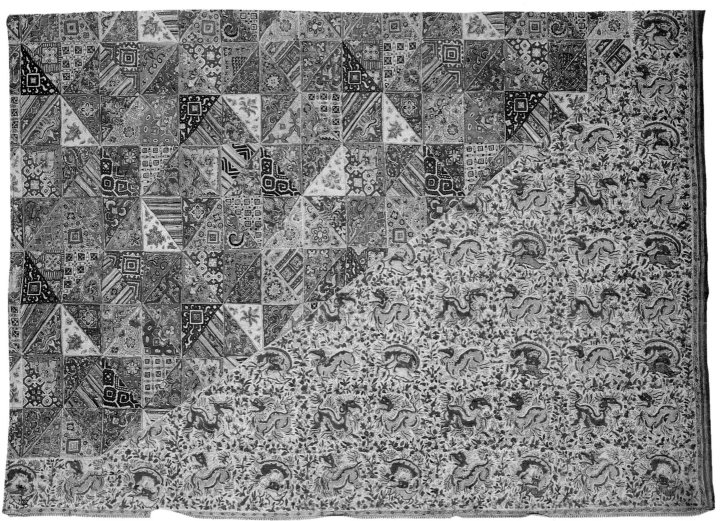

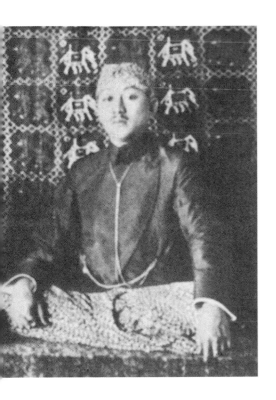

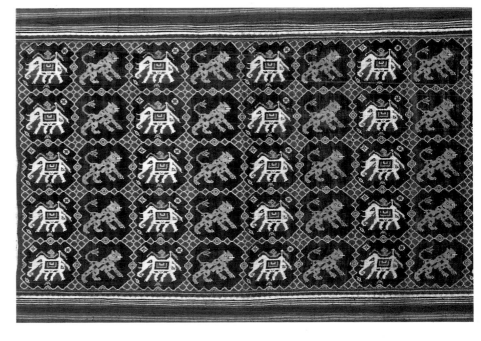

## The Hindu-Jain Tradition

The early Mughal rulers, eager to establish artists' workshops to rival the Muslim courts of Iran, discovered that they had a rich indigenous tradition upon which to draw. Earlier Muslim invaders, particularly of the Sultanate period (c.1200 to 1526), had made a similar discovery, and recruited local artists to produce illustrated books in the Islamic vertical codex in a style imitative of contemporary Iranian painting. Other artists in turn, working for local patrons, absorbed elements of these foreign subjects into the style in which they were trained, the indigenous Hindu-Jain tradition.[15]

### Western India

The earliest surviving manuscript paintings in the Hindu-Jain tradition date from around the twelfth century and are executed on the palm-leaf folios and wooden covers of religious manuscripts. In the course of the thirteenth century paper was introduced into northern India and the Deccan by the newly established Muslim courts and gradually displaced palm-leaf as the principal manuscript medium. Palm-leaf manuscripts continued to be produced in western India up to and including the fifteenth century, though they are rare after that. These kingdoms maintained close trade and cultural ties with the Islamic lands, particularly Iran, which through a series of cultivated rulers, was in the process of creating a painting style of unrivalled refinement. Elements of this courtly style were taken up by local artists but the resilience of the indigenous tradition was such that they were confined to the representation of foreign subjects, the introduction of new luxury pigments and the extension of the decorative repertoire, particularly as seen in the borders of paintings. These elements had little impact on the style or composition of indigenous painting which, although not static, evolved slowly until the late fifteenth century when the pace of change quickened. The first half of the sixteenth century witnessed a revolution in Indian painting styles which contributed significantly to the character of the school created under the patronage and close scrutiny of the young Mughal emperor Akbar (r.1565–1605).

Western Indian painting of the medieval period, (twelfth to sixteenth century), is often described as being in the Jain style, as the great majority of surviving paintings from this period appear in illustrated religious texts belonging to Jainism, an ascetic and non-violent religion widely practised among the merchant and trading communities of western India and the Deccan. However, a significant number of Hindu manuscripts in this style survive to make the 'Jain' nomenclature inadequate. As most of the earlier examples at least can be associated with Gujarat, Rajasthan and Malwa, 'Western Indian style' appears a more satisfactory title, notwithstanding the discovery of provenanced manuscripts from Yoginipur (Delhi region), Jaunpur and other sites in North India.

The Western Indian style had its origins in a school of Jain painting which emerged towards the end of the first millennium largely in the service of the Svetambara ('white clad') sect. The two most frequently illustrated texts were the *Kalpasutra* (Book of Ritual), the major canonical text, and the *Kalakacaryakatha* (The Story of Kalaka), the most important work of non-canonical Jain literature. These texts were copied and illustrated at the request (and expense) of the Jain laity who presented them to their spiritual mentors. Early Jain religious texts, such as the *Uttaradhyayanasutra* (containing the last teachings of Mahavira, the historical founder of Jainism), warn Jain monks and nuns of the power of paintings to arouse sensual thoughts and passions, and the *Kalpasutra* actually prohibits monks and nuns from practising the art of painting.[16] These injunctions appear to have gradually been relaxed. The earliest known illustrated Jain folios are those of the Jaisalmer manuscript, dated 1060.[17] Early Jain painting has survived in far greater quantity than their Hindu counterparts. This is largely due to the institution of the Jain *bhandars*, temple libraries built and maintained by the Jain community, the establishment of which may date as early as the fifth century. Over the centuries the Jain *bhandars* became the protectors of a sacred literature and, almost incidentally, the custodians of an important painting tradition.[18]

The development of the Western Indian style is marked by the rapid abandonment of the naturalism and illusionism of the mural and manuscript style of earlier Hindu-Buddhist painting [16] in preference for a style based on linear expression and a limited stock of figure-types and postures. In the earliest Jain painted manuscript covers the limited use of shading and the gradation of colour for purposes of modelling were still employed.[19] These conventions had largely disappeared by the mid-fourteenth century when the earliest illustrated Jain manuscript on paper appears. By the early fifteenth century, when dated examples become more numerous, the prevailing style is clear: a brilliant palette and simple forms, with little interest in enriching the background of the painting or the page margins. A painting on cotton dated 1447 is exceptional in that it has some excellent landscape and details of the natural world [17]. Numerous early texts, such as the *Samyutta Nikaya*, refer to the use of cloth (*khaddar*) in early Indian painting, together with murals and polished wooden panels, although little survives. This example is one of the earliest extant Jain dated cloth paintings. The centre-field is filled with sacred syllables (*mantras*) painted in gold lettering in a configuration known as *bija mantra*. An exceptional feature of this *yantra* (sacred diagram) is the representation of Hindu deities in the upper register honouring Jainism. Worshippers, including a princely figure on a richly caparisoned elephant, flank the ritual umbrella (*chattra*), the devotional focus of the painting [4, illus. p.18].

An important canonical text, the *Uttaradhyayana* prescribes the

**17. Jain** *yantra* (detail) ▶
Gouache, ink and gold on cotton
Gujarat, dated 1447
137 x 110.5cm
IM 89–1936

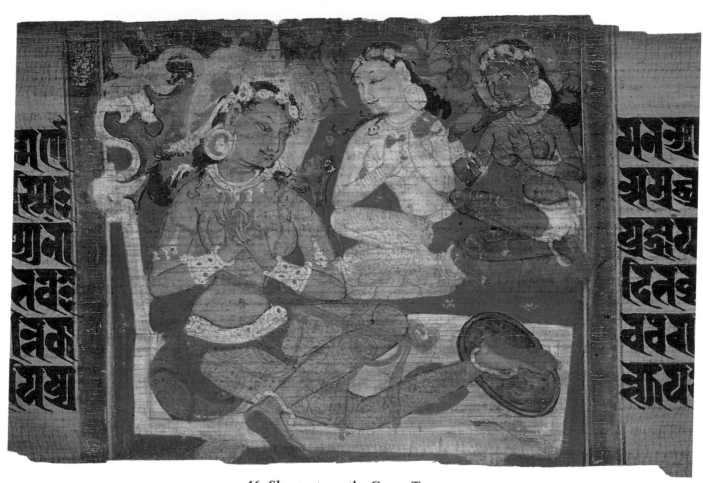

### 16. Shyamatara, the Green Tara

Ink and gouache on palm-leaf
Eastern India
Pala period, *c.*1120
Folio 6.5 x 52.5cm
IS 8–1958

From a dated manuscript copy of the
*Ashtasaharasrika Prajnaparamita* text.
Manuscripts of this kind were pro-
duced for use in the Buddhist teaching
monasteries of eastern India; this one
was donated by a lay worshipper,
Udaya Sinha, in the 36th year of the
reign of the Pala king Ramapala.

rules of behaviour for the monastic community. One folio illustrates the maxim that those monks seeking perfect chastity should avoid the attractions of women [18]. A monk clad in the white robes of the Svetambara sect stands unmoved while two youthful women attend him and another dances to the accompaniment of female musicians. The human figures have an exaggerated angularity, a feature particularly pronounced on the women with their full breasts and slender waists. Faces are shown in three-quarter profile but with the farther eye allowed to project beyond the profile, a curious convention which occurs in the twelfth-century murals of the Alchi monastery, Ladakh, and elsewhere. A feature of fifteenth-century Western Indian painting is the introduction of rich pigments borrowed from Persian art, notably the often lavish use of ultramarine, crimson, gold and silver. This painting is confidently, if somewhat carelessly, executed, suggesting that it is the work of a studio engaged in the mass production of such manuscripts for the Jain community rather than of an artist striving to achieve the highest quality, despite the rich materials at his disposal. Colophons record that the major studio workshops engaged in the production of manuscripts were at the Jain centres of Patan and Ahmedabad. This manuscript bears a later colophon stating that it was produced at Stambhatirtha, the Jain centre of Cambay on the Gujarat coast.[20]

For much of India workshop activities, such as painting, were undertaken by members of particular castes whose role in society was determined by birth. It is particularly interesting in this context to discover that a number of the finest Jain manuscripts of this period, such as the *Kalpasutra* from Jaunpur (dated 1465) were written and illustrated by members of the Hindu caste of professional scribes, the *kayasthas* from Bengal.[21] As stated earlier the Western Indian style was not confined to the service of the Jain community alone: a number of fifteenth and sixteenth century Hindu illustrated manuscripts are known, and a recently discovered copy of the *Shahnama*, the Persian *Book of Kings*, establishes a Sultanate period Islamic manuscript firmly in the Western Indian style.[22]

One of the earliest and finest Hindu manuscripts is a Sanskrit copy of the *Balagopalastuti* (*Praise of the Youthful Krishna*) attributed to the mid-fifteenth century, which is in the Museum of Fine Arts, Boston.[23] This devotional work is attributed to the Vaishnava saint Bilvamangala (active *c*.1250–1350). His verses appear to have gained popularity in Gujarat towards the end of the fourteenth century, judging by the appearance of illustrated manuscripts of this text around that time. The subject of the text, the loving adoration (*bhakti*) of the god Krishna, appears to have inspired the artists to instil a *joie de vivre* rarely seen in contemporary Jain painting. Two folios from a copy of the *Balagopalastuti* in the Victoria and Albert Museum's collection illustrate how close these paintings are in style to Jain work. They depict the infant Krishna disturbing the cow-maids (*gopis*)

**18. A monk resisting the attractions of women**
Gouache and ink on paper
Cambay, Gujarat, mid-15th century
Folio 11.2 × 30cm
IS 2–1972

An illustration from the *Uttaradhyana Sutra*, a text containing the last teachings of Mahavira, the historical founder of Jainism.

**19. The infant Krishna tied to a mortar**
Gouache and ink on paper
Gujarat, late 15th century
Folio 10.5 × 23cm
IS 82–1963

From a *Balagopalastuti* manuscript, a Hindu text in praise of the youthful Krishna. The verses of this text inspired some of the most celebratory painting of the period.

churning the butter, and Krishna pleading with his foster mother who has tied the mischievous infant to a mortar in a grove of trees [19]. Part of the Sanskrit text reads: 'Tightly tied by Yasoda with a cow halter to a mortar, rubbing his eyes with the palms of his hands, the Butter-thief quietly wept . . .' This popular subject matter, and its endearing nature, provided the artist with an opportunity to explore new compositional solutions, but despite this there is a remarkable degree of continuity of tradition in the treatment of this subject, reaching back to earlier sculptural prototypes. The figure types, although lively and expressive, remain stereotyped. The architectural detail however, is elaborate and complex by standards of the day and in the treatment of trees, foliage and cloud motifs foreshadows Hindu painting of the early sixteenth century. It could be said that this series of early Hindu paintings provides the continuity between the hieratic and conventionalised style of Jain manuscripts and the exciting developments which occur in Hindu painting over the next fifty or so years.

A group of undated illustrated manuscripts in the early Rajput style, often collectively known as the *Caurapancasika* group (after a manuscript of that name in the N.C.Mehta Collection, Ahmedabad) signal the beginning of this new chapter in Indian painting.[24] It was from artists trained in this new Hindu style that the Mughal atelier was recruited, together with Persian artists trained in the court styles of Tabriz and Herat. This group of Hindu illustrated manuscripts included both devotional literature, such as the *Gita Govinda* (a twelfth century poem recounting Krishna's love for Radha), and secular romantic works, such as the *Caurapancasika* (*Tales of a Love-Thief*) and the *Laur Chanda* (a popular North Indian ballad). This style is represented in the collection by a folio from a *ragamala* series, the *Bhairavi Ragini* [20], which cannot be far removed from the *Caurapancasika* manuscript in either place or time. It shares many common features with the style: the figure types and facial profiles are retained but the projecting eye convention has been abandoned. A wonderfully expressive 'fish-eye' convention gives great presence and sweetness to the figures. The *Bhairavi Ragini* depicts a female devotee performing worship (*puja*) at a shrine of Lord Shiva. The garlanded *linga* is in an architectural setting inspired by the Sultanate architecture of the late fifteenth century: note the crenellations, projecting eaves with slender brackets, and roof-top pavilions. The *makara*-standard eave decoration, seen also in the *Caurapancasika*,[25] confirms that these palace settings are those of a Hindu court. The provenance of this group is problematic; both Mewar in Rajasthan and the Delhi-Agra region have been suggested. Mewar, a stronghold of Hindu culture resistant to the rising tide of Islamic influence, is a very probable source. This painting was in fact acquired in Udaipur, the capital of Mewar, in 1931.

One of the most remarkable manuscripts in this early Rajput

**20. A devotee performing puja**
Gouache on paper
Possibly Mewar, *c.*1520–40
21.2 × 16.4cm
IS 110–1955

An illustration to the musical mode *Bhairavi Ragini*, depicting a woman devotee worshipping at a *lingam* shrine.

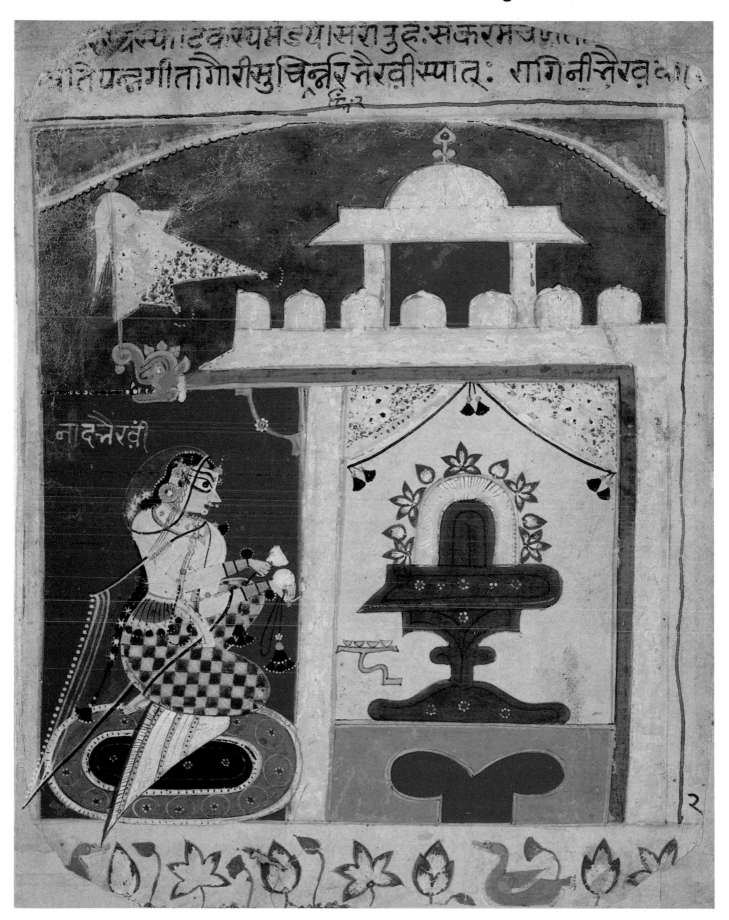

style is a dispersed copy of the *Bhagavata Purana*, a Sanskrit text in praise of Krishna. The paintings, in landscape format, dominate the folios in a way not previously seen; text has been largely relegated to the reverse of the folio and, apart from names identifying the characters depicted, the only other inscription is the name 'Sa Nana', or alternatively, 'Sa Mitharam', which appear on most of the folios and most probably refer to the joint members of a Hindu family who owned the manuscript.[26] These paintings, of which two are in the collection, have a freshness and vigour not seen in earlier works. In *Akrura presenting the jewel Shyamantaka to Krishna* [21], the figures are depicted in a palace interior, with Sultanate period architectural elements visible above. The costume details are richly observed and the composition is given a remarkable intensity through the use of a saturating red and green background to offset the two groups of figures. This event, described in Book 10 of the *Bhagavata Purana*, is set in the golden city of Dwarka. The surrounding water, represented by a basket-weave pattern, is inhabited by ducks. A unifying feature of Hindu painting of this period is the charming observation of such natural details. These paintings, inspired by the devotional literature they illustrate, become a celebration of life and a confirmation of the Hindu world view.

### Eastern India

The development of Hindu painting in the middle of the sixteenth century, and the syncretism of Hindu, Sultanate and the Persian traditions as seen in such early Mughal works as the *Tutinama* and the *Hamzanama* [46], are the subject of chapter 3. Later Hindu painting in the courts of Rajasthan and the Punjab did not escape the pervasive influence of Mughal culture. Traditional Hindu painting did, however, survive in regions where the Islamic presence was less effective, such as parts of eastern India and in the South.

A painted cover for a manuscript copy of the *Vishnu Purana* [22], the (now lost) colophon of which was dated to 1499 (Bengali Samvat 1421), shows the vitality of the Hindu religious tradition.[27] This cover (and its companion cover now in the British Museum) is a rare survivor of the medieval painting tradition of eastern India in the post-thirteenth century period following the collapse of the Pala dynasty. This manuscript cover chronicles the shift from the modelling techniques of the classical style as it survived in Pala Buddhist painting [cf.16] to the linear style long prevalent in western India. It can be seen to document the victory of the folk tradition of village India, with its stress on expressive, economic line, over the naturalism and fidelity so prized in the classical style of the courts and temple establishments. The *Vishnu Purana* is one of the earliest of the Sanskrit devotional texts, dating from around AD 500, recounting the legends of Vishnu. This cover depicts the ten incarnations (*avataras*) of Vishnu. The manuscript was collected early this century at Vishnupur, Ban-

**21. Akrura presenting the jewel ▶ Shyamantaka to Krishna**
Gouache on paper
Mewar or possibly Uttar Pradesh,
*c.*1520–40
17.5 × 23.5cm
IS 2–1977

From a now dispersed *Bhagavata Purana* manuscript of some three hundred folios. It is inscribed on the reverse with verses from Book 10, chapter 57 of the *Bhagavata Purana*, the Sanskrit text recounting Krishna's exploits.

**22. The ten incarnations of Vishnu**
Gouache on wood
Bengal, Bankura district(?), dated 1499
9 × 56.5cm
IS 101–1955

Cover from a *Vishnu Purana* manuscript, an early text recounting the various 'descents' (*avataras*) made by Vishnu through the Ages in order to perform some heroic act on behalf of mankind. The ten *avataras* illustrated here are among the most popular stories in the Hindu tradition.

kura district, in south-western Bengal, close to Orissa. The linear style has close affinities to that of Orissan painting, particularly in the facial profiles and treatment of the eye [cf.24].

The most popular form in which this Hindu folk tradition persisted into recent times was the painted narrative scroll illustrating devotional stories. The wandering *patua* (artist-storyteller) is known from literary sources to have been practising his craft as early as the seventh century.[28] With the revitalization of Hinduism in sixteenth century Bengal through the activities of Chaitanya (1485–1534) and the *bhakti* (devotion) movement, Vaishnava themes, particularly those centred on Krishna and Rama, became the most popular subjects [23]. As witnessed by the survival of the *patua* tradition, Hindu painting in Bengal retained a vitality not in evidence in other schools of Indian painting which were, by this period, either under the spell of the late Mughal school or given over to catering to European taste.

An archaic style of manuscript illustration in which the design was incised on palm-leaf (*palmyra*) folios, a technique largely abandoned in the fourteenth century with the widespread availability of paper, persisted late in Orissa. Paper appears not to have been widely used in Orissa before the eighteenth century, and palm-leaf was still in use for manuscripts early this century. The texts and their illustrations are mostly devoted to Vaishnava subjects. A folio from a dispersed Ramayana manuscript [24] illustrates the style. This technique was also employed for the production of secular manuscripts, particularly erotic treatises.[29] The use of a metal stylus to incise the design, which is then rubbed with lamp-black, and the limited use of added colour ensure that these illustrations have a sharp, linear quality. This Orissan style, essentially a survivor of the late medieval Hindu tradition, appears to have been untouched by Islamic influence, despite the incorporation of Orissa in the Mughal empire in 1592 and the presence of strong Muslim rulers in neigbouring Bengal.

*Hindu Art in the South*

With the large-scale penetration of Islamic influence into northern India in the centuries leading up to the formal annexation of many regions into the Mughal empire, and the emergence of new sultanates in the Deccan, the Hindu kingdoms of southern India found themselves increasingly on the defensive. The South had traditionally seen itself as the great defender of Hindu values and laid claim to the purest lineage of Brahmanical culture. The temple establishments of South India survive to this day as powerful centres of economic and social influence as well as of religious authority. A traditional part of consolidation of political power for any ruler lay in the close identification he and his family had with a particular temple. Temple establishments were richly supported by all levels of society, and royal donors often directed their support to the renovation of temples

**23. Scene from the *Ramayana*** ▶
(detail)
Gouache on paper
Murshidabad, Bengal, c. 1800
863 x 51cm
IS 105–1955

**24. Scene from the *Ramayana***
Ink and colour on palm-leaf
Orissa, 19th century
4 x 39.35cm
IS 24–1967

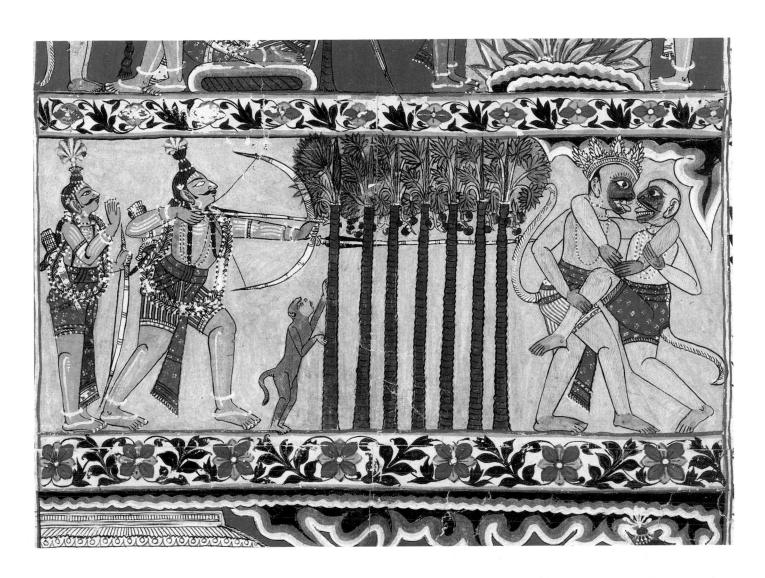

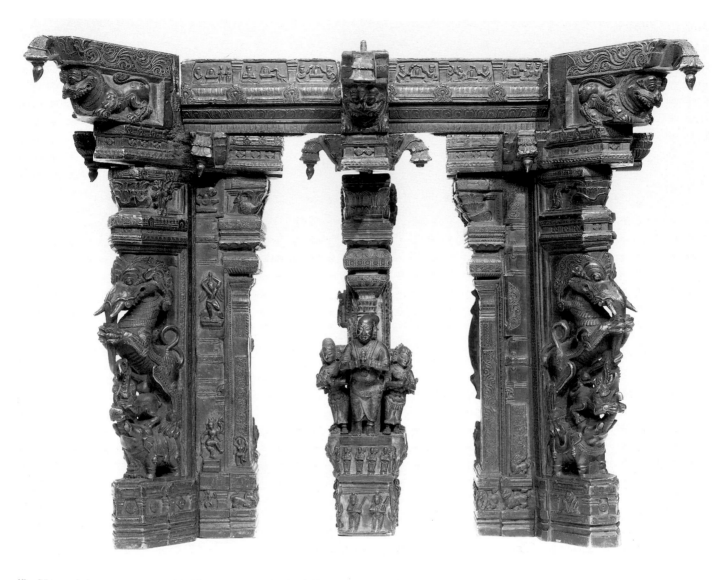

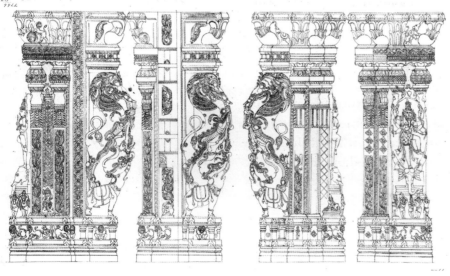

## 25. Model of a section of Tirumala Nayak's *Pudu Mandapa*, Madurai

Bronze
Madurai, *c*.1780–89
32 x 46 x 20cm
98–98d – 1870
Given by J. Heywood Hawkins

A scaled model of sections of this hall were produced under the direction of Adam Blackader in Madurai in the 1780s and presented to the Society of Antiquaries in London in 1789, marking the beginning of an antiquarian interest in India among European scholars.

## 26. Preparatory drawing for the bronze model of Tirumala Nayak's *Pudu Mandapa*, Madurai

Madurai, *c*.1780–89
Ink on paper
38.25 x 54cm
AL 7766 (137)

and the addition of new enclosure walls (*prakaras*) pierced by massive gateways (*gopuras*). The building of pillared halls (*mandapas*) became a particular feature of royal patronage in South India in the sixteenth and seventeenth centuries.

Patronage under the Nayaks, the Hindu kings of South India in this period, represented a continuation of the traditions encouraged by the Vijayanagar rulers of the southern Deccan. The Nayaks were prolific builders and have left a legacy of monumental temples throughout Tamilnadu, the most famous of which include those at Srirangam, Vellore, Kancipuram and Madurai. The most enthusiastic patrons were the Nayaks of Madurai, and so prolific was their building activity that this last phase of Vijayanagar architecture became known as the Madurai style. Tirumala Nayak (r.1623–59), the first Nayak to assert his independence from the Vijayanagar kingdom, was an energetic patron. The construction and endowment of temples and the support of religious festivals formed a major part of his activity as a ruler eager to assert his political autonomy. The Great Temple of Madurai, dedicated to Minaksi and Sundaresvara (Shiva), was substantially rebuilt by Tirumala Nayak and a spectacular pillared hall, the *Pudu Mandapa*, was built beyond the east gate. This hall attracted considerable attention from early European visitors to Madurai, not least because of its series of portrait pillars of the Nayak rulers of Madurai. Adam Blackader, a British surgeon resident in the city, according to his own account published in 1792, employed his 'leisure hours for three years in making drawings of the temple . . . and in forming the pillars of the great *choultree* [pillared hall]'.[30] Sections of this model, in bronze, and a series of preparatory drawings, survive [25 and 26]. They illustrate the flamboyant 'baroque' style of seventeenth-century Nayak architecture with its exaggerated elements and the rather rigid sculptural treatment. Nayak temple architecture and sculpture was richly polychromed; the walls and ceilings of shrines were decorated with elaborate murals of which much survives *in situ*.

Hindu patronage in the Nayak kingdoms was not confined to temple building. A strong tradition of ivory sculpture for example, both devotional and secular, was another achievement of the later Hindu tradition of the South. To some extent it continued the themes and motifs given expression on the decorated pillars of Nayak architecture, particularly the use of the *yali* (mythical lion or leogryph) and rearing equestrian warriors [26]. Much of it, however, is of a more gentle nature, concerned not with public expressions of power but with the intimate relationship of a devotee and his god. A relief depicting the marriage of Shiva and Parvati, *Kalyanasundaramurti* ('the Wedding of the Charming One'), is an ivory sculpture of remarkable tenderness [27]. The marriage of Shiva and Parvati has a special significance at Madurai where it is celebrated in local myth; the two principal shrines of the Great Temple are devoted to Minaksi (said

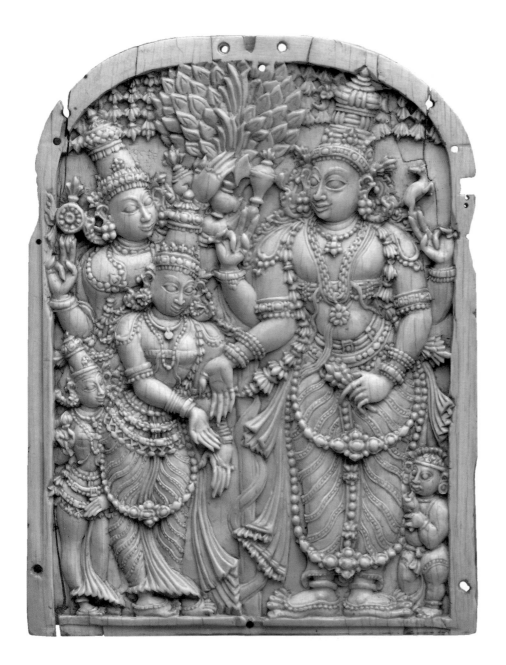

## 27. The Marriage of Shiva and Parvati

Ivory
South India, possibly Madurai, *c*.17th century
16 x 11cm
IM 70–1930

to be an incarnation of Parvati as a beautiful daughter of a local Pandyan king) and Shiva (known locally as Sundaresvara) and their images are brought together during the festival of Citra (April–May), the biggest festival in the ritual calendar of the Madurai temple. This ivory may well be associated with the city of Madurai whose Great Temple celebrates this marriage.

### The Pre-Mughal Islamic Tradition

Islamic kingdoms began to emerge in the Indian subcontinent as early as the eleventh century in the wake of the military campaigns conducted by the Afghan Mahmud of Ghazni between 999 and 1027. Lahore became the centre from which Islamic cultural influence was introduced to India. Delhi was taken in 1192 after the defeat of the Rajput ruler Prithviraj Chauhan and a Muslim sultanate established there in 1210, with Persian as the court language. This and succeeding sultanates ensured the spread of Islam from Sind to Bengal. By 1335 most of the subcontinent, with the exception of the fiercely independent Rajput states and Madurai in the extreme south, was under the suzerainty of Muhammad ibn Tughluq (r.1325–51), the Sultan of Delhi. Tughluq's empire proved ungovernable and quickly disintegrated into a series of independent Muslim states.

These new sultanates gradually evolved as important political and cultural forces in the life of northern India and the Deccan in the fourteenth and fifteenth centuries. With them emerged what may be termed the 'Sultanate style', visible in their distinctive architecture and painting. This style was shaped by three forces: the patron's cultural origins in Iran, Afghanistan and Central Asia, a devotion to Islam, and a dependence on artists and craftmen trained in the local Hindu-Jain tradition. As the rulers of the new sultanates turned their attention to establishing a court culture of their own, they were obliged to recruit artists trained in the local tradition. The result was a syncretism which reflected the interpretation of Iranian styles through the prism of Indian traditions.

The Muslim rulers also set about the construction of mosques and other monuments to mark the beginning of a new era. This involved the active destruction of many Hindu and Jain monuments, both to generate the necessary building materials and symbolically to underscore the victory of Islam. Stone images and the richly decorated sections of demolished temples were often turned face inwards and used in the construction of mosques, tombs and fortifications. The desecration of the native population's places of worship was a common feature of the imposition of Islamic rule in India. One of the first acts of the Turks after the capture of Delhi was the construction in 1197 of the Quwwat al-Islam (The Might of Islam) mosque, built, according to a contemporary inscription, with materials plundered from twenty-seven Hindu and Jain temples.[31] Although designed on an Arab plan, it incorporated many elements

of contemporary Indian architecture, particularly Jain. In 1199 Qutb al-Din Aybak built nearby the first stage of the Qutb Minar, a remarkable tower of Islamic inspiration celebrating the supremacy of Islam.

Muslim rule was established in eastern India at the beginning of the thirteenth century, following the capture of the Hindu capital of Gaur in 1198 by Muhammad Bakhtyar Khilji. The architectural legacy of the early sultanates of Bengal is to be seen at Gaur, spanning the period from the beginning of the thirteenth century to the abandonment of the site, apparently as a result of plague, in 1575. Apart from a brief interlude at the beginning of the fifteenth century when Raja Ganesh restored Hindu rule, the region remained under Muslim control. The monuments, however, display a Hindu love of vegetal decorative detail, a feature also characteristic of other early Islamic architecture in India, as seen in such Sultanate structures as the screen of the Quwwat al-Islam mosque (1199) in Delhi and the Arhai din ka Jhompra mosque (1199–1200) at Ajmer. Although Islamic in conception, these structures were strongly influenced, in both their detailing and in some structural elements, by the local Hindu architectural tradition in which the craftsmen were trained. Some new architectural forms had their inspiration in Timurid Iran, with whom the rulers of Gaur maintained contact through maritime trade. The monumental Adina mosque near Pandua (*c*.1360) displays the syncretic architectural style of Gaur: flamboyant lotus arabesques and palmette scrolls, with large lotus roundels in the spandrels, applied to a cusped arch [28]. An arched niche, most probably from the Adina Masjid, may have served as a blind window within a pulpit (*mimbar*) or as the surround to a prayer niche (*mihrab*) [29]. The tight design is typical of Islamic architecture of Sultanate Bengal.

A uniquely Islamic contribution to Sultanate architectural decoration is the use of large-scale calligraphic reliefs, particularly in association with doorways, gates and niches [cf.28, upper left]. The fifteenth-century inscriptions of Gaur are particularly impressive for their use of a cursive 'bow and arrow' style of Tughra script. An inscription from a gateway, dated 6 January 1495, illustrates this style [30]. It records the donor and date of dedication:

[This] gate [was built] in the reign of the Sultan 'Ala al-Dunya wa'l-Din Abu'l-Muuzaffar Husayn Shah al-Husayni – May Allah perpetuate his rule and sovereignty – on the twentieth day of the month Rajab, the year 900.[32]

Many of the monuments of Sultanate Bengal, both Islamic and Hindu, were built of brick, often faced or detailed in stone. The extensive use of brick generated an interest in the decorative qualities of clay, which manifests itself in a strong local tradition of terracotta relief decoration. The exterior of many monuments from Sultanate Gaur display this distinctly Bengali feature. A local development from this tradition was the introduction of glazed tiles, a pan-Islamic

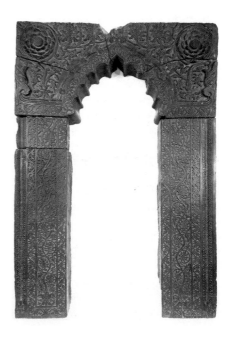

**29. Arched niche**
Black shale
From Pandua or Gaur, Bengal, late 15th century
Ht. 124cm
IS 3396–1883

This cusped arch may came from the Adina mosque near Pandua. The flamboyant plant designs and bursting lotus medallions illustrate the meeting of Hindu design and Islamic form in the Sultanate period.

**28. View of the Adina mosque, near Pandua *c*.1360, Bengal**
Photograph *c*.1860s
(After J.H. Ravenshaw, 1878)

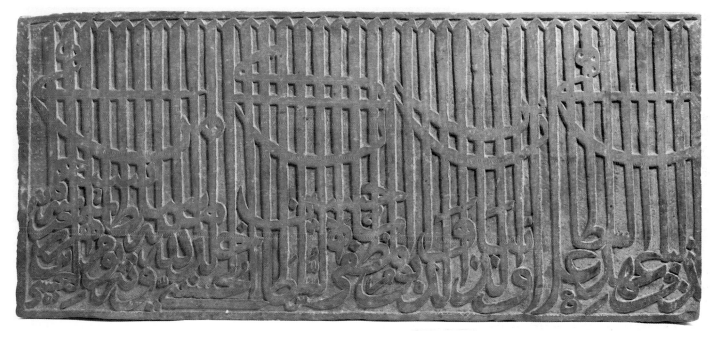

**30. Dedicatory inscription**
Black shale
From the Malda district, Bengal, dated
6 January 1495
34 x 75cm
IS 154–1984

Arabic inscription in the 'bow and arrow' Tughra script, dedicating a gateway built by Husayn Shah (r. 1493–1519), a patron responsible for numerous mosques and tombs in Bengal.

feature of architectural decoration seen elsewhere in the Indian subcontinent in the pre-Mughal period. The earliest dated appearance of glazed tiles at Gaur are on the Eklakhi tomb, generally accepted as the mausoleum of Sultan Jalal al-Din (d.1431). By the late fifteenth century and beyond their use had became prolific, although in Bengal confined to Muslim buildings.

The tiles occur in a variety of shapes: medallions, diamonds, squares; and rectangles with a repeat design to form a continuous border [31]. The designs are a mixture of standard Islamic patterns, formal and repetitive, and more organic vegetal motifs clearly growing out of the earlier Hindu tradition. However, as Robert Skelton has observed, 'even in recent times, the makers of glazed tiles (*kashigars*) have been Muslims whereas Hindu builders (*sutradhars*) have restricted themselves to working with unglazed terra-cotta'.[33]

In 1576 Akbar absorbed Bengal into the Mughal empire. The local rulers of Bengal however, both Muslim and Hindu, enjoyed a remarkable degree of independence and were able to cultivate a Bengali culture which owed little to that of their Mughal overlords. Local Islamic architecture, for example, drew heavily on indigenous forms rather than relying on pan-Islamic models. Hindu art remained fiercely independent, inspired by local Hindu revivalism. The arrival of the Portuguese in the sixteenth century did little to dilute the distinctive regional character of eastern India.

**31. Glazed tile**
From Gaur, Bengal, late 15th–early 16th century
27.5 x 19cm
IM 565 5/11–1924
Given by the Royal Asiatic Society, London

### The Portuguese and Early European Trade

The sixteenth century was marked by two dramatic developments in India's cultural history: the beginnings of European involvement in India's international trade and the establishment of the Mughal empire.[34] The first Europeans to secure a presence in India were the Portuguese who established a trading settlement ('factory') at Cochin in 1503 and shortly afterwards at Goa (1510). Goa quickly emerged as their major entrepôt, where goods from all over India and further east were assembled for despatch to Europe.

The wealth which attracted the Portuguese fleets lay not only in the massive profits to be made from sending spices and 'novelties' back to Europe, but also in participation in the inter-Asian trade. In the first quarter of the sixteenth century the Portuguese succeeded in establishing a presence which stretched from Hormoz in the Persian Gulf to Japan, and included 'factories' in India, Sri Lanka, Malaya, eastern Indonesia and Macao. A vital link in this trading chain was Malacca, captured in 1511, through which much of the region's textile and spice trade was controlled. Portuguese profits were, however, made largely at the expense of Muslim traders, Arab and Gujarati. The precise role assumed by the Portuguese has only become clear in recent studies which have shown that it was Indian capital which underpinned many of these ventures, operating under Portuguese protection.[35]

Portuguese prosperity in India was at a peak in the first half of the sixteenth century when they enjoyed a brief monopoly of Western influence. This situation was soon to be challenged by the Dutch, British and French. Some remarkable examples of Indo-Portuguese art produced during the sixteenth and early seventeenth centuries record the beginnings of a long and profitable association between Indian producers and European consumers. A unique product of this early exchange is a small group of ivory caskets which appear to have been produced in Sri Lanka expressly for despatch to Portugal as diplomatic gifts. These caskets have the distinction of being the earliest datable examples of Indo-Portuguese art. An exceptionally fine example, acquired in Portugal and known as the 'Robinson Casket', illustrates the style [32]. The casket is constructed of solid ivory panels (rather than veneer, which is characteristic of later work) and the lock set with sapphires, most probably Sri Lankan. A recurrent feature of these caskets is the depiction of biblical subjects including, in this example, the Betrothal of the Virgin, the Nativity and the Tree of Jesse, the latter subject after early sixteenth-century woodcut illustrations, such as appear in a book of hours published by Thielmann Kerver in 1523.[36] The first Portuguese contact in Sri Lanka was with the kingdom of Kotte, which governed the prosperous south-west of the island. The establishment of a fort at Colombo in 1518 gave the Portuguese a more secure foothold. An uneasy alliance grew up between the kings of Kotte and the Portuguese, the latter gaining considerable influence by intervening during succession disputes. This box was probably commissioned by King Dharmapala of Kotte to accompany the announcement to the Portuguese court of his conversion to Christianity in 1558. A similar despatch is recorded as occurring in 1542. These conversions appear to have been largely symbolic, a reflection of the ruler's dependence on Portuguese protection.

One of the most distinctive products of the Portuguese trade with India was a group of embroidered bedspreads and wall-hangings, apparently produced at Satgaon, the old mercantile capital of Bengal, near modern Calcutta. The Portuguese were attracted to Bengal, as traders had been since the early centuries AD, by the quality of the region's textiles. These 'Bengalla quilts', of embroidered wild silk (*tasar*, *munga* or *eri*) on a cotton or jute ground, combined European and Indian motifs. The earliest reference to their sale in London, at an auction in 1618, describes the type: 'a Bengalla quilt 3½ yards long and 3 yards broad . . . embroidered all over with pictures of men and crafts in yellow silk'.[37]

References to artisans skilled in this work being recruited in Malacca by Alfonso de Albuquerque, governor of Malacca, indicate that Bengal was not the only centre for the production of this type of cloth. J.H. van Linschoten, who was based in Goa as secretary to the archbishop in the 1580s, observed that Cambay also produced

## 32. Casket

Ivory with gold fittings mounted with sapphires
Kotte, Sri Lanka, c.1540–58
13.7 x 22.8 x 12.7cm
IS 41–1980

This object (known as the 'Robinson Casket') belongs to a small group of caskets which are the earliest documented examples of Indo-Portuguese art. It was probably commissioned by King Dharmapala of Kotte to accompany a diplomatic despatch to Portugal.

## 33. Coverlet

White cotton, quilted and embroidered with red silk
Portuguese settlement, probably Satgaon-Hooghly region, Bengal
First quarter of the 17th century
320.3 x 250.3cm
T 438–1882

This embroidery bears the coat of arms of the Portuguese family Lima da Villa Norvada Cerveira.

**48**

silk embroidered quilts.[38] Nonetheless the local skills employed in Bengali embroidered *kantha* made it an obvious centre for this work and its origins must lie in an enterprising Portuguese commissioning Bengali artisans. An example in the collection [33] is decorated not in the characteristic yellow *tasar* silk so typical of Bengali work, but in red cultivated silk, raising the possibility of a non-Bengali provenance. It displays the characteristic blend of European motifs and subjects, including Portuguese men hunting boar with lances in the Indian manner, as well as muskets and bows, and in the alternate borders musicians and dancers. Portuguese armed merchant ships (*carrack*) appear in a seascape populated with monstrous fish. While the majority of these embroideries were intended to be sold on the open market, a significant number, including this example, have a family crest as the central medallion, indicating that they were private commissions.

The other major product of Portuguese patronage was hardwood furniture, typically richly decorated with inlaid woods and ivory. The forms were generally adapted from European furniture, enriched with expensive inlays in a style inspired by Indian, principally Mughal, decorative arts. A luxury trade grew up in these items, which were assembled in Goa for shipment to Europe from a number of production centres in India, including Sind, Gujarat and the Deccan. Chests, travelling boxes and games boards were among the more favoured items. Seventeenth-century Europeans resident in India refer to this trade and the popularity of the furniture in Europe. J.H. van Linschoten observed in his *Voyage to the East Indies* (1598), that the copying of European furniture, including small cabinets, was underway at this time. The production of Indo-European furniture appears to have begun as a luxury trade destined for the discriminating consumer in Europe, but as greater numbers of Europeans spent longer periods of time in India (particularly in the seventeenth century following the founding of the East India Companies), a considerable 'home market' developed among the European communities.

A classic example of the Indo-Portuguese cabinet is to be seen in **34**. Its simple form is richly decorated with fine marquetry of contrasting woods pegged with bone. It was not uncommon for Chinese and Japanese metal mounts to be imported by the Portuguese from their eastern 'factories' for use in such cabinets. A hardwood cabinet with inlaid ivory and wood mosaic (*sadeli*) [35] is a direct copy of a seventeenth-century northern European bureau. The decorative scheme reveals the hand of a designer trained in the Mughal style of the early seventeenth century. Its simple, architectural form is transformed by the rich inlay which envelops its entire surface, including the inner surfaces of the doors. It was probably made in Sind, a region renowned for its fine *sadeli* work, a technique which appears to have been introduced to Sind from Shiraz in the sixteenth century. A travelling box also decorated with inlaid ivory and hard-

**34. Cabinet on stand**
Wood marquetry with bone pegs and metal mounts
Portuguese settlement, probably Goa, late 17th century
63.5 x 45.7cm (with stand 132 cm)
W 781–1865

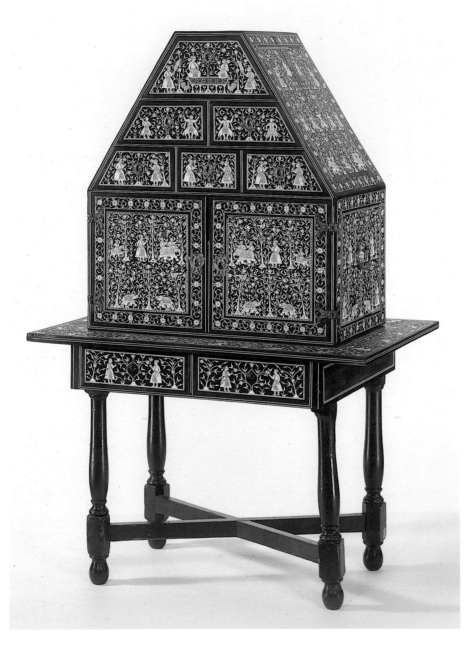

### 36. Travelling cabinet on stand

Wood with ivory inlay
Western India or Deccan, late 17th-early
18th century
46.3 x 64.1 x 42.9cm (with stand 83.2cm)
IS 44 & A–1972

Items of this type were largely prod-
uced under Portuguese direction
for export to Europe, where most
recorded examples survive today.

### 35. Cabinet and table-stand

Wood, with ivory and wood inlay and
metal fittings
Probably Sind, early 17th century
73.5 x 65 x 36.5cm (with stand 136.5cm)
IM 16–1931
Given by the Trustees of the British
Museum

A bureau, made to Portuguese
commission, modelled closely after
northern European models and
intended for export to Europe.

### 37. Travelling box
Mother-of-pearl set in black lac over a wooden frame
Gujarat, probably Ahmedabad, early 17th century
35 x 51 x 28.5cm
155–1866

Travelling boxes of this type were mentioned in seventeenth century European accounts as popular export items to Europe.

### 38. Communion table
Blackwood with ivory inlay
Possibly Sind, early 17th century
84 x 106 x 82cm
15–1882

Church furniture was commissioned by the Portuguese to use both in Asia and for export to Europe, as inventories as early as 1608 record.

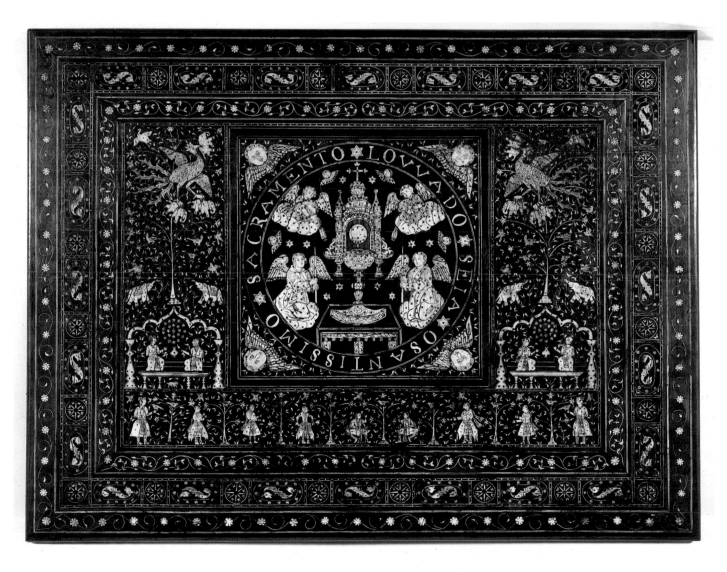

woods [36] shows a close affinity with the painting and decorative arts of the Deccan.[39] The interest in acrobats, dancers and musicians suggests that it was intended for a European market, foreshadowing a favourite subject of Company painting in the following century.

Mother-of-pearl was another material widely used in the decoration of such items, particularly small storage chests [37]. The centres of production appear to have been Ahmedabad and Cambay, and later Surat. A bevelled lid and pedestal foot is a distinctive feature of such chests. The mother-of-pearl overlay in this example is very fine and the Timurid-inspired scalloped medallion on the lid of exceptional quality. This technique of decoration, with mother-of-pearl set in a black lac ground, is in evidence in Gujarat on wooden tomb-covers of the early seventeenth century, and mother-of-pearl was employed as inlay as early as the 1460s in Islamic tomb decoration.[40] The centres of production appear to have been Ahmedabad and Cambay. Much of this work was produced for supply to the Turkish market, as examples preserved in the Topkapi Sarayi Museum, Istanbul, testify. Gujarati craftsmen were also brought to Fatehpur-Sikri, Agra and Delhi to carry out commissions for their Mughal patrons.[41] An example recorded in a European inventory of 1602 confirms the early arrival of such items in the West.[42]

A feature of early Portuguese activity in India was the close alliance of the soldier-merchant and priest, less in evidence among later European intruders. Churches and missions were established throughout Portuguese Asia to further their evangelical work. This generated a need for furnishings and the other trappings of a well-appointed church, including religious images in wood and ivory. One type of Indo-Portuguese furniture produced largely for use in Asia appears to have been the Communion table, in demand from Jesuit missionaries throughout Portuguese Asia. These tables are typically decorated with a dominant Christian motif, such as angels adoring the sacraments, with Indian designs as subsidiary motifs [38]. Such tables are known to have been commissioned by Jesuits (including those proselytising in Japan) as early as the 1580s. A number of examples are recorded in English collection inventories between 1608 and 1624.[43]

Crucifixes and the Child Jesus as the Good Shepherd became stock subjects [39].[44] In the seventeenth century these images tended to follow closely the Portuguese baroque style; by the eighteenth century this had softened into a more naive folk style, possibly reflecting the influence of Portuguese religious folk art as well as revealing the hands of local converts at work. These Christian ivory sculptures are generally associated with Goa, although they circulated throughout Portuguese Asia, including Macao and Japan.

The India which the Portuguese 'discovered' at the close of the fifteenth century was politically fragmented. In the course of the following century the Mughals succeeded in unifying India to a

**39. The Child Jesus as the Good Shepherd**
Ivory
Portuguese settlement, probably Goa, late 17th–18th century
Ht. 43.5cm
A 58–1949

The Portuguese commissioned religious images for use in their churches throughout Asia. Much of the finest work was produced in Indian workshops.

degree not seen in the subcontinent since the 1330s, under the reign of Muhammad ibn Tughluq, sultan of Delhi. A variety of cultural influences were absorbed during the Mughal period – including those of Europe as transmitted through political agents and trade. The Mughals drew liberally on the reservoir of traditional skills at their disposal within the subcontinent and, in turn, helped shape the development of the fine and decorative arts in India.

1. Daniélou, 1965, pp.18–21.
2. Wheeler, 1946–7
3. Schoff, 1912, p.47.
4. Ibn Battuta, 1929, p.229.
5. Recorded in inscriptions and business letters preserved in a synagogue in Fostat, see Stern, 1967.
6. Chaudhuri, 1985.
7. Gittinger, 1982, pp.31–57 and Kubiak, W. and Scanlon, G.T., 1989.
8. Schoff, 1927, p.73.
9. Hirth and Rockhill, 1911, p.92.
10. Codrington, 1882–3.
11. Guy, 1989.
12. Chou Ta-kuan, 1967, p.23.
13. Pires, 1944, p.45.
14. Digby, 1982, p.144.
15. For the origins of painting in India as preserved in mural and early manuscript traditions, see Guy, 1982.
16. Chandra, 1948, p.8.
17. Shah, 1976, pp.2–4, figs.6–8.
18. Shah, 1978.
19. Chandra, 1948, fig.199.
20. Losty, 1982, p.60.
21. Ibid, p.45.
22. Goswamy, 1988.
23. Brown, 1930.
24. See A. Topsfield in Gray, 1981, p.160 and Shiveshwarkar, 1967.
25. Barrett and Gray, 1963, p.66.
26. Khandalavala and Mittal, 1974, p.28.
27. French, 1927.
28. Topsfield, 1979, p.34.
29. Guy, 1982, pp.38–9
30. Guy, 1990.
31. Nath, 1978, p.9.
32. Digby, 1973, pp.590–1.
33. Skelton, 1979, p.30.
34. For a discussion of Portuguese motives, see Pearson, 1976
35. Boxer, 1980, p.43.
36. In *Hore intemerate virginis Marie . . .* , Paris, 1523; see also T. Wilcox, Indian Department Archives.
37. Egerton Ms., quoted in Irwin and Schwartz, 1966, p.48.
38. Mendonca, 1978, p.15.
39. For a discussion of this type of work and its provenance, see Digby, 1962–64.
40. See Digby, 1986, p.214.
41. Welch, 1985, pp.139–40.
42. Preserved in the Green Vaults, Dresden, and first recorded in the inventories of the Elector of Saxony in 1602; Digby, 1986, p.214.
43. Irwin, 1953.
44. Collin, 1984.

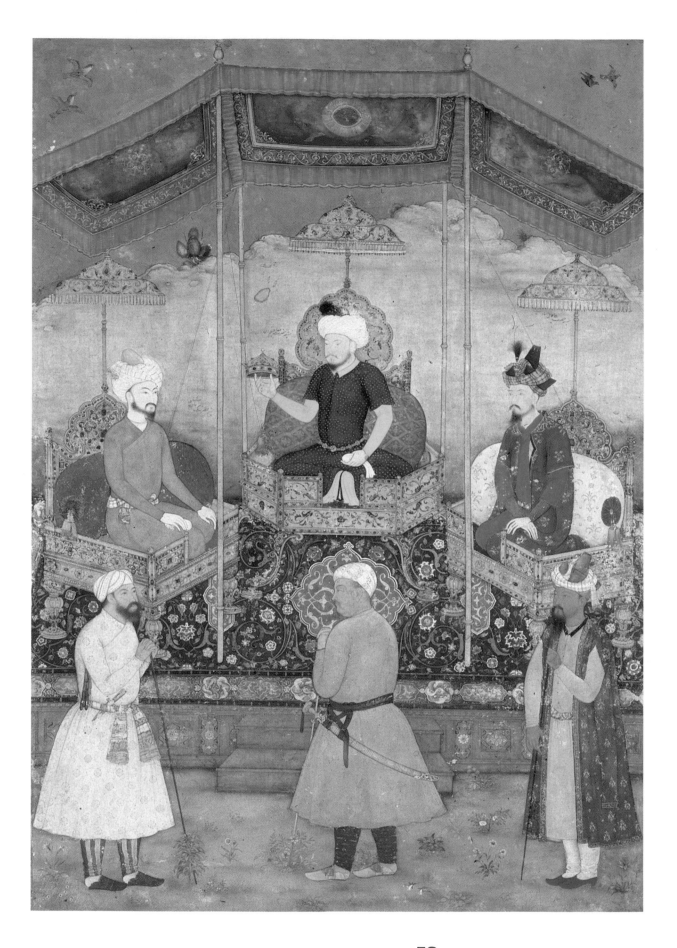

# 3.
# The Age of the Mughals

**Babur, Humayun and Sher Shah Sur**

The founder of the Mughal empire won his first military victory at
the age of fourteen. Zahir ad-Din Muhammad Babur (r.1526–30) was
descended from the famous ruler Timur-i Leng (the Tamberlaine of
Christopher Marlowe's play) on his father's side, and from Jenghiz
Khan through his mother. He inherited the Timurid kingdom of
Ferghana in 1494 at the age of eleven but, as a Timurid prince, he
soon looked beyond the borders of his own small, rather insignificant
inheritance to Timur's great city of Samarkand. After three years of
struggle, including a seven-month seige, Babur managed to capture
Samarkand from his cousin and proclaimed himself ruler. Only a
hundred days later, however, he was forced to leave in order to save
Ferghana, where his younger brother had been induced to rebel
against his authority. The move was disastrous. He failed to quell the
rebellion and, in his absence, Samarkand was taken by a rival. Babur
was without a throne, a condition which was to be almost constant
over the next few years and which, he recalled, was not met with
equanimity: 'It came very hard on me; I could not help crying a good
deal.'[1] Accompanied by two to three hundred men, he went to
Khujand where his mother, grandfather and the families of his fol-
lowers joined him.

Two further attempts to regain Samarkand also ended in failure
and his thoughts began to turn towards Hindustan, or northern India,
which Timur had briefly occupied in 1398, and which was seen as a
legitimate area of conquest by his descendants. The military experi-
ence of his 'throneless' years enabled him to take Kabul in 1504, and
this provided a secure base from which to launch his various raids
into the Delhi sultanate between 1505 and 1515. In 1526 he made his
final, successful attack. Ibrahim Lodi's army of 100,000 men and 1,000
elephants set out to meet Babur's considerably smaller army: the
armies faced each other at Panipat.[2] Although Babur's army had
artillery, it would seem that this was not in sufficient quantity to
influence the battle's outcome; the decisive victory came from su-
perior strategy and highly disciplined forces. Babur marched on to
Delhi to proclaim himself *padshah* (ruler), on 27 April 1526 and then
proceeded to Agra which his eldest son, Humayun, had already
captured.

**40. Timur handing the imperial
crown to Babur**
> Gouache and gold on paper
> By Govardhan
> Mughal, *c*.1630
> 29.3 x 20.2cm
> IM 8–1925

Made for a royal album of Shah Jahan
and inscribed with the name of the
artist in the emperor's hand, this
painting is one side of a double
composition illustrating the Mughal
line of descent from the Mongol
ruler Timur. At least part of the album
came into the hands of the Earl of
Minto who was Governor-General of
India from 1807 to 1813; it was
dispersed in 1925.

Babur had a more complex character than these military exploits might suggest. His writings, even when known only through translation, show him to have been highly educated. He makes frequent reference to the poets, writers, artists and architects of the Islamic world, accompanied by his own analysis of their work. He wrote poetry in Turki, his native language, and in Persian, as well as a long, versified treatise in Turki on Muslim law for the education of his son, Kamran. He seems also to have been an accomplished calligrapher, devising his own script in 'Baburi' style. He was acutely sensitive to his physical surroundings, noting points of interest as he travelled, and leaving a vivid description of his first impressions of the newly conquered lands of Hindustan in his book, the *Baburnama*. He found the country completely exotic; it seemed to him a different world. 'Once the water of Hind is crossed, everything is in the Hindustan way: land, water, tree, rock, people and horde, opinion and custom.'[3] He found it 'a wonderful country', 'full of produce',[4] and he described in detail the birds, animals, fruits, flowers and plants he had never seen before. Other sections give seemingly random impressions of what he found. He notes the names given by the inhabitants to days of the week and seasons of the year, how they measured time, and their system of accounting, pertinently adding that the use of high units such as the *lakh* (100,000) and *crore* (100 *lakhs*), were proof of the great wealth of the country.[5] He concluded with a list of the merits and demerits of the land, which seems to have been influenced by the excessive character and pestilential winds of the hot season of 1526. The first attractions of Hindustan to its new ruler were its size and its enormous possessions of gold and silver (though supplies of precious metals were almost all imported, as recorded in the earliest written accounts of India's trade (see p.21). It had 'unnumbered and endless workmen of every kind'.[6] Yet even the advantages were tempered by criticisms: the rains were a good thing, but the climate was impossible because the dampness permeated everything, spoiling books, armour and clothing.

His list of Hindustan's defects[7] seems to stem mostly from the unfamiliarity of what he found. Social manners were different, and were perceived as inferior. He could not obtain good bread, or cooked food in the bazaar, or find ice, melons, grapes or fine horses. He complained that there was no 'form and symmetry' in art, revealing the difference between the work of a craftsman or artist working in a Muslim tradition and one brought up in the traditions of India where surface pattern and, often, form derive from nature.

Babur soon began to alter his surroundings to make them harmonise with his tastes. Noting that Timur had taken Hindustani stonemasons to Samarkand to work on one of his mosques, he now employed 680 masons daily on new building in Agra alone.[8] One of his complaints concerning the towns he saw was their impermanence. Settlements rose up quickly, disappearing as rapidly, and leaving no

trace of their existence. His monuments were intended to survive and he records employing 1,491 stonemasons daily on his entire building programme which covered Agra, Sikri, Bayana, Dholpur, Gwalior and Kuil.[9] Unfortunately, most of these structures have now disappeared.

Babur was always influenced by the beauty of nature, being inspired by the spring flowers on the foothills of the Hindu Kush to write poetry, or describing in his book the leaves of an apple tree tinged with the colours of autumn, near Kabul. This side of his nature, shared later by his great-grandson Jahangir, found expression in one of his earliest building projects. Only a few days after his arrival at Agra he went out to find a suitable site for a new garden, to be laid out in the geometrical, Iranian *chahar-bagh* style, where the square enclosure is divided into four by axial canals or walkways, each quarter divided further if required. The first expedition was dispiriting; he described crossing the only suitable area 'with a hundred disgusts and repulsions'.[10] However, as there was no alternative, a chambered well was begun there, to supply the streams and fountains he thought essential to a garden. Perhaps out of impatience to impose form and symmetry on 'disorderly Hind', digging began in the rainy season and the walls collapsed several times, killing workmen; despite this, the garden, with its octagonal pool, was completed the following year and was filled with tamarind trees, roses and narcissus. Later Babur brought particularly beautiful deep red oleanders from Gwalior and sent for a melon specialist from Balkh to grow the fruit he missed so much. Grapes were also grown successfully. He made other gardens, and must have spent many peaceful hours in them: his daughter, Gulbadan Begam, for instance, describes him sitting in the garden at Sikri, writing the *Baburnama*.[11] His grandson Akbar selected the image of his grandfather directing the laying-out of a garden to illustrate his own copy of the *Baburnama* [41].

Babur's initial victory over Ibrahim Lodi brought immediate, enormous wealth. The Agra treasury was quickly examined and its contents distributed, Humayun being presented with an entire, unchecked section for his own use together with a vast sum of money. Money was given to every man in the victorious army and gifts were sent to faraway relatives, to holy men in Samarkand and Khurasan, and to Mecca and Medina. Humayun had also acquired a large quantity of jewels and valuables from the Raja of Gwalior, Bikramajit, who happened to be at Agra at the time of Ibrahim's defeat. He probably had little choice but to hand over his treasures, including a diamond of which Babur said 'every appraiser has estimated its value at two and a half day's food for the whole world'.[12] This is thought to have been the famous Koh-i-Noor which Humayun presented to his father. Babur graciously returned the gift, though it was not long in Humayun's possession. Babur's account is now sprinkled with evidence of the craftsmanship of Hindustan: he presented gold-hilted

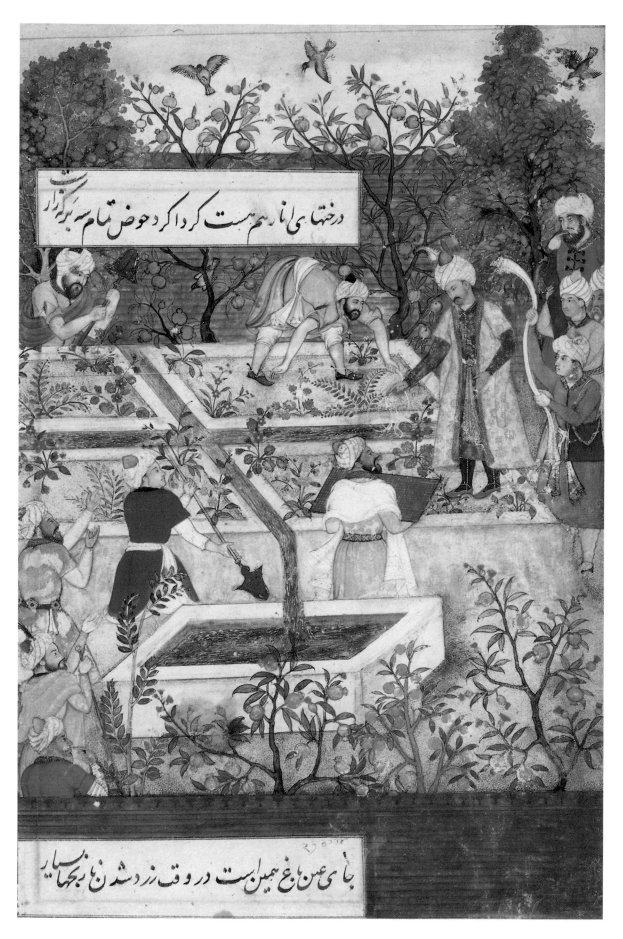

درختهای انار هم هست کردا کرد حوض تمام سبز کرده زار

جای عین باغ زمین است در وقت زرد شدن با بجهار بسیار

knives, jewelled daggers and sword belts from Ibrahim Lodi's personal store to his followers;[13] later he sent a stool inlaid with mother-of-pearl to his son Hindal,[14] an early reference to a craft originating in Gujarat [cf.37].

Babur did not live long enough to enjoy the benefits of his new empire. In 1530 he died, and was succeeded by Humayun, whose hold over the extensive conquered territory was tenuous because there had not been time to institute firm, centralised, administrative control. In order to maintain his inheritance, Babur's successor needed not only a shrewd political sense, but also military prowess and diplomatic skills to defeat and then pacify those he sought to rule. Unfortunately Humayun lacked most of these qualities.

A series of considerable victories early in his reign proved he possessed military skills, but he did not have the strength of purpose to consolidate his successes. An account written by one of his most loyal servants, Jauhar, barely conceals the author's exasperation. Having taken Gaur, the most important city of Bengal, Humayun then inexplicably shut himself up in his harem, devoting the next few months to indulgence in opium.[15] Meanwhile the rising Afghan ruler of Bihar, Sher Khan Sur, seized back his fortress at Chunar, and the city of Benares (Varanasi), both recently acquired by the Mughal army, while Humayun failed to comprehend the seriousness of the threat to his empire. Even without this weakness of character, Humayun's position was made difficult by the fact that his three brothers and two cousins all coveted his throne and periodically rebelled against his authority. Gradually Humayun lost territory to Sher Khan, chasing off to save one city or fortress after another in response to the Afghan's attacks. After ten years of almost constant battle, Humayun's fortunes declined to the point at which Sher Khan, having taken Delhi and Agra and adopted the title Shah, was able to drive him out of Hindustan.

At the beginning of 1540, accompanied by a pathetically small band of followers, Humayun fled to Sind (where his son, Akbar, was born in 1542) and began a period of exile and wandering. The reverse in his fortunes was total. His sister, Gulbadan Begam, described the earlier days of feasting at the Mughal court. The emperor would sit on a jewelled throne, surrounded by carpets from Iran and hangings embroidered with gold. Immensely long strings of pearls hung down, each supporting a glass globe. The guests would listen to musicians and recitals of poetry, while drinking and eating *pan* or fruit from vessels of pure gold and silver. In adjacent rooms were to be found books, beautifully calligraphed, or a symbolic array of weapons, jewelled and gilt, under a gold-embroidered canopy, and richly embroidered floor coverings and cushions.[16]

During his flight Humayun's circumstances were so reduced that when he gave orders for a horse to be killed to provide food for his companions, they were forced to cook some of the meat in a

**41. Babur supervising the laying out of the Garden of Fidelity**
Gouache and gold on paper
By Bishndas, portraits by Nanha
Mughal, c.1590
21.9 x 14.4cm
IM 276–1913

Akbar had at least five copies of his grandfather's memoirs, the *Baburnama*, made by the royal studios, none of which have survived intact. This garden was one of many created by Babur in his new empire.

helmet for want of cooking pots.[17] Camp morale was desperately low: at one point Humayun had to sit up all night to prevent his followers deserting.[18]

In 1544 Humayun finally sought help from the ruler of Iran, Shah Tahmasp. Treated alternately with courtesy and contempt, Humayun seems to have obtained help simply by buying it: diamonds (including the Koh-i Noor) and rubies of 'inestimable value' were given to the Shah, who eventually gave the exiled emperor 14,000 cavalry.[19] Taking the strategic fort of Qandahar on his return journey, Humayun reclaimed Kabul in November 1545. From here he dealt with his troublesome brothers – one was banished, one blinded and allowed to make the pilgrimage to Mecca, and the third died in battle – before finally recapturing Delhi and the empire in July 1555. Six months later, after a fall down a flight of steep stairs in one of the buildings in Sher Shah's citadel in Delhi, he died.

Humayun had returned to a transformed empire. Although Sher Shah had died in 1545, he had, in a remarkably short space of time, created an efficient, controlled administration. The economy had been strengthened by a combination of a new land revenue system, currency and tariff reforms, and new roads connecting the most important cities of the empire.[20] His rule was said to have been just and, though a devout Muslim, he had displayed religious tolerance towards his Hindu subjects. Had he lived longer, he would almost certainly have been one of the great figures of Indian history. As it was, he left behind a few monuments of great merit [42][21] and, more importantly, a secure foundation on which Akbar was able to build his great empire.

Humayun, on the other hand, provided the artistic foundation. His nature was intellectual; he was knowledgeable in mathematics and keenly interested in astronomy and astrology [43]. That he cared deeply about books is shown by his anguish at losing his most precious volumes during a battle and his joy at recovering them later by chance. Even during the most impoverished years of his exile he had been accompanied by at least one artist. While camping near Umarkot in 1542, a beautiful bird suddenly flew into his tent. He had the bird caught, cut off some of its feathers, and then 'sent for a painter, and had a picture taken of the bird', before ordering its release.[22] In Iran he met the master artists Mir Sayyid ᶜAli and Khwaja ᶜAbd as-Samad who joined him in Kabul in 1549 and who were said to have instructed the young prince Akbar. They followed Humayun to India, and there set up an imperial studio from which were to flow some of the masterpieces of Indian painting.

### Akbar

The reign of Jalal ad-Din Muhammad Akbar (1556–1605) witnessed the most extraordinary transformation of the arts of the lands he conquered; the vigour of the emperor's character, combined with his

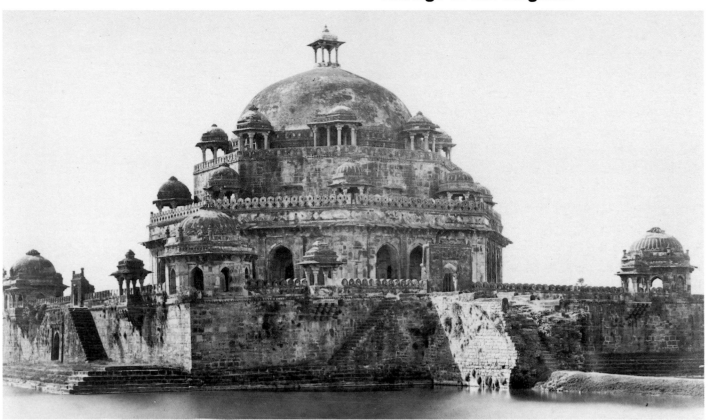

### 42. The mausoleum of Sher Shah Sur at Sasaram

Photograph by J.D.Beglar, *c.*1870
Archaeological Survey of India, Indian Museum

### 43. Celestial sphere

Brass, engraved and inlaid with silver and black lac
Inscribed as the work of Ziya al-Din Muhammad
Lahore, dated 1067 AH/1656–7
Diam. 13.1cm
2324–1883 IS

Humayun's interest in astronomy led him to employ Shaikh Elahdad as his astrolabe-maker. His descendants, who included Ziya al-Din Muhammad, continued to make astrological instruments throughout the reigns of Akbar, Shah Jahan and Aurangzeb.

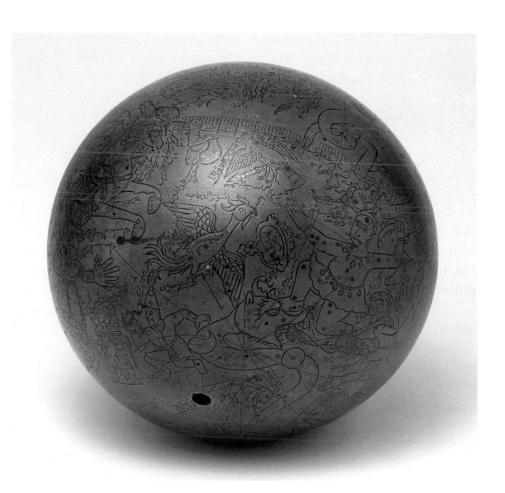

boundless curiosity, seemed to breathe a new spirit into artistic production of every kind.

Humayun had left behind him an empire which was far from secure. The descendants of Sher Shah Sur were a serious threat, Mughal control over parts of the Punjab was precarious, famine and plague had devastated other areas and the loyalty of the army and senior ministers could not be predicted. Moreover, the new emperor was only thirteen years old. Akbar could not have survived without the guidance and military skills of his guardian, Bairam Khan, who now directed the young ruler's forces to victory against the various Sur factions. In 1556 he eliminated them by retrieving from their control Delhi and Agra after the second decisive victory at Panipat in the dynasty's short history. Over the next three years, Ajmer, Jaunpur and the strategically important Gwalior were taken, making the empire's survival more plausible. At this point, however, conflicts began to develop between Akbar and his mentor, leading to Bairam Khan's dismissal. He was assassinated by Afghans at the beginning of 1561 [44] and from then on Akbar ruled for himself, strengthening his position by an aggressive policy of territorial expansion.

Despite all this military activity, Akbar's impressive energies were also directed into areas which might be expected to flourish only in times of peace. As early as 1564 he gave orders for the foundations of a new fort to be laid at Agra, followed closely by the construction of Lahore fort [45]. These were acts as symbolic as they were practical: he intended his dynasty to survive, and to leave tangible evidence of its survival. But he also, significantly, wished these fortresses to be of architectural merit; in the words of his court historian, Abu'l Fazl, they were 'to protect the timid, frighten the rebellious, and please the obedient.'[23]

Akbar's most remarkable building project was the creation of a new city, twenty-four miles west of Agra. This was near Sikri, where Babur had earlier created one of his famous gardens, and built on a rocky outcrop overlooking a lake. The city, now known as Fatehpur-Sikri, was built to mark the birth of his first son. Sikri was the home of the Muslim Shaykh Salim ad-Din Chishti, a member of a religious order held in high esteem by Akbar and to whom he went to seek blessing for his desire to have a son. Shortly afterwards his wife Maryam az-Zamani went to Sikri, where she gave birth to a son, named Salim after the shaykh: he was to succeed his father as the emperor Jahangir.

Construction of the city began in 1571 and proceeded with breathtaking speed. By 1576 most of the main structures, including the Great Mosque, seem to have been completed, changing the area beyond recognition.[24] Within a city whose walls extended for seven miles lived a population which was judged by an English visitor in 1584 to be greater than that of Elizabethan London. The buildings which survive today are all from the palace complex and are made

**44. The widow of Bairam Khan and her infant son ʿAbd al-Rahim being escorted to Ahmadabad in 1561.**
Gouache and gold on paper
By Makand
Mughal, c.1590
32.1 x 19cm
IS 2–1896 (6/117)

Bairam Khan was assassinated in Gujarat on his way to Mecca and his widow was then given imperial protection. Her son rose to become one of the most influential members of the Mughal court, and under Jahangir was given the highest position of Khan-i Khanan. He was a considerable patron of the arts and had his own studio of painters. From an imperial copy of the *Akbarnama*.

**45. Elephant bracket**
Sandstone
Lahore fort
Mughal, c.1617–18
61 x 86.4cm
IS 1066–1883

This came from 'Jahangir's Quadrangle' in Lahore fort which was begun by Akbar and completed during Jahangir's reign. It reflects the same interest in Hindu palace architecture as seen in the early Mughal buildings of Agra and Fatehpur Sikri.

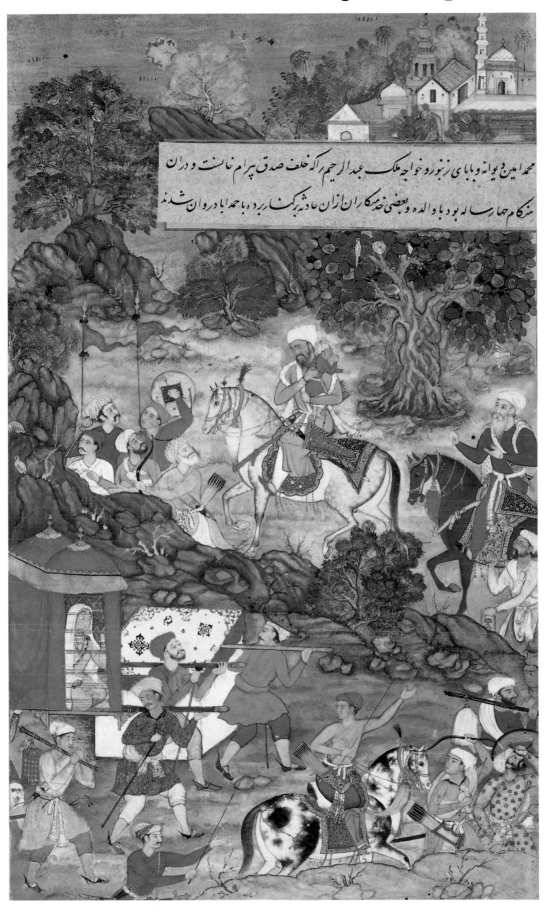

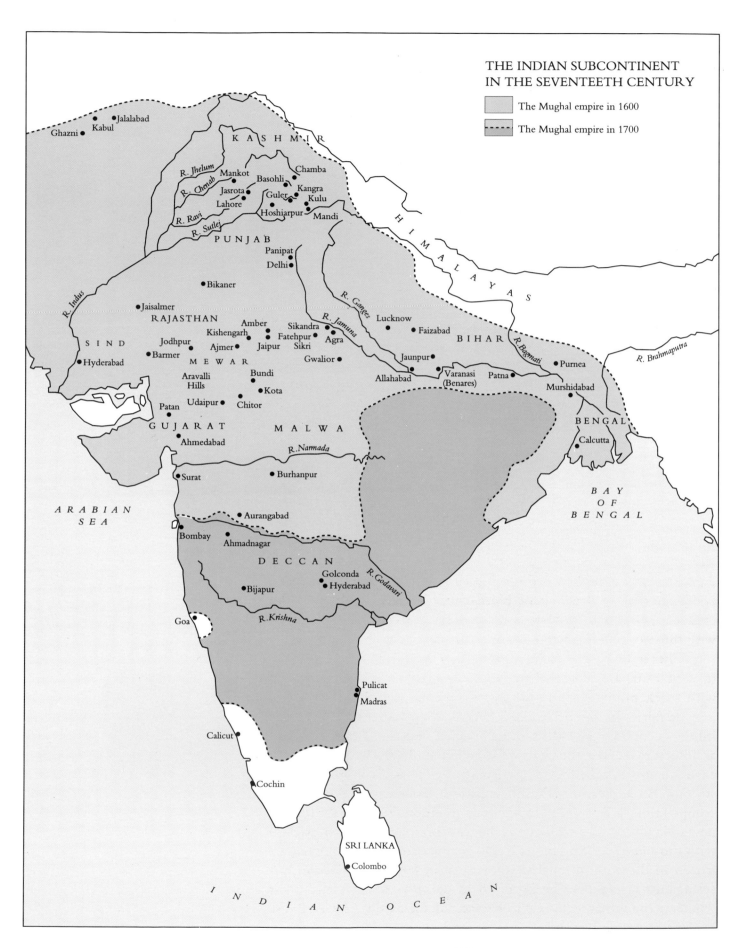

THE INDIAN SUBCONTINENT
IN THE SEVENTEETH CENTURY

The Mughal empire in 1600

- - - The Mughal empire in 1700

Ghazni
Jalalabad
Kabul

KASHMIR

R. Jhelum
R. Chenab
Mankot
Basohli
Chamba
Jasrota
Guler
Kangra
Lahore
Kulu
R. Ravi
Hoshiarpur
Mandi
R. Sutlej

PUNJAB

Panipat
Delhi

Bikaner

R. Indus

Jaisalmer

RAJASTHAN
R. Ganges
Lucknow
Amber
Sikandra
R. Jamuna
Faizabad
Kishengarh
Fatehpur
BIHAR
Jodhpur
Ajmer
Jaipur
Sikri
Agra
R. Bagmati
SIND
Barmer
Gwalior
Jaunpur
Purnea
Hyderabad
MEWAR
Allahabad
Varanasi
Patna
R. Brahmaputra
Bundi
(Benares)
Murshidabad
Aravalli
Kota
Hills
Udaipur
Chitor
BENGAL
Patan
Calcutta
GUJARAT
MALWA
Ahmedabad
R. Narmada
BAY
Surat
Burhanpur
OF
BENGAL

ARABIAN
SEA
Aurangabad

Bombay
Ahmadnagar

DECCAN
Golconda
R. Godavari
Bijapur
Hyderabad

Goa
R. Krishna

Pulicat
Madras

Calicut

Cochin

SRI LANKA
Colombo

INDIAN     OCEAN

**66**

from the red sandstone of the ridge on which they stand. They show that, except for the mosque, predominantly indigenous forms and trabeate methods of construction were used, exploiting the highly developed skills of the Indian stonemasons to maximum effect. Surfaces are treated as if made of wood, carved with fluid, deeply chiselled and seemingly effortless lines. Geometric decoration, complex exercises in interlocking and overlapping shapes which are common throughout the Islamic world, combine with the exuberant naturalism of the Hindu and Buddhist traditions; scrolling lines, for example, intermingle with pomegranates bursting with ripeness to reveal the seeds within. Akbar lived in Fatehpur-Sikri almost constantly until his campaigns drew him away in 1585 and it must have been here, in the royal workshops, that many important developments in the fine and decorative arts took place.

The imperial painting studio was by now well established, having completed the enormous *Hamzanama* project under the direction of the two Iranian masters brought to India by Humayun. Mir Sayyid ᶜAli and ᶜAbd as-Samad had guided the production of fourteen volumes, each with one hundred illustrations,[25] containing the epic adventures of Hamza. He was a character based partly on a historical, insurrectionary Iranian leader from Sistan and identified also with the uncle of the Prophet Muhammad; Akbar was particularly fond of these legendary tales, heavily laced with adventure and magic. Work may have begun as early as 1562 and took fifteen years to complete, clearly involving a considerable number of artists.[26] Fewer than 120 illustrations have survived and all of these have been remargined, thus removing any names of artists which may have been written on them, and no colophon has ever been discovered. However, the impact of the northern Indian artists who must have been added to the small group of Humayun's Iranians is obvious: the characteristics of their own regional schools (see pp.28-36) mixed with those of their Iranian masters to create a new idiom [46].

The style of the *Hamzanama* is broadly Iranian: the format (except for its inexplicably large size), the high viewpoint, combined with stock motifs such as the cypress and flowering cherry trees, winged fairies (*peris*) and spotted, fang-bearing demons, all show the influence of Mir Sayyid ᶜAli and ᶜAbd as-Samad. Yet the Indian architectural details, such as the flat-roofed buildings with projecting eaves, *chattris* and the faceted, red-sandstone pillars, are immediately striking. Broad swathes of brilliant crimson sometimes cut across the composition, a feature of indigenous traditions translated into the new style [cf.20]. The vibrancy of the paintings, some of them packed with tumbling, fighting figures, others concentrating on individuals frozen in the conventional gestures seen in Iranian miniatures but set against an agitated background of dense vegetation and birds wheeling in flight, gives them a character all their own. The liveliness of the scenes compensates for the sometimes crudely applied paint,

which contrasts sharply with the delicacy and precision of the arabesque and geometric decoration on walls and floors, textiles and armour.

Akbar's own influence on the project must have been considerable. Abu'l Fazl wrote a detailed history of the Mughal dynasty (the *Akbarnama*), including in it an encyclopaedic account of the administration of the court and empire (the *A'in-i-Akbari*, or *Institutes of Akbar*). He comments that, as a boy, Akbar had been taught painting by ʿAbd as-Samad and that he looked upon it later 'as a means both of study and amusement'.[27] Akbar selected the passages of the texts he wished to have illustrated and examined the work of his artists regularly. By 1590, when the *Akbarnama* was completed, Abu'l Fazl notes that over a hundred of them were considered to be 'famous masters of the art', with many more working on a less exalted level.[28]

The production of royal illustrated manuscripts involved much more than simply gathering together the best available artists, and a great many people must have been employed to prepare the paper and bindings, colours and gold leaf. The manuscript was copied by a calligrapher, whose skill was considered to be pre-eminent among the arts of the book. The Arabic script is that of the Koran, the book of divine revelation, and the letter, as described by Abu'l Fazl, was 'spiritual geometry emanating from the pen of invention.'[29] It conveyed in concrete form the 'ray of God's knowledge [which] falls on man's soul.'[30] The royal calligraphers copied books on history, philosophy and religion, as well as works in prose and poetry, many of them translated into Persian from Sanskrit [47], Kashmiri, Hindi, Turkish or even Greek. Akbar's curiosity was infinite and, although he could not read, these were read to him and stimulated lively philosophical discussion, which led him, ultimately, to formulate his own syncretic religion, the *Din-i Ilahi*.[31]

Abu'l Fazl devotes much less space to the art of painting, reflecting its secondary importance, but the emperor's interest in the subject is not in doubt. The leading artists, headed by Mir Sayyid ʿAli and ʿAbd as-Samad, are named. Most of them are Hindus, of whom Abu'l Fazl noted: 'Their pictures surpass our conception of things. Few, indeed, in the whole world are found equal to them.'[32] The artists illustrated Persian literature, the great Sanskrit epics translated for Akbar into Persian [47], and histories of the dynasty, as well as recording the appearance of the leading personalities of the age for keeping in albums.

Abu'l Fazl presented his great work to Akbar in 1590. One hundred and seventeen miniatures from this royal copy are now in the Victoria and Albert Museum; they cover the events from 1561 to Akbar's triumphant entry into Surat, following its capture in 1573 [1]. These paintings are an extraordinary document of life at the Mughal court, depicting the battles to overthrow the great Rajput

**46. A prince attacking a demoness**
Gouache and gold on cotton
Mughal, *c.*1562–77
71.1 x 54.6cm
IS 1513–1883

From the *Hamzanama*, the first major project undertaken by the new painting studio of the Mughal court. Directed by two Iranian masters brought to India by Humayun, work began under Akbar and was said to have taken fifteen years to complete, drawing in artists from all over northern Hindustan.

### ◄ 47. Krishna's combat with Indra

Gouache and gold on paper
Mughal, *c.*1590
29.6 x 18.4 cm (with border 43.6 x 32.5 cm)
IS 5–1970
Bequeathed by the Hon. Dame Ada Macnaghten

From the *Harivamsa*, or Genealogy of Hari, a supplement to the *Mahabharata* dealing with the life of Lord Krishna was translated into Persian for the emperor Akbar.

### 48. The Deposition from the Cross

Gouache and gold on paper
Lahore
Mughal, *c.*1598
19.4 x 11.3cm
IS 133–1964 (f.79b)

Copied by a Mughal artist from a Flemish print, which was in turn adapted from a lost painting by Raphael, this was painted at Lahore under the personal supervision of Jahangir while he was still a prince, the exact circumstances being recorded in a letter from one of the Jesuit priests who witnessed the scene.

fortresses of Chitor and Rantanbhor, the hunt, the arrival of embassies to the court, rejoicings at the birth of a prince, and the building of Fatehpur-Sikri. The artists, some of whom are the great masters listed by Abu'l Fazl, are identified in marginal inscriptions. Two artists usually worked on each painting, the senior artist supplying the detailed, preliminary outline and sometimes the final work on faces, the other meticulously applying the layers of paint which were burnished, from the back, between applications to produce the final rich, opaque colours. The miniatures have the scale and technical perfection of the best works of Iran but maintain, in a highly refined and sophisticated form, the naturalism and gusto of the *Hamzanama*. In the battle scenes the tumult and brutality of warfare are emphasised by the zigzagging lines of the composition, the rolling of heads and spurting of blood. In the scenes of the hunt, the speed of the cheetahs chasing their frightened prey is reinforced by the swirling arrangement of the tents and enclosure, though each detail, including the armour and tent walls, is rendered with painstaking care [50].

Some of these paintings open out on to a faraway horizon, tinged with blue to give the illusion of distance, a device copied from European artists. Akbar's craftsmen had made direct contact with Western art when he sent some of them to the Portuguese settlement at Goa in 1575 in order to bring back rarities and to learn foreign craft skills. They stayed for two years and returned sporting European clothes and beating Western drums. It is likely that the first exposure to Western painting techniques occurred then, but by 1580 contact is certain: Akbar was given two painted altarpieces and seven volumes of the Antwerp *Polyglot Bible*, their title pages illustrated with engravings, by three Jesuit Fathers who arrived at Fatehpur-Sikri.[33] Though in this mission and the others which followed the Fathers did not fulfil their modest intention of converting the emperor to Christianity, these contacts had an important influence on Mughal painting. Akbar's artists, apart from beginning to use Western perspective in their work, also copied specific paintings or engravings [48]. European work was now actively collected and was to be valued as much by his successors as by Akbar himself.

With the important exceptions of painting and architecture, little now survives of the torrent of artistic production under Akbar. The artisans of the one hundred imperial workshops must have been able to draw on the finest materials for their work as the wealth of the empire was now immense. By 1590 there were three separate treasuries for precious stones, gold and jewellery, as well as a further twenty-one containing cash receipts.[34] The royal coffers were filled with the spoils of war, tribute from those wishing to fend off future attacks, presents from embassies to the court and the land revenue from a well-administered empire.

A unique jewelled gold spoon, dating from about 1600, provides a glimpse of the splendour of courtly artefacts [49]. The minute

**50. Akbar hunting**
Gouache and gold on paper
Outline and portraits by Miskina, painting by Sarwan
Mughal, *c*.1590
32 x 19cm
IS 2–1896 (55/117)

From an imperial copy of the *Akbarnama*, the official history of the reign.

**49. Spoon**
Gold, engraved and set with rubies,
emeralds and diamonds
Mughal, late 16th or early 17th century
L. 18.6cm
IM 173–1910

**51. Dagger**
Steel with traces of gilding
Mughal, *c*.1600
L. 31cm
IS 86–1981

emeralds and rubies are carefully shaped to fit the elegant Safavid floral arabesque pattern; tiny diamonds are set into the rim of the bowl, with a large diamond, retaining its natural faceted form, in the knop. The spoon aptly illustrates the ability of the Mughal craftsmen to absorb new influences: the decoration is Iranian, the form European but the technique Indian. This method of setting stones is listed by Abu'l Fazl as a technique of the Hindus, together with others such as granulation, enamelling and inlaying,[35] though it is probable that some of these were brought to the subcontinent at an earlier period.

Akbar was an energetic patron, even allowing for Abu'l Fazl's wish to present the emperor in the best light. He encouraged the manufacture at court of any artefact that came from abroad and which appealed to him, or for which there was a demand; clearly this was a sound economic policy. In the earliest reference to the production of pile-carpets in India, the royal chronicler notes that the carpets of Iran and Turan (Turkestan) were no longer thought of after Akbar caused them to be made in India. Carpet weavers from Iran settled in the royal cities of Agra, Lahore and Fatehpur-Sikri,[36] their products at first barely distinguishable from their Iranian prototypes. The production of Kashmir shawls was encouraged 'in every possible way' and in Lahore there were 'over a thousand' shawl workshops.[37] India's textile workers would have had little to learn from abroad in the way of technique as her dyers and weavers had been famed throughout the ancient world. Nevertheless, the huge demand from a burgeoning, wealthy empire, coupled with the lively patronage and eclectic tastes of its ruler, can only have stimulated production. The miniatures of the period depict carpets, wall-hangings, floor coverings and tent panels, brocaded or embroidered *jamas* (robes), woven *patkas* (sashes) and fine shawls. Abu'l Fazl makes clear the scale of what was consumed by the court and its entourage alone. When the court travelled, for instance, a vast city of tents would be created for each evening's halt.[38] One thousand carpets covered the floor of just one of the enclosures: the *Divan-i khas* (Hall of Private Audience) was then said to resemble 'a beautiful flowerbed'. Tent walls and partitions for the different enclosures would be lined with chintz [50] or embroidered, often with gold. Carpets would cover the dusty ground throughout, laid over thick cotton mats.[39] The whole collection had to be duplicated so that one set could always be sent on ahead and erected to await the arrival of the emperor and his followers; each encampment required 100 elephants, 500 camels, 400 carts and 100 bearers, as well as hundreds of foot soldiers and labourers. When the army also travelled, the size of the encampment was even more impressive, including all the support services and bazaars as well as the soldiers themselves.

As might be expected from an empire constantly expanding through warfare, the manufacture of arms and armour was an important matter. The safety of the empire depended on it and Akbar gave

it his personal attention, Abu'l Fazl reassuringly commenting that, because of the emperor's interest, matchlocks no longer burst on being fired as they had done in the past.[40] The emperor had his own personal weapons, each with their own name and worn by him in strict rotation; whenever they were given away as marks of the highest favour, a replacement would be commissioned. Illustrations of all the weapons and armour in use during Akbar's reign were included in the *A'in-i Akbari*.[41] Many may be seen, depicted with considerable accuracy and beautifully ornamented, in contemporary paintings [cf.**51**].

In addition to what was produced in the royal workshops, artefacts were also acquired from the provincial centres whose work in specialised areas, depending on local conditions or raw materials, had particular renown. Often these centres were able to adapt their work to the market. Sind, for instance, was famous for its ivory-inlaid wooden boxes and cabinets [35], and could produce work in a 'vernacular' or in a Mughal style, while Gujarat produced inlaid mother-of-pearl boxes for the Mughal or even Turkish market [37].

## Jahangir

Salim became emperor on the death of Akbar in 1605, taking the title Jahangir (World Seizer). Before this, however, he had already assumed the role of independent monarch for a short time: in 1600 he had rebelled by seizing Allahabad and, in 1602, called himself 'Shah'. To confirm his sovereignty he had coins struck in his own name and, in an act of open provocation, sent these to Akbar. As a final devastating insult he had Abu'l Fazl, Akbar's close friend and official court historian, murdered. Despite all this, the two were uneasily reconciled, though Salim spent most of his time until 1604 at Allahabad and Akbar was forced to withdraw from his Deccan campaigns (see p. 109) in case of further trouble.

Little is known of how Salim spent his time at Allahabad apart from over-indulging in opium and wine, but a small number of inscribed manuscripts make it clear that his own artists were with him.[42] As early as 1589 the Iranian artist Aqa Reza had been in his service; Aqa Reza's son, Abu'l Hasan, grew up in the prince's household and, trained by his father, became one of Jahangir's greatest artists, with the title Nadiru'l Zaman (Wonder of the Age).

Jahangir's situation on accession was radically different from that of his predecessors. He inherited a stable, wealthy empire, together with royal artists and craftsmen whose style and working practices were confident and established. The emperor was himself mature and he had a highly refined aesthetic sensibility. Given these circumstances, the arts could only flourish. Jahangir wrote an account of his reign up to the year 1624, providing a fascinating insight into both his character and the events he regarded as significant. He also reveals his artistic preferences:

## 52. Vase

Brass, engraved and inlaid with black lac
Lahore, *c.*1580–1600
Ht. 12.3cm, diam. 15.4cm
21–1889

The decoration of this vase, engraved inside and outside with finely calligraphed religious inscriptions, is based on Iranian designs of the period of Shah Tahmasp (r.1524–1574). It is one of the earliest examples of metal wares known so far in the Safavid manner but with strong Indian characteristics.

My liking for painting and my practice in judging it have arrived at such a point that when any work is brought before me, either of deceased artists or those of the present day, without the names being told me, I say on the spur of the moment that it is the work of such and such a man. And if there be a picture containing many portraits, and each face be the work of a different master, I can discover which face is the work of each of them. If any other person has put in the eye and eyebrow of a face, I can perceive whose work the original face is, and who has painted the eye and eyebrows.[43]

In 1618 the emperor gave the order for his account of the first twelve years of the reign to be copied and illustrated. When Abu'l Hasan showed him the painting of his accession which was to be the frontispiece, Jahangir wrote: 'It was a masterpiece.'[44] Illustrations from the *Jahangirnama* or *Tuzuk-i Jahangiri* (*Memoirs of Jahangir*) have not so far been identified in conjunction with identifying text, as is the case with the various copies of the *Akbarnama* and *Baburnama* but, on the basis of their subject matter and quality, several paintings are probable candidates.

On 18 February 1614 [45] the Maharana of Mewar, Amar Singh, went to the encampment of Jahangir's son, Khurram, to admit defeat after a series of terrible battles against the Mughal armies. This was an occasion of profound significance as it marked the downfall of the last bastion of Rajput resistance to Mughal supremacy (see p.128) and was described with great satisfaction by Jahangir: the moment of submission, with Amar Singh bowing before the enthroned prince, would seem a fitting illustration to the text [53]. The painting includes an intriguing detail: in the midst of the assembly of Mughal and Rajput nobles is the kneeling figure of an artist, seemingly drawing Amar Singh's face. He is identified by a minute inscription as Nanha, who had earlier worked for Akbar. The line of development of the painting from those produced in the later years of Akbar's reign is clear, as the conventions of style and composition are broadly maintained. However, the characters are individualised, their bodies are given a greater sense of volume and their postures are more convincing.

A new artistic emphasis is revealed in another *Jahangirnama* page. Throughout Jahangir's writing a keen and scientific interest in the natural world is apparent; threaded between the details of military conquest, the descriptions of the comings and goings at court and the court ceremonial, are careful observations on birds, animals and flowers. In 1612 a consignment of exotic birds and animals arrived at the court from Goa, sent by the emperor's trusted servant Muqarrab Khan, who had been commissioned to buy rarities of all kinds from the Portuguese. Jahangir wrote: 'As these animals appeared to me to be very strange, I both described them and ordered that painters should draw them in the Jahangirnama, so that the amazement that

arose from hearing of them might be increased.'[46] He then described, in considerable detail, the appearance of a turkey which was part of the group, and which spread out its feathers and strutted like a peacock [54]. The artist chosen to illustrate this marvel was Mansur, whose skills were second only to those of Abu'l Hasan, and who was given a similar title, Nadir al-ᶜAsr (Wonder of the Epoch).

Paintings focusing on a single subject against an unadorned or discreetly decorated ground were produced in greater numbers for Jahangir than for any other emperor. The model had been provided by Akbar, who had his artists record the appearance of notable personages, usually on pale green grounds; these likenesses were then kept in an album. Jahangir followed this tradition, each portrait probably being used to supply tracings so that the image could be reproduced as required in other paintings. This partly explains the similarity in size of figures in the crowded compositions of court scenes, whether placed in the foreground or background. These paintings, together with treasured examples of fine calligraphy, were often mounted in albums with beautifully decorated borders, a practice continued by Shah Jahan [55].

When Jahangir travelled, artists such as Mansur accompanied him. During an expedition to Kashmir in 1620, the emperor's intense pleasure at the beauty of the spring flowers (recalling that of Babur nearly a century earlier) led him to ask Mansur to paint over a hundred of them.[47] Depictions of flowers in Mughal painting of the early seventeenth century should not, however, be thought of in terms of Western realism. They are usually recognisable (although the leaves may be those of another flower altogether) but follow a set representational formula. This derives either from the clumps of flowering plants scattered across the ground of Iranian painting and copied by the Mughal artists or, by the middle of Jahangir's reign, from the illustrations in European herbals.[48] These floral studies were then used as a decorative motif in every field of artistic production, becoming an overwhelming theme during the reign of Shah Jahan.

Many paintings reveal the dramatic change that had taken place in Mughal style. Akbar's appearance in miniatures had always been extremely simple, the fabrics of his clothes rather plain and his jewellery kept to a minimum. The opulence of his life is inferred from contemporary accounts; it is not visually stressed. Under Jahangir, painting illustrates in precise detail the wealth and splendour of the dynasty. A portrait of his third son, Khurram, who succeeded him as Shah Jahan, presents an image of imperial magnificence [56]. A necklace, for instance, has rubies and emeralds of extraordinary size alternating with immense pearls, and his hands, wrists and turban are weighed down with jewelled gold ornaments. The prince holds a gold turban aigrette set with an emerald and diamond which must have been two of the most important stones in the treasury. Whenever significant gemstones were acquired, they were inscribed with the

**53. The Maharana of Mewar making submission to Prince Khurram**
Gouache and gold on paper
By Nanha
Mughal, *c.*1618
31 × 19.8cm
IS 185–1984

This event took place in 1614 and is described by Jahangir in his memoirs, the *Jahangirnama*, which were first copied and illustrated in 1618. The painter of this page is depicted at right.

**54. A Turkey Cock**
Gouache and gold on paper
By Mansur
Mughal, *c.*1612
12.8 x 12.2cm; page 39 × 26.4 cm
IM 135–1921
Bequeathed by Lady Wantage

The arrival of the turkey from Goa is described in the *Jahangirnama* for which this was an illustration.

### ◄ 55. Page from an album

Ink, gouache and gold on paper
Calligraphy by Sultan ᶜAli al-Mashhadi
(1442–1519) in a Mughal mount
38.9 × 26.4cm
IM 120a–1921
Bequeathed by Lady Wantage

The calligraphy is by one of the most
eminent Iranian masters of the art
and was mounted on a richly
decorated page during the reign of
Jahangir. It was then set into a larger
album with floral borders.

### 56. Portrait of Shah Jahan as a prince

Gouache and gold on paper
By Nadir al-Zaman
Mughal, *c.*1616–17
20.6 x 11.5 cm; page 39 x 26.7cm
IM 14–1925

A later inscription by Shah Jahan on
the border reads: 'A good likeness of
me in my twenty-fifth year and the
fine work of Nadir al-Zaman.' This
was the title of the artist Abu'l Hasan.

emperor's titles [57] before being placed in the treasury or displayed in a setting which itself indicated sovereignty, such as a throne or turban jewel.

The painting also reveals how quickly elements of Western art were absorbed into mainstream courtly styles. Encircling the prince's head a golden halo is delicately indicated, copied from the paintings of Christian subjects acquired by Akbar and inherited by Jahangir, who actively collected more. The halo then began to be used in depictions of the royal family, a convention borrowed (with many others) by the Rajputs [118].

European influence was also maintained in the decorative arts. A gold thumb ring [58] set with rubies and emeralds relates in style and technique to the spoon made towards the end of Akbar's reign; its shape is similar to those depicted in the portrait of Khurram. Its enamelled inner surface, however, is in Renaissance style. The enameller could actually have been a European. Jahangir had at least one Western goldsmith in his service, whose work over three years on a jewelled gold and silver throne earned him the emperor's high praise and the title Hunarmand, meaning 'skilful.'[49] Equally, the enamelling may have been copied from a Western model; Indian craftsmen have been famous throughout history for their facility to imitate almost anything to perfection and were encouraged in this by Jahangir. The skill of his painters in this field is described by Sir Thomas Roe, the official ambassador of James I of England, who was sent to the Mughal court to negotiate trading rights. Jahangir discovered that Roe's entourage included an artist and had him immediately summoned before the royal presence. The ambassador seems not to have rated the work of the amateur artist and insisted on showing Jahangir a portrait by Isaac Oliver, the leading English miniaturist of the day. Roe thought his work incomparable and was scornful of the opinion of the emperor's 'Cheefe Paynter': 'The foole answered he could make as good.'[50] The conversation took place on 13 July, 1616; on 6 August, Jahangir showed Roe six identical miniatures and challenged him to determine which was the original. Roe was forced to admit that he did so with difficulty. He pointed out its small distinguishing characteristics, 'not to be judged by a Common eye', which Jahangir must have greatly enjoyed.

Roe's absorbing and informative account of the embassy, which lasted from 1615 to 1618, reinforces the suggestion of conspicuous consumption given in the paintings. He was not easily impressed, but was nevertheless amazed by the emperor's jewels and described Khurram 'in a Coate of Cloth of silver, embroidered with great Pearle and shining in Diamonds like a firmament.'[51] He even caught a glimpse of the royal ladies, who peered at his exotic appearance from behind a screen and wrote: 'If I had had no other light, ther diamonds and pearles had sufficed to show them.'[52]

The court ceremonial was dazzling, particularly at the time of

**57. The 'Carew Spinel'**
 Spinel, drilled and set on a gold pin with a diamond at top and bottom
 Mughal
 Weight 133.5 carats, 4 x 2.3cm
 IM 243–1922
 Bequeathed by the Rt. Hon. Julia Mary, Lady Carew

This precious stone is engraved with the titles of Jahangir, Shah Jahan and Aurangzeb and the dates 1021 AH/ 1612–13, 1039 AH/1629–30 and 1077 AH/1666.

**58. Thumb ring**
 Gold, chased and engraved and set with rubies and emeralds, the inside enamelled in opaque, turquoise, pale green, white and black
 Mughal, first half of the 17th century
 L. 3.7 cm, diam. 3cm
 IM 207–1920

### 59. Wine-cup of Jahangir

Nephrite jade
Mughal, dated 1022 AH/1613–14
Ht. 3.8 cm, diam. 8.8cm
IS 152–1924

The Persian verse round the rim has been translated as 'From King Jahangir, the world found order. By the ray of his justice, the age was illuminated. From the reflection of red wine, may the cup of jade be always like a ruby [ie may it be always be full].'

### 60. *Huqqa* base

Green glass with gilt floral decoration
Mughal, first half of the 18th century
Ht. 18.9 cm, diam. 17.8cm
IM 15–1930

the emperor's birthday, when he was weighed against jewels, precious metals, fine fabrics and foodstuffs, which were all afterwards distributed to the poor. He then sat on a gold throne inlaid with diamonds, pearls and rubies, with a gold table before him covered with golden vessels, all encrusted with precious stones: Roe had never seen such wealth. Occasions such as this, or the festival for the new year, Nauroz, were always accompanied by a lavish exchange of gifts. Many of those given, or received, are carefully itemised (and valued, exactly) by Jahangir in his book.

The emperor had a connoisseur's instinct and this, combined with his desire for novelty, led to important artistic innovations. His dynastic link with Timur, for example, was stressed throughout the reign and he collected objects or paintings that had belonged to his Timurid ancestors.[53] Some of these included inscribed jades and when Jahangir gained access to the rare nephrite jade of Khotan, he had small vessels made for himself [59]. The use of the new material, worked by Indian craftsmen in exactly the same way as they had always worked other hardstones such as carnelian and crystal, extended to jewellery, sword and dagger hilts, perfume phials and powder horns for priming guns, all of which would probably have been presented as marks of royal favour.

Tobacco was introduced to Mughal India on the eve of Jahangir's accession, Asad Beg bringing it back to the court from his Deccan embassy of 1604.[54] It was smoked using a *huqqa* (water pipe), which over the next two centuries would be made from the most precious or rare materials for courtly use [e.g. **60**] or the poorest, such as coconut. Jahangir had an aversion to smoking as strong as that of his contemporary James I and, in 1617 he ordered that no one should smoke.[55]

Architectural activity during the reign was not especially prolific though extensive alterations were made to Lahore Fort,[56] but significant new themes were introduced. Akbar's mausoleum at Sikandra was built substantially under Jahangir's direction, being completed in 1613. The facade and entrance were inlaid with different coloured marbles in bold geometrical patterns and the top storey was built entirely of white marble, open to the sky and with a finely carved cenotaph of the same material surrounded by pierced marble screens at the centre. Inlaid coloured stone decoration and white marble were used in more refined form in the tomb built by Jahangir's wife, Nur Jahan, for her father Itimad ad-Daula in 1628, and became the keynotes of Mughal architectural style, producing some of the world's most renowned monuments.

### Shah Jahan

The monument most universally identifiable with the Mughal emperors is the Taj Mahal, built as a mausoleum for the wife of Shah Jahan, Mumtaz Mahal, who died giving birth to her fourteenth child

**61. Hunting coat**
  Satin embroidered with silk
  Mughal, period of Jahangir (1605–1627)
  Ht. 97cm
  IS 18–1947

Fine chain stitch of the kind used here was particularly associated with Gujarati craftsmen. The style of the coat, and the cool palette of the colours of the design, suggest Iranian influence.

in 1631. It took fourteen years to complete and is now one of the most renowned buildings in the world [62].

Shah Jahan (r.1628–56) was the great architectural patron of the Mughal dynasty. Drawing on the most advanced trends of the buildings of Akbar and Jahangir, he added his own eclectic innovations to produce a style which would be imitated throughout the subcontinent for the next two centuries. The forerunner of the Taj Mahal was the tomb of the emperor Humayun, built in Delhi by his widow Hajji Begam in 1565.[57] Set in the geometrically divided garden (*chahar-bagh*) introduced to India by Babur, it has a dome clad in white marble whose shape is copied directly from Iran, as is the overall conception of the tomb building. The Taj Mahal develops these themes, imitating the distinctive dome and using white marble for the entire structure. Built on a terrace overlooking the River Jumna, its beauty owes at least as much to its setting and material as to its architectural form and decoration. The faintly sparkling marble changes subtly in colour according to the time of day, taking on the golden hue of dawn or the pale rose reflection of sunset, and blending in with the mist which rises from the river as night falls. It is surrounded by a garden which is criss-crossed by avenues and water channels, the smaller gardens thus created planted with vibrantly coloured flowers whose scent fills the air. Symmetry prevails: the tomb building is framed by four tall, detached minarets placed at each corner of the white marble podium on which it stands, and a red sandstone mosque to the west is perfectly balanced by an identical structure, a reception pavilion, to the east. Inside, the tomb at ground level is matched by a cenotaph immediately above it at terrace level, directly beneath the dome.

On Shah Jahan's death his tomb and cenotaph were placed by the side of those of his wife, introducing the only irregular feature. All these are exquisitely inlaid with flowers of lapis lazuli, green jade, carnelian and other semi-precious stones in a technique known as *pietra dura* [63], and with black marble calligraphy. Black marble was also used for the calligraphy on the facade, and black marble lines frame the various elements of *pietra dura* decoration, internal and external, or give definition to particular architectural features. There are also panels of floral decoration carved in the marble in low relief on the dadoes inside and outside the building. White marble and *pietra dura* became the hallmarks of the reign, used for the tomb built by Shah Jahan at Lahore for Jahangir, and in the extensive rebuilding of Akbar's fort.

Shah Jahan's most grandiose project was to follow Akbar's example and create a new city. In 1638 he decided to move the capital from Agra to Delhi and gave orders for construction to begin on Shahjahanabad, whose most significant remnants today are the palace within the Red Fort (named after its rather forbidding red sandstone walls) and the Friday Mosque nearby, built between 1644 and 1658.

**62. The Taj Mahal seen from Agra Fort**
Photograph by Christina Gascoigne, 1970

**63. Frieze panel**
Marble inlaid with carnelian, yellow and black marble and serpentine
Agra
Mughal, *c*.1640
24.5 x 82.6cm
1534–1855

**64. *Jali* screen** (detail)
Marble, carved and pierced
Mughal, *c*.1640
58.5 x 76.5cm
07071 IS

Bazaars lined the routes into the palace at the centre of the fort which must then, asnow, have been crowded, noisy and bustling. They opened out into peaceful gardens flanked by single-storey, white marble pavilions overlooking the Jumna, linked and cooled by water channels which had, at intervals, fountains set in lotus-shaped white marble basins. Here were the fundamental elements of the imperial image Shah Jahan wished to project. In the *rang mahal*, a small chamber beautifully painted and gilt, is a pierced marble screen surrounded by a carved marble relief of the Scales of Justice, symbolising the rule of law under Shah Jahan, the spiritual and worldly leader of his subjects. At the heart of the palace complex was the Hall of Public Audience (*Divan-i 'Am*), where the emperor would hold court twice a day from a raised *jharoka* platform, sitting beneath a marble canopy supported on marble columns, all inlaid with *pietra dura* flowers. The wall immediately behind is set with an extraordinary combination of small, imported Italian *pietra dura* panels of birds in trees, linked by a tracery of fruit trees in which sit more birds, inlaid in the same technique, presumably by Indian craftsmen. At the top is a panel depicting the figure of Western classical myth, Orpheus, who by his music made wild animals live peacefully together. A recent study of the decoration describes the rich symbolism of the setting in which the emperor chose to appear,[58] with its allusions to the harmony of the age under the rule of Shah Jahan. Many of his paintings reinforce this notion, presenting the period as a Golden Age akin to an earthly Paradise; the palace complex at Delhi, through its architectural decoration, is intended to evoke a paradisal garden, as explicitly stated by the Persian inscription in the *Divan-i Khas*: 'If there be Paradise on the face of the earth, it is this, it is this, it is this.' The evocation must have been further enhanced when the structures were populated and furnished.

The floral theme was certainly not unique to Shah Jahan's reign, but until then it had never had such prominence. The formula of a flowering plant, its stem bending slightly under the weight of its blossoms, its leaves and petals curling over and, sometimes, with tiny butterflies or Chinese clouds floating around it, was infinitely adaptable. Within a rectangular frame in a vertical format, it could be applied to the page of a manuscript, a wall hanging [66], or carved in stone and set into a wall. A horizontal format could be produced simply by including two or more plants which could then be applied to textiles, inlaid in ivory on the sides of wooden boxes, or even applied to vessels or boxes where the decoration was confined to a central panel of decoration [67]. Enclosing the plant, or a section of it, by a cartouche, lent still more variety. On more complicated surfaces such as those of metal ewers with handles and spouts, ribbed boxes with curved sides or asymmetrical hardstone cups, the motif might extend or contract to fill the required area, or elements such as flower heads and buds could be detached and used on scrolls. This

**65. Glazed tile**

*Cuerda seca* technique
Mughal, second half of the 17th century
19.2 x 19.7cm
25–1887 IS

style gradually encroached on every area of courtly production, so that Shah Jahan would have been surrounded by wall-hangings, carpets, jewelled vessels and weapons, all elaborating the floral theme. From this rarefied level the style then filtered down into widespread commercial use.

The emperor's own tastes inevitably influenced what was produced at court. His love of painting, although perhaps less intense than that of his father, is indicated by the lavishly produced albums which held his most precious miniatures and calligraphy by famous masters, many of which had been owned by Jahangir or Akbar [55]. These were mounted in alternating pairs of miniatures with similar themes, such as portraits, and pages of calligraphy, surrounded by floral borders whose colours have the delicate bloom of Western pastel painting, here highlighted with gold.

Like Jahangir he valued his Timurid lineage and, in a painting illustrating his line of descent, used the idiom of the imaginary scene introduced by his father:[59] the enthroned Timur hands his imperial crown to Babur, with Humayun and their respective chief ministers looking on [40]. A companion painting shows the Timurid crown being transferred by Akbar to Shah Jahan;[60] both are inscribed with the artist's names by the emperor himself. The range of the atelier is impressive. The artists produced highly refined, formal miniatures and decorative pages or borders for the royal albums and manuscripts, notably the *Padshahnama* or official history of the reign,[61] charming scenes of informality such as the emperor playing with his son [70], direct copies from European subjects and studies of musicians or holy men [71].

Shah Jahan's predilection for jewels is known from a number of sources, and his remarkable skills in gemmology were described by his father.[62] Jahangir also described the prince's practical skills demonstrated in a sword hilt 'made in his own goldsmiths' shop; most of the jewels he had himself set and cut.'[63] These qualities explain the choice of *pietra dura* decoration for his monuments; they certainly produced some of the most extravagant schemes for interior decoration, such as a gallery seen later by the French merchant-jeweller Tavernier. The emperor's plan had been

> to cover it throughout with a trellis of rubies and emeralds
> which would represent, after nature, grapes green and
> commencing to become red; but this design, which made
> a great noise throughout the world, required more wealth than
> he had been able to furnish, and remains unfinished, having
> only two or three wreaths of gold with their leaves, . . .
> enamelled in their natural colours, emeralds, rubies and
> garnets making the grapes.[64]

He did, however, have sufficient wealth to complete the famous Peacock Throne, on which he first sat on 12 March 1635[65] and which must have been a *tour de force* of the jeweller's art. It combined

**90**

### 66. Wall hanging
Cotton, embroidered with silk
Mughal, *c.*1650–1700
117 x 81.25cm
IS 168–1950
Given by F.J.Lefroy

◀ ### 67. Beaker and cover
Silver, the inside gilt, chased and
engraved
Mughal, mid-17th century
Ht. 14.2cm, diam. 8.3cm
IS 31–1961

### 68. Bowl
Carved rock crystal
Mughal, mid–17th century
Ht. 8.2cm, diam. 12.8cm
986–1875

◀ **69. Muhammad ᶜAli Beg, Iranian ambassador to the Mughal court**

Gouache and gold on paper
Inscribed 'the work of Hashim'
Mughal, *c*.1630
38.5 x 26.4cm
IM 25–1925

From the Minto album.

**70. Shah Jahan with one of his sons**

Gouache and gold on paper
Mughal, *c*.1620
19 x 13.6cm
IS 90–1965

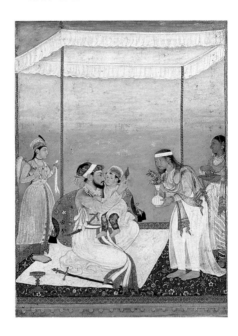

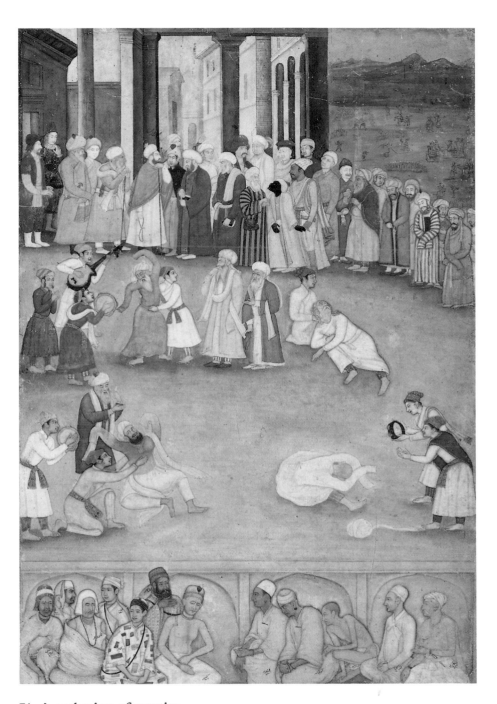

**72. A Mughal prince riding the elephant Mahabir Deb**

Water-colour, ink and gold on paper
Mughal, *c*.1645
31 x 37cm
IM 23–1928
Given by R.S.Greenshields

**71. A gathering of mystics**

Gouache and gold on paper
Mughal, *c*.1650
41.5 x 28.4 cm; with border 43.9 x 30.5cm
IS 94–1965

Formerly in the collections of Warren Hastings (Governor-General of India 1774–85) and Captain E. G. Spencer-Churchill.

enamelling with patterns of inlaid gemstones, but was primarily intended to display, in the most public and impressive way possible, the largest stones in the imperial treasury. This was to be one of the countless treasures plundered by Nadir Shah of Iran in 1739 (see p.106).

The reign of Shah Jahan also produced astounding examples of the art of hardstone carving. A wine cup of white nephrite jade has the organic form of a halved gourd, which curves sinuously to terminate in a superbly naturalistic ram's head inspired by European Mannerism [73].[66] The solid, intractable material is given a lightness and delicacy by the skill of the craftsman, who produced a flawlessly smooth surface, perfectly precise detail and a rim worked to such thinness that it is translucent. The cup is inscribed with the title adopted by the emperor, 'Lord of the Second Conjunction', linking him directly with Timur, who had styled himself 'Lord of the Conjunction', in reference to his birth at a time when two favourable planets were in conjunction, thus determining his subsequent good fortune.

Cameos make a brief appearance in this period, again indicative of Shah Jahan's interest in the minutely intricate working of difficult and precious hardstones. A cameo portrait of the emperor [74] may be the work of a Western craftsman employed in the royal workshops, as the features are modelled with a sensitivity and realism more in keeping with Western traditions, whereas the purely eastern feature of the feather plume in the turban is poorly observed. Instead of curving elegantly downwards, it projects woodenly at an odd angle, its shape that of any large bird's feather rather than the heron's feather which was normally selected for imperial use, carefully shaped and often weighted down with pearls.

Enamelling also reached a peak of excellence under Shah Jahan, judging from the few pieces which can reasonably be attributed to his reign.[67] His monuments certainly inspired the choice of colours most frequently seen even after the Mughal dynasty had ended: a brilliant, translucent red and deep, translucent green on a white ground evoke the *pietra dura* inlays on marble. The technique and style went on to be adopted by the Rajputs and the regional courts of the nawabs, though the court of Oudh produced its own distinctive palette, dominated by translucent blue and green (p.180).

The style set by Shah Jahan was followed by other courtly patrons. His son Dara Shukoh, for instance, employed artists who produced an album in the best imperial manner[68] and owned a sword which suggests access to the finest craftsmen available [75]. Production on other levels was necessarily more conservative, the craftsmen working in ways familiar to them and using pattern books to provide a decorative repertoire that would change slowly, away from the dynamism of the court and without the resources to produce experimental work.

**73. Wine cup of Shah Jahan**
White nephrite jade
Mughal, dated 1067AH/1657
L. 18.7cm, W. 14cm
IS 12–1962
Bought with the assistance of the National Art Collections Fund, the Wolfson Foundation, Messrs Spink and Son, and a private friend of the Museum

The cup is engraved with the title of the emperor, *sahib-i qiran-i sani*, 'Second Lord of the [Auspicious] Conjunction', which he used in emulation of his ancestor Timur who had been the First Lord of the Conjunction.

**74. Cameo portrait of Shah Jahan**
Sardonyx
Probably the work of a European at the
Mughal court, *c.*1630–40
2.3 x 2.0cm
IS 14–1974

## 75. Sword of Dara Shukoh

Steel, the hilt overlaid with gold, the watered blade with stamped and gold-inlaid inscriptions, the wooden scabbard covered with green velvet and red brocade, and with enamelled gold mounts
Mughal
Inscribed as belonging to Dara Shukoh (1615–69) and stamped with the date 1050(?)AH/1640–41
L. 85.1cm
IS 214–1964
Given by Lord Kitchener

## 76. Carpet fragment

Wool with cotton warps and silk wefts, Mughal, mid–17th century
52 x 56cm
IM 153–1926
Given by Mr. V. Behar

## 77. Velvet border

Mughal, mid–17th century
35.5 × 265cm
320a–1898

This may be seen in a carpet commissioned by an official of the English East India Company, William Fremlin, who arrived in India in the year of Shah Jahan's accession [132].[69] Ownership of oriental carpets in Britain at that time was a mark of wealth and prestige, and Fremlin was not the first to take advantage of his Indian service to acquire one: Sir Thomas Roe had earlier brought home 'a great carpet with my armes theron' and another was commissioned in 1631 by an East India Company director. Fremlin became president of the Council of Surat in 1637 and, though there is no reference to the carpet in contemporary documents, he presumably ordered it between then and 1644 when he left India. His ownership is established by the repetition of the Fremlin arms at intervals on the main field of the carpet and round the border. The motifs and basic character of the design are Iranian, reflecting the traditions brought to India during Akbar's reign by the first carpet weavers, but the animals which leap and fight between flowering trees are arranged with the greater freedom which gradually gave way to the new repertoire of ornament [76].

Under Shah Jahan, the empire reached its greatest prosperity and this, combined with his own character, led to the production of masterpieces in every area of artistic activity. However, his reign ended in tragedy and ignominy. During a severe illness in 1657 which was expected to be fatal, each of his sons rushed to declare himself emperor. A violent fight for the succession broke out, from which the experienced and disciplined soldier Aurangzeb emerged the ultimate victor, declaring himself emperor in 1658. His brothers were imprisoned and put to death, and his father was kept in captivity in the fort at Agra until his death in 1666, from where he could see, but not visit, the tomb of his wife.

### Aurangzeb

The personality of the emperor Aurangzeb, who took the title 'Alamgir, tended towards an asceticism that became increasingly marked as he grew older. This, inevitably, influenced the development of the arts over his long reign (1658–1707) although, at first, the lives of his craftsmen and painters must have carried on virtually unchanged as they responded to the demands of court ceremonial. The royal artists continued to illustrate manuscripts, to record major events and to paint the portraits of key personalities for the emperor and for posterity. The craftsmen of the imperial workshops must have been constantly employed making the gifts used to impress ambassadors, to reward the achievements of those surrounding the emperor or those who attained high office, as well as supplying the daily needs of the court.

Although the emperor's outward appearance became increasingly simple as time went on, early in the reign he seemed to wish to embody the splendour of the dynasty. Jean-Baptiste Tavernier,

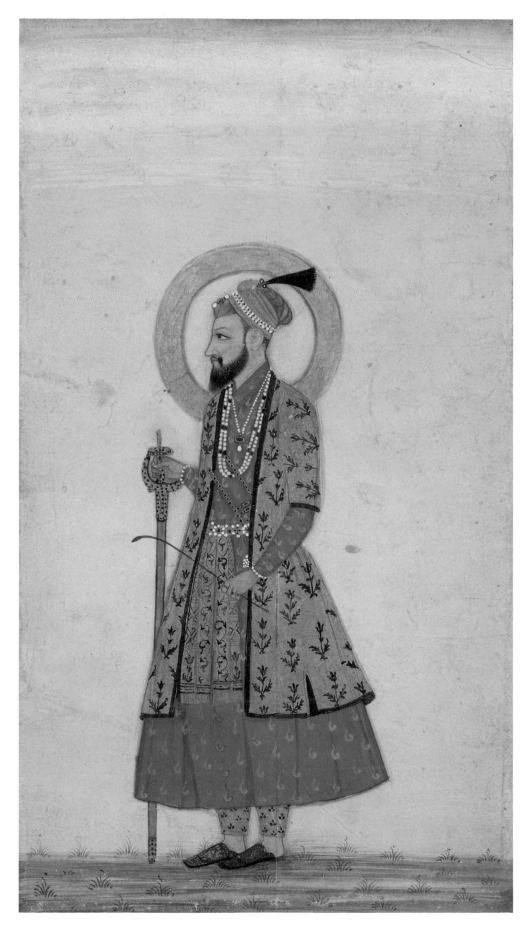

the French jeweller and seasoned traveller to India, reported Aurangzeb's anxiety over the matter which caused him to send an urgent message to his father: 'He begged him, as he was about to ascend the throne in a few days, to have the kindness to send some of his jewels to be used on that day, so that he might appear before his people with the same magnificence as the other emperors, his predecessors, had done.'[70] As Shah Jahan had been not only deprived of his rule but also imprisoned by Aurangzeb, it may not be an entirely fanciful story that, in a fit of rage, he called for a pestle and mortar, declaring that he would rather grind the jewels to a powder than allow his son to own them. Shah Jahan seems gradually to have resigned himself to his position but would, in any case, have had little choice over these dynastic possessions, which belonged to each succeeding emperor as long as he had the power to retain them.

Despite Tavernier's comments that Aurangzeb was not personally interested in jewels,[71] the wealth of the Mughal empire ensured that what little ornamentation he allowed himself was of the highest quality. The French physician François Bernier described him in 1663, seated on his throne wearing a turban of gold cloth, in which was 'an aigrette whose base was composed of diamonds of an extraordinary size and value, beside an Oriental topaz, which may be pronounced unparalleled, exhibiting a lustre like the sun. A necklace of immense pearls, suspended from his neck, reached to his stomach.[72] The throne was one of a collection of seven, all heavily encrusted with pearls and gemstones, of which the most valuable was the Peacock Throne made for Shah Jahan.

A history of the reign, the *Ma'asir-i ʿAlamgiri*, is strewn with references to the gifts presented or received at court, indicating the range of skills of the royal artisans and the volume of their work. Ornate weapons had always featured strongly in the lists of items presented to favoured individuals by the Mughal emperors but under Aurangzeb many, particularly daggers, display an innovation in form and decoration that seems to have diminished in other areas of the arts. Hilts of ivory, jade or crystal, for instance, are worked into the shape of animal heads [79], producing small sculptural masterpieces which are often delicately embellished with precious stones set into fine gold. Others imitate, in hardstone, the swirling contours of hilts made of metal strips which have been twisted together during the forging process or have a simple, practical shape which is then decorated with scrolling floral decoration. Less expensive, though no less skillfully-made models were of steel, watered and patterned with gold or carved, finely ornamenting simple shapes such as the traditional Indian punch-dagger [80], breast-plates and helmets, or the various types of sword. The quality of the weapons of the period is perhaps not surprising given Aurangzeb's love of the hunt,[73] the military activity of his formative years and, particularly, the almost constant campaigning of the second half of his reign.

**78. The emperor Aurangzeb (1658–1707)**
Gouache and gold on paper
Mughal, c.1700
19.8 x 11.3cm
IM 286–1913

### 79. Dagger

Horse's-head hilt of green nephrite jade set with rubies in gold; the blade of steel, the velvet-covered scabbard with enamelled silver mounts
Mughal, *c.*1700
L. 42cm
02566 IS

◀ ### 80. Punch-dagger

Steel, the blade carved and inlaid with black lac, the hilt inlaid with gold
Mughal, first half of 18th century
L. 38cm
3452 IS

### 82. Primer

Ivory, carved and with minute traces of gilding
Mughal, 17th century
L. 16cm
Circ. 597–1923

In other areas the court style began to move in a different direction. Immediately after his accession, Aurangzeb had to tackle the economic problems of the empire caused by the immensely destructive wars of succession. The most oppressive taxes and duties were lifted but the subsequent fall in revenue had to be offset by economies at court. One of the most significant was the closing of the department set up by Akbar to collect all the official economic statistics and political information concerning the empire, which had provided the factual basis for the *Akbarnama*, the *Jahangirnama* and the *Padshahnama*, as well as for the beginning of an *ʿAlamgirnama*.[74] With its closure, the official history of the reign stopped. In 1668 Aurangzeb abolished the costly ceremony of the twice-yearly weighing of the emperor against precious materials on his solar and lunar birthdays'[75] while other economies were in keeping with his religious convictions. In 1669 he banned the use of cloth of gold for personal use because 'the wearing of it was opposed to the Holy Law';[76] in 1677 he decreed that the imperial workshop making presentation robes, the *khil'at khana*, should produce embroidered cloth rather than fabric with gold and silver flowers worked on it, and that the Chanderi factory which supplied the court with high quality fabric should be closed.[77] The extension of rulings such as these was the order for the destruction of Hindu temples and the reintroduction of the *jizya*, a poll tax on non-Muslims which had not been levied since Akbar had abolished it in 1564.[78]

Whether or not these public announcements of austerities were followed through, the precious nature of the gifts mentioned in the *Ma'asir-i ʿAlamgiri* remained consistent with Aurangzeb's position as ruler of one of the richest empires in the Islamic world. Princes were showered with jewellery, costly robes and richly caparisoned horses and elephants to celebrate their marriages,[79] individuals were given costly emblems of office, such as jewelled maces or crystal inkpots on appointment and, at the onset of winter in 1684, the emperor sent out new robes to 'all the imperial servants at the Court and the provinces.'[80] There is a striking emphasis on artefacts made from jade and crystal which may perhaps indicate Aurangzeb's artistic preferences. In 1699 he was presented with a beautifully striated hardstone vessel which he greatly admired. His reaction was to request other items in the same material, which led to his being sent carpet weights, used to hold down the corners of lightweight floor coverings, as well as a throne, fountain and even a bedstead.[81]

It is nonetheless clear that Mughal art gradually lost its dynamism as the themes established by Aurangzeb's predecessors in painting, architecture and the decorative arts were followed with increasing stiffness and stylisation. Although little apart from painting may now be attributed with certainty to court patronage, the process may be seen clearly in the emperor's architectural commissions. In 1662 the Pearl Mosque or Moti Masjid was completed within the walls of the

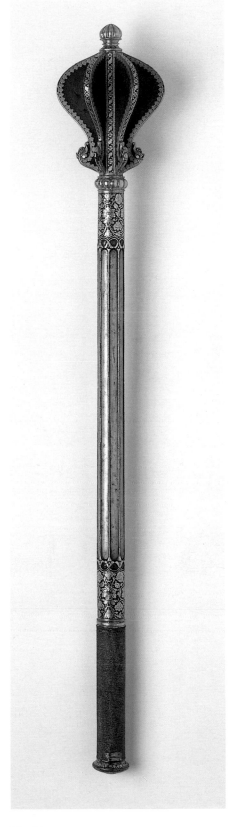

**81. Mace**
Steel, finely inlaid with gold
Mughal, first half of the 18th century
L. 58.5cm
3526 IS

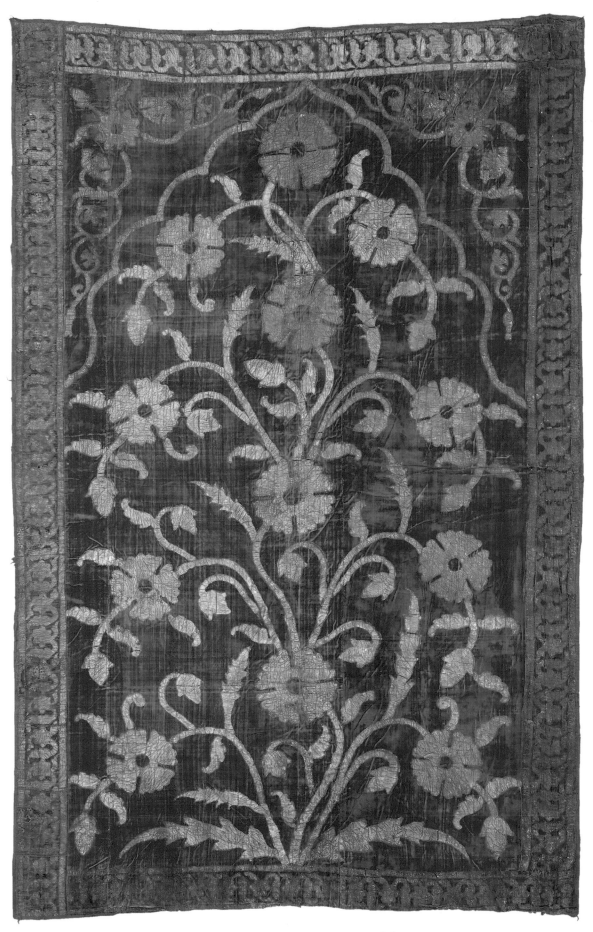

102

fort at Delhi. It is constructed entirely from white marble, carved with floral designs in conscious emulation of Shah Jahan's similar mosque of 1654 at Agra. Although the carving is of superb quality, there is already a sense of decadence in the lack of control over the elements of the decoration, with flowers filling their allotted space awkwardly and standard motifs such as bowls of fruit suspended rather strangely in the composition.[82] For his most important architectural project, the Badshahi Mosque in Lahore, Aurangzeb simply adapted the model used by Shah Jahan for his Jami Masjid in Delhi, enlarging it significantly so that it was, and remains, the largest courtyard mosque in the subcontinent.

While the Badshahi mosque was under construction, the first great reactions against Aurangzeb's rule were taking place. The success of the empire had always depended on a rule of religious toleration and, when this disappeared, the alienation of his non-Muslim subjects quickly developed into open hostility. Uprisings of Sikhs and Rajputs were soon put down but in the south, after initial successes which marked the watershed of the reign, control became increasingly difficult to maintain. The two surviving, independent sultanates of Bijapur and Golconda were so enfeebled that it required only the emperor's personal direction for the Mughal armies to annex them in 1686 and 1687 respectively. These victories had the potential to invigorate both the economy and the artistic life of the empire. Properly administered, and freed from their traditional squabbling, the sultanates were valuable prizes. Many individuals were taken into imperial service, the *Ma'asir-i ᶜAlamgiri* commenting: 'It would require another volume to describe in detail the coming of the Haidarabadis to the imperial Court . . . and the admission into the imperial service of professional men, men of skill, and artisans of every kind [84].'[83] Unfortunately, the political situation in the Deccan had changed by Aurangzeb's reign to include a new kingdom, that of the Hindu Marathas, which could not be dealt with easily and which destabilised the entire region.

Its founder, Shivaji, came from a family with a long history of fighting against the Mughals and as early as 1648 he had clearly intended to establish an independent state.[84] The desire was galvanised by Aurangzeb's order of 1669 to demolish certain Hindu temples and, after a period of continuous warfare, Shivaji had enough territory and confidence to declare himself ruler of the Maratha state in 1674. Marathi, not Persian, was to be the court language and Sanskrit provided the vocabulary for its administration and institutions. At his death in 1680 Shivaji left a nation with an identity that was the antithesis of that of the Mughal empire and skills in guerrilla warfare ideally suited to the Deccan terrain. Maratha incursions on Mughal strongholds trapped Aurangzeb in the Deccan for the rest of his life, occupied with campaigns that became increasingly pointless. The remarkable achievement of incorporating the elusive Deccan sultan-

**83. Tent hanging**
Velvet, stencilled and painted with gold leaf
Rajasthan, possibly Jaipur, probably 18th century
184 x 138cm
IM 30–1936

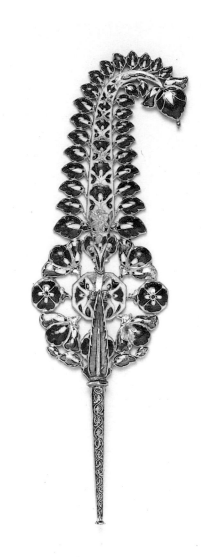

**87. Turban jewel**
Enamelled gold
Possibly Jaipur, *c.*1750
17.3 x 5cm
IM 47–1922

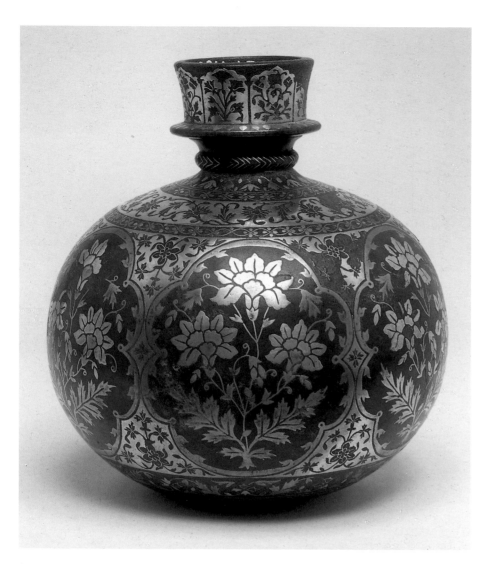

### 84. *Huqqa* base

Bidri, inlaid with silver and brass
Deccan or northern India, second half
of the 17th century
Ht. 18.6cm, diam. 16.8cm
IS 27–1980

The purely Mughal style of this floral
decoration makes it impossible to
determine whether it was made in the
Deccan, where the bidri technique
seems to have originated but which
at this time was under Mughal control,
or by Deccani craftsmen working at
the Mughal court.

### 85. Box and cover

Brass, chased and inlaid with lac
Mughal, second half of the 18th century
Ht. 7cm, diam. 10.4cm
IS 57–1985

### 86. Floorspread ▶

Cotton embroidered with silk
Mughal, *c.*1700
269 x 203cm
IS 34–1985
Purchased by the Associates of the
Victoria & Albert Museum

### 88. Helmet

Steel, engraved and partly gilt
Maratha, 18th century
Ht. 23 cm, diam. 25cm
3182 IS

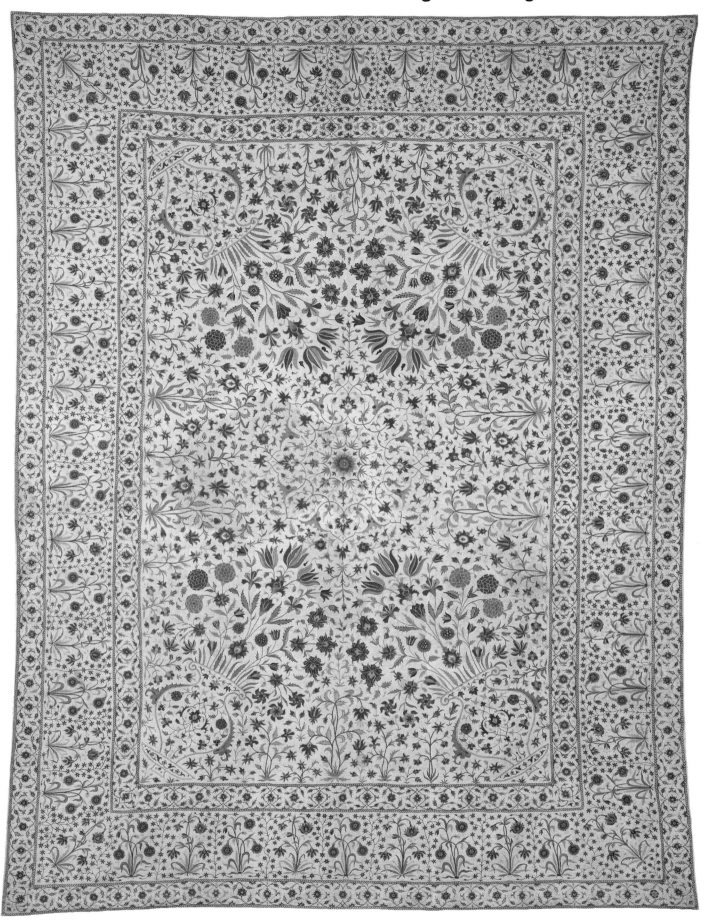

ates dwindled away as the ageing emperor was pulled from one fort to another in a desperate effort to maintain control over an area where, as soon as one rebellion was crushed, another sprang up. As the centre of power moved with the emperor to the south, Mughal control over the north began to disintegrate as small rebellions and petty wars broke out at regular intervals. The emperor's power, and the respect in which he was held by his more powerful subjects, inevitably diminished. The giving of honours which had traditionally been in the gift of the emperor alone began to be handed out by those not entitled to bestow them, to others not entitled to receive them. In 1693, for instance, Aurangzeb decreed that no one should make for himself turban jewels [87] as these could be presented only by the emperor;[85] after his death it became standard practice for these to be made for the nawabs and maharajas who presented them to senior members of their own courts as well as to others of sufficient status (see p.178).[86]

On Aurangzeb's death in 1707, the empire was devastated by war and famine in the south and riven by regional quarrels in the north. His successors lacked the abilities which would have been needed to revive Mughal fortunes and, in 1739, the Iranian ruler Nadir Shah took the opportunity of raiding the Mughal capital. His attack, like that of Timur's almost exactly four hundred years earlier, was one of slaughter and pillaging, its repercussions felt all over India. The treasury was emptied and the greatest possessions of the Mughal emperors, including the Peacock Throne and the Koh-i-Noor diamond, were taken back to Iran. Having graciously restored the Mughal emperor, Muhammad Shah, to his throne (though with his territory reduced and his wealth removed) Nadir Shah left, taking with him stonemasons, goldsmiths and other craftsmen, so that he could create in Iran a city on the model of Delhi.[87] Although the dynasty survived in name until 1857, the raid ended effective Mughal rule. Power was henceforth in the hands of the rulers of the provincial courts.

1. *Babur-Nama*, 1922, p.91.
2. For an account of the battle see *Babur-Nama*, 1922, pp.470–1 and Majumdar, vol.7, pp.34–5.
3. *Babur-Nama*, 1922, p.484.
4. Ibid., p.480.
5. Ibid., p.518.
6. Ibid., p.520.
7. Ibid., p.518.
8. Ibid., p.520.
9. Ibid., p.520.
10. Ibid., p.531.
11. Beveridge, 1902, p.103.
12. *Babur-Nama*, 1922, p.477.
13. Ibid., p.528.
14. Ibid., p.642.
15. Stewart, 1832, p.13.
16. Beveridge, 1902, p.118 ff.
17. Ibid., p.68.
18. Stewart, 1832, p.34.
19. Ibid., p.68.
20. Majumdar, vol.7, pp.83–6.
21. See Brown, 1956, chapter XV.
22. Stewart, 1832, p.43.
23. *A'in-i Akbari*, vol.1, p.232.
24. Brand and Lowry, 1985, p.38.
25. P. Chandra, 1976, p.63; Abu'l Fazl gives 12 volumes and the same total number of illustrations in the *A'in-i Akbari*, vol.1, pp.116–18.
26. Date suggested by P. Chandra, 1976, and followed by most commentators. Abu'l Fazl gives the information on the duration of the project.
27. *A'in-i Akbari*, vol.1, p.113.
28. Ibid., vol.1, p.114.
29. Ibid., vol.1, p.103.
30. Loc. cit.
31. Wellescz, 1930.
32. *A'in-i Akbari*, vol.1, p.114.
33. Brand and Lowry, 1985, p.98 and fig.61.
34. *A'in-i Akbari*, vol.1, p.12.
35. Ibid., vol.3, pp.345–7.
36. Ibid., vol.1, p.57.
37. Ibid., vol.1, p.98.
38. Ibid., vol.1, p.47.
39. Bernier, quoted by Murphy in Skelton *et al*, 1982, p.79.
40. *A'in-i Akbari*, vol.1, p.120.
41. For example, a manuscript in the British Library (Or. 2169) dated 1621.
42. Beach, 1978, pp.33–40.
43. Rogers and Beveridge, 1909, vol.II, pp.20–1.
44. Ibid., vol.II, p.20.
45. Majumdar, vol.7, p.343; cf. Rogers and Beveridge, vol.I, pp.249–51 and 273–6.

46. Rogers and Beveridge, 1909, vol.I, p.215.

47. Ibid., vol.II, p.145.

48. Skelton in Pal, 1976; cf Beach, 1985.

49. Rogers and Beveridge, 1909, vol.II, pp.80, 82.

50. Roe, 1967, p.214.

51. Ibid., p.320.

52. Ibid., p.321.

53. Skelton in Watson, 1972, p.98–110.

54. Elliot and Dowson, 1953, pp.102–4.

55. Rogers and Beveridge, 1909, vol.II, pp.370–71.

56. Koch, 1988.

57. Cf. J. Leoshko in Pal, 1989, p.73.

58. Koch, 1988.

59. See, for example Beach, 1981, pp.29–30.

60. Skelton *et al*, cat.52, p.41.

61. Beach, 1978, pp.78–85.

62. Rogers and Beveridge, 1909, vol.I, p.322.

63. Ibid., vol.II, p.78.

64. Tavernier, vol.I, p.89.

65. Sarkar, 1919, p.18.

66. Skelton, 1966.

67. For example, Ivanov, 1984, fig.163. This was taken by Nadir Shah from the imperial treasury in 1739 and subsequently presented to the Russian empress.

68. Archer and Falk, 1989, pp.72–81.

69. Irwin, 1976, pp.65–6.

70. Tavernier, vol.1, p.295.

71. Ibid., vol.1, p.317

72. Bernier, p.268.

73. Sarkar, 1947, p.23.

74. Ibid., pp.iii–iv.

75. Ibid., p.48.

76. Ibid., p.50.

77. Ibid., p.100

78. Ibid., p.108 and Majumdar, vol.7, pp.115 and 235.

79. Ibid., pp.77 and 93.

80. Ibid., p.154.

81. Ibid., p.247.

82. Gascoigne, 1970, plate p.209.

83. Sarkar, 1947, p.184.

84. Majumdar, vol.7, p.255.

85. Sarkar, 1947, p.217.

86. Stronge, 1985.

87. Lockart, 1900, p.154

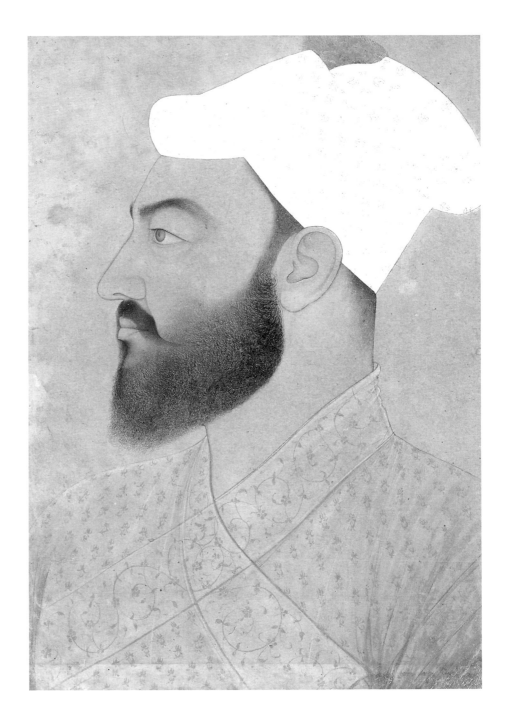

**89. The emperor Bahadur Shah (1707–1712)**
Gouache and gold on paper
Mughal, *c*.1710
28 x 18.15cm
IM 36–1922

بشنیدند برو منجب شده از فصاحت و بلاغت او منجب شد و
روی به نزدیکان خود آورد و گفت مرد هنرمند که جم نام او حم بود عقل

و د آتش اونی اختیار فضایل او بر قوم ظاهر کرد از آنجا که فروغ
آتش اگر فرورنده خواهد که پست بسوزد البته بر به بلندی کشد
آنجا که نشان عشق یارست بر آینه وی آشکارست د هنذرنیا
سخن شاد شده د انگشت که افسون او از شیراز کرده و غریب او

۹

# 4.
# The Sultanates of the Deccan

By the late sixteenth century, Akbar's control over the north of the Indian subcontinent was secure. The empire extended from Kabul in the far north, to Thatta and Gujarat in the west and Bengal in the east. To the south lay the independent and temptingly wealthy Muslim sultanates of the Deccan. In 1596 Akbar annexed Berar, the northernmost region, thus beginning a process that was to take successive Mughal emperors almost a hundred years to complete and which, ultimately, led to the fall of the empire.

The Deccan sultanates emerged, politically and culturally, from the Bahmani dynasty which had been founded in 1347. From the outset, the dynasty drew much of its cultural, religious and aesthetic inspiration from beyond its own borders. Its first ruler claimed descent from the renowned Iranian hero-king, Bahman, from whom the dynasty took its name. Whenever peace interrupted the turbulence of wars with the neighbouring Hindu kingdoms of Vijayanagar and Warangal, the court attracted scholars, poets, artists and craftsmen from all over the Muslim world, including the northern Indian sultanates. Many of these settled permanently but, by the middle of the fifteenth century, the constant influx into the kingdom had caused a split in the ruling Muslim aristocracy.

The internal situation deteriorated until each administrative province, beginning with Berar in 1484, successively declared independence from Bahmani rule, centred in Bidar. Bijapur, Ahmadnagar and Golconda followed, Bidar itself dispensing with the last vestiges of Bahmani suzerainty in 1526 or 1527. Berar was subsequently absorbed by Ahmadnagar until its incorporation into the Mughal empire.

The reasons for Akbar's decision to conquer the Deccan are not hard to fathom. The *Akbarnama* notes 'conquest is the great rule of princes',[1] but there were also important economic motives. The Portuguese had gained great influence in the Deccan courts but, more significantly, controlled strategic foreign trade routes and major Indian ports. An alliance between the Portuguese and the Deccan sultanates would have been disastrous. Access to foreign gold and silver mines, and a reliable sea trade, were crucial to the survival of the Mughal empire. The sultanates were, however, worthy prizes in their own right. The famous diamond mines were in the Qutb

**90. Page from the *Anvar-i Suhayli***
Gouache and gold on paper
Golconda, *c.*1580
26.5 x 16cm
IS 13–1962 (f.61)

**109**

Shahi sultanate of Golconda, Bijapur having another important field. These, until diamonds were discovered in Brazil in 1725, and in South Africa in 1867, supplied the world.[2] The Deccan was also the main source for the iron ore that could be made into steel, and which was exported internationally for use in high-quality weapons manufacture.

With the exception of architecture, little of the artistic production of the sultanates has survived, and that which has is usually uninscribed and undocumented. Nevertheless, the superb quality of some of the surviving artefacts provides a tantalising glimpse of a world of courtly splendour and cultural refinement, others indicating traditions which, though less elevated, are lively and appealing.

Where the arts of the book are concerned, a few dated manuscripts have been discovered from Ahmadnagar, Golconda and Bijapur, but none was produced earlier than 1565. Nothing at all remains from sixteenth-century Bidar or Berar. An early, and intriguing, Deccani manuscript is the Victoria and Albert Museum's *Anvar-i Suhayli* [90, illus. p.108], conventionally attributed to Golconda. Its date of completion is generally accepted as 990 AH (1582–3)[3] but, though convincing, this is not certain: the manuscript has been extensively repaired and the date has been written over a restored corner of the final page.

The *Anvar-i Suhayli*, often called *The Lights of Canopus* in English, is a Persian version of fables originally composed in India and, at some point, written down in Sanskrit. These had travelled westwards and had been re-written in the languages of the countries through which they moved, some of the stories being incorporated into Aesop's *Fables*. The Persian version was written by Husayn Va'iz al-Kashifi of Herat in the fifteenth century and takes its name from an allusive, punning reference to the author's patron, Shaykh Ahmad al-Suhayli. In this form the fables returned to India where they enjoyed wide popularity.[4] For many years, the Victoria and Albert Museum's manuscript was thought to be from a provincial Iranian school.[5] The expressionless faces of the figures, the asymmetrical arrangement of architectural settings on the page and the high viewpoint are typically Iranian, as is the treatment of spatial depth, which is suggested by minutely patterned blocks, each indicating a different space. The artists borrow freely from Iranian conventions (for example, in the use of stock motifs such as flowering cherry trees, or more unusual features such as bizarre, striped clouds),[6] but the vibrant use of colour and denseness of detail, together with the naive depiction of snarling animals and the thick, rather crude application of paint, strike a false note when compared with Iranian traditions.

The debt to Iran is not surprising: the Qutb Shahi dynasty was founded by Sultan Quli Qutb al-Mulk, an immigrant from western Iran who, after a career in Bahmani service, declared his independence in 1512 or 1518, making his capital in Golconda.[7] The Qutb

Shahis were Shias, like the ruling Safavid dynasty of Iran, and contacts between both were close; in the reign of Muhammad Quli Qutb Shah (1580–1612), Shah ʿAbbas of Iran sent an embassy to Hyderabad, the second capital, in an attempt to form an alliance between his son and the sultan's daughter. Though the attempt was unsuccessful,[8] the embassy stayed six years, adding to what must already have been a considerable Iranian community. Anthony Schorer, a servant of the Dutch East India Company who had been to the Golconda court in 1609, comments that the ruler 'bestows large sums in religious benevolence, especially on Persians, who come from Persia in great numbers, men of noble ancestry but small means'.[9] He also notes that in Nizampatnam, or Petaboli, the Dutch trade in porcelain was greater than elsewhere because of the demand from local Iranian merchants 'who eat from porcelain, while the Gentus [Hindus] do not'.[10]

In other sultanates, Iranian influence is also marked but local traditions are sometimes more pronounced. In the Bijapuri painting of a horse and groom [91] the delicately painted flowering plants, the apparent weightlessness of the groom, and the horse with its raised foreleg all derive from Safavid conventions. Yet the modelling of the man's face and limbs, with their pale highlighting and shadows, hark back to the treatment of figures in the Buddhist frescoes of Ajanta.

The ruler of Bijapur at this time was Ibrahim ʿAdil Shah II (1586–1627), the most powerful of the Deccan sultans. In 1601 Akbar had advanced his Deccan plans to the extent of occupying Ahmadnagar, prompting Ibrahim to offer one of his daughters in marriage to Akbar's son Daniyal, a gesture of conciliation which he hoped would halt the march of the Mughal armies. A Mughal envoy was sent to discuss the arrangements but failed to return, seduced by Ibrahim's hospitality which seems to have been inspired by a desire to prevaricate.[11] An enraged Akbar sent a second envoy, Asad Beg, to bring back the miscreant. Asad Beg left an account of his mission which, when combined with the paintings of Ibrahim which have survived, suddenly illuminates a particular period of Deccani history.

Many of the paintings of Ibrahim[12] hint at the splendour of his court. He is often depicted heavily adorned with jewellery and draped with beautifully patterned, coloured silks, as in a drawing in the Victoria and Albert Museum [92], where the brilliant red and blue of his shawl, highlighted with gold, stand out against the restrained, colour-washed background, as do the golden fruit dishes and the Chinese blue and white vase.

Although much of the court's culture was necessarily influenced by the Islamic world, Ibrahim was very much a product of his Deccan upbringing. A deep understanding of Persian, the *lingua franca* of the day, was inevitable, and Ibrahim patronised many Persian scholars and poets of note. Yet, according to Asad Beg, he also spoke Marathi and his collection of songs, the *Kitab-i Nauras*, was written in the

◀ **91. A royal horse and groom**
Gouache and gold on paper
Bijapur, *c.*1590, mounted in a later
album page
11.4 x 10.3cm
IS 88–1965

**92. Ibrahim ᶜAdil Shah II (1580–1627)**
Water colour, ink and gold on paper
Bijapur, *c.*1630?
10.4 x 8.2cm
IS 48–1956 (f.1b)
Given by Mr John Goelet

From the Small Clive Album, which
is thought to have been given to
Robert Clive by the Nawab of Oudh,
Shuja ad-Daula. During his last visit to
India from 1765–7, Clive restored to
the Nawab the province of Oudh,
which had been lost to the British in
1764.

newly developing language of Deccani Urdu. The songs were written for Indian musical modes, some of them in praise of the famous Muslim saint of Gulbarga, Sayyid Husain Gesu Daraz, while many of the others sing of the Hindu deities Saraswati and Ganesha.[13] *Ragamala* subjects were by now an established feature of Deccani painting and, although it is not yet known where or for whom they were produced, Ibrahim has been suggested as a plausible patron for such works.[14]

The sultanate must, by this time, have been the settled home of considerable numbers of Hindus who had fled Vijayanagar, following its collapse in 1565 when a cataclysmic military defeat was inflicted by a confederacy of its Muslim neighbours. Under Ibrahim, Hindus were certainly given positions of great political and economic power. One of his most trusted officials was Antu Pandit; another Hindu, Ramji, was head of the Bijapuri guild of jewellers and advised Asad Beg on the purchase of jewelled ornaments for Akbar.[15] Asad Beg's account indicates the great number of metalworkers in the city and, given the highly developed, indigenous metalworking traditions of the region, it is unlikely that Hindus would not have been found in significant numbers. Having persuaded a reluctant Ibrahim to present to Akbar one of his favourite elephants, Chanchal, Asad Beg was told that it would have to be suitably adorned, and a large amount of gold was made available for the purpose. Suspecting this might be a ruse to detain him, the envoy insisted the work should be carried out under his own supervision. By the following day, no fewer than one hundred artisans had been produced and the project, to Asad Beg's surprise, was completed in ten days.[16] The extent of the work involved may be gauged by the richly caparisoned elephant in the drawing by the Bijapuri artist ᶜAli Reza [94].

Although the culture of the Deccan sultanates was overwhelmingly Iranian, the most successful industries of the region were based on skills and craft traditions which stretched back in time far beyond the arrival of the Muslims in India. Pre-eminent among these was the textile industry, producing what was later to be renowned in the west as chintz (see chapter 6). Archaeological evidence from Mohenjo-Daro, in present-day Pakistan, establishes that the complex technology of mordant dyeing had been known in the subcontinent from at least the second millennium BC.[17] Its Deccani origins are unknown, but the astounding expertise of the region's dyers is clear from a group of textiles of the early seventeenth century:[18] the durability and glowing intensity of their colours, particularly the reds, combined with a common decorative vocabulary, make the group distinctive.

These are all painted on cotton, a process fraught with so many technical difficulties, yet rendered with such consummate skill, that it is evident they are the product of a long tradition. The designs were produced by transferring certain elements from a stencil on to

**93. Chess pieces**
Carved ivory with traces of red pigment
Vijayanagar, Karnataka?, late 16th century
Ht.4 and 4.2cm
IS 85–1963 and IS 86–1963

**94. A royal elephant** ▶
Gouache on paper
By ᶜAli Reza
Bijapur, *c*.1610
35.5 x 23.7cm
D 398–1885

the cloth, and then using a brush to paint other motifs free-hand, as well as to fill in solid areas of colour. In 1605 Dutch merchants established a settlement in Golconda territory; the English followed suit in 1611. Their activities were primarily concerned with the spice trade of the Indonesian archipelago: in order to buy spice, their ships left Europe laden with bullion which was exchanged in India for cotton piece-goods, which were then taken to the spice islands and bartered. These merchants soon noticed that Golconda produced, in relatively small quantities, painted cotton cloth of a quality far superior to that obtained anywhere else. Europeans usually referred to it as being from Masulipatam, but this was simply the port where it could be bought or commissioned. The actual centres of manufacture were Palakollu, about eighty miles north of Masulipatam, and Petaboli (Nizampatnam), about forty miles to the south. Both the Dutch and the English kept factors in these towns: buying at source reduced the price by some thirty per cent.

As early as 1607 it had been recognised by the Dutch that the source of the red dye was confined to a specific locale. In 1634 the English resisted a suggestion that their Petaboli factory should be moved, stating categorically it should remain there 'chiefly for reds, because no other place affords like colour.' The plant producing the dye was known locally, and in European trade records, as 'chay', sometimes called by the English 'East India madder' (see chapter 6).

Nizampatnam was in Golconda territory, but was administered by a Hindu governor who, according to Schorer, paid the Qutb Shahi ruler an annual amount for the post. The craftsmen seem to have been Hindus working in family-based units, each specialising in a different stage of the process. The painters worked from patterns supplied to them and determined by whoever commissioned the work, which explains the variety in the overall character of these textiles. Within this predetermined framework they added their own touches, providing consistency across the group in small decorative details.

The Victoria and Albert Museum's *rumal* [96] draws on Safavid motifs and themes. Its central arrangment of linked cartouches borrows from Iranian manuscript illustration or book-binding; its figures illustrate the courtly pursuits of drinking wine, listening to musicians, romantic dalliance and hunting. The influence of miniature painting provides the piled-up rocks (here painted in patchwork-like sections, each with a different motif and ground colour) and the wisps of Chinese clouds. The isolated clumps of flowering plants derive from Safavid painting, but the flowers have sprouted to become a more dominant part of the design. The densely filled border incorporates appealing, almost accidental details such as the two startled hares at lower left and the two plump birds nearby. A large floorspread [137] is in related style and depicts duck hunters and other figures stalking through a forest filled with multi-coloured birds and strange flowers.

**95. Sultan ᶜAbdullah Qutb Shah (1626–72)**
Gouache and gold on paper
Golconda, mid-17th century
19 x 10cm
IS 18–1980

**96.** *Rumal*
   Cotton, stencilled, painted and dyed
   Golconda, *c.*1625–50
   62 × 89.5cm
   IS 34–1969

**97. Ewer**
   Bidri, inlaid with silver and brass
   Deccan, mid–17th century
   28.5 x 18.4cm
   1479–1904

**98. Bowl**
   Bidri, inlaid with silver and brass
   Deccan, early 17th century
   6.2 x 14cm
   IS 10–1973
   Given by Mr. Simon Digby

It was once in the collection of Mirza Raja Jai Singh of Amber (1622–68) whose seal is stamped on the front.[19] The third textile from this group, a large wall-hanging [138], has a completely different character, although its shared provenance is indicated by the quality of its colours and technique and by the small motifs which it has in common with the *rumal* and floorspread. The subject matter has never been properly explained, but it illustrates vividly the cosmopolitan world of the Deccan in the early seventeenth century. Figures in Dutch, Indian and Iranian dress, or hybrid elements of all three, are surrounded by exotic wares which include Chinese vases, European swords, inlaid wooden boxes, a ewer and rosewater sprinklers of Iranian form (though perhaps made in India), an Italian *latticino* glass stand filled with pomegranates and a European glass goblet.[20] The architectural details of this hanging, and related examples in other collections, belong specifically to the Deccan and convincing arguments link them with South Indian Hindu wall-painting traditions.[21]

Textiles such as these, using the most highly skilled craftsmen and raw materials available only in limited supply, were clearly destined for the luxury market and production could never have been large. By 1636 European traders could no longer procure them as, they reported, the dyers' work was monopolised by the Mughal emperor and the Shah of Iran on the orders of the 'king of Golconda'.[22]

One of the other major craft industries of the Deccan involved the production of inlaid metalwork which, from the mid-eighteenth century, has been known as bidri ware. Its name, taken from the city of Bidar, links it firmly with the Deccan. Bidri is made from a metal alloy in which zinc predominates, but which includes small amounts of copper and tin, as well as lead in varying proportions. Due to the problems of extracting zinc metal from its ore (unlike copper or iron, for instance, it vaporises into the air when heated and requires a special furnace) the metal could not be used in the west on an industrial scale until an Englishman, William Champion, patented his zinc distillation process in 1738. In India, however, zinc had been produced at least as early as the sixteenth century and in Rajasthan may go back to the fourteenth or fifteenth century.[23] It was probably used mainly in the production of brass, but by the mid-seventeenth century the bidri craftsmen must have been absorbing considerable amounts: surviving pieces [97] and depictions of bidri in miniature painting indicate a flourishing industry.[24]

The earliest documentary evidence linking bidri with Bidar does not appear until the eighteenth century. A history of India, the 1759 *Chahar Gulshan*, includes a statistical account of each region based on an earlier compilation of about 1720. Under the section dealing with Bidar, it notes: 'In this *subah* the fine and rare bidri vessels are made . . . . The craftsmen of this place make them with such delicacy that even a painter could not imagine them'.[25] Many of the finest

### 99. Fragment of a garment ▶

Painted and dyed cotton
Madras–Pulicat region or Golconda,
17th century
43 x 26.9cm
Circ. 344a–1932
Given by Professor K. de B. Codrington

### 100. Sash (*patka*) (detail)

Cotton, printed, painted and dyed
Burhanpur (?), 18th century
526 × 72.5cm
IM 311–1921

Formerly in the collection of the
Nizam of Hyderabad

### 101. Man's robe (*jama*)

Cotton, printed, painted and dyed
Burhanpur, 18th century
Ht. 105cm
IM 312–1921

Formerly in the collection of the
Nizam of Hyderabad

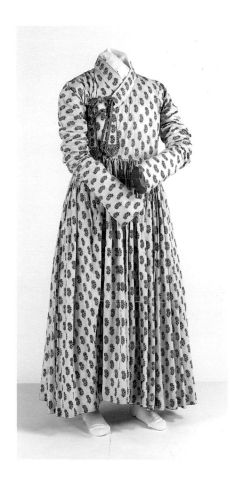

◀ 102. Nawab Sikandar Jah, Nizam
of Hyderabad, with four ministers

Gouache on paper
Hyderabad, Deccan, *c*.1810
34 x 24cm
IS 107–1951

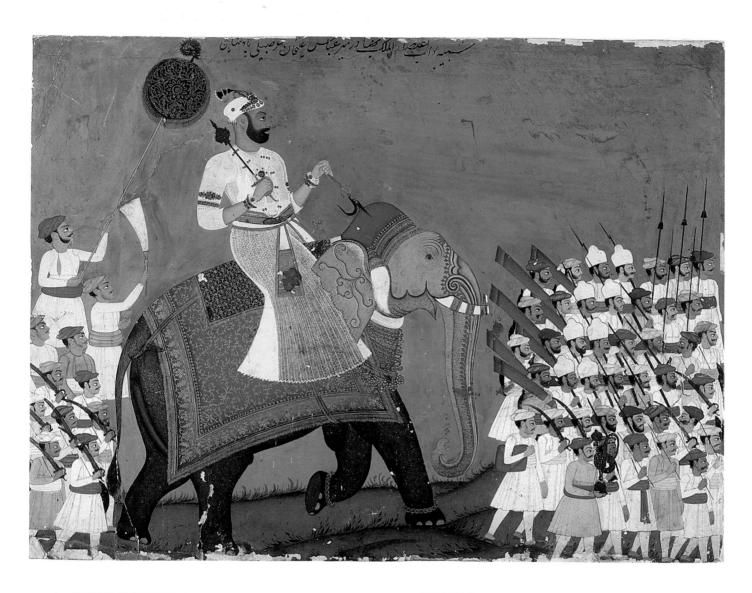

### 103. Nawab I'tisam al-Mulk on an elephant

Gouache and gold on paper
Hyderabad, Deccan, *c.*1795
30.7 x 40.5cm
IM 258–1921
Bequeathed by Sir Robert Nathan

### 104. Casket

Papier-mâché, painted and laquered,
with ivory edging
Probably painted by Rahim Deccani
Golconda, *c.*1660–70
9.6 x 13.6 x 9.2cm
851–1889

seventeenth- and eighteenth-century pieces known today are in purely Mughal style. The floral decoration within cusped cartouches on a *huqqa* [84], for example, is similar to that on tilework produced for contemporary Mughal monuments far to the north [cf.65]. This reflects the political situation at that time.

Jahangir had not been able to advance his father's plans for expansion into the Deccan, largely because of the qualities of those ruling Bijapur and Ahmadnagar, in fact if not in name. It was not until their deaths that progress could be made, assisted by devastating famines between 1630 and 1632 which weakened the sultanates considerably. In 1636 Shah Jahan arrived at Daulatabad, poised for attack. His mere presence was enough for Golconda, which immediately acknowledged Mughal suzerainty. Bijapur followed suit shortly afterwards and sizable parts of Ahmadnagar were absorbed into the empire. Shah Jahan then swept out again, leaving the eighteen-year-old Aurangzeb as viceroy of the Deccan. Although Mughal political control was not yet absolute (the sultanates did not become formally part of the empire until the 1680s), Mughal aesthetic influence reigned supreme. Deccani artists and craftsmen borrowed motifs, forms and designs to an extent that their own distinctive identity barely survived. By the eighteenth century this was even more pronounced: a painting may identify its subject as the Nizam of Hyderabad [102] but his stateliness is presented through Mughal idioms, with his jewellery, richly decorated dagger and sword, all emblems of his position, similar to any of those depicted in contemporary paintings to the north.

Yet, despite all this, Deccani traditions persisted. Mughal expansion into the Deccan was one of the major factors in the downfall of the empire; it became unmanageable. On the secure foundations laid by Akbar grew an edifice which became ever more fragile as it grew larger. Although Aurangzeb's achievement in conquering the region was remarkable, it could not be sustained. With the gradual collapse of central power under his successors, power shifted to the regional courts whose brilliance, though sometimes evanescent, often equalled that of the Mughal rulers they consciously emulated.

1. *Akbarnama*, vol.3, p.409.
2. Somers Cocks, 1980, p.12.
3. Losty, 1982, p.71.
4. Akbar had two copies of this manuscript prepared for him, the first dating to 978 AH (1570–71) (Losty, 1982, p.87) and the second to *c.* 1590 (see Wilkinson, 1929); Jahangir had a further copy made, at least part of which was begun at Allahabad before his accession (Beach, 1978, p.24).
5. Losty, 1982, p.71, for references.
6. Cf. Titley, 1983, p.88.
7. Sherwani, 1974, pp.301 ff.
8. Majumdar, vol.7, p.472.
9. Moreland, 1931, p.56.
10. Ibid., p.55.
11. Joshi, p.186.
12. See Zebrowski, 1983, chapter 4 *passim*.
13. Ahmad, pp.62–5.
14. Zebrowski, 1983, chapter 2.
15. Joshi, p.192.
16. Ibid., p.192.
17. Gittinger, 1982, p.19 ff.
18. This group of textiles was first identified and analysed by John Irwin, 1959, in an important article from which this account is largely taken.
19. See Irwin and Brett, 1970, cat. 1, p.64; cf. Smart, 1986.
20. Irwin and Brett, 1970, p.65.
21. Irwin, 1959, pp.25–6; Gittinger, 1982, p.113.
22. Irwin, 1959, pp.14–15.
23. Craddock, *et al.*, 1985; further references in Stronge, 1985, p.13.
24. Stronge, 1985, cat. nos. 1, 2 and 3; pls. 2, 3 and colour pls. A and B.
25. Ibid., pp.15–16.

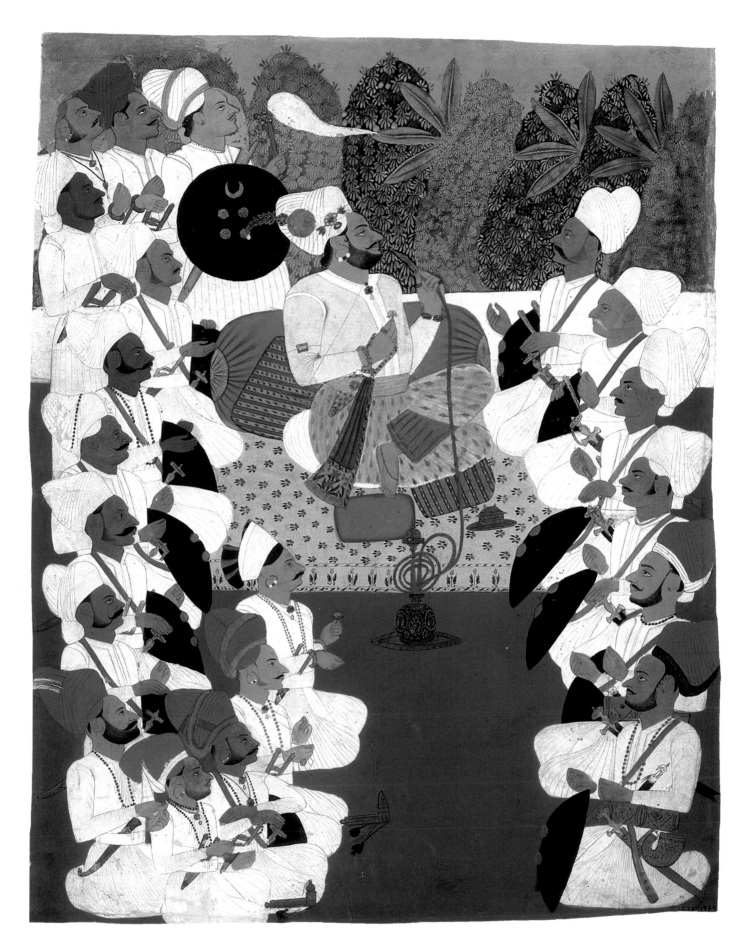

**124**

# 5.
# The Rajput Courts

### The Rajputs

When the Mughals seized power in Delhi, they had to overcome more than the declining Muslim sultanate before they could establish sovereignty over the north of India. In the Rajput kings who held the territories to the west of Delhi the new rulers encountered formidable opposition, not only in terms of fierce military resistance. The Rajputs [105] – clans of a warrior caste whose name literally means 'Sons of Kings' – had established themselves in central and northern India some time during the first millennium AD, and had gravitated towards the area which is now the state of Rajasthan and parts of neighbouring Madhya Pradesh from about the seventh to fifteenth centuries. They thus had a strong claim to an area which ranged in physical richness from the forested and well-watered slopes of the Aravalli hills in the south-east to the inhospitable but strategically placed desert of the north-west. Although each Rajput principality was independent, and frequently at war with its neighbours, many were interrelated by marriage, or by direct descent from the rulers of other states, with the result that they held in common far more fundamental characteristics than the territorial issues that kept them constantly skirmishing among themselves. These essential bonds ensured that the majority of the Rajput houses could never easily accept Mughal sovereignty, even though capitulation might bring them wealth, often much needed by the desert states, and influence at the Mughal court.

The most deeply felt characteristics of the Rajputs were the interlinked essentials of fierce pride in their origins, utter devotion to the clan deities, and belief in the Rajput role as *kshatriya*: warrior-rulers who are the traditional protectors of the Brahmin or priestly class. The various Rajput clans had traditional genealogies tracing their origins back to the sun or moon, and frequently also to deities such as Rama. Such illustrious descent would not easily be submitted to the rule of Muslims, and still less easily to adulteration of the Rajput blood-lines by intermarriage with them. Although Muslims, like Jains, had long been accepted within Rajput society, fulfilling especially the mercantile roles, they were still seen as outsiders. They might have useful contributions to make to society but, by virtue of the traditional caste system, they could never be absorbed into it through marriage, and could certainly never rise to its highest levels.

### 105. A Rathor ruler and his nobles

Gouache and gold on paper
Jodhpur, Rajasthan, *c*.1790
40.8 x 31.5cm
IS 27 1979

The strong colours and bold composition of this group are typical of Rajput painting, although the idea of painting real people from life was introduced to India by the Mughals.

**125**

As might be expected of such traditional and long-established societies, the Rajput kingdoms were already highly developed in cultural terms by the time the Mughals finally imposed their authority on them in the late sixteenth and early seventeenth centuries. Many important aspects of Rajput culture were sustained through a popular tradition rather than a courtly one – a feature which reflected the egalitarian aspect of traditional Rajput rulership, in which the raja was seen as the first among equals rather than a uniquely elevated being superior to his subjects. Thus literature was the domain not only of formally educated intellectuals and *pandits*, but also of the *charans* (hereditary bards), whose primary function was to recite and compose verses in praise of past and present rulers and their brave warriors. Some semi-divine heroes such as Pabuji and Gogaji [106], originally historical figures, had become so celebrated over generations that they had shrines and festivals dedicated to them just as the local gods did, and countless ballads were sung in their honour. Music was thus closely linked to oral history and popular religion, and was an essential part of court life which became influential on the visual arts through the depiction of musical modes in *ragamala* paintings. Music also became intertwined with the theme of romantic and divine love both in village and court. Folk stories of legendary lovers such as Dhola and Maru or Sassi and Punun and their trystings, separations and elopements provided subjects for paintings as well as songs. These themes constantly recur also in illustrations to stories of the life of Krishna, as well as in *ragamala* paintings, in which the mood of a musical mode is frequently represented by the activities of lovers, and in *barahmasa* (twelve months) series where the months are characterised by types of romantic activity [120]. The twin themes of religion and love dominated painting at the Rajput courts until the taste for portraits of living rulers and historical figures was introduced through contact with the Mughal court.

Rajput culture and visual arts before the Mughal conquest have a sketchy history, as few paintings and artefacts survive from that time. We can assume, however, that popular crafts such as embroidery, which formed so an important a part of Rajput life, were subject to fewer outside and courtly influences than those arts such as painting and architecture which required wealthy patronage. The timeless patterns and traditional techniques which are particularly associated with the decoration of clothing and domestic textiles have in many cases seen little change over centuries [107]. While the courtly use of fine fabrics was heavily influenced by the Rajput chiefs' experience of imperial luxury on their visits to the Mughal court, the women of the villages continued the traditional skills taught them by their mothers.

Perhaps the most distinctive of western Indian textile arts is that of *bandhani* or tie-dyeing [108 and 109], which, like embroidery and block-printing, was used widely throughout the whole range of

**106. Image of the folk hero Gogaji on his horse**
Bronze
Rajasthan, 19th century
20 x 18.5cm
IS 156–1984

Deified heroes are frequently revered by both Hindus and Muslims in village society. Gogaji (or Gogadev) is especially associated with snake worship.

**126**

◀ **107. Man's shawl** (detail)
Block-printed cotton, embroidered
with silk and decorated with mirrors
Sind or western Rajasthan, early 20th
century
267 x 160cm
IS 7–1981
Given by Mrs Shireen Feroze Nana

The desert regions of western India
and Pakistan are renowned for their
fine embroidery, and it is often com-
bined on costume pieces with other
techniques such as tie-dyeing or block-
printing.

**108. Hanging or awning** (detail)
Tie-dyed cotton
Kota, Rajasthan, mid–19th century
158 x 394cm
IS 18–1983

Tie-dyeing is still used in Rajasthan
for clothing, but highly-detailed
figurative designs are now rarely
found. This one was made for the
court at Kota, a renowned tie-dyeing
centre.

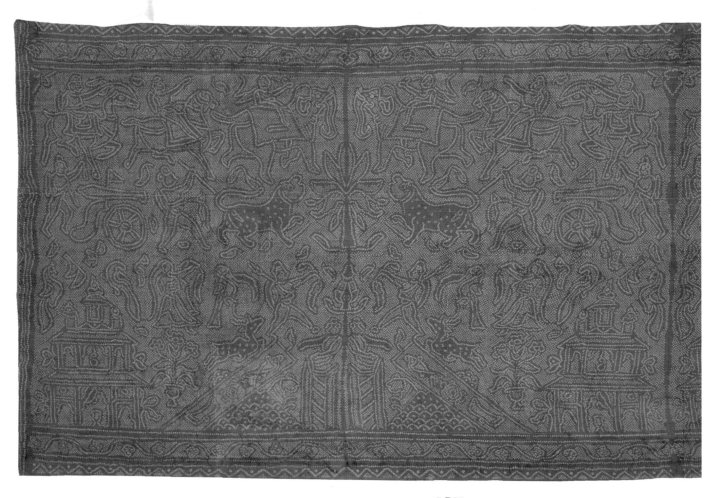

society. Carried out by small-scale professional workshops for sale in the local bazaars, the yellow and red tie-dyed *odhani* (head-cover), for example, is still worn by village women in Rajasthan today, while richer ladies invest in silk saris and *odhanis* of incredibly fine workmanship in which an intricate pattern is outlined in tiny dots, each one bound by hand with waxed string to resist the dye. This technique also had its place at court, and tie-dyed hangings, less widely seen than costume, were produced in centres such as Kota [108], where specialist craftsmen were employed to supply tie-dyed cloth exclusively to the local court. Tie-dyeing in a different form, known as *lahariya* [109], was equally widespread, and found particular favour amongst the Rajput rulers. These zigzag patterns are formed by folding the cloth in pleats before tying in bands, and are particularly well suited to turban-cloths.

Block-printing also has a long history in Rajasthan, and the small town of Sanganer, near Jaipur, is particularly renowned for the fine floral patterns that it has produced for the Jaipur nobility (and latterly bourgeoisie) at least since the eighteenth century.[1] Although several centres such as Barmer and Deesa manufacture coarser block-printed cottons for the *gaghras* (full skirts) worn by Rajasthani village women, Sanganer is known only for its finely printed textiles. Most exhibit strong Mughal influence, and were used for *jamas* (robes) and turbans, as well as linings for brocade coats and even armour. A speciality of the Rajasthani cotton printer was the application of gold on to cloth, a technique still used today. Sanganer block-prints were on occasion overprinted with gold to add extra glamour. The finest textiles were printed with real gold leaf pressed on to gum [111], but lower-quality cloth merited only metallic dust or even ground mica.

The most enduring manifestations of pre-Mughal Rajput culture are architectural. The Rajput forts and palaces that stand today are palimpsests of styles and periods overlaid on each other, often with the later, Mughal, style predominating. Two of the most magnificent examples of Rajput architecture, however – the forts of Chitor and Gwalior – were certainly built during the pre-Mughal period, mostly during the fifteenth century. Both of these extensive palace complexes make use of traditional Hindu building styles, such as corbelled arches, flat roofs, deep *chajjas* (eaves) and *jharoka* balconies, in combination with Islamic elements brought over from contemporary Sultanate architecture: domes, ogee arches, vaulting and polychrome tile decoration. Although a synthesis of Hindu and Islamic features was thus already present in Rajput culture, it was only with the advent of the Mughals and their domination of the Rajput courts that major stylistic and aesthetic changes began to take place.

## Mughal Domination of the Rajput Kingdoms
In spite of all their warlike skills, reckless bravery and devotion to their cause of repelling the Mughal invasion, the Rajput clans never

**109. Turban cloth** (detail)
Tie-dyed (*lahariya*) cotton
Jaipur, Rajasthan, mid–19th century
Approx. 700 x 20cm
5735 (IS)

Fine muslin is rolled diagonally or pleated before tying in bands to give a striped or zigzag effect. These multi-coloured turbans were often worn at festivals, when a special colour or design would be used.

**110. Canopy for a Hindu shrine** ▶
(detail)
Cotton, painted, printed and resist-dyed
Northern Deccan, early 19th century
264 x 216cm
IS 25–1983

Temples and shrines are often bedecked with textiles, and this canopy recalls a painted wooden ceiling in its decoration and colouring. Although made in the northern Deccan, possibly at Burhanpur, its use would be appropriate to temples in Gujarat or Rajasthan as well.

succeeded in forming a sufficiently strong confederacy to maintain their independence. Mewar, seat of the Sisodiya clan, was the last stronghold of the Rajputs, finally surrendering to Jahangir's forces only in 1615 [see **53**]. For all the other Rajput states the inevitable had already happened and the imperial forces (with help from the Raja of Amber) had crushed their fragmented opposition – Bundi was conquered in 1569, Bikaner and Jaisalmer in 1570 and Jodhpur in 1581. Amber had capitulated voluntarily to Akbar as early as 1562 and established the symbiotic relationship with the imperial court that was to ensure the prosperity of the rulers of Amber, and their later capital Jaipur, for generations to come. Other rajas, less concerned with feathering their nests, submitted resentfully to Mughal service. They retained their warrior status by accepting high rank on the emperor's campaigns, and closer links with the him, which he hoped would encourage loyalty, were forged by the Mughal policy of intermarriage with Rajput princesses. And yet in spite of the material and political advantages of their high standing at the Mughal court, the true allegiance of the rajas was to their own clans above all. In Mughal succession disputes they supported the claimant most likely to further the Rajput cause, and they did not hesitate to change sides if their former opponents offered interesting terms. Maharaja Jaswant Singh of Jodhpur, for example, who spent much of his life on campaign for Shah Jahan, supported all three of the emperor's sons in turn when they fought for the throne, and his posthumous son Ajit Singh was a central figure in the Rajput rebellion against the successful claimant, Aurangzeb.[2]

Just as the Rajputs took whatever they could make use of from the Mughals in terms of position and privilege, so they adopted those aspects of Mughal cultural and courtly life which appealed to them. Resentful at being mere attendants at court in Delhi, by emulating the opulence of the Mughal court in their own palaces they could reassure themselves of their sovereignty in their own lands. Everything from the architecture of the maharajas' palaces and the rich furnishings within them to the subjects and styles of paintings fell under the influence of the Mughal court. The pillared halls of the Mughal-style palace called for hangings and screens to provide privacy and warmth, and in the imperial milieu these were usually beautiful embroidered or woven panels. The highest-quality velvets or woven silks were not normally available to the provincial rulers, but there was no lack of professional embroiderers to embellish the textiles at the Rajput courts, and it was in embroidery that they excelled. Some of the fine textiles made for Rajput rulers are in no respect inferior in quality and sophistication to those produced for imperial use: the exquisite embroidered knuckle-pads [**112**] made to protect a warrior's hand inside the shield, for example, are of a design based closely on miniature painting, executed in a chain stitch certainly as fine as that on Mughal court textiles. Of all the grandiose

**111. Woman's head-veil or sari**
(detail)
> Cotton, printed with gold leaf
> Rajasthan, probably Jaipur, 19th century
> 510 x 127cm
> IS 9–1983

Metal is often added to textiles in Rajasthan, although nowadays it is usually in powdered form rather than the lavish gold leaf used here. The pattern is stamped in gum, and the gold leaf laid on top.

**112. Knuckle-pad cover for the back of a shield**
> Cotton embroidered with silk
> Rajasthan, probably Bundi or Jaipur, 18th century
> 13 x 13cm
> IM 107–1924
> Given by Mr Imre Schwaiger

This embroidered design in fine chain-stitch is closely related to miniature painting. These exquisite knuckle-pads would have been invisible when in use, and were probably made by Rajput ladies for their husbands.

palaces built by the Rajput rulers, the palace at Amber, in particular, came closest to the splendour of the Mughal court. Through their close association with the emperors, the wealthy Amber rajas built up a huge collection, from the seventeenth century onwards, of velvets, embroideries, painted cottons [137], carpets and miniature paintings second only to that of the emperor himself.

### Rajput Court Painting

The beginnings of local styles of Rajput painting emerged in the first half of the seventeenth century, having already broken away from the archaic Western Indian style as exemplified by Jain manuscript painting (see chapter 2). Several key works in the early chronology of the Rajput schools of painting survive which date from the seventeenth century. One of the earliest pieces of secure documentation is a *ragamala* (garland of melodies) done in 1605 by the Muslim artist Nasiruddin at Chawand, the temporary capital of the Mewar ruler Amar Singh. Although none of their predecessors from this centre survives, these lively paintings [113] are undoubtedly the product of a well-developed school of Rajasthani painting. While the traditional horizontal palmleaf-shaped format had by now been abandoned in favour of the book-shaped rectangle used in Islamic painting, these paintings show scarcely any hint of Mughal influence, in spite of the fact that by the time they were produced three Mughal emperors had already occupied the throne in Delhi. The pointed robes and sashes, stylised landscape, architecture and poses of the figures, as well as the composition with its flat blocks of colour, all point to links with the earlier *Caurapancasika* style (see chapter 2). Mewar painting was to retain a distinctive and somewhat archaic appearance even after Mughal conventions of naturalism had begun to make themselves felt among the court artists during the later seventeenth century. This aloofness from imperial culture was characteristic of the Sisodiyas, who were the only Rajput clan not forced to send representatives, or princesses, to the Mughal court. Mewar's leading court artist under Maharana Jagat Singh I (r.1628–52) was the Muslim Sahibdin, who illustrated many Hindu texts and *ragamalas* in a style that progressed from earlier formality to a somewhat more complex blend of traditional and Mughal ideas of painting. His characteristic style became the basis of court painting in Udaipur (the Mewar capital from 1567) and was to endure in modified forms until the nineteenth century.[3]

Another important dated *ragamala* series is that done at Chunar, near Benares, in 1591 [114]. Although not itself painted in Rajasthan, this series plays an important part in the development of painting at Bundi, seat of the Hara Rajputs, which was to produce some extremely fine work during the seventeenth century [115]. The *ragamala* was painted by three Mughal-trained artists[4] and came into the possession of one of the rulers of Bundi, who had been governors of Chunar. Whether or not it was painted *for* him, the set found its way

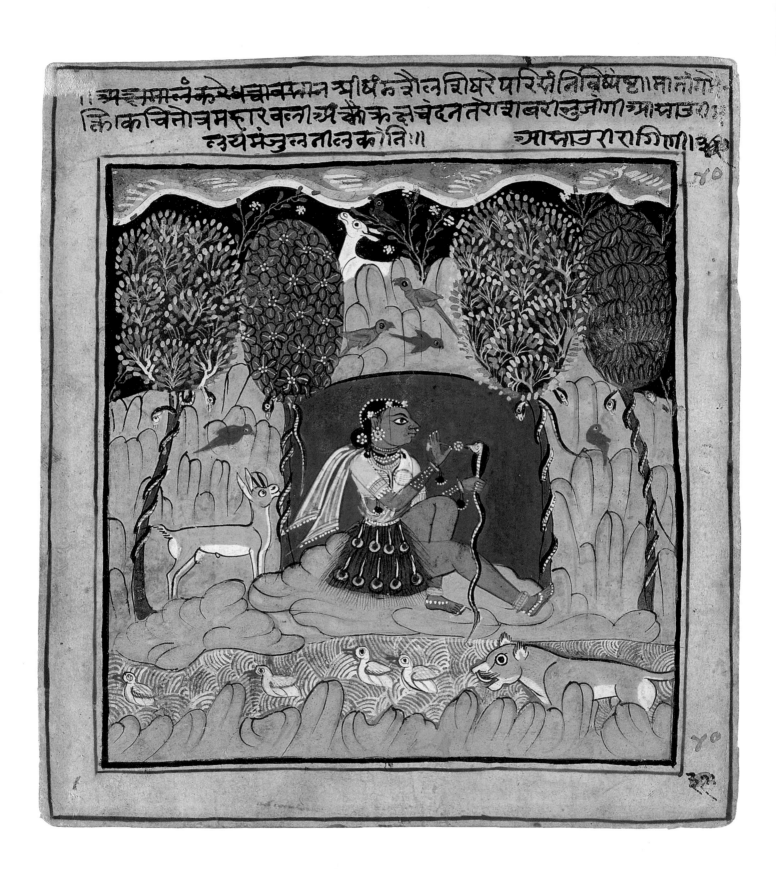

◀ **113. A lady in a peacock skirt charms the snakes out of the trees**
Gouache on paper
Chawand, Mewar, Rajasthan, from a
series dated 1605
20.2 x 19cm
IS 38–1953

This painting illustrates the musical
mode *Asavari ragini*, and is from a
dated *ragamala* series.

**114. The god Shiva with his consort Parvati**
Gouache on paper
Chunar, near Varanasi, 1591
25.2 x 15.1cm
IS 40–1981

Shiva in his terrifying form, Bhairava,
is shown in this *ragamala* painting
seated under an elephant-hide
canopy. Painted by three Mughal-
trained artists, the set from which it
comes was taken to Bundi in Rajasthan
and influenced the local painting style
there.

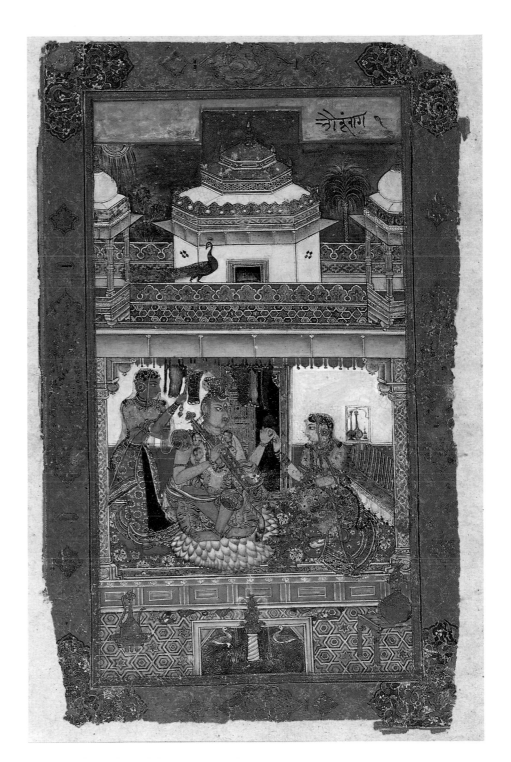

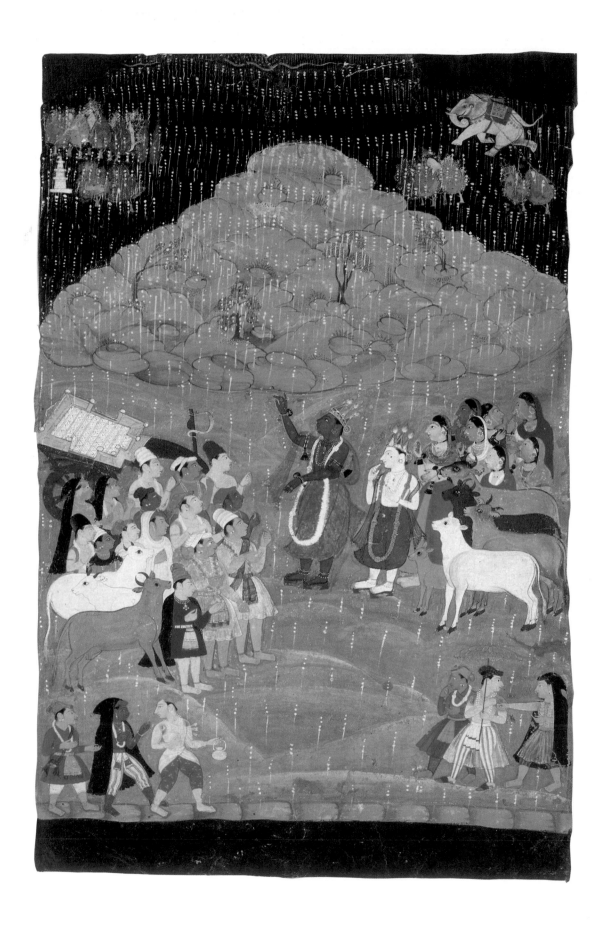

to Bundi, and became the model, in terms of composition if not palette, for later *ragamala* paintings from Bundi. These glowing colours are to be found in many seventeenth-century Bundi paintings which, although they show some Mughal features in the naturalism and accomplished drawing of the figures, remain firmly based in a local pre-Mughal tradition.

Perhaps the most conservative of all the seventeenth-century Rajput painting styles was that of the so-called 'Malwa' school [**116** and **117**]. Although the precise place of origin of these bold and direct paintings is still the subject of debate, they seem to have been done in an area around southern Rajasthan and western Madhya Pradesh which avoided direct Mughal interference. In spite of their distinctively archaic-looking composition, they appear on the scene at a surprisingly late date: a *Rasikapriya* dated 1634 [**116**] is painted in a more delicate palette, with a wonderfully light touch, but compositionally seems to be related to the more mainstream Malwa paintings in which deep blues, reds and browns predominate [**117**]. These dramatic paintings continued to be produced until about the 1680s, when, astonishingly, they still exhibited the flat planes of colour and highly stylised treatment associated with painting styles of at least eighty years earlier.

For the majority of centres of Rajput painting the seventeenth century brought major changes, which came about as a direct result of Mughal domination. The most profound impact was that of the Mughal taste for portraiture and what may be called the art of reportage. The image of the raja seated with his nobles, on horseback, or hunting deer seems today the epitome of Rajput painting, and yet this way of recording actual people and events (albeit in an idealised version) was introduced to India only in the Mughal period. Traditional Rajput painting, as we have seen, did not concern itself with living people, but rather with deities or conceptual types. The Mughals, on the other hand, had since Akbar's time used portraiture both as reportage and as propaganda, two concepts quite foreign to Rajput society. Heroic activity of the type so often depicted in Akbar's manuscripts was immortalised for the Rajputs by bards rather than painters; so too was their sovereignty and their illustrious history. When the rajas became exposed to Mughal courtly culture, however, portrait painting presented itself as a new and prestigious boost to their self-esteem, just as the adoption of a regal lifestyle enabled them to emulate the emperor in their own palaces. The rajas had their first experiences of portraiture as subjects rather than patrons when they were included in *darbar* (audience) or warfare scenes painted for Jahangir or, more frequently, Shah Jahan. Individual portraits were painted of influential figures at the Mughal court, such as the rajas of Jodhpur, Amber and Bikaner, and they frequently had these copied or took the originals back with them to their palaces. Some Rajput rulers also began to employ Mughal-trained artists at their own

◀ **115. Krishna raising Mount Govardhan**
Gouache on paper
Bundi, Rajasthan, *c.*1640
35.8 x 23cm
IS 150–1949

**116. Illustration to the *Rasikapriya***
Gouache on paper
Malwa, from a series dated 1634
18 x 13.8cm
IS 86–1958
Given by Mr John Goelet

Paintings from Malwa in Central India are characterised by bold colours arranged in flat blocks with little surface decoration. This illustration shows Krishna seated in a grove, with his human lover, Radha, before him.

courts, furthering the dissemination of the Mughal style throughout the Rajput courts.

Although illustrated manuscripts of the traditional Hindu texts continued to be produced, portraits of the rulers and scenes of their activities soon became the most widely favoured subjects for paintings. In spite of their new-found realism, there were still strict conventions to be observed, although the Rajput court scenes always appeared less formal than their brilliant but often lifeless Mughal equivalents. The main reason for this (besides an unfamiliarity with the polished precision of the Mughal style) was the rajas' fondness for paintings depicting festivals at court and other light-hearted activities and amusements [118 and 119]. The Rajput calendar was liberally sprinkled with religious holidays, which were almost always occasions for merry-making, especially at the riotous spring festival of Holi. As well as providing a huge wealth of subject matter, festivals encouraged painting in other ways: it was customary at many courts for specially painted works, usually on religious subjects, to be presented by the artists to their masters on certain feast days, such as Dassehra, the Durga festival.

Although all the Rajput courts eventually adopted their own variations on the Mughal style, developments in painting progressed along differing paths at the various centres. In Mewar, Sahibdin's 'traditional' style remained continuously influential, but the new genre of portraiture took hold under Maharana Amar Singh II (r.1698–1710). Unusually sensitive paintings of the ruler and his nobles were produced, some using a distinctive *nim-qalam* (grisaille) technique.[5] Amar Singh's successors, Sangram Singh (r.1710–34) and Jagat Singh (r.1734–51), enthusiastically took up the theme of documenting court activities and commissioned huge numbers of paintings, often on a large scale, recording the *darbars* and festivities of the court,[6] a practice that continued into the twentieth century.

The desert kingdoms of Marwar (Jodhpur) and Bikaner in western Rajasthan also swiftly adopted the concept of portraiture, and high-quality Mughal-style paintings were produced in both centres during the later seventeenth century.[7] In Jodhpur, however, during the eighteenth century, the *darbar* scenes and the portraits of nobles on their horses took on a distinctive local flavour, in which the bold colours and rather angular lines of earlier Marwar painting began to reassert themselves [105]. Mughal-trained artists, most notably the highly accomplished Dalchand, came to Jodhpur during the early eighteenth century,[8] bringing with them the cool precision of Mughal painting under the Emperor Farrukhsiyar, and this contributed to the high standard of much of the work done for Maharaja Abhai Singh (r.1724–49) and his successors. At the other extreme of the range of court painting, the eighteenth century also saw the emergence of distinctive, and often attractive, local painting styles in several of the minor courts of Marwar and Mewar. The *thakurs* (rulers) of

**117. Krishna and a lady in a pavilion**
Gouache on paper
Malwa, *c.*1660
20 x 14.5cm
IS 55–1952

Illustration to the musical mode *Bhairava raga*. Malwa painting retained its traditional and rather archaic style with minimal Mughal influence right up to the end of the 17th century.

138

Ghanerao, for example, employed several imaginative artists who used individual styles that blended elements of folk art, mainstream Jodhpur and Mewar painting, and Mughal styles which had by now become somewhat distantly removed. Jodhpur painting later took an even more exuberant turn under Maharaja Man Singh (r.1804–43), and dozens of paintings of the ruler, his nobles and his ladies were made.[9] Most of these are densely packed scenes of festivity or processions, but Man Singh was a devoutly religious man, and he also commissioned many paintings of his *gurus* and of himself at worship.

Painting in Bikaner followed a course that kept more closely to the Mughal tradition. Muslim artists had settled there during the seventeenth century, and the delicate and highly refined Mughal style that they brought with them dominated Bikaner painting, even when illustrating traditional Hindu texts such as the *Bhagavata Purana*. Deccani paintings brought back from imperial military service also contributed a distinctive use of colour. As in Jodhpur, painting in Bikaner began to develop a more Rajasthani character during the eighteenth century [120], although it never acquired the flamboyance or eccentricity of the later Jodhpur portraits.

The distinctive and lyrical style of Kishengarh, in central Rajasthan, enjoyed a brief flowering under Raja Sawant Singh (r.1748–64), a mystic and poet whose love of Krishna provided the theme for many of his court paintings. Influenced to some extent by contemporary Mughal painting, his chief artist, Nihal Chand, developed an extraordinary 'mannerist' style which exaggerated the slender curves and almond eyes of his figures [121]. After Sawant Singh's death, Kishengarh painting lost much of its originality, and the bravura of Nihal Chand's works gave way to overblown decadence in the course of the nineteenth century.

The kingdoms of Bundi and Kota, in south-east Rajasthan, developed more consistently interesting painting styles. After their seventeenth-century beginnings discussed earlier [114–15], Bundi paintings began to concentrate on court scenes under Rao Chattar Sal (r.1631–58) and Bhao Singh (r.1658–81), and many scenes of nobles, lovers, and ladies in palaces were produced throughout the seventeenth and eighteenth centuries. The adjacent kingdom of Kota had been created by Mughal decree in 1625, and some artists seem to have worked at both centres. One anonymous artist in particular, however, transformed painting in Kota in the late seventeenth and early eighteenth centuries into a refined and imaginative *genre* with his masterly drawings of elephant fights[10] and of his royal patrons.[11] Kota became renowned for the superb hunting scenes painted in the eighteenth century [122], but competent court paintings continued to be done even during the nineteenth century. The last great patron of Kota painting, and indeed one of the last patrons of Rajput painting in general, was Rao Ram Singh II (r.1827–65), an ebullient ruler who commissioned a number of well-drawn and finely detailed scenes of

**118. Night-time entertainment in a courtyard of the City Palace**
Gouache on paper
Udaipur, Mewar, Rajasthan, *c*.1775
47.2 x 41.4cm
IS 77–1990

The young maharana of Mewar, probably Raj Singh II, is shown with a halo, seated with his nobles while dancers and musicians perform in the courtyard. The indoor garden, planted with palm trees, can still be seen today in the City Palace.

**119. Playing cards**
Paper, painted and varnished
Karauli, Rajasthan, mid–19th century
Diam. 6cm
01316 (IS)

The pack of Indian cards, or *ganjifa*, is divided into as many as eight suits with numerical and court cards, represented by symbols such as a crown, a harp or a gold coin. The circular shape is still common in Indian *ganjifa* sets.

**140**

worship at the shrine of his family deity,[12] as well as the more conventional hunt, *darbar* and processional scenes.

Painting in most Rajput kingdoms suffered a severe decline in the late nineteenth century with the advent of photography and the increasing political and cultural influence of the British. Just as they were later to become enthusiasts of the newest motor cars, many rulers took to recording festivals, weddings and the visits of neighbouring princes on film rather than on paper. After a brief flirtation with the painted photograph, painting virtually died out at the courts, and the ever-traditional court at Udaipur remained one of the few to continue to patronise painting into the twentieth century.

### Painting in the Punjab Hills

Although the term 'Rajput painting' is often used to refer solely to the art of Rajasthan, important and quite distinct artistic developments were also taking place among the small Hindu kingdoms of the Punjab Hills. This long, narrow region of the Himalayan foothills was split up, like Rajasthan, into many independent states, some of which had been founded in ancient times when branches of the Rajput tribes had travelled north from Rajasthan, Bengal and parts of Central India. They adhered strictly to the Hindu religion, especially in the form of Devi, the Goddess, and observed the conservative customs of feudal society. In spite of their remoteness and inaccessibility, however, they too had been conquered by the Mughals: the strategic Kangra fort was captured by imperial forces in 1620, and the smaller states were also nominally subject to Mughal rule. The situation differed from that in Rajasthan, however, as the Pahari (hill) states were basically insignificant in military and political terms, and as a result Mughal interference in the region was minimal.

Although many aspects of the development of painting in the Punjab Hills have parallels with that in Rajasthan, there is no comparable continuity from medieval manuscript illustration to full-blown courtly art. A rare landmark in the development of Pahari painting was provided, however, with the discovery and publication of an early and very beautiful manuscript of the *Devi Mahatmya*, now in Simla Museum.[13] The illustrations are in the 'Early Rajput' style familiar to us from its use in the plains [see **21**], and yet the colophon, which gives the date as 1552, states that the manuscript was prepared in a town in the Kangra region of the Punjab Hills. This is the earliest evidence we have for miniature painting in the hill area, and it raises interesting questions about the degree of contact between the hills and the plains, which was hitherto thought to be minimal. We are still left, however, with a significant gap, both chronologically and stylistically, until the appearance of the earliest group of paintings which show strongly individual Pahari elements.

These were painted in about 1660–70 in Basohli [**123**], and are illustrations to the *Rasamanjari* by Bhanudatta – a Sanskrit text on the

**120. The month of Karttik**
Gouache on paper
Attributed to the artist Murad
Bikaner, Rajasthan, *c.*1725.
26.2 x 17.3cm
IS 32–1980

Families of Mughal-trained artists settled in Bikaner during the 17th century, and worked in a refined, Mughal style. During the 18th century a more characteristically Rajasthani style evolved, and this illustration to a *Barahmasa* (twelve month) series is typical of this transitional court style.

### 121. The sage Sukhdev addressing King Parikshit and a group of *sadhus*

Gouache on paper
Kishengarh, Rajasthan, *c*.1760
22 x 32cm
IS 556–1952

The mannered style developed by the artist Nihal Chand is evident in this painting which uses the lakes and hills of Kishengarh itself to illustrate a mythological scene.

### 122. Raja Umed Singh of Kota hunting lion

Gouache on paper
Kota, Rajasthan, *c*.1790
40.2 × 33.1cm
IS 563–1952
Given by Col. T.G.Gayer–Anderson and Major R.G.Gayer–Anderson, Pasha

behaviour of lovers, which often takes Radha and Krishna as its idealised subjects. These superb paintings still show some affinities with the 'early Rajput' style – the horizontal format, the use of flat planes of bold reds and yellows, the stylised architecture and figures – but their remarkable use of decorative conventions and dramatic compositions remain unique. The stylised faces, with exaggeratedly large and bulging eyes and straight profile, owe more to metal and stone sculpture of the Himalayan region than to early Rajput models. Although the precise dating of this series is not known, it was almost certainly made for a ruler of Basohli, probably Sangram Pal (r.1635–c.1673), and many magnificent and wild paintings were made there, concentrating most frequently on religious subjects.[14] Portrait painting, however, also appealed to the Basohli rulers, and the Mughal conventions of the seated ruler were adapted to great effect in Basohli and neighbouring Mankot in particular [124]. Retaining the fiery colour schemes and forceful profiles of the local style, these bold compositions are even further removed from their Mughal counterparts than their Rajput equivalents are. Just as in Rajasthan, the conventions of portraiture were put to use in many *ragamala* sets, such as the typically dramatic Kulu series in the Victoria and Albert Museum [125]. Painting in Kulu had been strongly influenced by Basohli artists, but had developed its own distinct style during the eighteenth century, which used deep, often sombre colours, including an unusual purplish brown, and rather squarer figures than the attenuated Basohli type.

Other regional schools also matured during the early eighteenth century. A highly individual style had grown up in Mandi, a small kingdom south of Kulu, under Raja Sidh Sen (r.1684–1727), of whom several idiosyncratic and idealised portraits survive. Breaking from the Mughal-influenced refinement of its earliest, seventeenth-century, phase, these were painted in distinctively sombre colours, and show the ruler as a gigantic figure who even, on occasion, takes on the form of an incarnation of his favoured deity, Shiva.[15] These murky colours and heavy shading are also seen in a powerful study of the five-faced Shiva [126].

In spite of the strength and vitality of the local painting styles, the Pahari schools were not immune to Mughal influence. On the contrary, during the early eighteenth century Mughal-trained artists were to introduce a new naturalism and tranquillity that became as characteristic of the later development of Pahari painting as energy and passion had been of the earlier phase. This transformation was largely the work of a single family of influential artists who may have originated in Kashmir and settled in Guler. Although members of the family, headed by Pandit Seu, worked at several centres in the hills, the style that developed in Guler itself is the most typical of this later phase, with its lyrical and cool depictions of ladies [127] who

### 123. A lady blames her cat for scratches inflicted by her lover

Gouache on paper
Basohli, Punjab Hills, *c.*1660–70
23.5 x 32.5cm
IS 20–1958
Bequeathed by Lady Rothenstein

An illustration from the *Rasamanjari*, a poem describing lovers and their behaviour.

### 124. Raja Ajmat Dev of Mankot ▶ smoking a *huqqa*

Gouache on paper
Mankot, Punjab Hills, *c.*1730
27 x 19cm
IS 23–1974

### 125. A lady in a pavilion conversing with her lover

Gouache on paper
Kulu, Punjab Hills, *c.*1700–10
37.5 x 25.2cm
IS 69–1953

This illustration to the musical mode *Achanda raga* comes from a large *ragamala* set of which the Museum has 32 paintings. The deep colours, square format and bold composition are all typical of the Kulu painting style.

bear their lovers' absence with much more equanimity than the distraught and passionate heroines of the earlier Basohli school.

Of Pandit Seu's prodigious family, his son Nainsukh is the best known and the most innovative. His familiarity with Mughal idioms suggests that he received part of his training from artists in the plains working in the Mughal style. He was employed throughout the 1740s and 1750s by a minor raja named Balwant Singh (1724–63), probably of the ruling house of Jasrota, and while some of the paintings he did for him are conventional though sensitive scenes of hunting or entertainment [128], many are highly individual and intimate studies of Balwant Singh going about his everyday affairs – writing a letter, preparing for bed, or walking alone on the battlements of a palace.[16] This series of paintings of Balwant Singh as an individual, and one who tends towards melancholia, rather than as an aloof and powerful ruler is unique in Indian portraiture, and points to an unusual trust and companionship between patron and artist. Such a relationship was particularly rare in a traditional Indian context, as artists were considered artisans on a par with carpenters or scribes, and consequently carried low social status. After Balwant Singh's death in 1763, Nainsukh moved to Basohli, where his older brother Manaku was already beginning to adjust to the new naturalistic style. A *Bhagavata Purana* series painted in Basohli in about 1760–70 is typical of the controlled realism that predominated there under Guler influence.[17]

The influence of Nainsukh's family and his style is also apparent on the remarkable embroideries done in the hill states in the late eighteenth century. The centre usually associated with the highest quality embroideries is Chamba, and it is significant that one of Nainsukh's sons was a court artist for Raj Singh (r.1764–94), ruler of Chamba. These *rumals* (coverlets) usually bear a design relating to Krishna and his playful love-making with the *gopis* (women cowherds), and even when they depict a wedding scene [129], Krishna is frequently introduced. The finest of the embroideries, which were done in differing styles and degrees of fineness into the twentieth century, were certainly designed and drawn out by court artists before being worked in fine floss silk by the ladies of the *zenana*.

The final flowering of the Mughalised Guler style occurred in Kangra under Raja Sansar Chand (r.1775–1823). Here, under the third generation of Pandit Seu's dynasty, the lyrical Guler style [130] reached a high point with illustrations to texts such as the *Bhagavata Purana*[18] and the *Gita Govinda*, in which the love of Radha and Krishna is described.[19] Sansar Chand also commissioned many *darbar* scenes of himself and his nobles,[20] but these are in a stiffer, formal style which relies on bright yellows and oranges to enliven them.

Sansar Chand's reign ended unhappily, with his kingdom impoverished by the expense of war against the encroaching Gurkhas. He was eventually forced to accept the sovereignty of the Sikh ruler Ranjit Singh [164], and although he managed to maintain an interest

**126. The five-faced Shiva**
Gouache on paper
Mandi, Punjab Hills, *c.*1730–40
26.6 x 18.2cm
IS 239–1952
Given by Col. T.G.Gayer-Anderson and Major R.G.Gayer-Anderson, Pasha

Painting flourished in Mandi under the charismatic raja Sidh Sen. This form of Shiva, with the fifth face unseen at the back of his head, was worshipped at the main temple in Mandi.

**◄ 127. A lady smoking a *huqqa* and listening to musicians**

Gouache on paper
Guler, Punjab Hills, *c*.1800
24 x 16.3cm
IS 146–1953

**128. A fireworks display**

Gouache on paper
Attributed to the artist Nainsukh
Jammu, *c*.1751
24.6 x 15.8cm
IM 5–1912

## 129. Coverlet (*rumal*)

Cotton embroidered with silk
Chamba, Punjab Hills, *c.*1880.
68 × 124cm
2096 (IS)–1883

This decorative embroidered coverlet
depicts Krishna and his marriage to
Rukmini. Krishna is shown at the top
of the scene, while Rukmini is led into
the wedding *mandapa* in the centre.

## 130. Ladies celebrating Holi ▶

Gouache on paper
Kangra, Punjab Hills, dated 1788
15.5 × 25.8cm
IS 9–1949
Bequeathed by P.C.Manuk and Miss
G.M.Coles

in painting and music throughout his last, powerless years, his patronage had ceased. Other kingdoms had already succumbed to the Gurkhas, the Sikhs and finally to the British, who annexed much of the Punjab in 1849. With the traditional courtly environment and even the existence of the smaller states swept away by these upheavals, royal patronage went into sharp decline, and painting in the hills was unable to survive far into the nineteenth century.

1. Singh, 1979, pp.xxx–xxxiii.
2. See Hallissey, 1977, pp.47–59.
3. For examples of Sahibdin's work, see Topsfield, 1981, pp.231–8.
4. Skelton, 1981, pp.123–39.
5. Cimino, 1985, no.66; Topsfield, 1980, no.56.
6. Topsfield, 1980, nos.71–85; Desai, 1985, nos.47, 52–5; Cimino, 1985, nos.41, 70, 74, 82–6.
7. Leach, 1986, pp.222–3; London, 1983, no.49.
8. Ashton, 1950, nos.431–2.
9. Goswamy, 1986, p.37; Gray (ed.), 1981, p.170.
10. London, 1983, no.20; Welch, 1985, p.359.
11. Welch, 1985, p.358.
12. Desai, 1985, no.98; Kramrisch, 1985, no.55.
13. Goswamy *et al.*, 1985; Goswamy and Fischer 1990, pp.15–27.
14. Leach, 1986, p.256; Welch, 1985, p.390; Ehnbom, 1985, nos.87–8.
15. Goswamy, 1986, p.199.
16. Archer, 1973, vol.2, pp.145, 150–1; Desai, 1985, pp.103–11.
17. Ibid., vol.2, pp.36–9; Gray (ed.), 1981, fig.188.
18. Archer, 1973, vol.2, pp.210–12.
19. Ibid., vol.2, pp.205–9; Welch, 1985, no.275.
20. Archer, 1973, vol.2, pp.198–202; Desai, 1985, p.113.

# 6.
# Europeans and the Textile Trade

## The Lure of the Spiceries

The most prolific period of this trade had its beginnings in the Portuguese 'Discoveries' of the later fifteenth century. Initially it was the desire for spices, or rather for a monopoly of the spice trade, which gave the quest its impetus. The key role of Indian textiles in that trade was soon evident, and eventually the textiles themselves became the chief commodity. The spices, aromatics, drugs, dyes, porcelain, textiles and assorted curiosities of 'the Indies',[1] and 'Cathay' (China) had been known to the rich of Europe at least since Roman times (see chapter 2). The importance of pepper and other spices in medieval European cookery can hardly be exaggerated. The great attraction of spices was their unique ability to enliven the staple luxury diet of meat and fish (often imperfectly preserved), white bread, wine and puddings sweetened with honey.

Europeans knew that far to the east lay the fabled lands of the Indies and Cathay, whence came the coveted spices and curiosities such as textiles and porcelain. A number of Europeans had already visited those countries overland, and some, such as Marco Polo, the thirteenth-century Venetian merchant, had written accounts of their travels.[2] To the majority who stayed at home, the countries round the eastern seas seemed a single vast region of mystery. Few could distinguish between the products of the various parts. As late as 1616, a travelled and cultivated Englishman, appointed by James I as his ambassador to the Mughal court, confessed his disappointment on discovering that India was not the source of the Chinese novelties sold in London toy shops: 'I thought all India a China shop, and that I should furnish all my friends with rarities; but this is not that part,[3] and: 'Here are none of the rarities of India; they all come from the Eastern part [i.e. China] . . .'[4]

As seen in chapter 2, it was the Portuguese who, in the early sixteenth century, first succeeded in wresting control of the highly lucrative spice trade from the Asian and Arab traders. Their success stemmed from ideas of maritime discovery originating in the fourteenth century. Prince Henry 'the Navigator' (1394–1460), a grandson of John of Gaunt, is the best-remembered pioneer of the Portuguese 'Discoveries', though tradition has perhaps over-emphasised his contribution. Henry sought the riches of the Indies, but 'his aim was as

**131. A European**
Gouache on paper
Mughal, c.1590
30 x 18.3cm
IM 386–1914

much the conversion of the heathen as the extension of the dominion and commerce of Portugal'.[5] This dual intent remained a feature which distinguished Portuguese operations in the East from that of their North European competitors. In the late fourteenth and early fifteenth centuries Portuguese discoverers sailed round the coasts of Africa. In 1498 Vasco da Gama commanded the first European expedition to sail across the Indian Ocean to western India.

For most of the sixteenth century Lisbon was the great spice mart of Europe. North European countries were supplied by the Dutch who bought from the Portuguese. Then in 1580 the annexation of Portugal by Spain, at a time when the Netherlands had risen against Spanish domination, put an end to direct Dutch dealing at Lisbon. Alarmed by the cost of buying through intermediaries, and encouraged by England's defeat of the Spanish Armada in 1588, the Antwerp merchants, then settled in Amsterdam, contemplated direct sea trade with the Indies. After a number of abortive attempts to reach there by a north-east or north-west passage through the Arctic, a fleet sent via the Cape of Good Hope made a successful voyage to and from the Indonesian spice islands in 1595–7. This spelt the beginning of the end for Portuguese monopoly of the Eastern Sea trade. Within a few years the Dutch had established a number of factories (trading settlements, usually fortified) in the islands. Their principal settlement in the early days was at Ambon in the Moluccas, and from this stronghold they dominated the Indonesian spice trade.

Meanwhile the British, equally impatient at paying exorbitant rates for spices, and ambitious to find profitable new markets for English goods – notably the fine woollen broadcloth for which their country was famed – had also found their way to the Indies by sea. Sir Francis Drake, in 1579 the first Englishman to sail round the world, was also in that voyage the initiator of direct sea trade between England and the 'spice islands' – then often called by the English 'the Spiceries'. He succeeded in persuading the ruler of Ternate in the Moluccas to grant England a purchase monopoly of all the island's clove production. During the next few years a number of Englishmen, mainly merchants, visited the Indies privately [131]. The first to reach the subcontinent of India was probably Thomas Stephens, who became rector of the Jesuit College of Salsette, in Goa. Stephens's letters home are said to have fostered the London merchants' enthusiasm for direct trade with India.

As in the Low Countries, further encouragement came with the elimination of the Spanish Armada. Another important development was the capture in 1592 by English privateers of a Portuguese carrack called the *Madre de Dios*. The great trading vessel was brought into Dartmouth richly laden with the treasures of the East. The cargo included jewels, porcelain, spices, aromatics, and an assortment of textile fabrics, together with *The Notable Register or Matricola of the whole Government and Trade of the Portuguese in the East Indies*. This

document proved its worth in 1599. Stung by another steep rise in the price of pepper, now a Dutch monopoly, the London merchants used the *Notable Register* as a basis for making out their case to Queen Elizabeth I when seeking a charter for an association to trade with the Indies. The East India Company of London [6] was incorporated in 1600, followed in 1602 by the Dutch company, a French company in 1604 and a Danish in 1612.

When the London Company began to trade in India – originally from a settlement at Surat, where the first English ships arrived in 1608 – the intention was to fund its purchases of the Indian textiles needed for barter in the spice islands by selling English goods such as broadcloth in India. However, there proved an insufficient market for these products, and the Company was obliged to export gold and silver bullion from England to finance the purchase of Indian textiles. An outcry from opponents at home who objected to this seepage of wealth from the country was countered by a new move: Indian textiles would be shipped to London for re-export to Europe, North Africa, Turkey and the Levant. Since this could be done more cheaply than by the traditional Red Sea, Persian Gulf and caravan routes, the Company would undercut the Arab and Gujarati traders. Further impetus was given to the re-export trade in the 1630s, when there was increased demand for the western Indian woven striped and checked 'Guinea cloths' required for barter in West Africa, also used as slaves' dress in the West Indian plantations. The Portuguese dealt in Guinea cloths when they succeeded the Arabs as the principal slave-traders in the sixteenth century. The East India Company was not itself engaged in the transatlantic slave trade, but the link was very close and highly profitable.[7]

### Centres of Export Textile Production

During the first half of the seventeenth century many European factories were established in India near traditional centres of textile production, since the newcomers were by now fully aware of the importance of Indian textiles in the spice trade. Cloth was produced throughout India at the village level, but the production of textiles for export was concentrated on three main areas. These were in western India, centred around Cambay, the Coromandel coast of south-east India and Bengal. Each had its seaports with facilities for ocean-going shipping, and access to the hinterland. In some areas local peculiarities of soil or climate accounted for the development of a regional characteristic. Each area had specialities for which it was renowned, but all three produced a wide range of goods differing in type and quality according to the markets they served.

The traditional textile exports of western India's main ports, Cambay and later Surat, included strong cheap calicoes (cottons), plain or coloured, notably the Guinea cloths mentioned earlier. Other export specialities of western India included cheap resist-dyed cottons

which went to the Middle East, such as the tomb-covers and miscellaneous fragments excavated at Fostat, Old Cairo (see chapter 2 and 10 and 11), and to South-East Asia as garment-pieces.[8] Higher-grade printed or painted and dyed chintzes with a characteristic glazed finish were popular in the Middle East for tailoring into garments. Chintzes also appeared as pictorial hangings and quilts of varying quality, and these were among early 'pintado' (painted calico-chintz) imports to Europe. Centres of production included Ahmedabad, Burhanpur, Sironj and Agra.

Among the quality exports were fine muslin sashes from Burhanpur, decorated with gold and silver thread, which were liked in the Middle East, eastern Europe and North Africa (this destination earning them their popular English name of 'Barbary shashes'), and 'Cambay embroideries' of coloured silk chain-stitch on white cotton grounds, which, like the chintzes, in the seventeenth century became coveted in Europe. Also exported from western India were pile carpets made at Agra and Lahore. Unlike the other Indian export specialities, pile carpet production was a relatively recent development, introduced from Persia by the Mughal Emperor Akbar in the sixteenth century. Seventeenth-century Europeans such as Sir Thomas Roe, James I of England's ambassador to the Mughal court, and William Fremlin, an agent of the East India Company, acquired Indian carpets during their stay (see chapter 3 and 132).

The textile industries of south-east India were generally identified with the Coromandel coast. Its most famous products were painted and dyed cottons (chintzes), particularly those of Golconda (see chapter 4). Because Masulipatam was the principal mart and port of the Coromandel coast, the chintzes made in the hinterland were generally known by its name. Further south, good chintzes also came from the Madras area, Pulicat being an important centre. As with western India, a wide range of woven cotton piece-goods was also produced, many sought after in the traditional export trade of barter for spices.

The most significant textile export from eastern India was the fine transparent cotton called muslin in Europe.[9] Indian muslins were well known in ancient Rome and appear to have been produced at centres in the Gangetic region at least since the Sunga period (second – first century BC) and probably earlier. There were many kinds, plain and patterned, and varying degrees of transparency. In the period of the European companies, the best Bengal muslins came from Dacca and Santipore. As in earlier centuries, the finest were engrossed by Indian courts. Other export textiles of eastern India were of silk, or silk and cotton mixtures. As seen in chapter 2, the *tasar* and other wild silk embroideries of Satgaon in the Hughli district had been a major export commodity in the age of Portuguese supremacy, but declined thereafter.

**132. The Fremlin carpet** (detail)
Woollen pile on warps and wefts of cotton
Mughal, probably Agra or Lahore, c.1640
L 599cm x 249cm
IM 1–1936
Purchased with the assistance of the National Art Collections Fund

The carpet, which probably served as a table cover, was made for William Fremlin, a servant of the East India Company between 1626 and 1644, and was probably made for him after 1637, when he became President of the Council at Surat. The family coat-of-arms appears both in the main field and in the border.

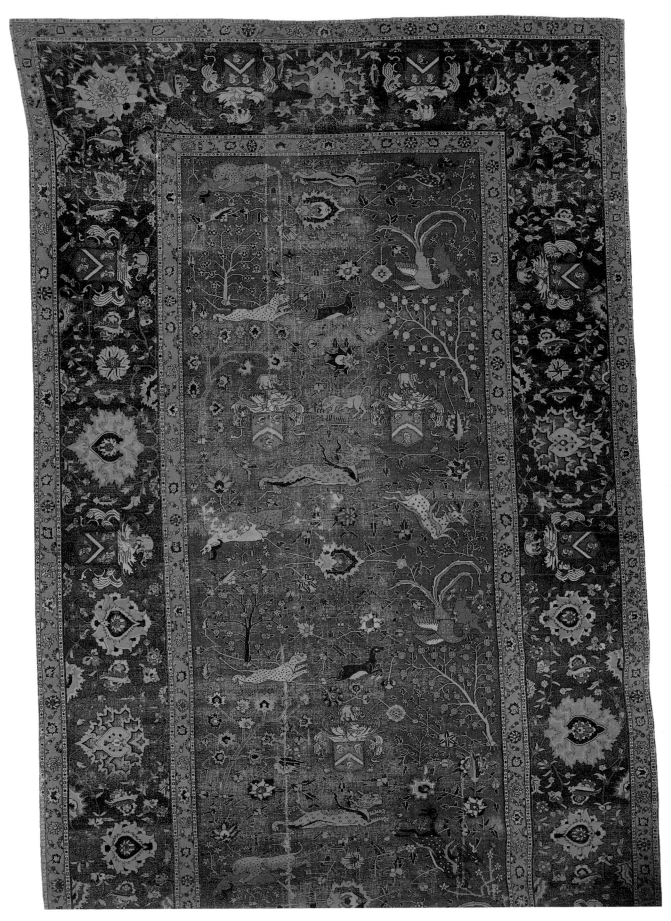

## Furnishing Fabrics

Large-scale demand for Indian textiles in the European markets was a relatively late development. Imports of cotton goods showed a steady increase throughout the first half of the seventeenth century. They were mainly cheap-to-medium quality goods suitable for modest household requirements: quilts, sheeting, towels, tablecloths and so on. From the 1660s onwards there was a dramatic rise in demand for high-quality Indian textiles. Indian furnishing fabrics, especially embroidered quilts and hangings, had long been appreciated by a small number of luxury consumers in Europe (see chapter 2). These were, however, isolated examples, listed in the inventories of royal palaces and stately homes,[10] occasionally appearing as status symbols in portraits of their owners.[11] In the later seventeenth century there was a fashion for complete sets of Indian room furnishings in chintz, embroidery, or a combination of both techniques. At that time no firm distinction was yet made between bedrooms and reception rooms, and even the grandest households were likely to include an imposing tester (roofed) bed in rooms where honoured guests were formally received. A complete set of furnishings for a grand room might comprise wall-hangings, bed-curtains with valances and coverlet, perhaps matching chair and cushion covers, and small carpets to surround the bed. Some purchasers were content to acquire only a coverlet or chintz yardage to line a small room. Indian furnishings were now within the purchasing power of moderate incomes such as that of the civil servant Samuel Pepys, who noted in his diary for 15 September 1663 buying his wife 'a chinte . . . that is paynted Indian callicoe for to line her new study which is very pretty'.

The great attraction of chintz, as opposed to European alternatives then available, was its brilliant colours which were permanently dyed and could not be harmed by repeated washings.[12] **133–6** illustrate parts of the process. Though very strong and durable, it was a lightweight fabric, and therefore easy to handle. The chintz vogue in England coincided with a fashion for printed wallpapers and an increasing craze for pseudo-orientalism in the decorative arts.

It was into this existing climate of taste for oriental decoration that the large-scale export of Indian furnishing textiles to Europe proceeded in the second half of the seventeenth century. Early exports to Europe included designs with human figures, like those of the Indians and Europeans in the Golconda hangings [**137** and **138**]. The diarist John Evelyn saw at Lady Mordaunt's house in December 1665 'a room hung with Pintado, full of figures great and small, prettily representing sundry trades and occupations of the Indians, with their habits [ie. costumes]: very extraordinarie'. A rare chintz furnishing from this period has as its centrepiece the Stuart Royal Arms of England, as current in the reigns of Charles I (1625–49) and II (1660–85), in a roundel, on a white field otherwise decorated with fruit, flowers, elephants and other creatures, some fabulous, in shades of

**133–136. Samples illustrating the chintz process**
Painted and dyed cotton
Coromandel coast, South India, early
20th century
49.5 × 42 cm
T.1d,e,f,g–1920

**158**

133. After mordanting and dyeing red

134. After waxing to protect areas not intended to be dyed blue

135. After dyeing blue

136. The complete colour scheme, after painting details yellow and overpainting yellow on blue to create green

red and purple [139]. The unusual shape of the design suggests use as a table or dais cover, or possibly a canopy. Its exact provenance and early history are unknown.

A type of hanging imported from western India from about the 1690s to early 1700s was in a style which showed interesting similarities to English embroideries of a century earlier, such as the Hulton cushion cover.[13] The designs were still more strikingly related to those of contemporary English crewel-work hangings.[14] The patterns consist typically of large-scale laterally repeating branches, with exotic leaves, flowers and fruit, growing from a rocky landscape, often including animals, birds and insects, occasionally with additional elements such as human figures and buildings. A set of western Indian cotton furnishings with this type of pattern, made in Gujarat around 1700, was among the contents of Ashburnham House in Sussex, auctioned in the early 1950s. There were curtains (one with a Gujarati inscription), hangings and a 'palampore' coverlet, some of the pieces being chintz and others embroidered, in typical Cambay style, in coloured silk chain-stitch. All were patterned from the same basic design of the type described above. One of the chintz hangings acquired by the Victoria and Albert Museum was little used, retaining most of its brilliant colours unfaded and even the original surface glaze [140]. A Cambay embroidery imitating another chintz-type design is seen in 141.

By about 1700 the main focus of fashionable trade in Indian chintz for Europe had shifted from western India to the Coromandel coast, where the English, Dutch, French and Danish Companies had all established factories during the seventeenth century. The cotton painters here, as in western India, copied from patterns provided by European merchants, and surviving examples give some idea of the wide variety available. European engravings were often used as models, and many textiles of the eighteenth century included heraldic devices, some filled with the patron's coat of arms, others with armorial bearings begun and partly erased, perhaps denoting a cancelled order, or with shields left blank to be completed by the purchaser in Europe. Among all this variety, the palampore design which most typifies eighteenth-century Indian chintz production is based on a central flowering tree growing from a rocky mound, perhaps flanked with a pair of vases, or confronted animals or birds, and surrounded by a series of borders, broad and narrow, often variants of a continuous undulating stem with repeating leaves and flowers. The concept is related to the centrally placed tree or vase-of-flowers motifs found on the tent panels associated with the Mughal lifestyle (see chapter 4). Such designs are of ancient origin and mixed ancestry, suggesting associations with the Middle Eastern Tree of Life motif, and the Hindu/Buddhist *Kalpa-vrksha* (Wish-Fulfilling Tree). In chintz it was frequently depicted arising from water, surrounded by sacred lotuses and marine creatures, reinforcing its sym-

**137. Floorspread** (detail)
Painted and dyed cotton
Golconda, *c.*1630
325 × 246cm
IM 160–1929

The floorspread has a circular stamp-mark identified as that of Mirza Raja Jai Singh of Amber (1622–68) and came from the Amber Palace, Jaipur.

**160**

### 138. Wall hanging

Painted and dyed cotton
Madras–Pulicat region, *c.*1640–50, with
18th century borders
259 × 152cm (without borders 198 ×
114cm)
687–1898

Probably made under European
patronage.

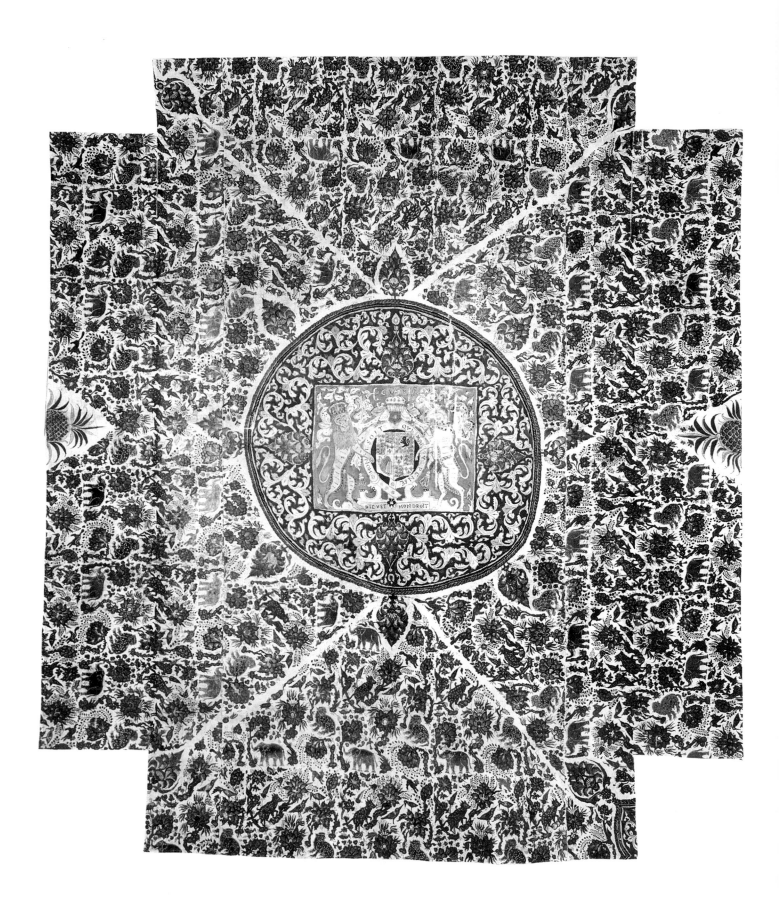

◀ **139. Cover**

    Painted and dyed cotton
Provenance unknown; for the English market, 17th century
245 × 212cm (selvage to selvage 109cm)
IS 21–1956
Given by Mrs E.A.Mauns

The textile bears the Royal Stuart coat-of-arms but it is not possible to determine whether it is contemporary with Charles I or Charles II of Great Britain.

**140. Hanging** (detail)

    Painted and dyed cotton
Western India; for the European market, *c.*1700
246.3 × 193.2cm
IS 156–1953

**164**

◀ **141. Palampore**

European linen and cotton twill,
embroidered in chain stitch with silk
Western India, for the English or Dutch
market, 1725 or later
264 × 225cm
IM 13–1930

Embroideries of this kind were based
on chintz designs and sometimes
called 'worked [that is, needle-
worked] chintz' by English patrons.
The technique is western Indian,
the design probably that of a South
Indian palampore.

**143. Palampore**

Painted and dyed cotton
Southern Coromandel Coast, for the
European market, second half of the 18th
century
264.1 × 223.8cm
IM 85–1937

**142. Part of a set of bed hangings**

Painted and dyed cotton
Southern Coromandel Coast, for the
Dutch market, first quarter of the 18th
century
317 × 112.5cm
IS 2–1967
Given by J.B.Fowler

bolic association with the idea of creation [142]. None of these ideas is likely to have been known to the Company agents who commissioned these designs, and it is uncertain whether the painters would have been aware that the designs had any such significance, beyond a lingering auspicious association.

The central flowering tree remained the dominant theme of South Indian palampore production into the nineteenth century, undergoing numerous stylistic changes governed by fashion. A vertical format remained the norm, though late examples are occasionally horizontal. Dutch taste of the early eighteenth century produced a substantial form with disproportionately large flowerheads. Many palampores of the 1730s–80s reflected the influence of the Chinese export wallpapers fashionable in Europe at the time, when the chintz tree took on a notched, angular trunk and branches, with chrysanthemum and peony flowerheads, interlaced with bamboo and entwined with plum blossom. Frivolous European taste, perhaps French, of about the 1770s, produced the variant with two crossed palm trees [143]. Most surviving chintzes date from the period 1700–1800, during which they were in fact prohibited imports in Britain, but such was their attraction that the well-off were prepared to risk heavy fines to acquire these most desirable smuggled goods.

### Costume and Accessories

Among remarks on the goods taken by the Portuguese from Cambay to Goa around 1610, Pyrard de Laval, a French observer, noted:

> ... the principal riches consist chiefly of silk and cotton stuffs, where with everyone from the Cape of Good Hope to China, man and woman, is clothed from head to foot. These stuffs are worked [i.e. embroidered], the cotton also made into cloths of the whiteness of snow, and very delicate and fine ... others are bespangled and painted with various figures ...[15]

Indian textiles for costumes were traditionally supplied as piece-goods (yardage), which would be cut out and finished for the purchasers. An interesting category of chintz piece-goods made for use in India as well as export consists of liturgical vestments produced under Armenian patronage. Armenian traders were actively concerned with chintz exports to the Middle East, and were themselves consumers. Christians of the Eastern rite, they commissioned vestments and hangings, some with dedicatory inscriptions, for their churches in India. It became policy for the English Company to provide churches in their settlements for Armenian communities above a certain size. An Armenian vestment depicting the Deposition from the Cross, after a European engraving, is illustrated in **144**. The Armenians also dealt in costume and secular hangings.

The extension of the ancient trade in garment pieces to encompass European consumers was a development of the later seven-

**144. Vestment**
Painted and dyed cotton
Provenance uncertain, 18th century
Ht. 139cm
IS 2–1953

Made under Armenian patronage.

teenth century. In 1682 the directors of the East India Company were writing from London to their agents on the Coromandel Coast with an order for 200,000

> Callicoe shifts . . . some fine enough for ladies and gentle-
> women: if some be wrought on the brests and on the sleeves, and
> in the collar with needlework, the price here will sufficiently
> pay for the work, and cost there, where labour and art are so
> cheap; take special care that the sewing be very good and all
> the cloth strong in its kind, as well fine as coarse.[16]

A quicker and more dramatic change was brought about by the rapid elevation of chintz from working class use to the heights of fashion wear in the later decades of the seventeenth century. Chintz for costume was fashionable on the continent of Europe, and especially in Holland, earlier than in Britain. In 1683 the directors of the English Company stated that it was 'the ware of gentlewomen in Holland, but of the meaner sort here'.[17] The vogue quickly spread to England, and in 1687 the directors noted that chintz was now 'the ware of ladyes of the greatest quality which they wear on the outside of gowns and mantuoes, which they line with velvet and cloth of gold'.[18]

Legislation to prohibit the importation of chintz and many other Eastern textiles to Britain other than for re-export was passed in 1700 and strengthened in 1720, but proved unsuccessful in preventing the widespread use of Indian textiles both as furnishings and costumes. Large quantities continued to be smuggled into the country throughout the eighteenth century. In France, where the earliest restrictive legislation had been enacted in 1686, chintz also remained fashionable for many years. A large quantity of chintz costume has survived in Holland, where no restrictive legislation was enacted. This includes fashionable dress, [145] but more folk-wear such as the distinctive regional costume of Hindelopen in Friesland [146].

In the late seventeenth and early eighteenth centuries, European trade in the piece-goods of Bengal underwent a major expansion. European consumers were most attracted by the many categories of fine cottons called muslin, and lightweight silks, often referred to as 'taffeties' or 'Bengals' in Company correspondence. Muslin was not among the categories of Indian textiles excluded from use in Britain by the Acts of 1700 and 1720, and it retained its great popularity until late in the eighteenth century, when its use was gradually replaced by cheaper machine-made muslins from Scotland and Lancashire. The early imports of muslin were mainly used as men's cravats (formal neck-cloths) women's neck-handkerchiefs and trimmings for garments. By the 1770s muslin was becoming popular as a dress fabric for Europeans both in India and the West, first for children, and from around 1780 for women, as the stiffly corseted formal silhouette of earlier years gave way to a simpler, more natural look. Fine muslin as a dress fabric was at its most fashionable in Europe during the

## 145. Petticoat piecegoods (detail)
Painted and dyed cotton
Southern Coromandel Coast, third
quarter of the 18th century
248.8 × 215.8 cm
IS 42–1950
Given by G.P.Baker

Intended for the patterned
underskirts worn with open robes of
the period, the fabric probably made
under Dutch patronage. Later
converted into a bedspread.

◀ 147. Fragment of a shawl border
*Pashmina* fabric
Kashmir, late 17th or early 18th century
14.6 × 36.8cm
IS 70–1954
Given by Miss Gira Sarabhai

early years of the nineteenth century, though British competition resulted in the closure of the East India Company's Dacca factory, source of the finest weaves, in 1818.[19]

In India and Europe from about 1770 it became fashionable for European women to wear over their shoulders fine woven shawls, the best of which were made from goats' fleece by the weaving technique known as twill tapestry. Shawls of this kind had been made in Kashmir for centuries [147]. In India their wear had been mainly associated with male dress, though Indian women had used them as wraps in the cold season. When adapted for European use, they were regarded essentially as a female accessory. Kashmir shawls were coveted possessions, and this led to their imitation in Europe from the end of the eighteenth century. British centres of shawl manufacture included Norwich, Paisley and Edinburgh. They were also extensively manufactured on the continent. The feathery cone or palmette design which typified the decoration of Kashmir shawls at that time was taken over by the European imitators, and eventually the motif came to be called the 'paisley' even in India.[20]

The English, Dutch, French and Danish East India Companies were all actively concerned in the eighteenth century with the export of piece-goods of handkerchief format. Tie-dyed silk handkerchiefs called bandannas, a major export from the town of Kasimbazar in Bengal, were being brought to Europe by the Dutch Company in the early eighteenth century, under the name of *taffetze foulards* (taffeta silk neck-cloths). There were also printed silk handkerchiefs called *choppa romals*.[21] From the later 1720s the English Company mainly monopolised this trade, and between that date and 1833 when the Company ceased to trade in textiles, many thousands of bandanna piece-goods were shipped to London annually, for auction at the Company's salerooms. Bandannas were particularly appreciated as best neck-cloths by working people such as sailors, market traders and agricultural labourers.

Bandannas were of pure silk, but most of the handkerchief-format piece goods exported from India were of cotton, or silk and cotton mixtures. Among chintzes made in South India under French patronage, probably in the Pulicat region of the Coromandel Coast, is the reversible handkerchief with red and blue sprigs on a white ground [148]. Chintzes 'painted both sides alike' are referred to in a letter of 1700 from Governor Pitt of Fort St. George, Madras,[22] but few have survived. Small, scattered-sprig designs like the one on this handkerchief were much admired in France, and imitated in that country's *toiles d'orange*. Reversible handkerchief prints called *Paillacas* were also copied in the 1750s there from imported Indian chintzes. Another speciality which appealed particularly to the French market in the eighteenth century was *mouchoirs à vignette* (handkerchiefs and other small piece-goods such as table-napkins), made in the Pondicherry region, their sprigged or plain grounds surrounding

**146. Gown (*wentke*)**
Painted and dyed cotton
Northern Coromandel Coast, first quarter of the 18th century
Ht. 142cm; Repeat 52.5 × 47cm
IS 18–1950
Given by G.P.Baker

Made under Dutch patronage, the *wentke* survived into the 20th century as regional dress in Friesland. The sober colouring may imply mourning wear.

**148. Reversible handkerchief**
Painted and dyed cotton
Provenance uncertain, probably
Pulicat, 18th century
87 × 88cm
IS 166–1950
Given by G.P.Baker

Probably made under French
patronage.

central motifs based on European engravings of subjects such as La Fontaine's fables or the purchaser's coat of arms.

Perhaps the best known eighteenth-century handkerchief export from South India was the woven Pulicat handkerchief, which by early in the nineteenth century was generally called Madras. Pulicats were of cotton, or silk and cotton mixtures, in varying degrees of fineness. The best were said to be beautifully dyed in multi-coloured checks and plaids, and as fine as the most delicate muslin. Woven pulicats were exported by the English, Dutch and French Companies from their Coromandel factories. They were popular in Europe, especially in France before the revolution of 1789, but their greatest vogue was in the French and Spanish colonies overseas.[23]

No genuine eighteenth century South Indian woven cotton pulicats are known to survive, but Bengal silk imitations of the period have been identified and the original tradition lingered in good quality Madras handkerchiefs of the nineteenth century, which retained similar colours and plaid designs.

Several centres in South India were famed in the eighteenth and nineteenth centuries for their red cotton handkerchiefs, permanently dyed with mordants. These were used by Indians as women's head-shawls and men's skirt-cloths, and widely exported to Europe and its colonies overseas. The glowing Indian red was produced by 'chay', the madder of South India, also used in chintz production. The best quality 'chay' grew in the northern part of the Coromandel Coast, around the delta of the Krishna river, where its excellence was attributed to the high calcium content of the estuarine soil, full of crushed shells. North Coromandel 'chay' provided the best red for chintz dyeing and was exported for use in other areas.

In the nineteenth century Indian handkerchiefs were gradually ousted from their traditional markets by mass-produced factory-made British cottons dyed 'Turkey red' with a substitute which synthesised the colouring principle of madder.

1. A term once current in Europe to encompass the subcontinent of India, the Indonesian islands and even the islands of the Caribbean, still popularly known as the West Indies. (The usage arose from medieval uncertainty about the sphericity of the world, and survived long after that fact was established.)

2. *The Book of Ser Marco Polo*, ed. H. Yule, London, 1871.

3. Foster, 1899.

4. W.N. Sainsbury, (ed), *Calendar of State Papers Colonial (East Indies) 1513–16*, London, 1862, p.457, no.1087.

5. Birdwood, 1891, p.158. For a recent re-assessment of the motives behind Portuguese expansion, see Pearson, 1987, chapter 1.

6. Originally called in full 'the Governor and Company of Merchants of London trading to the East Indies'. The name was soon abbreviated in practice. A rival 'English' Company was chartered in 1698, and the two were amalgamated in 1707 as the United East India Company.

7. Guinea cloths were auctioned at the East India Company's London sales and bought by merchants of the Royal Africa Company, who bartered them for slaves in West Africa.

8. Guy, 1989.

9. The name was originally associated with cotton fabrics from Mosul or Mausil in Mesopotamia.

10. For example, Indian embroidered quilts are listed in an inventory made in 1600 for the Countess of Shrewsbury ('Bess of Hardwick') at Hardwick Hall in Derbyshire.

11. J. Souch's portrait of Sir Jacob Aston at the deathbed of his wife, 1635 (Manchester Art Gallery), shows an Indian quilt used as a table carpet in the background.

12. The chintz process is undoubtedly of ancient origin in India, though the earliest detailed accounts are those of European observers in the eighteenth century, by which time the most sophisticated effects were available, based on the use of traditional wax resists and vegetable dyes. The madder reds and pinks were controlled by mordants (fixing agents) which enabled the dye to combine permanently with the cotton fabric. Mordant dyeing was already practised in the Indus Valley civilisation four thousand years ago. The other most famous and coveted ancient Indian dye used in chintz was indigo, which needs no mordant. For more detailed discussion see Irwin and Brett, 1970, and Gittinger, 1983.

13. Irwin and Brett, 1970, fig. 9.

14. Embroidery worked in coloured worsted wools on a ground of twilled cotton, linen or mixed fabric.

15. Pyrard de Laval, 1887–90, vol.II, p.247.

16. *Records of Fort St. George: Despatches from England, 1681–6*, Madras, 1916, p.15. A shift, later called a chemise, was then the basic female undergarment in Britain.

17. *India Office Records, Letter Book VII*, f.210.

18. *India Office Records, Letter Book VIII*, f.274.

19. For a comprehensive account of the Dacca muslin industry, see Taylor, 1851.

20. For the pioneer work on Kashmir shawls see Irwin, 1955; the theme is further developed in Ames, 1986.

21. See Murphy, 'The Bengal Export Market', in Murphy & Crill, 1990.

22. *Records of Fort St. George*: Despatches from England, 1681–6. Madras, 1916, p.15.

23. The most successful European imitations were made in Scotland from about 1790 mainly to supply this colonial market.

# 7.
# The Later Provincial Courts and British Expansion

## Historical Background

The courts of Murshidabad (Bengal), Oudh, Mysore and Lahore rose to prominence during the century which saw the breakdown of Mughal authority following the death of the emperor Aurangzeb in 1707. The conditions which fostered their growth also assisted the unlikely metamorphosis of a London-based trading company into the supreme governing body of India, a process which laid the foundations of the British Empire. The rise of the courts and the transformation of the East India Company, with all that implied, are aspects of the same story, so interdependent that they can most conveniently be considered in relation to each other.

Though it was not till after 1757 that the Company's rule began, the idea that its commercial interests in India might best be served by establishing territorial sovereignty at the settlements had started to emerge in the 1680s, when the Company was beset with problem at home and in India, and Sir Josiah Child was chairman. Child was politically aware, as perhaps none of his predecessors had been, and published numerous tracts. In the corrupt spirit of the age, he was obliged to find large sums to bribe the British Crown and buy off the Mughals, having at one stage had the temerity to go to war with the emperor Aurangzeb. In India the Company could operate only on sufferance, its trading privileges dependent on the whims of local rulers, and under constant risk of attack from the Mughals, Marathas, rival Europeans and assorted pirates. Territorial sovereignty, Child thought, would provide the Company with the independent political status needed to negotiate on terms of parity with existing power-bases in India. From fortifying their factories and protecting them with troops, it was but a short step towards raising revenue in the form of taxes on the local inhabitants, who, as well as the Company's own servants, would benefit from its protection. In a letter to Madras of 12 December 1687, probably drafted by Child, the Directors referred to the need for 'such a Politie of Civill and Military power, and . . . such a large Revenue to maintain both at that place [Madras], as may bee the foundation of a large, well grounded, sure ENGLISH DOMINION IN INDIA FOR ALL TIME TO COME'.[1] Pursuing a

**149. Nawab ᶜAliverdi Khan with his nephews and grandson on a terrace**
Gouache on paper
Murshidabad, c.1750-55
38 × 27.5cm
D. 1201–1903

**173**

policy devised in the interests of trade, Child was in fact sowing the seeds of empire, though he had no means of knowing where the changing conditions of the next century would lead the Company.

By 1700, in addition to numerous factories around the coasts of India, the Company had established its three main territorial settlements in Bombay, Madras and Calcutta. These were destined to become its Presidencies or regional administrative centres, each with a president and council, and from the mid-eighteenth century the headquarters of its Bombay, Madras and Bengal armies.

At the death of Aurangzeb in 1707, the Mughal empire was ripe for disintegration. Its vast territory covered many thousands of miles, Mughal sovereignty theoretically extending from Kabul in the north-west to Cape Comorin, the southern tip of the subcontinent. Aurangzeb had attempted the subjugation of all India, with its many rulers and religions; his death left an unwieldy empire of half-tamed provinces large enough to tempt their governors to rebellion. Hindu and Sikh subjects had been alienated by religious persecution. A succession of weak emperors unable to protect their shaky inheritance ensured a struggle for power. In 1739 the Persian ruler Nadir Shah sacked Delhi and carried off a huge booty of Mughal treasure, including the imperial Peacock Throne. Meanwhile the Marathas, a warrior race of Maharashtra in the Deccan, had become a confederacy headed by their hereditary chief ministers, the Peshwas of Poona. By 1740 they controlled the western Deccan and vast areas of central India and were spreading eastwards to overrun Bengal. The Gangetic provinces had been carved up between the Mughal governors of Oudh and Bengal, while the Punjab was a battlefield where Mughal officers, Sikhs and Afghans contended for supremacy.

Reference was made earlier to Sir Josiah Child and his forecast of a limited British dominion in India in the 1680s. In the very different conditions of the mid-eighteenth century, the vision of a full-scale European empire in India obsessed Francois Dupleix, the French East India Company's chief official in the subcontinent. As Governor of their headquarters at Pondicherry on the Coromandel coast of the Carnatic in South India, and fully aware of Mughal disintegration, he saw the rivalry of local factions in the Carnatic as an opportunity to establish French control of Indian courts, thus paving the way to empire. The achievement of his goal depended on eliminating British opposition. The outbreak of war between France and Britain in 1744 enabled Dupleix to attack the Company's Madras establishment, which was captured by the French in 1746, only to be restored to the British under the peace of 1748. There next arose a dispute over the successions to the thrones of Hyderabad and the Carnatic, the French and British supporting rival candidates. The defeat of the French axis at Arcot by Company troops under Robert Clive in 1751 effectively put an end to Dupleix's dream of a French empire in India, and he was recalled to France in 1754.

**174**

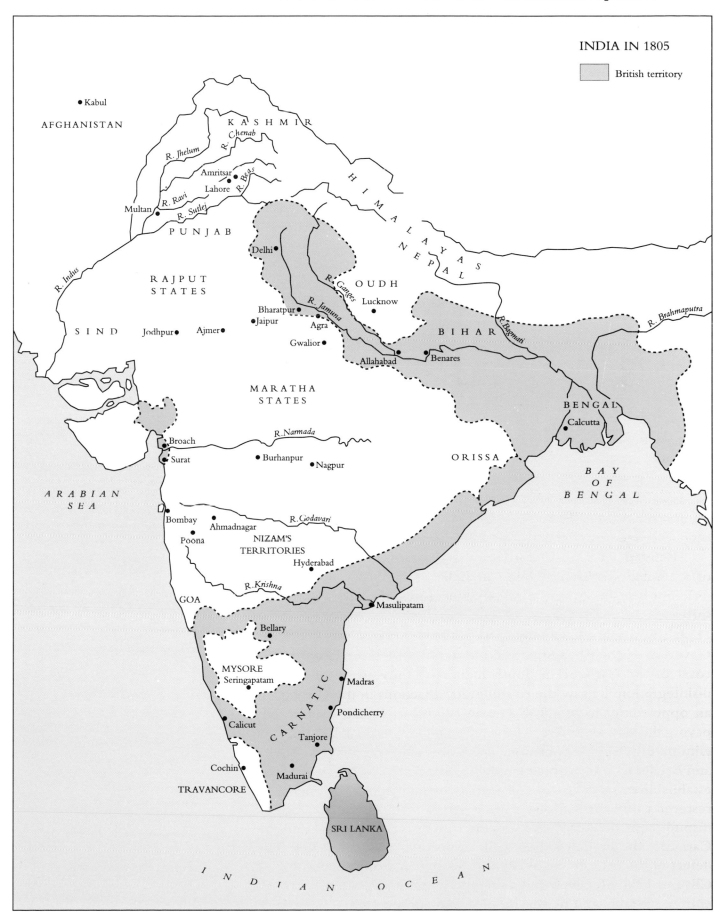

INDIA IN 1805

British territory

Hostilities between France and Britain were renewed on the outbreak of the Seven Years' War in Europe in 1757. When it ended, the Nawab of Arcot and the Carnatic had become a puppet of the British, and control of South India was divided between four powers: the British, the Nizam of Hyderabad, the new regime established in Mysore by Haidar Ali (a Muslim soldier of fortune who had ousted the weak Hindu dynasty), and the Marathas, whose expansion in upper India had now been severely curtailed following a crushing defeat by Ahmed Shah the Afghan at Panipat in 1761. Meanwhile the turn of events in Bengal had brought large areas of eastern India under British dominion. Conflict between them and Siraj-ud-daula, Nawab of Bengal, ended in the defeat of the nawab and his French allies by Clive's troops at Plassey in 1757. The new nawab would be a puppet of the British, and in 1765 the Mughal emperor, who was still the nominal ruler of India, recognised them as the administrators of Bengal, while the nawabs of Oudh, the neighbouring province, also became dependent on the Company.

While British ascendancy is generally considered to date from 1757, until 1790 only about one-eighth of India was actually under British control. A Regulating Act passed by Lord North's administration in Britain in 1773 provided for the revision of the revenue and judicial systems of British India. Warren Hastings, who was governor-general from 1774 to 1785, left India having laid the foundations of the administrative system in Bengal on which the structure of British government in India was established.

The major conflict in India in the 1780s and 1790s was between the British and the Mysore regime, first under Haidar Ali and then under his son Tipu Sultan. The fourth and last Mysore War ended in 1799 with the capture of Tipu's capital, Seringapatam, and the death of the sultan in battle.

The Company restored the Hindu dynasty in the person of a child raja under British protection. The Mysore Wars were followed in the early nineteenth century by the Maratha Wars, when the power of the confederacy was finally broken. The Peshwas' dominions were placed under direct British control, and other Maratha territories given autonomy under British supervision. Also in the early decades of the nineteenth century came conflict with the Gurkhas, a warlike tribe of Nepal, which resulted in large cessions of their territory and the establishment of permanent friendly relations with the Gurkhas, who ever since have provided recruits to the British army. A challenge from Burma in 1823 led in 1826 to the first annexations of territory in further India.

Over the next twenty years British expansion ceased. An *entente* was established with Ranjit Singh (1780–1839), the great maharaja who welded the warring factions of the Punjab into a powerful Sikh nation, astutely avoiding conflict with the British. On his death the Sikh kingdom fell apart in a monstrous bloodbath as kinsfolk

**150. Turban jewels**
Enamelled gold set with a sapphire, diamonds, rubies and emeralds and with a pendant pearl
Murshidabad, *c*.1750
16.9 × 6.1cm and 3.6 × 10.6cm
IS 3&A–1982

Presented to Admiral Charles Watson by Mir Jafar, Nawab of Murshidabad, in 1757.

**176**

slaughtered each other in contention for the throne. British prestige having suffered from defeats in Afghanistan, in 1845 the armies of the Sikhs crossed the Sutlej and invaded British territory. There followed the Sikh Wars which ended in the annexation of the Punjab in 1849. Sind had already been annexed in 1843 – an act which has been described as the one example of unqualified aggression on the part of the British government in India – and a fresh challenge from Burma resulted in the annexation of Lower Burma following the second Burmese War in 1852. A number of other territories came under direct British rule in the 1850s, the last annexation being that of Oudh in 1856.

By then about two thirds of India was under British rule and apparently at peace, the conquests having been achieved by troops of whom only a small proportion were Europeans.[2]

## Murshidabad

The city of Murshidabad – formerly Muxadabad – assumed a new importance and a new name early in the eighteenth century, when Murshid Quli Khan was appointed Mughal governor of Bengal, Bihar and Orissa, and made Murshidabad the administrative capital of the province in succession to Dacca. A most able administrator in that time of disintegrating central government, he was also a devout Muslim whose austere and frugal disposition made him an unpromising patron of the arts. Robert Skelton has, however, demonstrated that under this nawab and by about 1720 Murshidabad may already have attracted some of the court painters displaced by the decline of Mughal patronage at Delhi, and become the centre of a new school of provincial Mughal painting which was to achieve its definitive state under Nawab Alivardi Khan some thirty years later.[3] Skelton notes the influence of late Aurangzeb period court paintings on the formal style and sombre colour scheme of early Murshidabad work, anticipating the 'grey precision' which characterises Murshidabad painting of the mid-eighteenth century. Alivardi Khan, who with Murshid Quli Khan and others probably appears in the earliest painting attributed to Murshidabad (IS 133–1964), is seen again in a composition of 1750–5, seated on a garden terrace conversing with his nephews and favourite grandson Siraj-ud-daula [149].

Like Murshid Quli Khan, Alivardi Khan was a forceful personality and a capable ruler. In theory an imperial deputy, he took advantage of the Mughal decline to assume absolute control of his province. The stability provided by his rule encouraged the development not only of a school of painting but also of a range of crafts dependent on court patronage. These included metalwork and related jewellery [150], ivory carving [151], textile weaving and embroidery. While most had ancient antecedents in Bengal, from this time onward the products would be strongly influenced by Mughal decorative traditions.

**151. Two figures, probably chess-pieces**
Ivory
Murshidabad, Bengal, late 18th century
15.9 and 15.6cm
IM 374 & 375–1914

Events in the province were now moving towards a change as profound as it was dramatic. The importance of Bengal as a centre of export textile production, with its cheap labour and convenient water-borne transport, had been attracting European settlement ever since the Portuguese established their Hughli trading post in the sixteenth century. They had been followed by the Dutch, English, French and Danes, all eager to engross textile exports to Europe. The English Company's Bengal factories included a flourishing settlement at Kasimbazar in the Murshidabad district, concerned with the export of raw silk and manufactured silk handkerchiefs. Much more significant, 100 miles or so down river was the city of Calcutta, a British possession under Mughal suzerainty since the 1690s. Guarded by Fort William, from early in the eighteenth century it had been a Presidency and the seat of the East India Company's Bengal administration. It was also the leading seaport of Bengal with an export warehouse through which the manufactures of Eastern India were despatched to Europe. Theoretically all European settlements in India were held with the consent of the Mughal emperor through his local representative. Chequered relations between the East India Company's employees and the Nawabs of Bengal came to a head when ʿAlivardi Khan was succeeded by his grandson Siraj-ud-daula in 1756. The latter was by all accounts an unpleasant and depraved youth with few mitigating qualities beyond his apparent patronage of paintings.[4] Nevertheless he dealt decisively with his cousin's rebellion and provocation from the English at Hughli. His capture of Calcutta in June 1756 was followed by the incident known to history as the Black Hole of Calcutta, when 146 Europeans were imprisoned overnight in a small room with insufficient ventilation and only twenty-three survived. Siraj-ud-daula was blamed for this, though it is uncertain whether he was directly implicated, and the deaths may have been unintended.

The British intrigued with Siraj-ud-daula's commander-in-chief, Mir Jafar, and secured his allegiance by promising to install him as Nawab of Bengal. There followed Clive's defeat of Siraj-ud-daula at Plassey in 1757. The British were now masters of Bengal, and Mir Jafar installed as nawab. British success in the campaigns of the 1740s and 1750s was due in large measure to the back-up its land forces received from naval support. A month after Plassey the new nawab gave to Admiral Charles Watson, who commanded the British squadron in the Bay of Bengal, a turban ornament [150], similar to that held by Alivardi Khan in 149. Watson's gift was 'a rose and plume composed of diamonds, rubies, sapphires and emeralds which, though not of great value, made a pompous appearance'.[5] Recalling the stupendous riches of the nawab's treasury, Clive later was 'astonished at [his] own moderation'.[6]

Under Mir Qasim, who superseded Mir Jafar from 1760–3, patronage of paintings was largely restricted to portraits of the Nawab

**152. Woman smoking a *huqqa***
Gouache on paper
Murshidabad, Bengal, *c.*1760–3
24 × 16.3cm
D.1181–1903

An Indian lady, possibly the 'bibi' or consort of a European, sits in the Indian manner on a Dutch-style chair, while an English-style candlestand accommodates her *huqqa*.

**155. *Huqqa* base and box**
Silver, partly gilt and enamelled
Lucknow, late 18th century
Huqqa base: Ht. 18.5cm, diam. 18.5cm
Box & cover: 6.7 × 10.5 × 8.9cm
122–1886(IS) and IM 30–1912

and his officers, in a style deriving from that of Alivardi Khan's reign. An artist whose name is associated with this type of painting is Dip Chand. Works of his school include portraits of Europeans,[7] and others of Indians sitting on Dutch-style chairs [152]. At the same time there was a growing demand for mythological subjects[8] patronised by Hindu officials and zamindars (land-holders renting from the government), whose numbers were increasing.

Court patronage declined with the defeat and flight of Mir Qasim and the re-installation of Mir Jafar in 1763. Subsequent nawabs of Bengal were puppets of the British, and some Murshidabad painters worked for these new patrons, experimenting successfully with European styles and techniques (see 'British Patronage and Scholarship,' p.195).

### Oudh

Of all the courts that glittered for a time during the protracted extinguishing of the Mughal dynasty, that of Oudh – variously situated at Faizabad and Lucknow – was the richest in superlatives: the most brilliant, the most cultivated, the most cosmopolitan, the most luxurious, the most lavish in patronage and the longest to enjoy the limelight. Even in their final decadence its rulers achieved an awful distinction which rivalled the less tarnished splendours of earlier reigns.

The dynasty of the Oudh nawabs was founded in 1722, when the emperor Muhammad Shah appointed Sadat Khan to the *subadari* of that province. As the empire disintegrated, the ruler of Oudh, like other able governors, achieved practical autonomy while avoiding an open breach with the Mughal court. Three generations of the Oudh dynasty held other imperial appointments, one of which brought an additional title, and henceforth they were known as the Nawabs Wazir.

Shuja-ud-daula, who ruled Oudh from 1753 to 1775, was 'restless, impulsive, and an ambitious ruler',[9] of tall, dignified presence and powerful physique. He fought in two of the decisive battles of modern Indian history: at Panipat in 1761 he was on the winning Afghan side, when the Maratha hordes were vanquished; and the battle of Buxar in 1764 saw his army defeated by forces under General Sir Hector Munro, thus confirming British dominance in India.

Throughout its history, the Oudh dynasty offered considerable patronage to the arts and crafts: these included painting [153, 154 and 159], book-binding, enamelling on metal [155], carving, plating and gilding of thrones [156 and 157] and related objects, and textiles, particularly those associated with costume [158].[10] While the culture was Persia-oriented, Persian manners and Persian poetry always being appreciated, many of the artefacts have a markedly European character [156 and 157], others a European association [160], reflecting the cosmopolitan nature of society at the court. This began in the

**158. Turban band**
Canvas base, covered with red silk and embroidered with silver and silver gilt wire, sequins and floss silk, with velvet panels
Mughal style, probably Lucknow or Faizabad, c.1765–1800
L. 64.5 × 10.5cm
IS 85–1988

### 153. Nawab Shuja' ud-Daula of ▶ Oudh

In the style of Mihr Chand, after a
portrait by Tilly Kettle
Gouache on paper
Lucknow, *c.*1770
242.6 × 151cm
IS 287–1951

### 154. Nawab Shuja' ud-Daula and his sons being painted by a European

Gouache on paper
Lucknow, *c.*1800
36.4 × 54.2cm (without border)
IS 5–1971

This painting is based on an original
work by the English artist Tilly
Kettle, seen in the bottom left of the
picture with an up-dated haircut
suggesting the turn of the century.
Kettle worked as an artist at Faizabad
in 1772–3.

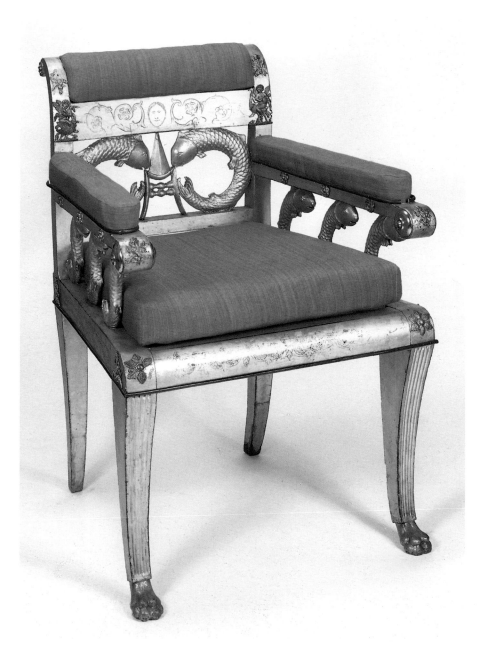

### ◄ 156. Throne chair

Gilt wood, with gilt metal mounts
Lucknow, c.1820
93 × 61cm
Lent by the Rt Hon. The Earl Amherst

Based on a European prototype of the Egyptian Revival, the chair was presented to the first Earl Amherst when Governor-General of India, 1823–8, by Gazi ud-din Haidar, Nawab Wazir and first king of Oudh (1814–27).

### 157. Design for a chair

Watercolour on paper
Lucknow, mid-19th century
13 × 8.4cm
E.276–1967

Designs of this kind reflect the influence of Robert Home, who was court painter to Gazi ud-din Haider, Nawab of Oudh 1814–27.

reign of Shuja-ud-daula, who in the aftermath of his defeat at Buxar decided to re-model his army on European lines. In the early 1770s he invited European officers to Faizabad, which was then the capital. They included the French Colonel Gentil, whose fascination with the manners and customs of Hindustan resulted in an album prepared for him by the court painters [160, see endpapers].

At about this time Shuja-ud-daula offered patronage to a British portraitist, Tilly Kettle, who visited India during the period 1770–7 and painted the Nawab Wazir in the favoured Abdali or Durrani dress which reflected his Afghan affiliations, and which had become fashionable in the wake of the Afghan invasions. In this costume a short overcoat shaped to the waist, tied with a belt or sash, often with a fur tippet round the neck, was worn over a calf-length *jama*, which revealed embroidered leather boots. Head-gear was either a fur hat or a turban, the latter typically completed by an embroidered and spangled band [158]. Another composition of Kettle's was a family group showing the Nawab Wazir surrounded by his ten sons. Both portraits were copied by Lucknow painters [153 and 154]. In 1773 the European presence was reinforced by a permanent British Resident appointed to the *darbar* (court), with Company troops to be maintained by Shuja-ud-daula in return for certain concessions.

In the next reign, that of Asaf-ud-daula (r.1775–97), crowds of Europeans were attracted to the court, now at Lucknow. Asaf-ud-daula was immensely rich and a lavish spender, of great generosity. He was also hopelessly in the grip of the bizarre passion for European objects and uniforms which seized certain Indian potentates at that time. Like several other rulers, he set aside a large room for his European collection, in which ornate mirrors, chandeliers and automata found special favour. Among the Europeans who shared his amusements were Colonel John Mordaunt, a sporting English nobleman, commander of the bodyguard, considered by his friends to be half-mad; and the French General Martin, an eccentric who built at Lucknow a vast palace-mausoleum named Constantia after an early love, arranging for his own burial in the basement to prevent the property from being seized by the nawabs. Martin was, like his patron, a lavish entertainer, but also a connoisseur-collector who amassed an important library of 4000 books in Latin, French, Italian and English, with Sanskrit and Persian manuscripts, Indian paintings,[11] and numerous European oil paintings. Another long-term continental resident was the Swiss Colonel Polier, also a connoisseur of European and Indian art, whose large collections included Indian manuscripts and paintings. Martin, Polier and many other Europeans at Lucknow and other courts adopted a semi-oriental life style, wearing *nawabi* dress, smoking the *huqqa*, reclining on cushions, listening to Indian music and watching nautch-dancers. In the absence of European females, of whom there were few in India at that time, they formed *zenanas* (harems) of Indian concubines, while some

**159. Fencing stick**
Painted wood, with enamelled silver pommel spike and ferrule
Lucknow, c.1780
L. 135cm
IS 10-1980

Exercise with fencing sticks was one of the traditional pastimes of Lucknow.

formed true domestic ties or even contracted marriages with Indian *bibis*, as they called their women companions.

Under the later rulers of Oudh the European vogue became more manic. Ghazi-ud-din Haidar (r.1814–27) and Nasir-ud-din Haidar (r.1827–37) were the chief exponents of the craze. Ghazi-ud-din Haidar appointed a Scottish artist, Robert Home, as his court painter. During this period the nawab was encouraged by the East India Company in 1819 to adopt the title of king. An interesting product of these circumstances was the portfolio of drawings Home prepared for the monarch, with sketches for all the impedimenta of Indo-European kingship: thrones [**156** and **157**], howdahs, boats, carriages, flags, crowns and assorted regalia, many of the objects decorated with the auspicious fish-symbol of the state. The kings adopted European-style costume and entertained European guests to banquets in an ornate pavilion with neo-classical decoration, tawdry in comparison with the Islamic palaces and mosques of earlier reigns.

Muhammad Ali Shah, who reigned from 1837 to 1842, was already sixty-three when he attained the throne. He was a careful and economical ruler who attempted to reform the administration of Oudh. He embellished the city of Lucknow with fine buildings and a new road by the river, and in his short reign did much to restore the dignity of Oudh. There followed the equally short reign of Amjad Ali Shah (r.1842–8), who accomplished little but was renowned for his piety. He was succeeded by Wajid Ali Shah, whose reign began auspiciously with attention to army reform and the judicial system. Soon, however, the new king, an incompetent administrator, returned to earlier habits, indulging the most decadent tastes, which he recorded in poetry and prose. This led in 1856 to the annexation of Oudh, which was thereafter to be administered by the British, who would maintain the ex-king and his establishment. In 1857 there followed the episode known as the Indian Mutiny or Sepoy Rebellion, in which Lucknow featured so prominently, and its fine buildings received serious damage. Despite its sad decline under the later monarchs, and the cataclysm of 1857, so persistent was the aura of its days of greatness that its unique and Persian-oriented cultural identity survived to influence the lives of the citizens for nearly a century, dispelled only by the changing circumstances which came with Indian independence.

### Mysore and Tipu Sultan

Of the many Indian potentates whose destinies were interwoven with those of European allies and adversaries in the turbulence of the 'Black Century',[12] none was involved in more melodramatic events, or achieved more posthumous fame, than Tipu Sultan of Mysore [**161**]. He was the son of Haidar Ali, the Muslim adventurer of great ability who by 1766 had ousted Mysore's ineffectual titular Hindu raja, usurping the throne. By the time of Haidar Ali's death nineteen

**161. Tipu Sultan** ▶
Gouache on paper
Mysore, *c.*1790
26.5 × 18cm
IS 266–1952
Given by Col. T.G.Gayer-Anderson and Major R.G.Gayer-Anderson, Pasha

**162. 'Tippoo's Tiger'**
Painted wood, with metal fixtures
Mysore, *c.*1795
71.2 × 178cm
2545 (IS)

The tiger, emblem of Tipu Sultan, mauls a European, who emits groans produced by bellows inside the tiger. Also concealed in its side is a miniature organ keyboard, and growls are produced by turning the handle on the tiger's shoulder.

**163. Tipu Sultan's saddle cloth**
Velvet, embroidered with silver gilt thread, wire and sequins
Deccan, late 18th century
143.5 × 142.2cm
784–1864

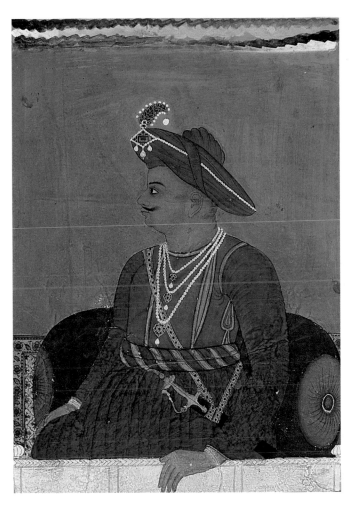

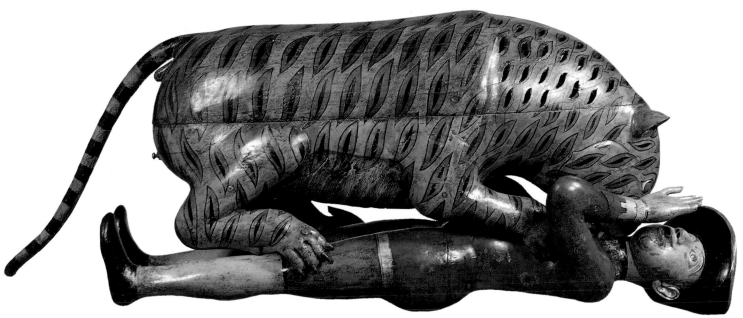

years later, he had enlarged the boundaries of Mysore by conquest and transformed it into a powerful and militant state with an army re-organised on European lines, offering the only serious threat to British expansion in the Carnatic. The progress of the power struggle was marked by treachery and counter-treachery, setting in train the four Mysore Wars, waged between 1767 and 1799. In 1782, during the second of these, Haidar Ali died and was succeeded by Tipu. The third Mysore War was concluded with the treaty of Seringapatam (the capital) in 1792. Under its terms, two of Tipu's numerous sons, aged about ten, were handed over to the British commander, Lord Cornwallis, as hostages. Negotiations were conducted in a 'tent of fine chintz', possibly the one which still survives at Powis Castle.[13] The boys were taken to Madras, the East India Company's headquarters in South India, and entertained as princely guests rather than captives. They were returned to their father two years later, but Tipu was deeply resentful of the affront and did not consider himself bound by the treaty. The fourth Mysore War culminated in 1799 with the siege of Seringapatam, when the city was invested by the combined forces of the Company, the British Crown and their Indian allies. On the eve of the final battle Tipu called a conference of his officers and was reported to have cried: 'Better to die like a soldier than to live a miserable dependent of the infidels on the list of their pensioned rajas and nabobs!'[14]

Seringapatam was taken on 4 May 1799 and Tipu died a hero's death in battle, as he had wished. (The fate he despised, however, awaited his large extended family, who were henceforth maintained by the British.) Tipu was buried next day with full military honours in the Mausoleum of Haidar Ali, where their tombs can still be seen. The ceremony took place in a violent thunderstorm, during which several British soldiers were struck by lightning, seen by Tipu's supporters as God's vengeance on the infidel. Meanwhile the city had been ransacked overnight by drunken mobs in which Company sepoys and British troops were joined by local elements. Colonel Arthur Wellesley, later the first Duke of Wellington, took command next morning. He reported:

> Scarcely a house in the town was left unplundered, and I
> understand that in camp jewels of the greatest value, bars of
> gold, etc, have been offered for sale in the bazaars of the
> army by our soldiers, sepoys and foreigners. I came in to take
> command on the 5th and by the greatest exertion, by
> hanging, flogging, etc., in the course of that day I restored order
> among the troops and I hope I have gained the confidence
> of the people. They are returning to their houses, and
> beginning again to follow their occupations, but the property
> of everyone is gone.[15]

After some initial disorder, a guard had however been placed on the palace, and its contents now passed into the hands of the

British. Many of the relics associated with Tipu were despatched to the Directors of the East India Company in London, either for their retention or for presentation to the Crown. Other items were taken to Britain by individuals who had been present at the capture of Seringapatam [163].[16]

Tipu was a devout Muslim who saw himself as God's instrument for driving the infidel British out of India. To further this aim both he and Haidar Ali negotiated with the French in the Carnatic and formed alliances with the French Government. In 1788 the Mysore regime sent three ambassadors to the court of Louis XVI at Versailles. The Sevres porcelain coffee service presented to Tipu by the monarch[17] was among numerous European objects in his collection,[18] which is said to have included ivory chairs, sofas and other furniture. It is possible, though far from certain, that the French influenced South Indian ivory chairs [177] and some of the Amherst Collection furniture [180] may have come from his palaces.

Friendly relations with France continued under the revolutionary government, when Tipu was called 'Citizen' and donned the Cap of Liberty. French artisans were employed in his court workshops, contributing to the renaissance of crafts Mysore enjoyed under his regime. The internal mechanism of 'Tippoo's Tiger' – most famous of his possessions to fall into the hands of the British on his death – is evidently of European workmanship and was probably made by a Frenchman in his service, while the casing is reminiscent of South Indian carved and painted wooden toys [162]. Musical automata, highly popular in Europe at the time, were equally appreciated in India. 'Tippoo's Tiger' had however a uniquely personal significance for the Sultan. Tiger motifs adorned most of his possessions, from his magnificent throne to the uniforms of his guards.

Among the most important objects to be decorated in this way were arms and armour. Much of his ordnance (for example, cannon and mortars), was cast in the form of tigers. The hand weapons, which included firearms incorporating the latest European technological innovations as well as the more traditional edged weapons, were generally embellished with gold and silver tiger motifs, the animal in some instances shown devouring a prostrate human figure or vanquishing the double-headed eagle of Hindu Mysore. They were also inlaid with Koranic or other pious Islamic inscriptions, in which the calligraphy was arranged to form tiger masks. Some contained references to 'the Victorious Lion [Haidar] of God', a title bestowed by the Prophet Muhammad on the Imam Ali, after whom Tipu's father was named. While the tradition that Tipu's own name means 'tiger' in Canarese (a South Indian language) cannot be substantiated, he undoubtedly saw himself as the royal tiger, appointed to devour God's enemies, and became known as the Tiger of Mysore. Tipu's Dream Book – a Persian manuscript found in the palace after his death, and now in the India Office Library[19] – records his pre-

occupation with tigers, and his association of the cult animal with the extermination of non-Muslims. The walls of houses in Seringapatam were said to have been painted on his instructions with life-size caricatures of Englishmen being devoured by tigers, and there were rumours of executions by this means. (Like other Indian rulers of his day, Tipu kept a supply of live tigers in the city for the wild-beast combats which were a favourite spectator sport.)

The 'Man-Tyger-Organ' – so-called in a note which accompanied it to England – may have been inspired by the gruesome fate which in 1792 befell a British youth mauled by a huge royal tiger while picnicking with friends on Saugor Island in the Bay of Bengal. The victim was the only son of General Sir Hector Munro, an old adversary who had been concerned in Haidar Ali's defeat at Porto Novo in 1781. Tipu would have relished the irony of young Munro's death, which was widely reported.

A controversial figure in his day and since, this Muslim ruler of a Hindu state was undoubtedly a leader of energy, courage and vision, who inspired loyalty in his followers and the horrified admiration of his enemies. In recent years he has become a popular hero of Islam and a symbol of Indian nationalism, identified with the struggle for independence.

### The Sikhs and Maharaja Ranjit Singh

A golden throne of distinctive waisted shape, suggesting the lotus seats of Hindu/Buddhist iconography, is among the most conspicuous and popular exhibits in the Indian collection of the Victoria and Albert Museum [165]. This is the throne of Maharaja Ranjit Singh (1780–1839), 'Lion of the Punjab,' [164 and 166] a ruler of outstanding qualities whose unique achievement was to reconcile the warring factions of the Punjab and create a Sikh nation.

The Sikh religion was founded in the late fifteenth century by Guru Nanak, a teacher who wandered the Punjab, preaching a monotheistic religion which was intended to unite Hindus and Muslims. Its tenets rejected mosques, temples, images, priesthood and caste, while stressing the importance of virtues such as honesty, loyalty, justice and benevolence. These teachings were passed on by his three immediate successors, the Gurus Angad, Amar Das and Ram Das. They attracted a large following among the Jat farmers of the Punjab, and the community became known as Sikhs from the Punjabi word for 'disciples'. Under Arjun, the fifth Guru, the religion became more structured. The writings of the Gurus and other theologians, Hindu and Muslim, were combined in a sacred book, the *Adi Granth*, while a code of conduct regulated religious and secular life. The town of Amritsar became the Sikh holy city and a pilgrimage centre.

Up to this time the Sikhs had been a peaceful sect. The execution of Guru Arjun in 1606 for rebellion against the Mughal emperor

**164. Maharaja Ranjit Singh with retainers**
Gouache on paper
Lahore, c. 1835–40
30.6 × 24.2cm
IS 282–1955
Given on behalf of the van Cortlandt family by Mrs L.M.Rivett Carnac.

**188**

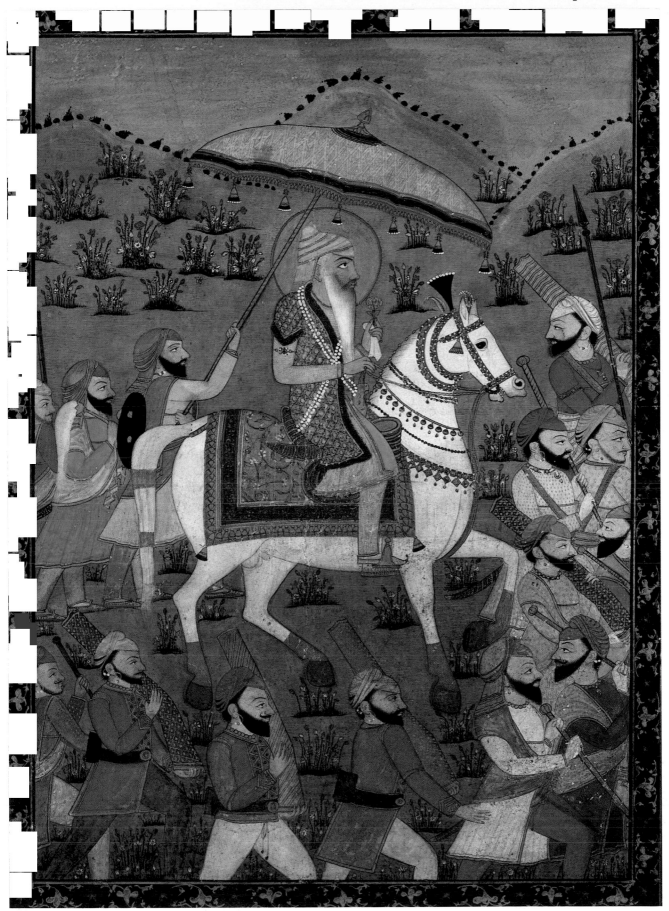

stimulated the growth of militancy, symbolised by the two swords which Arjun's son Guru Har Govind wore to represent spiritual and temporal power. He also armed his followers and vowed to protect Sikhism. It has been suggested that there was no rigid division between militant and peaceful Sikhs, the two roles being interchangeable, united as they were in devotion to the scriptures, and the will to resist oppression.[20]

In the third quarter of the seventeenth century, the personal influence of the Gurus became less important, belief being founded principally on studying the scriptures, and expressed in twice-daily worship. From 1658, with the accession of the Mughal emperor Aurangzeb, religious persecution of non-Muslims was re-activated. Tegh Bahadur, the ninth Guru, was tortured and executed in 1675 for his success in advocating peaceful resistance. His son, Guru Govind Singh, lived in retirement till 1695 and thereafter devoted his life to twin causes, political and spiritual. One was the formation of an independent Sikh state free from Mughal oppression, the other a spiritual renaissance. Govind Singh and a band of supporters took cover in a rough tract of low hills and jungle between the Punjab Hills and Plains, a strategic position from which they emerged to harry Mughal governors and hill rajas. Govind Singh built five forts there and by 1699 was sufficiently established to consider his second project.

Under his re-organisation Sikhism was seen primarily as a militant fraternity of 'the Pure' (*Khalsa*), initiated by ceremonial ablution and the caste-breaking joint consumption of mixed flour, butter and sugar. 'The Pure' undertook to abstain from smoking, from Muslim women and from eating meat slaughtered by Muslims; and promised to observe the five Ks: *Kesh* (hair, to be uncut), *Kangha* (a wooden comb worn in the hair), *Kara* (an iron bracelet), *Kach* (short drawers) and *Kirpan* (a sword). They were also to adopt the name of Singh (Lion).

The remainder of Govind Singh's life was martial, though he found time to compile the *Dasam Granth*, a supplementary book of scriptures. Having supported Aurangzeb's successor, Bahadur Shah, in the Deccan, he was assassinated by a Muslim in 1708.

Up to the mid-eighteenth century, now leaderless and fragmented by internal dissensions, the Sikhs formed individual warrior bands raiding the Punjab. As the Mughal administration weakened, Sikh power increased, and some of the groups amalgamated to form confederacies called *misls*, each identified with a particular region where its leaders held sway The chaos of the Afghan invasions and Maratha raids provided ideal conditions for Sikh brigandage. Lahore and Amritsar changed hands several times between 1757 and 1761. The defeat of the Marathas at Panipat in 1761 by the Afghans and their Indian allies ended with the Punjab nominally under Afghan rule, but in practice overrun by the Sikhs, who took Lahore again in

**165. Maharaja Ranjit Singh's throne**

Wood and resin core, covered with sheets of embossed gold
Made by Hafiz Muhammad of Multan, 1818 or later
94 × 90cm
2518 (IS)

1818 was the year when Multan finally fell to the Sikhs, and it is likely that the throne was commissioned to mark the event. The court of Ranjit Singh was then at Lahore and the throne is traditionally associated with that city, where it was found on the annexation of the Punjab in 1846. Thrones were portable objects, used in camp as well as in court.

**166. Order of Merit with a portrait of Ranjit Singh**

Enamelled gold set with emeralds and rock crystal
Lahore, 1837–9
9.1 × 4.8cm
IS 92–1981

This award seems to have been introduced by Maharaja Ranjit Singh in direct emulation of the French Légion d'Honneur worn by one of his foreign military commanders, General Allard. It may be the 'Star of the prosperity of the Punjab', instituted in 1837 on the occasion of the wedding of his grandson, and came from the collection of his son, Dalip Singh.

1767. Sikh unification remained elusive, as members of the *misls* fought over leadership and territorial issues.

In 1792 the chieftancy of the dominant Sukerchakia *misl* was inherited by Ranjit Singh, a boy of twelve whose father had reinforced the *misl's* power by marrying his son into the *misl* of another powerful clan, the Kanheyas. Of precocious maturity, Ranjit Singh embarked on a programme of Sikh unification. Backed by the Sukerchakia forces, he subdued rival *misls*, and in 1798 received from the Afghan Shah Zaman the title of Maharaja and the right to Lahore, which became his capital the following year.

There now followed thirty-five years of expansion by conquest and annexation, during which Ranjit Singh employed the restless energy and martial spirit of the Sikhs in building an empire. Many hill states were added to his territory between 1808 and 1828, though some maintained a degree of independence. Expansion in other directions included Multan, Rawalpindi, Kashmir, Ladakh and Peshawar. By 1805 his only serious rivals in North India were the British. In 1803 they had occupied Delhi, where the Mughal emperor was now a mere cipher. The Marathas had finally been vanquished in 1805. British apprehension was now directed north-west towards a possible threat from the Russians and Afghans. To contain this they had the option of fighting Ranjit Singh or treating with him. Mutual respect resulted in a treaty rather than war, both sides agreeing that the river Sutlej should form a permanent boundary between Sikh and British territory. Friendly relations were maintained to the end of Ranjit Singh's reign, when the anarchy which followed brought about the Anglo-Sikh Wars (1845–6 and 1848–9), resulting in the eventual British annexation of the Punjab. Like the Gurkhas a generation earlier the Sikhs became faithful allies of the British and regular recruits to the Bengal army of the East India Company, a tradition continued under the British Crown following the Company's dissolution in 1858.

The appearance and character of Ranjit Singh were topics of perennial fascination to Europeans who encountered him. The 'Lion of the Punjab' was at first sight a great disappointment: a small, spare man with a head sunk into his shoulders, his face much pitted with the smallpox which had destroyed one eye and left the other disfigured. One arm and foot were partly paralysed. He dressed in the simplest style, wearing plain white muslin or saffron-coloured shawl-cloth according to the season. Then the contradictions began to crowd in: his court and camp were of the most splendid, and visitors left dazzled by the jewels, shawls, kincobs (gold and silver brocades) and glittering armour of his myriad followers. He was not at all abstemious, but addicted to potent and costly liquors mixed with powdered pearls, under the influence of which he was reputed to indulge in 'every species of licentious debauchery'.[21] He was a superb horseman, sportsman and swordsman, yet a hypochondriac;

charming, gentle, courteous, but deceitful, selfish, avaricious. 'By sheer force of mind, personal energy and courage, he . . . established his throne on a firmer foundation than that of any other eastern sovereign',[22] and his unification of the Sikhs was a personal feat unequalled by any leader before or since. His funeral rites were marked by the apparently voluntary immolation of four Ranis (his Rajput consorts) and seven slave-girls.

As with other Indian rulers of the period, Ranjit Singh's companions included a number of Europeans, notably the mercenary officers he employed to re-model his army, with brilliant success. Among them were the Italians Ventura and Avitabile, the Frenchmen Allard and Court, and the Irish-American Gardner. His court physician was Dr Honigberger, a German.[23] Some of these and other Europeans appear in oil paintings of scenes at the court of the Sikhs by August Theodor Schofft, an Austro-Hungarian artist who spent the year 1841 in Lahore.[24]

Sher Singh was now Maharaja, and one of Schofft's paintings shows him seated on what appears to be the Golden Throne now in the Victoria and Albert Museum, though only its outlines appear surrounding his substantial form.[25] Sher Singh approved of Schofft's work and suggested a view in the Sikh sacred city of Amritsar, where Schofft was attacked by a band of *Akalis* (Immortals), the fiercely militant ascetics who were self-appointed guardians of the Golden Temple and its precincts. Smoking was forbidden, and the Akalis mistook the artist's pencil for a cigar. Schofft narrowly escaped with his life, but lost his trousers when his braces were severed in the pursuit. An *akali* turban of characteristic tall conical shape, equipped with razor-sharp bright steel *chakras* (quoits), can be seen in **167** with a Sikh painting of *Akalis* on the march. Quoits were lethal weapons when spun through the air by a practised hand. Arms and armour were a major focus of patronage at the court of the Sikhs. Another important aspect appears to have been seat furniture in the form of armchairs influenced by English Regency styles. Sikh paintings show some of these with the arms forming loops behind the back of the chair. This interesting variant of an otherwise common neo-classical prototype is not exclusively associated with Anglo-Sikh furniture but also appeared in Calcutta earlier in the century [182]. Paintings, which evolved from the existing schools of adjacent states absorbed into Ranjit Singh's empire, began to develop their typically Sikh characteristics only towards the end of his reign, reaching fruition in the following decade. Picturesque subjects such as the *Akalis* appealed to British collectors.

By this time (the 1840s), the popular hero of the Sikhs was Gulab Singh, [168], the Dogra Rajput from Jammu whom Ranjit Singh had appointed Raja of that state on its annexation in 1820. Gulab Singh survived the blood-letting which followed Ranjit Singh's death, and as Chief Minister, attempted to steer the Sikh state past the reefs of

### ◄ 167. A group of Akali Sikhs

Gouache on paper
Lahore, c.1850
18.5 × 24.3cm
IS 11–1987
Given in memory of
Michael Jones by his friends

### 171. Village scene, Rania, near Delhi

Watercolour on paper
Rania, Hariyana, c.1816
28.8 × 41.1cm (without border)
IS 13-1989
Purchased with assistance from
the friends of Robert Skelton to
commemorate his 60th birthday.

From the Fraser Album, which
incorporated paintings commissioned
by William Fraser (1784–1835), an
East India Company employee, and
his brother James (1783–1856) to
record local scenes through the
services of local artists.

### 168. Maharaja Gulab Singh of Jammu and Kashmir (1792–1857)

Gouache on paper
Lahore, c.1845cm
26.2 × 20.7cm (without border)
IS 194–1951
Purchased with the assistance of Lady
Rothenstein and the National Art
Collections Fund.

**194**

Anglo-Sikh confrontation, while maintaining the great Maharaja's policy of peaceful co-existence with the British. Unable to prevent the Anglo-Sikh Wars and British annexation of the Punjab, he nevertheless retained Jammu and was able to annex the neighbouring state of Kashmir, coveted for its shawl revenue. The Sikh court had made lavish use of woven goat-fleece shawls [169 and 170] as wearing apparel, tents and furnishings. The Generals Allard and Ventura were both connoisseurs in this field, and much involved in shawl transactions.

From 1849 the Sikh state ceased to exist, but in the villages traditional ways were long resistant to change. In the 1880s Jat women still tended their fields and flocks in the mantles of home-spun earth-coloured cotton closely embroidered with bright yellow and orange silk, known as *phulkaris*,[26] amid scenes little changed from the days of the Fraser Album [171] seventy years earlier.

### British Patronage and Scholarship

British patronage of living artists in India appears to have begun about 1760 when William Fullerton, a Scots surgeon of the East India Company stationed at Patna, commissioned work from the painter Dip Chand (see 'Murshidabad', p.180 and 152 and 172). By this time there was an existing market for ready made Indian paintings. The set of Indian rulers' portraits the East India Company employee John Cleland[27] brought from a Bombay dealer in 1736 was a type of painting which retained its collector appeal well into the nineteenth century. Meanwhile numbers of Britons working in India continued to collect Indian miniatures of various kinds, often not as mere curiosities but specialised subjects. A few such collections have survived largely intact. They include those acquired by Richard Johnson at Calcutta, Lucknow and Hyderabad from 1770–88, now in the India Office Library, London,[28] and by Sir Gore Ouseley at Lucknow between 1788 and 1808, now in the Bodleian Library, Oxford. Two groups of Murshidabad paintings stamped with the Persian seal of Sir Elijah Impey, first Chief Justice of the High Court of Calcutta from 1774 to 1789, survive in the Bodleian Library and the Victoria and Albert Museum.[29]

Of the collections that have been completely dispersed, that of Warren Hastings – a pioneer Indologist as well as a key figure in the history of British India – must be considered as the greatest loss. The royal albums of Lucknow and other paintings acquired by the first Lord Clive ('Clive of India') in the 1760s [92] were presented to him by Shuja-ud-daula, Nawab Wazir of Oudh (see 'Oudh', p.180). Part of an important miscellaneous collection of gifts, trophies, curiosities and objects of utility, they do not imply that Clive was a specialist collector of Indian art, his personal interests lying in the European field. His Indian collections were greatly enlarged in a similar spirit by his son and daughter-in-law, though the latter developed a more

**170. Shawl** (detail)
Wool, loom-woven
Kashmir, early 19th century
310 × 66.5cm
IS 50–1967

◀ **169. A shawl goat**
Watercolour on paper
Inscribed in Persian with the name of the artist, Zayn al-Din, 'native of Patna'
Calcutta, dated 1778
53.3 × 75.3cm
IS 51–1963

This was painted for Sir Elijah Impey and was part of a group of 63 bird, animal and plant studies given to the Linnaean Society, London.

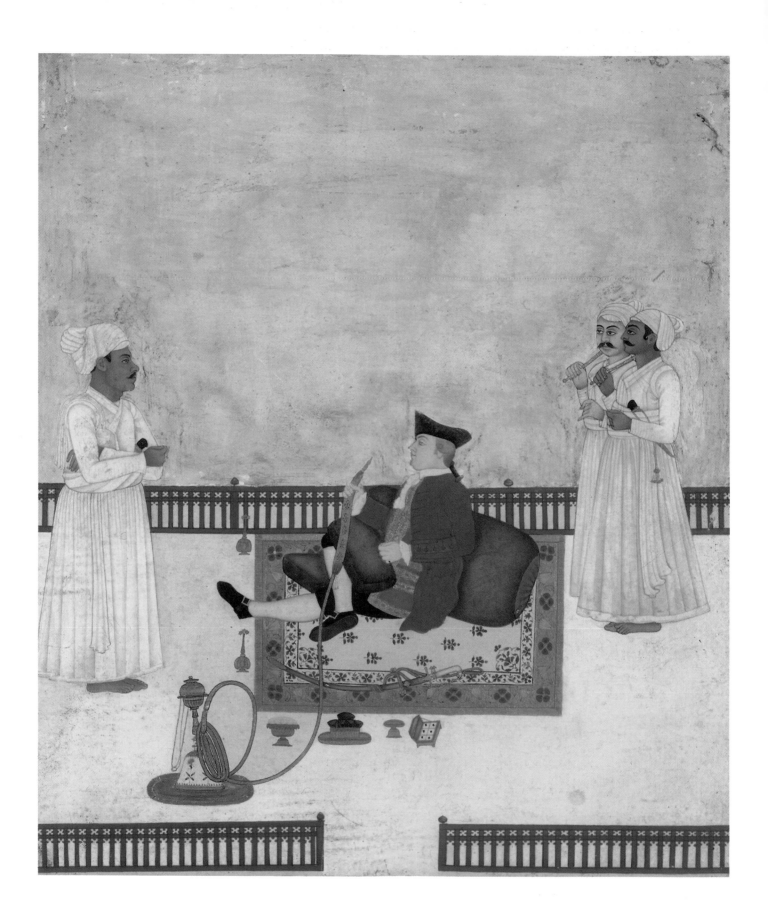

specialised interest. This Lady Clive also joined the ranks of collectors who, like Johnson, became patrons in the strict sense, since they not only acquired existing work, but also commissioned new, in Johnson's case copies of material unavailable for purchase.

The paintings Dip Chand and his school made for William Fullarton in the 1760s differed from standard Murshidabad court work of the period only in the choice of subject matter. The real transformation began in the next few years as court patronage declined and the painters adapted their skills to suit the tastes of European patrons, experimenting with styles and techniques learned from the drawings and watercolours which were a favourite recreation of middle-and-upper class Britons at the time. Intriguingly, the first isolated hint of such a tendency appears in a Johnson collection painting executed perhaps as early as 1750, a tiny moonlit landscape of great charm.[30]

From about 1770 there developed the 'Company' schools of painting, so called because East India Company employees were the principal patrons. In eastern India, the main centres were Murshidabad and Patna, some of whose painters also worked for the British in Calcutta. Outstanding among patrons there were Sir Elijah Impey (mentioned above as a collector of Murshidabad painting) and his wife. Three Patna artists were employed by them in the period 1776–82, producing a series of superb natural history drawings, faithfully depicted and coloured. The subjects were birds and animals resident at Lady Impey's Calcutta menagerie. The shawl goat [169] is one of these studies, and, like many in the series, signed by the artist.

The Marquess Wellesley must rank as the pre-eminent Calcutta patron during his period as Governor-General, 1798–1805. He too established a menagerie and an aviary in the extensive grounds of his country residence at Barrackpore. Here the creatures were described by the resident naturalist and their likenesses recorded by the painters. An equally important and prolific branch of natural history painting was plant illustration, which included the documentation of material in the Botanical Gardens established by the Company at Sibpur, near Calcutta, in 1787. The output from these two institutions was impressive, Wellesley's specimens being painted in duplicate, with one set for his personal retention. Public collections in Britain today include a total of more than 5000 illustrations from Barrackpore and Sibpur. The artists retained to complete the botanical project also undertook freelance work for individuals. Similar drawings were made by South Indian painters for Henrietta, Lady Clive, when her husband was governor of Madras from 1798 to 1804. The artists were perhaps associated with the Company's Botanical Gardens at Samalkot in Madras.

There were many other types of Company painting. Artists working at Calcutta and elsewhere portrayed the residences of the

**172. A European seated on a terrace with attendants**
By Dip Chand
Gouache on paper
Murshidabad, Bengal, c.1760–3
26.5 × 22.8cm
IM 33–1912

Probably a portrait of Dr William Fullarton, a Scottish surgeon of the East India Company, and a patron of Murshidabad painters.

### 173. A groom with a horse and carriage

By Shaykh Muhammad Amir of Karraya
Gouache on paper
Calcutta, *c.*1840–50
29 × 45cm
IS 5–1957

### 174. Government House, Calcutta

Aquatint, with water-colour details
Calcutta, *c.*1820
28 × 41.8cm
IM 23–1918

This view shows the house as re-built 1799–1803 for Marquess Wellesley by Charles Wyatt of the Bengal Engineers, under the influence of designs by James Paine and Robert Adam for Kedleston Hall, Derbyshire, England. From a watercolour by James Baillie Fraser, published in his *Views of Calcutta and its Environs*, London, 1824–6.

British, their servants, carriages [173], horses and dogs, and occasionally, as with Lady Impey, the patrons and their children.[31] The most popular Company paintings illustrated subjects of general interest to the stranger in India. Architecture (palaces, temples, mosques, tombs and other monuments), religious festivals, processions, nautch dancers, *sati* (Hindu widow–burning) and *darbar* (court) scenes, rulers historic and contemporary, costumes, castes and occupations were among the many romantic and picturesque subjects which appealed to the British in India. Before long the guaranteed demand for such work in places of British resort ensured a continuous supply of paintings prepared in advance, often in sets, just as picture postcards would be available to later generations. Some scenes were painted on sheets of mica, a glittering, transparent and flexible mineral, originally used for festive lamps and the illuminated windows of the *taziyas*, elaborate model tombs carried by Muslims in the Muharram festival processions, before immersion in the river. Murshidabad was a centre where the Muharram was celebrated with great splendour; the Company painters who worked on mica there and at Patna were perhaps descendants of earlier *taziya* decorators.[32] In Company work of the early nineteenth century mica was sometimes used for sets of approximately postcard size, in which a number of painted costume transparencies could be superimposed on a card painted with a human head, hands and feet. This type of toy had already been popular in Britain for many years, and cross-influence seems likely.

Delhi became the most prolific centre of Company painting following its occupation by the British in 1803. Favourite subjects there were the impressive monuments, including the Red Fort, Humayun's Tomb, the Jamma Masjid (central mosque), the Qut'b Minar and the Taj Mahal of Agra. Sets of portraits purporting to show the Mughal emperors and their ladies, and other Indian rulers such as Ranjit Singh (see 'Sikhs', p.192) were equally popular. *Darbar* and royal procession scenes were other favourites at Delhi. An interesting development there was the scaling-down of material, as painters took to working on ivory tablets, often oval or circular, some miniscule in size. The inspiration was presumably European miniature portraits. Delhi ivory miniatures enjoyed a considerable vogue in the second quarter of the nineteenth century and were adapted to various uses, which included being mounted on box lids, worn as buttons and set in jewellery.

This type of painting, though accomplished and attractive, was of necessity stereotyped, the portraits following a prescribed convention, with likenesses reduced to a formula. Delhi painters who rose above this norm included a small family group which excelled in portraiture of almost uncanny realism and vitality, also producing village scenes of striking immediacy. These artists, of the Ghulam Ali Khan family, were employed by William Fraser, a Company servant who was at that time Political Agent for the Nepal War (1814–

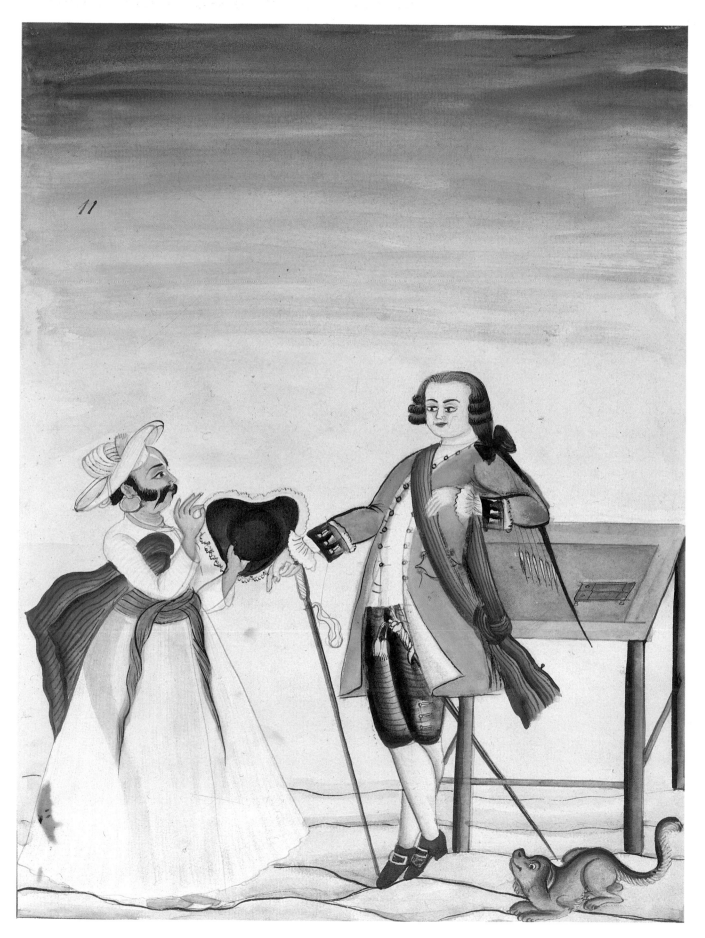

15) and appointed to oversee the affairs of Garwhal, a Punjab Hills state recently captured from the Gurkhas. The painters accompanied Fraser and his brother James – himself a talented amateur artist [174] – on a tour during 1815–16 of the newly settled territory, and some of the finest portraits show Gurkhas and other hill men William was recruiting.[33] The artists also worked over a period of years for William in Delhi. Ghulam Ali Khan was perhaps not personally responsible for the most outstanding portraits in the series, but probably produced the village scenes such as that in **171**. Like several others in the Fraser Album, which is now dispersed, it shows Rania, in the north-west of the Delhi territory, where lived William Fraser's *bibi* or Indian wife, and according to one account six or seven such ladies. The villagers were predominantly Jats, the sturdy peasant cultivators who formed the backbone of Sikhism and in these paintings a number of the women are wearing embroidered shawls, some suggesting the orange-yellow phulkaris traditionally associated with Jat female dress [171]. More specifically Sikh subjects such as *Akalis* on the march [167] were collected by British patrons at Lahore following the annexation of the Punjab in 1849.

In South India Tanjore and Trichinopoly were the main centres of Company painting, beginning during the Mysore Wars (1767–99) when British officers engaged in the campaigns against Haidar Ali and Tipu Sultan purchased souvenirs from local artists. Much of this work shows Maratha influence, depicting processions of Sarabhoji and other Tanjore Maharajas. This tendency is also suggested in the delightful naive presentation of the Boileau Album, showing the interaction of Europeans with the local inhabitants about 1780 [175].

In the field of handicrafts the most significant patronage offered outside the textile trade was the encouragement given to manufacturers of domestic furniture in wood and ivory. As seen in chapter 2, this had its beginnings with the advent of the Portuguese, followed by the Dutch. In the seventeenth century the most important aspect of this patronage was the trade in portable travelling cabinets, exported to Europe via Goa. With British expansion from the mid-eighteenth century there was a need to provide for furnishing residences in European style, since chairs, tables, desks and most of the other impedimenta seen as essential by Europeans had no part in the traditional life of India at any level of society. A type of bedstead known as *charpai* had been in almost universal use there for many centuries, and the thrones of rulers provided a tenuous link with European seat furniture; but that was the extent of common ground.

In the mid-eighteenth century there was a limited demand for European-style chairs and sofas, in large sets, intended to be formally arranged round the walls of vast reception rooms, leaving the floor area clear for dancing and promenading as in Europe. Sets of this kind, which furnished the grand residences of governors, were also acquired by Indian potentates who came under European influence

**175. A French officer handing his manservant his hat;** page from the Boileau Album
Gouache on paper
Madras, 1785
36.8 × 27cm
IS 75 (11)–1954

and kept rooms set apart for the entertainment of European guests, in palaces otherwise maintaining the Indian furnishing tradition of carpets, cushions and bolsters. Most surviving sets are now dispersed. **176** shows an ivory chair from one of these, now scattered among public and private collections. The furniture makers were hereditary carvers of wood and ivory, previously concerned with the embellishment of temples and palaces, with the thrones, bedstead, palanquins and howdahs required by Indian courts. In Bengal the ivory workers of the Murshidabad court were producing quality beds, chairs, sofas and tables for the British in Calcutta by about 1780, just as Murshidabad painters had attracted the same patronage. Warren Hastings and his wife Marian were admirers of Murshidabad furniture and received at least two consignments prepared for them on the instructions of Nawab Mir Jafar's widow, Mani Begam. It included an ivory 'cot', possibly the bed which Hastings later presented to Queen Charlotte. The chairs and sofas in this group had upholstered backs as well as seats and therefore cannot be identified with any of Hastings's surviving ivory furniture. Authenticated Bengal ivory furniture of this period is strongly influenced by neo-classical conventions.

Britons in Madras drew on the products of Vizagapatam, a coastal station in south-eastern India. This furniture was of two basic types – one of wood with ivory inlay [178], the other veneered with sheets of ivory on a wooden core [179]. In both types the ivory was decorated by incising a pattern and filling the depressions with black lac. In work for indigenous patrons, seen for example in South Indian thrones and temple cars, the lac is generally coloured. The monochrome black of work made for Europeans may reflect the influence of the engravings they provided as patterns for the craftsmen to copy [178]. Clive of India and Warren Hastings both owned superb desks and other items of this work.

Another type of furniture widely used in South India in the eighteenth century was carved blackwood, often referred to in contemporary inventories simply as 'Coast' (that is, Coromandel Coast) furniture, to distinguish it from the blackwood already being manufactured in Bombay. 'Coast'-type furniture, earlier made under Portuguese and Dutch patronage, also came from Ceylon (Sri Lanka). Simple European-style chairs are seen being made or repaired in a Company album from the Malabar Coast of western India [180]. As with most Indo-European chairs and sofas, the seats are of canework, which was often later replaced by upholstery.

A more complex aspect of patronage was that offered to businesses of European origin and management. Conspicuous in this category were the grand silversmiths, of which Hamilton & Co. of Calcutta, and Orr & Sons of Madras, are the best known. These were in effect British concerns which incidentally happened to have been established in India to cater for the requirements of an upwardly-mobile British life-style. While the products are virtually undis-

**176. Armchair**
Ivory, carved, painted and gilt
South India, late 18th century
92.4 × 78cm
1075–1882

This chair and that illustrated in **177** are traditionally associated with Tipu Sultan.

**177. Armchair**
Ivory, carved and gilt
South India, late 18th century
87 × 51.5 × 46cm
Lent by the Rt Hon. The Earl Amherst

**178. Cabinet and stand**
Rosewood, inlaid with engraved ivory
Vizagapatam, c.1770
176.5 × 104.1 × 53.3cm
IS 289 & A–1951

The engraved ornament on the two upper drawers shows Old Montagu House, Bloomsbury, London, original home of the British Museum; after S.Wale and J.Greene, c.1760.

**179. Mirror and drawers**
Ivory, with engraved designs
Vizagapatam, late 18th century
99 × 50.9 × 30cm
IS 31–1975

Neo-classical ornament of this type characterizes Vizagapatam work of the 1790s.

### ◄ 180. A chair-caner and his wife

Gouache on paper
Malabar coast, South India, *c*.1830
19 × 23cm
IS 263–1951

### 182. Nob Kishen's nautch party

By Sir Charles D'Oyly
watercolour on paper
Patna, *c*.1825–8
17.4 × 23cm
IS 2–1980

Intended as an illustration to D'Oyly's satirical poem *Tom Raw, the Griffin* (London, 1828), but omitted from the published version. The assorted chairs depicted include one with the back-looped arms later associated with the court of the Sikhs.

tinguishable from their British Regency counterparts [181], Indian craftsmen were involved in the manufacture.[34]

The second half of the eighteenth century was a time of major achievement for British scholarship in Indological studies. A pioneer in this field was Zephaniah Holwell, a 'Black Hole' survivor (see 'Murshidabad'), whose *Interesting Historical Events, Relative to the Province of Bengal, and the Empire of Indostan* (1766–7) included four essays on Hinduism written in a spirit of tolerance and understanding in marked contrast to the censorious comments of earlier Western observers. Holwell, the first Englishman to study Hindu antiquities, was presumably also a patron of Bengal artists, since his book was illustrated with engravings of images taken from Indian drawings. His contribution is of further interest in that, born in 1711, he belonged to the old unregenerate tradition of Company employees who theoretically went to India with no idea beyond that of exploiting its resources. The liberal attitude set forth in his essays sets the scene for his successors, younger by one and two generations. They were Company civilians active in the new Bengal of Company administration, their achievements closely associated with the reform of the revenue and judicial system supervised by Warren Hastings as Governor of Bengal in the 1770s. His enlightened patronage of Hindu learning won the trust of the Brahmins, the co-operation of whose pundits was essential in order to gain knowledge of their laws. The corpus of this learning existed only in Sanskrit, the ancient language of Hindu India. The first European to master it was Sir Charles Wilkins in the late 1770s. Wilkins regarded Warren Hastings as the catalyst in persuading the Brahmins to admit a Briton to the secrets of their law. Meanwhile ten Brahmins from Banaras, the sacred city of Hindu orthodoxy, visited Calcutta to prepare a summary of Sanskrit law. This was translated into Persian (the courtly language of India) by Nathaniel Brassey Halhed, whose *Code of Gentoo [Hindu] Laws* was published in 1776. Encouraged by Hastings, in 1775 Wilkins also published his own translation of the *Bhagavad-Gita*, a Sanskrit devotional work, and in 1788 of the *Hitopadesa*, a book of fables. In Hinduism, religion, law and literature were inseparably connected.

Further to the codification of Hindu law, Sir William Jones, already an orientalist of note before his appointment as a judge of the High Court of Calcutta, began to study Sanskrit shortly after his arrival there in 1784. His progress was rapid and brilliant, marking him as a foremost scholar in the field of Indian studies. In the same year he founded the Asiatick Society of Bengal, which had as its object the study of 'the history and antiquities, the natural productions, arts, sciences and literature of Asia'.[35] From 1789 the Society published a journal, *Asiatick Researches*, covering a wide range of topics. One contributor was Sir Henry Colebrooke, a leading Sanskritist of the next generation. The achievements of these early orientalists did not occur in a vacuum, but were related to cultural trends in the Europe

**181. Sugar basin and cover**
Silver
Made by David Hare
Calcutta, 1800–1815
17.2 × 12.5cm
IS 24–1986
Purchased by the Associates and Friends of the Victoria and Albert Museum

An elegant Regency-style design made by one of Calcutta's resident British silversmiths.

of their day, when the 'Enlightenment' – a spirit of rationalism and enquiry into phenomena of every kind – was softened by the growing cult of romanticism and sensibility.

In 1768 there had been published the first English work on Indian history. This was Colonel Alexander Dow's translation from Persian of the seventeenth century Ferishta's *History of Hindostan*. Dow, who had studied Sanskrit under a Banaras *pandit* (learned man) but failed to make progress, included in his work a dissertation concerning the *Customs, Manners, Language, Religion and Philosophy of the Hindoos*, and a catalogue of Hindu gods. Indian geography, modern and historical, was the province of Major James Rennell, who became Surveyor-General of Bengal in 1764 and in 1779 published his *Bengal Atlas*, followed in 1783 by his *Memoir of a Map of Hindoostan*, with the first authentic maps of India, constructed from his own field surveys. Early in the nineteenth century Dr. Francis Buchanan Hamilton carried out statistical surveys: Mysore and Malabar in 1800, Bengal in 1807–15, the latter later published by R. Montgomery Martin as *Eastern India* (1838). Meanwhile, military engineers in the Company's armies were surveying the ancient monuments of India, recording their inscriptions and ornament with the assistance of local artists. An eminent name in this field is that of Colonel Colin MacKenzie of the Madras Engineers, who was Surveyor of Mysore from 1799 to 1806, Surveyor-General of Madras in 1807, Commanding Engineer in Java 1811–15, and Surveyor-General of India in 1819.

Thus by the early nineteenth century the British administration in India had accumulated a vast archive of information on subjects of Indian interest. New civilians coming out had the benefit of their predecessors' work, and many were also among the first generation to receive the specialised education the Company now offered its juniors. The Marquess Wellesley, grandest of the Lords Sahibs, while Governor-General (1798–1805), had founded Fort William College in Calcutta where the 'Griffins'[36] [182] would undergo a three-year training in Indian history, law and languages, together with a broad general curriculum. The Directors in London refused to sanction this, but instead set up their own East India College in 1806. Temporarily housed in Hertford Castle, it moved to specially designed buildings at Haileybury in 1809. In 1812 came the foundation of Addiscombe College for the training of the Company's military cadets. But though knowledge of India had increased, there was no corresponding growth of understanding or tolerance of her people, rather a mutual growing apart of the Indian and British communities. While a number of factors contributed to this, an important single element was the fact that Company servants were encouraged to marry British wives and raise families at a time when militant Evangelical Christianity was exerting a powerful influence on the lives of middle-class Britons. Their consequent withdrawal into a family and social life which corresponded as far as possible with the conventions of the home

**206**

country contributed to a growing isolation and estrangement from the indigenous population, whose customs were regarded with increasing revulsion. Individualists who refused to conform could anticipate ostracism by the memsahibs.

In 1833 the East India Company agreed to abandon the vestiges of its trade in return for being permitted to 'continue the government of India'. For many years the administrative aspect of its functions had been paramount, and when its rule was superseded by that of the imperial parliament following the events of 1857, the machinery of empire had long been in place.

1. Birdwood, 1891, p.231, fn.

2. The rank and file of the Company's armies was largely composed of 'Sepoys' (*Sipahis*), recruited from the indigenous population of India, which also supplied many of the N.C.O.s and junior officers.

3. Skelton, 1956.

4. Ibid, pp.13–14.

5. Discussed in Stronge, 1985, p.51.

6. Rowell, in Archer, Rowell and Skelton, 1987, p.22.

7. Skelton, 1956, fig.11.

8. Ibid, fig.12.

9. Sharar, 1975, p.44.

10. Ibid, Chapters 32–37; Crill, 1985, figs.31–33.

11. The natural history drawing of a spoonbill (V&A., IS 7–1955) was commissioned by General Martin.

12. An expression which alludes to the political upheavals and presumed consequent economic decline which affected India during the eighteenth century.

13. Murphy in Archer, Rowell and Skelton, 1987, cat.131.

14. Archer, 1959, p.20.

15. Ibid, p.21.

16. Forrest, 1970, appendix V, 'Relics of Tipu Sultan'.

17. A number of cups and saucers from this set are now in the Clive Collection at Powis Castle (Archer, Rowell and Skelton, 1987, cat. 244.

18. Those in the Victoria and Albert Museum include a telescope (IS 153–1964) and a pocket watch (IS 70–1963).

19. Archer, 1959, p.22.

20. Archer, 1966, p.2.

21. Ibid, p.72

22. Ibid, p.9.

23. J.M. Honigberger, *Thirty-five years in the East*, 2 vols., London, 1852.

24. Ranjit Singh had died in 1839, but Schofft copied existing portraits in order to include him in the compositions; see Aijazuddin, 1979, chapter 1 and pls.1–5.

25. Archer, 1966, pl.43.

26. Steel, 1888.

27. Better known as the author of the erotic novel *Fanny Hill*, 1748–9.

28. Falk and Archer, 1981, pp.14–29 and cat. entries.

29. Skelton, 1956, p.19.

30. Ibid, fig.13.

31. Welch, 1978, fig.3, *Lady Impey supervising her household*. The companion painting shows the Impey children and their ayahs in the nursery.

32. Skelton, 1956, p.10, quotes a contemporary account to show that 'artists were employed to paint sheets of mica for the festival lamps' at Murshidabad in the reign of Murshid Quli Khan.

33. Archer and Falk, 1989, pl.66.

34. Wilkinson, 1973 and 1987.

35. Quoted from Jones's inaugural address to the society, in Archer and Lightbown, 1982, p.25.

36. Word of obscure origin used in late eighteenth – early nineteenth century Anglo-Indian parlance to describe a raw recruit.

# 8.
# The Raj: India 1850-1900

Although the profitability of British territorial expansion in India was still in question at the end of the eighteenth century, by 1850 any doubts Britain might have had about the advantages of its Indian empire had been resolved. Lancashire's mills were transforming India into a large market for its manufactures, capital was flowing into the Subcontinent and routes to her shores had improved. The trade in Indian luxury textiles had declined but there were new trade commodities such as opium, and India continued to be the base from which British traders successfully exploited markets further east. Mysore, Sind, the Punjab and the Maratha country had all been subdued and most of the Rajput princes had come to terms (see map on p.175). India was the key to a specific sort of colonial system, playing a subtle role as the chief support of an extensive eastern trading system. A major function of the British state in India was to protect and promote this infrastructural role. This meant collecting and guaranteeing the sources of enough revenue to run the administration, to do the minimum necessary to oil the wheels of overseas trade and to maintain an army that had the military muscle to protect Britain's wider economic interests.

To raise funds the British had to fall back on land revenue, the standby of previous rulers of India; to be successful, revenue settlements had to be modelled along lines laid down by custom and approved by influential sectors in local society. Moreover, to be a useful and productive part of the British empire, India had to be secure and at peace. This was brought home dramatically in 1857, when native regiments of the English East India Company's Bengal army mutinied, the last of the Mughals, eighty-two year old Bahadur Shah II, became titular head of the rebellion, and there was widespread though unco-ordinated civil disturbance in large parts of North India. The 'Mutiny', which shocked the British out of their complacency and coloured British reactions to India in the mid-nineteenth century, dramatically demonstrated army grievances and the need for the army to adapt to its new role as an army of occupation rather than one of conquest. It also underlined the fragility of the connections between the British and their local collaborators.

In 1858, in the wake of the Mutiny, the East India Company's governing powers were abolished and India came under the direct

**183. Sari** (detail)
Woven silk
Bahadarpur, near Baluchar,
Murshidabad District, West Bengal,
mid-19th century
479 x 110cm
6107 IS

Repeat design from the end section of a sari, depicting a European seated on a chair mounted on an elephant. The European reads a letter while the mahout holds a flag standard and a goad.

rule of the Crown. Imperial interests remained central, but as time went on even London came to appreciate that the secret of successful government in India was to keep taxation low, cultivate policies of salutary neglect, stick scrupulously to strict neutrality in regional matters, keep administration cheap and the British element in it small. As the decades passed and more finance was needed, new ways of winning collaboration were sought. More Indians were brought into the bureaucracy and local government, causing gradual changes in the location of political arenas that were to have long term effects on Indian politics.[1] And, of course, imperial strategy also entailed a policy of non-interference in a good third of India – the princely states. Neither benevolent paternalists nor blatant oppressors, the British ruled India only in a formal sense, creating the illusion of power by means of drama and pageant, colouring their optimistic pronouncements with a wash of fiction.

### British Society in India

The British never settled in India. The British community was small (at the height of empire a mere half per cent of India's population) and predominantly male. The great majority were employed by the government, half of them in the army. The rest were civil servants, railway personnel and merchant shippers, managers of plantations, estates, forests and mines, traders, policemen, lawyers, doctors, teachers and even priests and bishops. Most private merchants and traders were dependent on government for business. Not surprisingly the British population was concentrated around the centres of government – military encampments, administrative headquarters, railheads, plantation areas – and was most in evidence in the Presidency towns of Calcutta and Bombay. But the British presence, except around these immediate headquarters of the Raj, hovered above its Indian subjects rather than moving among them.

The British in late nineteenth-century India were not major patrons of indigenous arts. Civilians increasingly remained apart from local society in cantonments and white towns. After the Mutiny, British army officers and men alike were distanced from the Indian troops, and differences in army dress reinforced these distinctions. Civilians lived as British a style of life as possible, looking constantly to London for ratification of their tastes. But the desire to follow up-to-date European fashion was often thwarted by the length of time it took to get goods from London, and the British were forced to patronise the small number of European businesses in the larger towns. They also had to turn to Indian craftsmen for some of their needs. In Bombay in 1864 there were over 10,000 'Hindu or other caste' goldsmiths, but a mere twenty Europeans followed the trade. Larger businesses run by Europeans (such as Hamilton & Co., of Calcutta, which made good-quality silverware for the princes of India, British royalty and government officials and their families [see

**184. Necklace**
Engraved gold set with rubies, diamonds and pastes
Madras, *c.*1850
3.8 x 4.4cm
03314 IS

The form of the necklace, and the claw setting of the stones of the pendant show obvious European influence, but the motifs are larger and the gauge of the metal thicker. Acquired by the Indian Museum in 1855 from an exhibition.

**210**

### 185. Handkerchief

White muslin with white cotton and
pink silk embroidery
Calcutta, mid-19th century
Approx. 42 x 42cm
0542 IS

Border pattern includes figures in a
type of Muslim dress and early steam
locomotives (the East India Railway
opened between Calcutta (Howrah)
and Pandua in 1854). This superb
example of *chikan* embroidery was
shown at the Paris exhibition of 1867.

### 186. Necklace

Enamelled gold plaque and pendants,
some set with pearls and green glass
beads, the strands of the pearls
terminate in emerald and ruby beads.
North India, 19th century
L. 29cm
03183 IS

191]; and P. Orr and Sons in Madras) traded in Western-style jewellery but employed local craftsmen. Such jewellery, made by Indian craftsmen to European designs [184], exhibits small peculiarities that distinguish it from items of Western provenance. Inevitably work for Europeans influenced the work for indigenous patrons. Claw settings became commonplace, techniques such as *cannetille* (curled gold wire filigree) were used, and Western forms composed of entirely Indian motifs were produced in many centres for tourists or for export to the major international exhibitions.[2]

The same was true in other spheres. Although the equipment travellers were advised to take to India included full sets of clothing, some women were not wholly indifferent to the quality of Indian textiles. Muslin embroiderers in Calcutta began to cater for the tastes of memsahibs, who purchased muslin handkerchiefs with *chikan* (white cotton thread) embroidered decoration [185], and the British purchased Delhi and Agra silk and velvet embroideries for use as curtains, screen-cloths and table-centres.[3]

Craftsmen responded to the demands of Europeans and manufactured items specifically for their use ranging from furniture to items such as cuff-links, card-cases, matchboxes, scarf-rings and brooches. In some crafts this market became a significant part of the local production. By the 1880s Europeans purchased possibly a third of the enamelware produced in Jaipur. 'Traditional' Delhi jewellery came into fashion [186] and the British continued to be fascinated by the skills of the Delhi miniature painters, commissioning painted copies of photographic portraits on ivory throughout the period.[4]

In the sphere of public architecture the British continued to impose their own forms, albeit adapted to the local climate. Officialdom, in the form of the government's Public Works Department, believed that European styles would inspire awe and reaffirm imperial authority [see 172]. A new generation of architects and engineers however, trained in Britain in the 1850s and 1860s when Indian craft traditions were beginning to win the respect of influential critics, began to use a mixed style which drew on Indian sources. Recognising the importance of working with local artisans, and responding to Indian design traditions and work practices, they designed important public and private buildings both in British India and the princely states.[5]

### The Princely States
The importance attached to public symbolic statements about authority in India was equally evident in Britain's dealings with the Indian princes. Stripped of their military power, and unable to expand or contract their territories, they were reduced to nominal rulers under British suzerainty. The maharajas and nawabs were of diverse origin, in part a paradigm of the curious results of British expansion. Adventurers who had recently acquired power or the heirs of ancient

**187. Turban ornament (*jigha*)**
Enamelled gold
Jaipur, first half of 19th century
12 x 13cm
IM 241–1923

This turban ornament from the royal treasury, depicting a peacock in full display, shows why Jaipur was considered to be the supreme centre for enamelling in India.

dynasties, most had in 1857 made the choice to retain their titles and privileges by collaborating with the British rather than risk further losses by an act of rebellion.

As the century wore on and communications improved, the British found many occasions for the display of the romanticised pageantry that had become an important part of the imperial self-image, and the princes played a key part in this drama. Whether at court in London, at Osborne House or at durbars in India, the princes had to appear in traditional Indian royal dress and frequently outdid the most extravagant expectations [189]. Yet their states were also expected to be exemplars of the changes that the British hoped to introduce into India. Torn between these conflicting demands the princes sustained their roles as traditional Hindu or Muslim rulers, maintained the trappings of feudal court life and made religious endowments, but also adopted the external habits of a Westernised lifestyle. They modernised their states and set up the institutions of the new India – schools, colleges, hospitals, courts, charitable and learned societies. Although they continued to patronise traditional artisans and artists, their tastes became eclectic and their styles ex-travagant.

Where traditional patronage of the arts was well established, as, for example, at the great Rajput courts, it continued. In Jaipur the court remained the largest and most important purchaser of enamels in traditional forms – handles for swords, daggers, fans, yak-tail or peacock-feather whisks; horse, camel and elephant trappings; and, of course, jewellery. A turban ornament from the Jaipur treasury is an exquisite product of that patronage [187]. A highly decorated elephant goad of gold set with diamonds, with a painted enamel grip [188], which would have been part of the traditional *khil'at* (dress of honour) given by the Maharaja to a higher noble,[6] indicates the extravagant style that was becoming popular. Ceremonial weapons continued to be produced despite a decline in warfare, and elaborate gold-embroidered (*zardozi*) furnishings, saddle-cloths and elephant-covers [194] continued a style established earlier [163]. The patronage of painters, by contrast, began to undergo significant changes. Although court painting continued, traditional artists faced increasing competition from the new art of photography [189 and 190],[7] and by the 1880s several rulers had appointed court photographers. It is this medium which provides the best record of the changing lifestyles of the Indian princes and the growing influence of Europe.

European travellers such as Louis Rousselet were fascinated by this mixture of feudal pageantry and Western influence. The palace of the Maratha ruler, the Gaekwar Khande Rao (r.1856–70) at Baroda, was:

> striking only from its immense size. As for the apartments, they are adorned with great luxury and little taste. The furniture and other articles of European manufacture contrast

**188. Elephant goad (*ankus*)**
Gold set with diamonds on blue, green or red enamel with polychrome painted enamel on the grip
Jaipur, *c.*1870
L. 54.5cm
02693 IS

This elaborately ornamented goad, with scenes of the hunt on the grip, was made for ceremonial purposes. It was acquired by the India Museum after being shown in the 1871 Exhibition.

**189. H.H. Shahu Chhatrapat: Maharaj of Kohlapur**

Photograph, 1894
Courtesy the India Office Library and Records, London

**191. The Maqbara (mausoleum) of Vizir Sahib Baha-ud-Din Bhar at Junagadh**

Photograph, 1900
Courtesy the India Office Library and Records, London

The rulers of Junagadh built a series of unusual mausolea during the nine-teenth century. Spiral stairs encircle the minarets of this spectacular tomb.

with Hindoo hangings and sculptured columns. . . . [The collection of crown jewels] was the most beautiful thing that could be imagined in the way of precious stones – streams of diamonds, diadems, necklaces, rings, bracelets, costumes and mantles embroidered with pearls and precious stones of marvellous richness. . . . The Guicowar came in and found me admiring a magnificent Hindoo costume. The coat, the pantaloons, and the scarf were of black silk, covered with delicate embroidery in pearls, rubies, and emeralds; the shoes, the epaulettes, and the turban glittered with diamonds . . .[8]

The Maratha princes began building in earnest in the late nineteenth century. Baroda's new palace, designed by English engineer Major Charles Mant and completed by Robert Fellowes Chisholm, was reputedly the most expensive building constructed by a private individual in the period. A romantic confection of Rajput and Mughal forms, Jain domes, Gothic and classical features, it was decorated internally with Venetian mosaic, Italian marble and English stained glass. In Gwalior the Durbar Hall in the new, Italian-style palace was a spectacular chamber. Its magnificent arched roof carried two of the world's largest chandeliers, a carpet of a size unmatched in Asia covered its floor and its furniture and ornaments were of solid crystal.[9] The trend towards opulence and eclecticism was widespread [191]. The palaces of many of the smaller princely states, however, retained a traditional decor:

> Up country you may pass through a whole palace, and the only furniture in it will be rugs and pillows, and of course the cooking pots and pans, and gold and silver vessels for eating and drinking, and the wardrobes and caskets, and graven images of gods. But you are simply entranced by the perfect proportions of the rooms, the polish of the ivory white walls, the gay frescoes around the dado and the beautiful shapes of the niches in the walls, and of the windows, and by the richness and vigour of the carved work on the doors and projecting beams and pillars of the verandah.[10]

In 1876 the princes took part in one of the great ceremonies of empire – the visit of the Prince of Wales to India. In demonstration of their loyalty they made substantial presentations to the heir to the throne, gifts which ranged from highly symbolic heirlooms and superb examples of traditional craftsmanship, to modern pieces in eclectic style. The Prince's collection of gifts toured Britain and was shown in Paris, where it became the focus of discussion about European influence on Indian art:

> No collection from India has ever shown this great and growing evil so flagrantly as that of the Prince's presents. It was desired to do the Prince the utmost honour, and the native chiefs and princes, in many instances despising their

**190. Thakur Bakhtawar Singh of Agolai**
By Fateh Muhammad
Gouache on paper
Western Rajasthan, c.1880
34 × 26cm

A nobleman posed as if in a photographer's studio, painted in a style inspired by contemporary portrait photography.

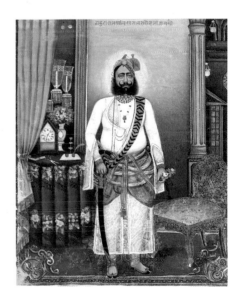

own arts, had literal copies executed, in solid silver, of the latest Birmingham patterns in teapots (which came originally from India) and paper weights, and centre pieces, as the most acceptable gifts they could lay before the Prince. It was fortunate that they did so, for an evil which has been made so conspicuous will be checked.[11]

Not everyone shared Birdwood's views. The British hoped gradually to transform and modernise Indian society. By the middle of the nineteenth century, however, they had begun to lose confidence in their ability to dispel the 'clouds of darkness and superstition' which they believed hung over India. Evangelical Christianity had made no impact on the Subcontinent's great religions, and Indians showed little enthusiasm for social reform. Legal reform seemed to offer some hope and the decision to introduce Western-style education was seen as a triumph. But the new Western-educated class, though it expanded fast, neither had the character nor followed the line of development expected by the British.[12]

### Indian Patronage in British India

The British ruled India from its cities, and it was here that most changes could have been expected. In the cities of North India the British worked with local notables – wealthy bankers, merchants and owners of commercial property. But although the great princely courts had gone and with them much artistic patronage, the lifestyles of the elite that remained changed little. Calcutta, a city created by the British and India's capital until 1912, showed a greater degree of European influence. By 1900 it had a population of over a million, including the largest concentration of the British in India, and controlled the bulk of British capital and half of the Subcontinent's foreign trade. The city was clearly divided into two – a salubrious southern area, with British-style buildings, dominated by a Government House modelled on Kedleston Hall in Derbyshire [172], and a northern 'native' area. The majority of Calcutta's Indian population was Hindu, and half was high caste – Brahmin, Vaidya and Kayasth. For the first half of the century, key families from these communities, the beneficiaries of the land settlements of the beginning of the century, exercised their social influence through the leadership of *dals* (associations).

The palatial residences of Bengal's aristocracy reflected their wealth and status. Here European influence was striking. The most exaggerated examples, such as the Marble Palace of Raja Rajendra Mullick, demonstrated an eclectic taste similar to that found in the Europeanised princely palaces. Baroque in character and furnished in ornate style, the houses were also decorated with European sculpture and paintings. Copies of Renaissance masters hung alongside neo-classical paintings of Royal Academicians and life-size portraits of family members commissioned from European artists working in

**216**

India.[13] These aristocrats, like the princes, would have appreciated the flamboyant bidri *huqqa* [192] – a hybrid of Indian and high Victorian taste with its naturalistic lotus flowers twining around the central stem – made by Hamilton & Co. in the 1860s. But even some of these families had collections of traditional paintings and, in contrast to their increasingly Europeanised taste in the visual arts, their interest in literature, theatre or music remained closely oriented to local and classical Indian traditions, which underwent a renaissance in the period. In the city and on their country estates they continued to sponsor religious ceremonies and festivals.[14]

In Bombay, now a major port and industrial centre, Indians controlled the fast-developing mill industry. The new industrial magnates – Parsees, Hindu and Jain Banias, and Gujarati speaking Muslims – lived in style in smarter parts of the city. The Parsees were the most anglicised community, but most of these magnate families maintained only the outward symbols of a Westernised lifestyle:

> In Bombay the wealthy native gentlemen have their houses furnished in the European style, but only the reception rooms, from which they themselves live quite apart, often in a distinct house, connected with the larger mansion by a covered bridge or arcade. Europeans, as a rule, and all strangers, are seen only in the public rooms; and only intimate friends in the private apartments.[15]

The reception rooms typically had French-polished furniture, made of *shisham* (blackwood) and elaborately carved in a style derivative of earlier furniture produced for the Dutch and Portuguese in India. The inner chambers, by contrast, had only the mats, floor-coverings and bolsters of the local style.

Outside these two great cities Western styles made even less impact. Ahmedabad established cotton mills, but the city and its leading families retained their traditional character. Madras, although the capital of a Presidency, was no rival to Bombay or Calcutta. The bankers, merchants and men of property in South India's towns, which had never been manufacturing centres on the scale of the great cities of the North, remained relatively untouched by Western influence.[16]

In all these cities the growing class of intelligentsia and professionals, with their more modest lifestyles, changed steadily but less visibly. New styles of men's dress with both European and Indian elements evolved for wear in the office but at home dress remained unchanged. However, it was this class, exposed to western education, that provided a significant part of the growing market for new *genres* of popular art that evolved throughout India as a result of the spread of woodcut printing [193], lithography, printing and other reprographic techniques.[17]

India remained a predominantly agrarian society and rural areas were even less susceptible to change than the towns. Investment took

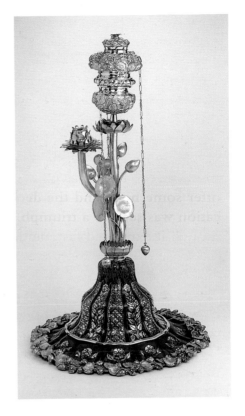

**192. *Huqqa***

Base and stand: silver inlaid bidri work
Stem, *chilam* (pipe-bowl), *sarpush* (cover) and applied decoration to the stand: silver
Ht. 85cm, diam. 50cm max.
Hamilton & Co. (*sarpush* stamped with maker's mark)
Calcutta, 1860s
2510 IS

This flamboyant water pipe was almost certainly made for the 1867 Paris exhibition. Hamilton & Company was founded in Calcutta in 1808 by Robert Hamilton of Edinburgh. In 1817 Hamilton left India but the company grew to include silversmiths, lapidaries, goldsmiths, cabinet makers and, almost certainly, bidri workers. A few Europeans smoked *huqqas* as late as the 1860s although it was becoming less socially acceptable in English circles.

**193. Sikh railway train**
Woodcut print on paper
Lahore or Amritsar, c.1870
31.8 × 47cm
IM 2/51–1917
Given by Rudyard Kipling from the
Lockwood Kipling Collection

Woodcuts became a popular medium
in the Punjab, providing an
accessible alternative to the more
expensive ivory portraits of Sikh
leaders. This print shows Sikh and
British passengers in separate
carriages; the driver and fireman are
British and the station staff are Sikhs.
It symbolises both the separation of
Sikh and British social life and the need
for Sikh and British collaboration
after the annexation of the Punjab.

the traditional forms of money-lending, the purchase of land, gold
and silver jewellery [194] and brass and copper vessels.[18] Styles of
jewellery and dress continued to reflect regional and community
identity and changed little. Status was reaffirmed by conspicuous
consumption at life-cycle ceremonies and religious philanthropy. In
South India this pattern was particularly marked. Cloth remained the
major item of local consumption, after food, and even the rural élite
had little demand for luxury goods as rural wealth was typically
expended on ritual and domestic functionaries and services rather
than consumer goods.

### The Decline of the Crafts?

The rapid expansion of British foreign trade in the second half of
the nineteenth century was built on the export of manufactured
textiles, and India was Britain's largest market.[19] This represented a
major source of competition for local industry. The expansion of the
railways opened up more and more markets for British imports. The
new clerical and professional classes were beginning to adapt to
European styles of dress. In the rural areas consumption of types of
English cloth that could be used in Indian styles of dress increased.
Contemporary British observers also expected an imminent Indian
industrial revolution. There were real fears that this dual attack would
deal a death blow to Indian handicraft industries, particularly textiles.
However, Indian mechanised industry, hampered by lack of invest-
ment, remained a thinly spread phenomenon and was restricted to
isolated enclaves.

Although the Indian mill industry remained overwhelmingly a
spinning industry and was for many decades unable to compete with
the heavily protected Lancashire cloth industry,[20] it had a growing
impact on traditional methods of production. Increasing use of mill
yarn, first from Britain and later from the Indian mills, effectively
killed the practice of hand-spinning. Manchester cloth made inroads

**218**

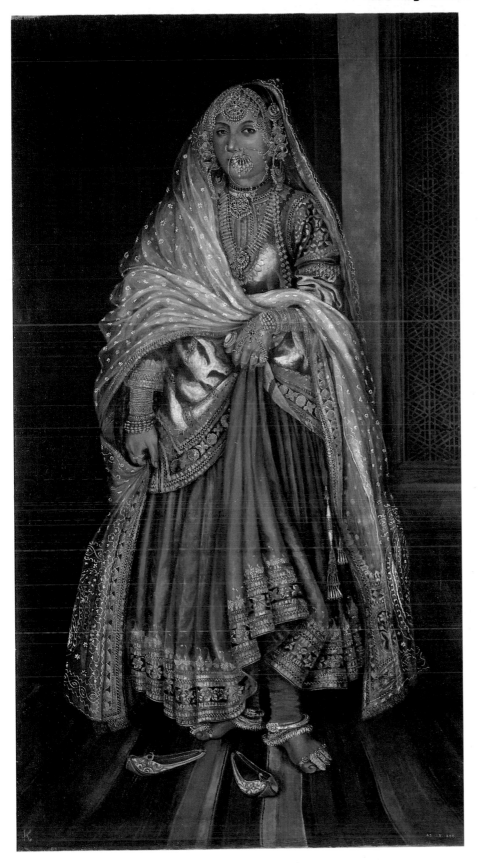

### 194. 'Native lady of Umritsur'

By Van Ruith
Oil on canvas
Amritsar, 1880s
181 × 99.5cm
IS 45–1886
Given by the Municipality of Amritsar

This painting, shown in the Colonial and Indian Exhibition in London in 1886, represents one model of European painting accessible to Indian art students. It also serves as a documentary record of costume and jewellery of the region and was acquired by the Museum for that purpose. The woman wears a full set of head, ear, nose, neck, arm, hand, ankle and foot jewellery, and a costume richly decorated with *zardozi* (gold wire/thread) embroidery.

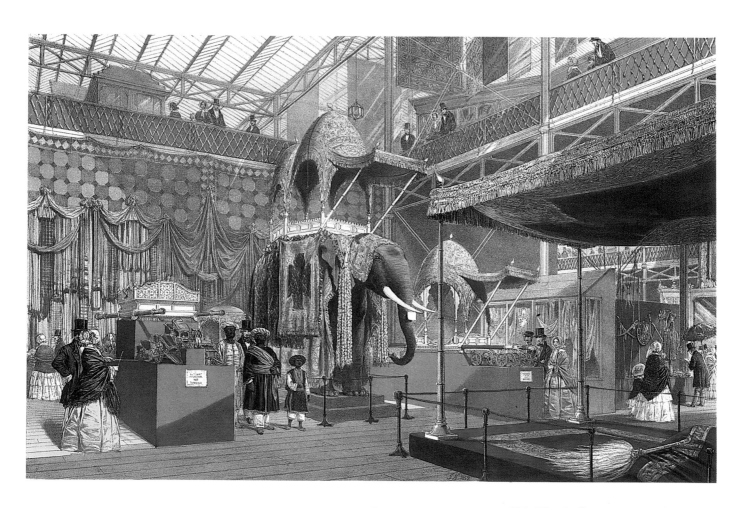

### 195. The Indian court at the Great Exhibition

Coloured lithograph
From Dickinson, *Views of the Exhibition*, 1851
44.4 × 59.8cm
19536 (11)

The *howdah* with its magnificent trappings worked in gold and silver was sent to Queen Victoria by the Nawab of Murshidabad. After much searching a stuffed elephant was discovered in Saffron Walden. The elephant and *howdah* became a major attraction at the Exhibition.

into domestic markets, particularly in Bengal and North India, and caused disruption in some centres of production. By 1910 Indian mill cloth and imported cloth each took a third of the total domestic market, leaving only a third for the hand-loom industry. But although the hand-loom industry declined, it did not die.

Muslin production at Dacca had fallen sharply through the first half of the nineteenth century. A number of fine Dacca muslins, however, were shown in the Great Exhibition of 1851 and even later in the century there was still a small demand for fine muslins from the princely states and neighbouring countries. The British themselves provided a tiny market for items like muslin handkerchiefs with embroideries of appropriately modern subject matter [185]. The silk-looms of Murshidabad, which had supplied the courts of the Mughal and the Nawab and serviced the European export trade, were running down, and many once-famous varieties of silk were no longer made (see chapter 6). With changing tastes, patronage for particular silks, such as the Baluchar brocade saris, declined and knowledge of their production technique was in danger of passing into history.[21] The only commissions were coming from a small number of enlightened British officials [183, illus. p.208]. Decorative content reflected new patronage, but these were objects of curiosity rather than use and were often destined for exhibitions and museum collections. In South India imported mill goods of medium quality took much of the market for cloth in the towns and specific local declines in production were being reported by the 1880s. Manchester goods were said to be on the verge of destroying the famous centre of Masulipatnam, but it was in fact still producing cloths for Burma, the Malay straits and the Persian Gulf. The market for highly coloured *lungi* (men's waistcloths) and 'Madras handkerchiefs', which had long sold well in South-East Asia and the Persian Gulf, was boosted by demand from migrant Tamils in Ceylon, Burma, the Straits and elsewhere. With a growing population and an increasingly prosperous elite, the South Indian industry actually began to grow at the end of the century.[22]

Elsewhere the expanding population and the continuing need for special fabrics for particular communities and ritual functions helped to maintain traditional textile crafts.[23] Locally produced coarse cloths were favoured for their durability, and in outlying districts remained cheaper than European goods because of the expense of transportation. Domestic embroideries of a high standard continued to be made by women and some types, such as the embroidered coverlets (*kantha*) of Bengal were of particularly high quality during the late nineteenth century.[24]

Despite this there were far-reaching changes in the textile industry. There was a shift in the balance between fine and coarse cloth production. Local demand for sumptuary goods declined with the demise or impoverishment of many of the smaller courts and *zamin-*

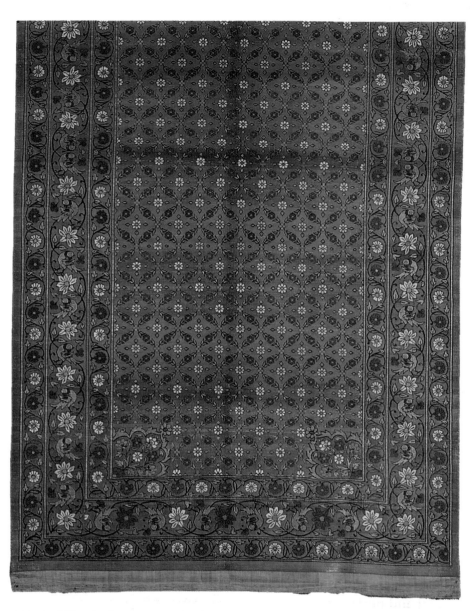

## 197. Filigree Necklace
Gold wire with stamped florets and
applied flat discs and hemispheres
Calicut, c.1850
Approx. 33.5 x 34cm
124–1852

This necklace was purchased by the
South Kensington Museum from
the Great Exhibition as an example
of modern Indian work. It represented
all the qualities that British commen-
tators admired in Indian craftsmanship.
Ironically some of the individual
elements had not been separately
crafted but made by a stamping
process.

## 196. Saddle-cloth
Woven silk and gold ground with extra
weft design in coloured silks
Ahmedabad, Gujarat, first half 19th
century
136 x 94cm
0683 IS

The balance of colour in the trellis
pattern and floral decoration on this
saddle cloth represent exactly the
design qualities that Owen Jones, the
author of *The Grammar of Ornament*
(1856), so admired in the saddle cloth
he saw at the Great Exhibition of
1851.

*dari* families. Local taste in design and colouring had been affected, particularly by the introduction of synthetic dyes. There was growing concern among a small British minority about the perceived decline in Indian craft traditions but, as was the case with many aspects of British Indian life in the period, this was as much a function of concerns at home as of problems in India.

### India and design in Industrial Britain

In Britain by the 1830s there were fears that industrialisation had led to a loss of design vitality and to the decline of traditional craftsmanship, to stylistic confusion and to the misuse of illusionist ornament. A parliamentary committee set up in 1835 found English industrial products inferior to those produced elsewhere in Europe and advised that the education and training of artisans be improved. A school for industrial workers was set up in 1837, exhibitions were mounted and the activities of a concerned group of influential designers and critics culminated in the Great Exhibition of 1851, organised with the object of improving design by bringing together for comparison artefacts from nations all over the world. The first international exhibition of its kind, it was to set the style for exhibitions for many decades. India was an influential participant [195]:

> The Exhibition of the Works of Industry of all Nations in 1851 was barely opened to the public ere attention was directed to the gorgeous contributions of India. Amid the general disorder everywhere apparent in the application of Art to manufactures, the presence of so much unity of design, so much skill and judgement in its application, with so much of elegance and refinement in the execution . . . excited a degree of attention from artists, manufacturers, and the public, which had not been without its fruits . . .[25]

Owen Jones, the apologist for Britain's new design movement, found Indian and Islamic art, with its flat treatment of forms and non-illusionist representations, critically important in his formulation of 'correct' principles of design:

> In the equal distribution of the surface ornament over the grounds, the Indians exhibit an instinct and perfection of drawing perfectly marvellous. The ornament . . . from an embroidered saddle cloth, excited universal admiration in 1851. The exact balance obtained by gold embroidery on the green and red grounds, was so perfect that it was beyond the power of a European hand to copy it with the same complete balance of form and colour [196].[26]

The Great Exhibition and subsequent international and local Indian exhibitions,[27] showed historical artefacts from the collections of princes and magnates as well as contemporary products. Their impact was complex. They were to influence the developing debate about the state of India's craft traditions and, by creating new markets,

**198. Ewer**
Silver, partly gilt with chased and engraved decoration on a ring matted ground
Lucknow, mid–19th century
Ht. 33.3, Diam. 17.8cm
778–1869

This ewer, with its delicate foliage motifs, was purchased by the South Kensington Museum from the Paris International Exhibition of 1867, as an example of modern Indian work.

were themselves to affect Indian design. They increased awareness, among a small British minority in India, of the rich variety of Indian artistic traditions. Sale products filled out museum collections and exhibition catalogues and descriptive accounts recorded both the development and the decline of specific crafts.[28]

Objects that were seen to display qualities of chaste design and exact balance of ornament consistently won accolades from the pro-Indian critics of the period. The filigree necklace from Calicut [197], purchased from the 1851 Great Exhibition as an example of modern jeweller's skills and the silver, partly gilt ewer from Lucknow, shown in Paris in 1867 [198], both display the quality of elegant and controlled ornament which was so admired. Another type of metalware singled out by Owen Jones to illustrate his concept of correct ornament was *bidri*.[29] Excellent examples of this sophisticated work were shown at the Great Exhibition and a demand for *bidri* ware developed in Europe [199]. Thirty years later *bidri* was still among items displayed in international exhibitions and was still on sale in the Oriental Galleries at Liberty & Co. in London. Demand stimulated by the exhibitions saved the industry at Lucknow, and affected Purneah, though that centre catered mainly for the domestic market and slowly declined as local tastes changed. But a vicious cycle was also set in motion. Increased and uncritical demand led to a decline in the very standards and qualities that had created the demand initially – shapes and patterns became repetitive and the quality of inlaying deteriorated.[30] Shawls from Kashmir and the Punjab shown in 1851 and 1855 won exceptional praise, but the very scale of the market in the West stimulated competition from English and French manufacturers and eventually destroyed the trade.[31] An equally important trade, in Indian carpets, developed in the wake of the Great Exhibition, but by 1878 standards here too had dropped. Although the quality of wool was still good, the quality of the dyeing was heavily criticised, the arrangement of colours being considered harsh and inharmonious.

It was the fear of further dramatic deterioration in quality, loss of artistic integrity and the destruction of traditional modes of production that roused George Birdwood, a professor of medical science and founder of the Victoria and Albert Museum in Bombay, to an impassioned outburst in his introduction to the Indian section of the Paris Universal Exhibition of 1878:

> Indian collections are now also, unfortunately becoming at every succeeding exhibition, more and more overcrowded with mongrel articles, the result of the influences on Indian art of English society, missionary schools, schools of art, and international exhibitions, and, above all, of the irresistible energy of the mechanical productiveness of Manchester and Birmingham, and Paris and Vienna.[32]

Birdwood's concerns were genuine, if sometimes overstated.

**199.** *Huqqa* **base**
Silver inlaid bidri
Bidar, *c.*1850
Ht. 18.5cm, diam. 20.1cm
136–1852
**Spittoon**
Silver inlaid bidri
Bidar, first half of 19th century
Ht. 12.4cm, diam. 9.9cm
105–1898
Bequeathed by Mrs Donald Campbell

The *huqqa* base is inlaid with the archetypal Bidar design of the nineteenth century, the poppy motif. It was bought by the South Kensington Museum from the 1851 exhibition for £2 10s as 'Indian, modern'. The spittoon, acquired at the end of the century, illustrates that skills were still being maintained. The diagonal design suggests European influence.

His image of the Indian craftsman, living in a democratic village community, producing his wares with the most elementary of tools in his own home, had romantic elements. But his anxiety about the dangers of market exploitation and official encouragement of industrial development in India was identical to that of contemporary design critics and the leaders of the Arts and Crafts movement in England. India came to represent an ideal artisan society which had long disappeared in Europe. The importance of the argument was not lost on the nationalist leaders in India. A few decades later these same ideas were used effectively in the *swadeshi* (home industry) campaigns of 1905–10 and further elaborated by Mahatma Gandhi in the 1920s and 1930s.[33]

Birdwood had two particular criticisms of government policy. Its introduction of carpet production into the alien environment of Indian jails had, he argued, both cheapened the product and impoverished traditional caste weavers. Furthermore, the School of Art in Bombay, far from supporting Indian craft traditions, had succeeded only in 'getting the natives all over Western India to imitate the hardware jugs of Messrs Doulton' [200].[34]

### Schools of Art in India

Following their introduction in England, schools of art were established in Madras, Bombay and Calcutta in the 1850s and in Lahore in 1875. From the start these enclaves of British influence were riven with contradictions. The British debate about the purpose of art schools – whether training grounds for artisans or institutions providing a generalised artistic education – had an added complexity in India. Contemporary British opinion had little or no sympathy with India's own fine art traditions, so the schools aimed to inculcate the 'right' – that is Victorian – taste for art in their students. At the same time their practical purpose was to provide a new generation with useful and employable skills in the industrial and ornamental arts – a vocational training for those in the expanding middle classes who were unable to undertake a literary or scientific education.[35] Once graduated they worked as technical draughtsmen, modellers and printers for the government or responded to the demands of the growing commercial market for prints, illustrations and religious pictures.

During the 1870s and 1880s, as the debate on the state of Indian crafts got under way, the purposes of the schools were reviewed but remained contradictory. In Calcutta there were token attempts to support a few surviving traditional art industries but there was also a new emphasis on training in the techniques of Western academic art. In Bombay students made copies in oil on canvas of the frescoes at Ajanta.[36] In Lahore Lockwood Kipling,[37] took charge of the new Mayo School of Art, determined to support indigenous crafts and craftsmen. He played an active role in the Calcutta exhibition of

**200. Four-handled vase**
Red earthenware with slip painted ornament under a lead glaze
Bombay School of Art, c.1880
Ht. 44cm, diam. 17.5cm
IM 41–1917

As well as imitating European models, pottery students at the Bombay School of Art produced designs based on earlier Indian ceramic traditions. The pattern on this vase, however, reflects the School's interest in another aspect of earlier Indian art – the frescoes in the rock-cut caves at Ajanta in the western ghats.

1883, helped set up the influential *Journal of Indian Arts and Industry*, worked with the American designer Lockwood de Forest to promote the export of Indian crafts, and with Indian artisans designed and installed a billiard room for the Duke of Connaught at Bagshot Park in Surrey and the dining room at Osborne House for Queen Victoria. Yet the West, though dazzled by increasingly extravagant Indian pavilions at international exhibitions and happy to relax in oriental coffee rooms, never developed a real taste for the Indian style.[38]

The Schools of Art, however, affected future artistic developments in India in other ways. A number of independently trained gentlemen 'artists' of the period, such as Raja Ravi Varma of Travancore, who worked in the Western academic tradition of oil painting [201], won great fame. Relatively few students of the Schools achieved the same success, but these establishments did play a role in making art a respectable middle class career. By the end of the century the Calcutta School had also become associated with the developing nationalist movement. E.B.Havell, the director of the School from 1896 to 1906 and an ardent critic of British policy on the arts, encouraged the study of India's own fine arts traditions and supported the painter Abanindranath Tagore's development of a new 'Indian style' of painting. Although academic painting was to continue into the twentieth century, this 'neo-Bengal' school of painting stimulated a reaction and set in train a cycle of stylistic innovation and experimentation with both indigenous and cosmopolitan modes of representation that continues today.[39]

**201. Portrait of a woman holding a fan**
By Raja Ravi Varma
Oil on canvas
*c.*1895
53.5 x 35.9cm
IS 59–1978

### Continuity and Persisting Skills

The British consistently exaggerated the importance of their impact on India. They, even more than earlier imperial powers, were birds of passage. Their rule left its relics and caused changes that influenced the patronage of the arts, but it did little to damage the heritage of skill or the roots of local and regional tradition – the continuing source of the Subcontinent's rich and vibrant creativity.[40] The debate about the arts of India that roused the passions of a few Britons and Indians in the late nineteenth century continues. India's craft traditions have been washed by the flood tide of industrial development but have not been drowned. The practical tasks of conserving and documenting, supporting and developing them are in dynamic hands. Urban popular arts flourish, and the fine arts, dependent as they always have been on wealthy patronage and responsive as ever to fresh influences and stimuli, have found new patrons and new markets.

1. Seal, 1973.

2. Stronge, Harle and Smith, 1987, pp.43–4

3. Watt, 1903, p.380.

4. M.Archer, 1972, p.170. Some British women did collect and wear traditional jewellery; see Stronge, Harle and Smith, 1987, p.44, and Rivett-Carnac, 1883, pp.6–7.

5. Davies, 1985; Head, 1986, pp.73–93.

6. Jacob and Hendley, 1886, p.11.

7. Photography arrived in India in the 1840s and was established as a professional and amateur activity among both Indians and Europeans by the 1890s; see Desmond, 1982, and Worswick, 1976 & 1980.

8. Rousselet, 1876, p.98.

9. Baroda, 1980, pp.108–13 and 156–7; Davies, 1989, pp.224 and 398.

10. Birdwood, 1880, p.199–200.

11. Birdwood, 1878, p.49.

12. Seal, 1971, pp.343–4.

13. Guha-Thakurta, forthcoming, chapter 2.

14. Gupta, 1958, chapters 20 and 21; Mukherjee, 1970, p.71.

15. Birdwood, 1878, p.69.

16. Baker, 1984, pp.334–5.

17. W.G.Archer, 1966, p.68; P.Ray, 1983, p.100.

18. 'Copper, being the chief metal used for domestic utensils and easily saleable when necessity arises, is in large demand in times of plenty and is instantly thrown on the market in bad years, so that the rise and fall of this traffic constitutes one of the safest indications by which to judge the economic condition of the people of India.' *Imperial Gazetteer of India*, 1907, vol.III, p.237.

19. In 1870 84 per cent of all imports into India came from Britain; in 1914 although this had dropped to 62 per cent, India imported little from other industrialised countries (Charlesworth, 1982, p.50).

20. Between 1880 and 1914 India took 40 per cent of Lancashire's cloth exports largely in the form of grey cloth. Between 50 and 60 per cent of all British exports to India were textiles.

21. Although Baluchar saris are no longer woven in Murshidabad District, similar fabrics are still being woven today at Bishnupur in West Bengal. See Mohanty, 1984, vol I, pp.244–8 and pp.317–19.

22. Baker, 1984, p.394.

23. Watt, 1908, p.618; Forbes Watson, 1866, vol.I, p.5.

24. Skelton and Francis, 1979, pp.66 and 69.

25. Jones, 1856, p.77.

26. *Ibid*, pp.78–9.

27. Major international exhibitions in the period 1850–1900 were held in Dublin (1853), Paris (1855), London (1866), Paris (1867), Vienna (1873), Philadephia (1876), Paris (1878), Melbourne (1880), Calcutta (1883), London (1886), Glasgow (1888) and Paris (1889 and 1900). In India important exhibitions were held in Madras (1859), Agra (1867), Simla (1881), Jaipur (1883), Calcutta (1883–4) and Delhi (1903).

28. See particularly: Birdwood, 1878 and 1881; Mukharji, 1888; Hendley, 1883; the official report of the Calcutta International Exhibition; and Watt, 1903. From 1886 onwards these exhibitions were reported in the *Journal of Indian Art and Industry*.

29. Jones, 1856, Plate LXIX.

30. Stronge, 1985, pp.24–30.

31. The industry was badly affected by the loss of the French market at the time of the Franco-Prussian War (1870–1), and subsequent changes in fashion in Europe. For fuller accounts of the Kashmir shawl industry see Irwin, 1955; Ames, 1986; and Murphy, 1988.

32. Birdwood, 1878, pp.49–50.

33. Bayly, 1986, pp.309–15.

34. Birdwood, 1878, pp.101–4. Birdwood subsequently softened his criticism of the Art Schools when the essay received warm public support from the British art establishment. See the *Journal of Indian Art and Industry*, vol.VIII, Jan. 1899, no.65.

35. Guha-Thakurta, forthcoming, chapter 2.

36. After the loss of Major Robert Gill's set of fascimile copies in a fire in 1866, this new set was prepared by students under the direction of the Bombay School of Art's principal, John Griffiths, between 1872 and 1885.

37. The father of Rudyard Kipling, who studied art in South Kensington, and taught at the Bombay School of Art from 1865 to 1875.

38. Head, 1986, pp.111–18. Significantly Indian architecture made no real impact in Europe, and Indian crafts remained a minority interest among a small circle of aesthetes. See, for example, Stronge, Harle and Smith, 1987, pp.45–7.

39. Appasamy, 1968, p.109; Guha-Thakurta, forthcoming, chapter 4.

40. The folk roots of India's artistic traditions have received growing attention over the past few decades. See particularly: Fischer, Mahapatra and Pathy, 1980; Huyler, 1985; Jain and Aggarwala, 1989; Jayakar, 1980; Kramrisch, 1968; Michell *et al*, 1982; Mode and Chandra, 1984; and *Aditi: the living art of India*, 1982.

# Glossary

A = Arabic; B = Bengali; F = French; G = Gujarati;
H = Hindi; I = Italian; M = Malay; P = Persian;
Port. = Portuguese; S = Sanskrit; Sp. = Spanish

*akali* (S) lit. 'timeless'; a member of a body of Sikh zealots
who often carried several steel quoits round a tall,
conical turban

*ankus* (H) elephant goad

**bandanna** see *bandhani*

*bandhani* (H) tie-dyeing

*bania* (H) shop-keeper or merchant

*barahmasa* (H) lit. 'twelve months'. A series of paintings
depicting the activities of lovers throughout the year

*Bhagavata Purana* (S) the story of the life of Krishna

**bidri** metalworking technique taking its name from Bidar,
in the Deccan, describing objects made from zinc alloy
which is blackened and inlaid with silver or brass, or
both

**Brahmin** (S) the highest, priestly, level of the Hindu caste
system

*cannetille* (F) a style of gold filigree used in jewellery,
consisting of tightly curled wires and trails of gold
granules. Copied in India from the West in the early
19th century, it is still used in contemporary jewellers'
work

*chahar bagh* (P) lit. 'four gardens'; a square or rectangular
garden divided by paths or water-courses into four
sections, each of which may be further divided into four

*chajja* (H) eave

*charan* (H) bard

*charpai* (H from P) lit. 'four feet'; stringed bed or cot

**charpoy** see *charpai*

**chay** madder plant (*Oldenlandia umbellata*) of South India and
Sri Lanka, containing red dye in its roots

*chhatri* (H) a small pavilion or kiosk on the roof of a building

*chikan* (H) embroidery in white cotton thread on muslin

**chintz** probably from H *chitta* 'coloured'; cotton fabric,
usually with floral patterns, made in India for the
European market. The design is achieved by painting,
resist-dyeing and mordant-dyeing

*cuerda seca* (Sp.) lit. 'dry cord'; glazing technique where the
different colours of the pattern are kept from running
into each other by an outline of maganese mixed with
a greasy substance which disappears on firing, leaving only
the dark outline

*darbar* (P) court, or royal audience. In Anglo-Indian usage it

became **durbar**, meaning the audiences held by the Governor General or Viceroy

**Devi** (S) the Goddess

*Divan-i Am* (P) Hall of Public Audience

*Divan-i Khas* (P) Hall of Private Audience

**durbar** see *darbar*

**Durga** (S) a fierce form of the Goddess

*Gita Govinda* (S) lit. 'Song of the Cowherd'; a poetical work recounting stories of Krishna and the *gopis*, especially Radha

*gopi* (S) female cowherd

*guru* (S) spiritual master

**Holi** (H) Spring festival at which coloured powder and water are thrown over the participants

*ikat* (M) textile dyeing technique where warp or weft threads (in double ikat, both) are tied before weaving to resist dye

*jali* (H) pierced stonework screen or window

*jama* (P) close-fitting coat with full skirt worn by men. In India Hindus wore it fastened on the left and Muslims on the right

*jharoka* (H) balcony

*kantha* (B) a quilted coverlet; in Bengal it refers particularly to domestic embroideries of the 19th and 20th centuries

**kincob** brocaded silk with gold or silver thread

*khil'at* (A) a robe or set of garments bestowed by a ruler as a mark of honour

*Kshatriya* (S) second, warrior level of the Hindu caste system

*lahariya* (H) lit. 'wavy'; a form of tie-dying of textiles to produce a striped or zigzag pattern

*latticini* (I) glass technique associated with Venice where threads of opaque milky white glass alternate with clear glass

*lingam* (S) phallic symbol of energy and fertility associated with the god Shiva

*lungi* (H from S) man's waistcloth

*maharaja* (S) lit. 'great king'; a Rajput ruler

*masjid* (A) mosque

**Muharram** (A) first month of the Muslim year; on the 10th day Shia Muslims commemorate the death, in 61/680, of Husain, the son of Ali, who was the cousin and son-in-law of the Prophet Muhammad

**nabob** see **nawab**

**nawab** (P), provincial governor, vice-regent

*nim-qalam* (P) lit. 'half-pen'; a grisaille or shaded style of painting or drawing

*odhani* (H) woman's head-cover

**Pahari** (H) lit. 'of the hills'; a generic term applied to Indian paintings of the Punjab Hills

**palampore** from H *palang* (bed) and P *push* (cover); an embroidered or painted cotton bed-cover made in India for the European market

*pan* (H) leaves of the betel plant wrapped round chopped areca nuts, spices and lime, and chewed; used as a digestif and mild stimulant and offered to mark the end of a visit

*pandit* (H from S) lit. 'a learned man'; properly, well-versed in Sanskrit lore, but loosely used to mean adviser

*pari* (P) fairy or angel

*patka* (H) sash

*patolu* (G), plural *patola*; double ikat silk textile from Gujarat

*phulkari* (H from P) lit. 'flower work'; Punjabi embroidery worked in floss silk

*pietra dura* (I) inlay of semi-precious stones into hardstone

*pintado* (Port.) lit. 'painted'; the Portuguese term for painted cotton (chintz)

*ragamala* (S) lit. 'garland of melodies'; a series of paintings in which musical modes are represented by deities or lovers

*raja* (S) a Hindu ruler

**Rajput** (S) lit. 'son of a king'; member of the North Indian Hindu warrior communities

*Rasamanjari* (S) poetical text by Bhanudatta describing the types of lovers and their behaviour

*rumal* (P) towel or handkerchief

*sepoy* from *sipahi* (P) soldier

*stupa* (S) Buddhist domed monument symbolising the cosmos, around which pilgrims perform the rite of circumambulation

*subah* (H from P) a large division or province of the Mughal empire

*subadar* (P) governor of a *subah*

*swadeshi* (H) native, indigenous, belonging to one's own country; in the pre-Independence period often with the political meaning of nationalist

*tasar* (H from S?) inferior silk produced by various species of silk worms native to India

*thakur* (H) minor Rajput ruler

**Wazir** see *vizir*

*vizir* (A) a principal minister under a Muslim ruler; Nawab Wazir was also the title of the Nawab of Oudh, whose family were hereditary Wazirs

*zamindar* (P) landowner, landlord

*zamindari* (P) country or jurisdiction of a *zamindar*

*zanana* (P) women's quarters

*zardozi* (P) embroidery worked in gold and silver threads

# Bibliography

Abdul Aziz, *Thrones, tents and their furniture used by the Indian Mughals*, Lahore, n.d.
*Arms and jewellery of the Indian Mughuls*, Lahore, 1947.
*Aditi: the living art of India*, New Delhi, Handicrafts and Handloom Exports Corporation of India Ltd., 1982; rev. ed., Washington, Smithsonian Institution Press, 1985.
Ahmad, N., *Kitab-i-nauras by Ibrahim Adil Shah II*, New Delhi, Bharatiya Kala Kendra, 1956.
Aijazuddin, F.S., *Sikh Portraits by European Artists*, Delhi/Karachi, Oxford University Press, 1979.
*A'in-i Akbari, The*, by Abu'l-Fazl, Blochmann, H. and Jarrett, H.S. (trans.), 3rd ed., New Delhi, Oriental Books Reprint Corporation, 1977.
*Akbar-nama, The*, by Abu'l-Fazl, Beveridge, H. (trans.), Calcutta, Asiatic Society, 1907–39.
Ali, M. Athar, *The Mughal nobility under Aurangzeb*, Aligarh, Asia Publishing House, 1966.
Ames, F., *The Kashmir shawl*, Woodbridge, Antique Collectors' Club Ltd., 1986.
Appasamy, J., *Abanindranatha and the art of his times*, New Delhi, Lalit Kala Akademi, 1968.
Archer, M., *Tippoo's Tiger*, Victoria and Albert Museum monograph no.10, London, HMSO, 1959.
'Tilly Kettle and the court of Oudh', *Apollo*, February 1972, pp.96–106.
*Company drawings in the India Office Library*, London, HMSO, 1972.
*India and British portraiture 1770–1825*, London, Sotheby Parke Bernet, 1979.
*Company paintings. Indian paintings of the British period*, London, Victoria and Albert Museum, and Ahmedebad, Mapin Publishing, 1991.
Archer, M. and W.G., *Indian painting for the British, 1770–1880*, London, Oxford University Press, 1955.
Archer, M. and Falk, T., *India revealed*, London, Cassell, 1989.
Archer, M. and Lightbown, R., *India observed*, London, Victoria & Albert Museum, 1982.
Archer, M., Rowell, C. and Skelton, R., *Treasures from India: the Clive collection at Powis Castle*, London, Herbert Press/National Trust, 1987.
Archer, W.G., *Indian painting in the Punjab Hills*, London, HMSO, 1952.
*Central Indian painting*, London, Faber & Faber, 1958.
*Paintings of the Sikhs*, London, HMSO, 1966.
*Indian paintings from the Punjab Hills*, 2 vols, London/New York, Sotheby Parke Bernet, 1973.

Arnold, Sir T.W. and Wilkinson, J.V.S., *The Library of A. Chester Beatty: a catalogue of the Indian miniatures*, Oxford, Oxford University Press, 1936.
Ashton, Sir L. (ed.), *The Art of India and Pakistan*, London, Faber & Faber, 1950.
Atil, E., *The brush of the masters: drawings from Iran and India*, Washington, Freer Gallery of Art, 1978.
Aziz, Abdul *see* Abdul Aziz
*Babur-nama in English, The*, Beveridge, A. (trans.), 2 vols, London, Luzac, 1922.
Badauni, Abd al-Qadir, *Muntakhab at-Tavarikh*, Ranking, G.S.A., Lowe, W.H. and Haig, T.W. (trans.), 3 vols, Delhi, Idarah-i Adabiyat-i Delli, 1973.
Baker, C.J., *An Indian rural economy 1880–1955: the Tamilnadu countryside*, Oxford, Oxford University Press, 1984.
Bamfield, V., *On the strength: the story of the British Army wife in India*, London, C. Knight, 1974.
Baroda, Maharaja of, *The palaces of India*, London, William Collins, 1980.
Barrett, D., *Painting of the Deccan XVI–XVII century*, London, Faber & Faber, 1958.
'Painting at Bijapur', in Pinder-Wilson, R.H. (ed.), *Paintings from Islamic lands*, Oxford, Cassirer, 1969, pp.142–159.
Barrett, D. and Gray, B., *Painting of India*, Lausanne, Skira, 1963.
Basham, A.L., *The Wonder that was India*, London, Sidgwick and Jackson, 1954; 3rd rev. ed. 1967.
Bayly, C.A., 'The origins of *swadeshi* (home industry): cloth and Indian society, 1700–1930', in Appadurai, A. (ed.), *The social life of things: commodities in cultural perspective*, Cambridge, Cambridge University Press, 1986, pp.285–321.
Beach, M.C., *Rajput painting at Bundi and Kota*, Ascona, Artibus Asiae, 1974.
*The Grand Mogul: Imperial Painting in India 1600–1660*, Williamstown, Clark Art Institute, 1978.
*The Imperial Image: Paintings for the Mughal Court*, Washington, Freer Art Gallery, 1981.
'Mughal tents', *Orientations*, vol.16, no.1, January 1985, pp.32–44.
*Early Mughal Painting*, Cambridge, Mass., Harvard University Press, 1987.
Beer, A.B., *Trade goods*, Washington, Smithsonian Institution Press, 1970.
Bence-Jones, M., *Palaces of the Raj*, London, Allen and Unwin, 1973.

*The Viceroys of India*, London, Constable, 1982.

Bernier, F., *Travels in the Mogul Empire*, Constable, A. (trans.), London, Archibald Constable and Company, 1891.

Beveridge, A.(trans.), *Humayun-nama (the History of Humayun)*, by Gulbadan Begum, Royal Asiatic Society, 1902, repr.Lahore, Sang-e-meel Publications, 1974

Beveridge, H. and Prashad, B. (trans.), *Maathir-ul-umara, The*, by Nawwab Samsam-ud-daula Shah Nawaz Khan and his son 'Abdul Hayy, Calcutta, 1911–52; repr., Patna, 1979.

Bidwell, S., *Swords for hire: European mercenaries in 18th century India*, London, John Murray, 1971.

Binney, E., *Rajput miniatures from the collection of Edwin Binney, 3rd*, Portland, Art Museum, 1968.

*Indian miniature painting from the collection of Edwin Binney, 3rd. I: the Mughal and Deccani schools*, Portland, Art Museum, 1973.

Binyon, L., Wilkinson, J.V.S. and Gray, B., *Persian miniature painting*, London, Royal Academy of Arts, 1933.

Birdwood, Sir G.C.M., *Handbook to the British Indian Section of the Paris International Exhibition, 1878*, London, Offices of the Royal Commission, 1878.

*The industrial arts of India*, London, Chapman and Hall, 1880.

*The arts of India as illustrated in the collections of HRH the Prince of Wales*, London, R.Clay, Sons, and Taylor, 1881.

*Report on the old records of the India Office*, London, W.H. Allen, 1891.

Born, W., 'Ivory powder flasks from the Mughal period', *Ars Islamica*, vol.IX, 1942, pp.93–111.

Boxer, C.R., *Portuguese India in the mid-seventeenth century*, Delhi, Oxford University Press, 1980.

Brand, M. and Lowry, G., *Akbar's India: art from the Mughal City of Victory*, New York, Asia Society Galleries, 1985.

Broeze, F. (ed.), *Brides of the sea. Port cities of Asia from the 16th–20th centuries*, Sydney, New South Wales University Press, 1989.

Brown, P., *Indian painting under the Mughals*, Oxford, Clarendon Press, 1924; repr. New York, Hacker Art Books, 1975.

*Indian Architecture (Islamic Period)*, Bombay, Taraporevala Sons, 1956.

Brown, W.N., *The Story of Kalaka*, Washington, Freer Gallery of Art, Oriental Studies 1, 1933.

'Early Vaishnava miniature paintings from western India', *Eastern Art*, vol.II, 1930.

*A descriptive and illustrated catalogue of miniature paintings of the Jaina Kalpasutra*, Washington, Freer Gallery of Art, 1934.

Buck, E., *Simla past and present*, 2nd ed., Bombay, Times Press, 1925.

Buckland, C.E., *Dictionary of Indian biography*, London, Swan Sonnenschein, 1906.

Buhler, A., and Fischer, E., *The Patola of Gujarat*, 2 vols, Basel, Krebs AG, 1979.

Calcutta, *Official report of the Calcutta International Exhibition*, Calcutta, Bengal Secretariat Press, 1885.

Chaghatai, M.A., 'Khawajah 'Abd al-Samad Shirin-Qalam',

*Journal of the Pakistan Historical Society*, vol.II, 1963, pp.155–81.

'Mir Sayyid Ali Tabrezi', *Pakistan Quarterly*, vol.4, 1954, pp.24–9 and 60.

Chandra, M., 'A brass jewel casket of Akbar-Jehangir period', *Roopa Lekha*, vol.II, no.3, 1940, pp.9–13.

*The technique of Mughal painting*, Lucknow, U.P. Historical Society, 1949.

*Jain miniature paintings from Western India*, Ahmedabad, Manilal Nawab, 1948.

*Trade and trade routes in ancient India*, New Delhi, Abhinav Publications, 1977.

Chandra, P., 'Two early Mughal metal cups', *Bulletin of the Prince of Wales Museum*, no.5, Bombay, 1955–7, pp.57–60.

*The Tuti-nama of the Cleveland Museum of Art and the origins of Mughal painting*, Graz, Akademische Druck-u. Verlagsanstalt, 1976.

Charlesworth, N., *British rule and the Indian economy, 1800–1914*, London, Macmillan, 1982.

Chaudhuri, K.N., *The trading world of Asia and the English East India Company*, Cambridge, Cambridge University Press, 1978.

*Trade and civilization in the Indian Ocean. An economic history from the rise of Islam to 1750*, Cambridge, Cambridge University Press, 1985.

*Chhavi: Golden Jubilee Volume*, Krishna, A. (ed.), Varanasi, Bharat Kala Bhavan, 1971.

*Chhavi-2: Rai Krishnadasa Felicitation Volume*, Krishna, A. (ed.), Varanasi, Bharat Kala Bhavan, 1981.

Chou Ta-kuan, *Notes on the customs of Cambodia*, Bangkok, Social Science Association Press, 1967.

Choudhury, A.R., *Bidri ware*, Hyderabad, Salar Jang Museum, 1961.

Cimino, R., *Life at court in Rajasthan*, Florence, Mario Luca Giusti, 1985.

Codrington, O., 'On a hoard of coins found at Broach', *Journal of the Bombay Branch of the (Royal) Asiatic Society*, vol.XV, 1882–3.

Collins, F., 'The Good Shepherd ivory carvings of Goa and their symbolism', *Apollo*, vol.cxx, no.2, 1984, pp.170–75.

Coomaraswamy, A.K., *Catalogue of the Indian collections in the Museum of Fine Arts, Boston, vol.VI: Mughal painting*, Boston, Museum of Fine Arts, 1930.

Cousens, H., *Notes on the buildings and other antiquarian remains at Bijapur*, Bombay, Bombay Government, 1890.

Craddock, P.T., 'Early zinc production in India', *Mining Magazine*, January 1985.

Crill, R., *Hats from India*, London, Victoria & Albert Museum, 1985.

'Indian painted cottons', *Hali*, no.440, July/August 1988, pp.28–35

Dam-Mikkelsen, B. and Lundbaek, T. (eds.), *Ethnographic objects in the Royal Danish Kunstkammer 1650–1800*, Copenhagen, National Museum, 1980.

Daniélou, A., *Shilappadikaram*, New York, New Directions, 1965.

Das, A., 'Ustad Mansur', *Lalit Kala*, no.17, 1974, pp.32–43.
  *Mughal painting during Jahangir's time*, Calcutta, Asiatic Society, 1978.
  *Dawn of Mughal painting*, Bombay, Vakils, 1982.
Davies, P., *Splendours of the Raj*, London, John Murray, 1985.
  *Penguin guide to the monuments of India. Volume II: Islamic, Rajput, European*, London, Viking, 1989.
Delhi, *Coronation Durbar. Catalogue of loan exhibition of antiquities*, Delhi, 1911.
Desai, V., *Life at court*, Boston, Museum of Fine Arts, 1985.
Desmond, R., *Victorian India in focus*, London, HMSO, 1982.
Digby, S., 'A seventeenth century Indo-Portuguese writing cabinet', *Bulletin of the Prince of Wales Museum*, no.8, Bombay, 1962–4.
  'The Emperor Jahangir's autograph on paintings', *Islamic Culture*, vol.XXXVII, no.4, October 1963, pp.292–4.
  'The fate of Daniyal, Prince of Bengal, in the light of an unpublished inscription', *Bulletin of the School of Oriental and African Studies*, vol.XXXVI, 1973.
  'A corpus of "Mughal" glass', *Bulletin of the School of Oriental and African Studies*, vol.XXXVI, part I, 1973.
  'The maritime trade of India', *The Cambridge Economic History of India. Vol.I: c.1200–c.1750*, Cambridge, Cambridge University Press, 1982.
  'The mother-of-pearl overlaid furniture of Gujarat: an Indian handicraft of the 16th and 17th centuries', in Skelton, R. *et al* (eds.), *Facets of Indian Art*, London, Victoria and Albert Museum, 1986, pp.213–22.
Dikshit, M.G., *History of Indian glass*, Bombay, Bombay University, 1969.
Dwivedi, V.P., *Indian ivories*, Delhi, Agam Prakashan, 1976.
Ebeling, K., *Ragamala painting*, Basel, Ravi Kumar, 1973.
Edwardes, M., 'Britannia claims the wealth of the Indies', *The British Empire*, no.6, London, BBC Publications / Time Life Books, 1972.
Egerton, W., *An illustrated handbook of Indian arms, being a classified and descriptive catalogue of the arms exhibited at the India Museum*, London, Allen, 1880.
Egger, G., *Hamza-nama*, Graz, Akademische Druck-u. Verlagsanstalt, 1974.
Ehnbom, D., *Indian miniatures: the Ehrenfeld collection*, New York, Hudson Hills Press, 1985.
Elgood, R. (ed.), *Islamic arms and armour*, London, Scolar Press, 1979.
Elliot, Sir H.M. and Dowson, J., *The history of India as told by its own historians: the Muhammadan period*, 2nd ed., Calcutta, Susil Gupta, 1953.
Ettinghausen, R., *Paintings of the sultans and emperors of India*, New Delhi, Lalit Kala Akademi, 1961.
Falk, T.S., 'Rothschild collection of Mughal miniatures', in Goedhuis, M. (ed.), *Persian and Mughal art*, London, Colnaghi, 1976.
  (ed.), *Treasures of Islam*, London, Sotheby's/Wilson, 1985.
  'Inlaid and Ebony Furniture from British India', *Orientations*, vol.17, no.3, March, 1986, pp.47–56.
Falk, T.S. and Archer, M., *Indian miniatures in the India Office Library*, London, Sotheby Parke Bernet, 1981.
Falk, T.S., Digby, S. and Goedhuis, M., *Paintings from Mughal India*, London, Colnaghi, 1979.

Firishta, Muhammad Qasim, *History of the rise of the Mahomedan power in India*, Briggs, J. (trans. and ed.), 3 vols., Calcutta, reprinted 1971.
Fischer, E., Mahapatra, S. and Pathy, D. (eds.), *Orissa: Kunst und Kultur in Nordost-Indien*, Zurich, Museum Rietberg, 1980.
Forbes Watson, J., *Textile manufactures and the costumes of the people of India*, London, Eyre & Spottiswode, 1866.
Forrest, D., *Tiger of Mysore: the life and death of Tipu Sultan*, London, Chatto & Windus, 1970.
Foster, Sir W., *Early travels in India 1583–1619*, London, Humphrey Milford, 1921; repr., Delhi, S.Chand & Co., 1968.
  (ed.), *The embassy of Sir Thomas Roe to the court of the Great Mogul, 1615–19*, London, Hakluyt Society, 1899; repr. Nandeln, Kraus Reprint, 1967.
Freeman-Grenville, G.S.P., *The Muslim and Christian calendars*, London, Oxford University Press, 1963.
French, J.C., 'The land of wrestlers', *Indian Art and Letters*, vol. I, no.1, 1927, pp.15–30.
Gascoigne, B., *The Great Moghuls*, London, Jonathan Cape, 1971; repr. 1990.
Gittinger, M., *Master dyers to the world*, Washington, Textile Museum, 1982; repr. Singapore, Oxford University Press.
Glover, I., *Early trade between India and South-East Asia*, Hull, University of Hull Centre for South-East Asian Studies, 1989.
Goetz, H., *The art and architecture of Bikaner State*, Oxford, Bruno Cassirer, 1950.
  'A new key to early Rajput and Indo-Muslim painting', *Roopa Lekha*, vol.XXIII, nos.1–2, 1953.
  *The Indian and Persian miniature paintings in the Rijksprentenkabinet (Rijksmuseum), Amsterdam*, Amsterdam, 1958.
  *India: five thousand years of Indian art*, London, Methuen, 1959.
Goswamy, B.N., *Essence of Indian art*, San Francisco, Asian Art Museum, 1986.
  'Essence and appearance: some notes on Indian portraiture', in Skelton, R. *et al.* (eds.), *Facets of Indian art*, London, Victoria and Albert Museum, 1986, pp.193–202.
  *A Jainesque Sultanate Shahnama and the context of pre-Mughal painting in India*, Zurich, Museum Rietberg, 1988.
Goswamy, B.N. and Fischer, E., *Wonders of a golden age. Painting at the court of the Great Mughals. Indian art of the 16th and 17th centuries from collections in Switzerland*, Zurich, Museum Rietberg, 1987.
  *Pahari-Meister. Höfische Malerei aus den Bergen Nord-Indiens*, Zurich, Museum Rietberg, 1990.
Goswamy, B.N., Ohri, V.C. and Singh, A., 'A "Chaurapanchasika style" manuscript from the Pahari area', *Lalit Kala*, no.25, New Delhi, 1985, pp.9–21.
Gray, B., 'Portraits from Bijapur', *British Museum Quarterly*, vol.XI, 1937, pp.183–4.
  'Deccani paintings: the school of Bijapur', *Burlington Magazine*, vol.LXXIII, August 1938, pp.74–6.
  (ed.), *The Arts of India*, London, Phaidon Press, 1981.
Guha-Thakurta, T., *The making of a new 'Indian' art: Artists,*

*Aesthetics and Nationalism in Bengal, c. 1850–1920*, Cambridge, Cambridge University Press, forthcoming.

Gupta, A. (ed.), *Studies in the Bengal Renaissance*, Calcutta, National Council of Education, 1958.

Guy, J., *Palm-leaf and paper. Illustrated manuscripts of India and Southeast Asia*, Melbourne, National Gallery of Victoria, 1982.

'Mughal painting under Akbar: The Melbourne *Hamza-nama* and *Akbar-nama* paintings', *Art Bulletin of Victoria*, no.22, 1982, pp.25–41.

'Sarasa and Patola: Indian Textiles in Indonesia', *Orientations*, vol.20, no.1, 1989, pp.48–60.

'Tirumala Nayak's Choultry and an eighteenth century model', in Bautze-Picron, C. and Maxwell, T. (eds.), *Makaranda. Essays in honour of Dr. James C. Harle*, Delhi, Vikas, 1990.

(ed.) *Indian art and connoisseurship. Essays in honour of Douglas Barrett*, Ahmebabad, Mapin Publishing, forthcoming.

Haig, Sir T. W., 'The five kingdoms of the Deccan, 1527–1599', *The Cambridge History of India*, vol.III, chapter 17, Cambridge, Cambridge University Press, 1922; repr. Delhi, 1965.

'The kingdoms of the Deccan during the reigns of Jahangir, Shah Jahan and Aurangzeb', *The Cambridge History of India*, vol.IV, chapter 9, Cambridge, Cambridge University Press, 1929; repr. Delhi, 1965.

Hajek, L., *Indian miniatures of the Moghul school*, London, Springbooks, 1960.

Hallissey, R., *The Rajput rebellion against Aurangzeb*, Columbia and London, University of Missouri, 1977.

Hambly, G., *Cities of Mughal India*, London, Paul Elek, 1968; repr. 1977.

Haq, M.M., 'The Khan Khanan and his painters, illuminators and calligraphists', *Islamic Culture*, vol.5, no.4, 1931.

Haque, Z., *Gahana. Jewellery of Bangladesh*, Dhaka, Bangladesh Small and Cottage Industries Corporation, 1984.

Hartkamp-Jonxis, R.E., *Sits. Oost-west relaties in textiel*, Zwolle, Uitgevenig Waandres, 1987.

Hasrat, B.J., *Dara Shikuh: life and works*, Calcutta, 1953.

Hayward Gallery, *The Arts of Islam*, Michell, G. and Jones, D. (eds.), London, 1976.

Head, R., *The Indian style*, London, George Allen & Unwin, 1986.

Hendley, T.H., *Memorials of the Jeypore Exhibition*, London, W.Griggs & Sons, 1883.

*Damascening on steel or iron, as practised in India*, London, W. Griggs & Sons, 1892.

'Indian jewellery', *Journal of Indian Art*, vol.XII, 1906–9.

Hickey, W., *Memoirs of William Hickey*, Spencer, A. (ed.), 4 vols, London, Hurst & Blackett, 1913–25, (repr., London, Hutchinson, 1960).

Hirth, F. and Rickhill, W.W., *Chau Ju-Kua: his work on the Chinese and Arab trade in the twelfth and thirteenth centuries, entitled Chu-Fan-Chi*, St. Petersburg, Imperial Academy of Sciences, 1911; repr. Taipei, Cheng-wen Publishing, 1967.

Hobson-Jobson, *see* Yule, H. and Burnell, A.C.

Hodivala, S.H., *Historical studies in Mughal numismatics*, Calcutta, Numismatic Society of India, 1923.

Huyler, S., *Village India*, New York, Harry N. Abrams, 1985.

Hyderabad Government: Central Records Office, *The chronology of modern Hyderabad 1720–1890*, Hyderabad, 1954.

Ibn Battuta, *Travels in Asia and Africa 1325–1354*, Gibb, H.A.R. (trans.), London, Routledge and Kegan Paul, 1929; repr. 1983.

Irvine, W., *The army of the Indian Moghuls*, London, Luzac & Co., 1903; repr. New Delhi, Eurasia Publishing House, 1962.

Irwin, J., 'A Jacobean vogue for oriental lacquer-ware', *The Burlington Magazine*, vol.CV, no.603, June 1953, pp.193–4.

'A select bibliography of Indian textiles [part I]', *Journal of Indian Textile History*, no.I, 1955, pp.66–76.

'Reflections on Indo-Portuguese art', *Burlington Magazine*, vol.97, 1955, pp.386–8.

*Shawls: a study in Indo-European taste*, London, HMSO, 1955; 2nd ed., *The Kashmir shawl*, London, HMSO, 1973.

'Bibliography of Indian textiles. Part II. Travellers' records, 1300–1700 A.D.', *Journal of Indian Textile History*, no.II, 1956, pp. 58–62.

'Golconda cotton paintings of the early seventeenth century', *Lalit Kala*, no.5, April 1959, pp.11–48.

'The Girdlers Carpet', *Marg*, Bombay, vol.18, no. 4, 1965.

'Indian art at the Victoria and Albert Museum', *Marg*, vol. 29, no. 4, 1976.

Irwin, J. and Brett, K., *Origins of chintz*, London, HMSO, 1970.

Irwin, J. and Schwartz, P.R., *Studies in Indo-European Textile History*, Ahmedabad, Calico Museum of Textiles, 1966.

Irwin, J. and Hall, M., *Indian painted and printed fabrics in the Calico Museum*, Ahmedabad, Calico Museum of Textiles, 1971.

*Indian embroideries*, Ahmedabad, Calico Museum of Textiles, 1973.

Ivanov, A.A., Grek, T.V. and Akimushkin, O.F., *Al'bom indiyskikh i pyersidskikh miniatyur XVI-XVIII vv. (Album of Indian and Persian miniatures of the 16th–18th centuries)*, Moscow, 1962.

Ivanov, A.A., Lukonin, V.G. and Smesova, L.S., *Yuvyelirniye izdyeliya vostoka (Oriental jewellery from the collection of the Special Treasury, the State Hermitage Oriental Department)*, Moscow, 1984.

Jacob, S.S. and Hendley, T.H., *Jeypore enamels*, London, W. Griggs, 1886.

Jain, J. and Aggarwala, A., *National Handicrafts and Handlooms Museum, New Delhi*, Ahmedabad, Mapin Publishing, 1989.

Jayakar, P., *The earthen drum: an introduction to the ritual arts of rural India*, New Delhi, National Museum, 1980.

Jenkins, M., *Islamic art in the Kuwait National Museum. The al-Sabah collection*, London, Philip Wilson, 1983.

Jenkins, M. and Keene, M., *Islamic jewelry in the Metropolitan Museum of Art*, New York, The Metropolitan Museum of Art, 1982.

Johnson, B.B., 'A preliminary study of the technique of Indian miniature painting', in Pal, P. (ed.), *Aspects of Indian art*, Leiden, E.J. Brill, 1972, pp.139–46.

Jones, O., *The grammar of ornament*, London, Day & Son, 1856.

Joshi, P.M., 'Relations between the Adil Shahi kingdom of Bijapur and the Portuguese at Goa', in Katre, S.M. and Gode, P.K. (eds.), *A volume of Indian studies presented to Sir E. Denison Ross*, Bombay, 1939, pp.162–9.

'The reign of Ibrahim Adil Shah of Bijapur', *Bharatiya Vidya Bhavan*, vol.9, 1948, pp.284–309.

'Asad Beg's mission to Bijapur, 1603–1604', in Sen, S. (ed.), *Prof. D.V. Potdar 61st birthday commemoration volume*, Poona, 1950, pp.184–96.

Kahlenberg, M., 'A study of the development and use of the Mughal *patka* (sash)', in Pal, P. (ed.), *Aspects of Indian art*, Leiden, E.J. Brill, 1972, pp.153–166.

Kentshire Galleries, *Anglo-India: fine and decorative arts made for the British in India*, New York, 1985.

Khandalavala, K., *Pahari miniature painting*, Bombay, New Books, 1958.

'Brahmapuri', *Lalit Kala*, no.7, 1960, pp.29–75.

Khandalavala, K. and Chandra, M., *New documents of Indian painting – a reappraisal*, Bombay, Prince of Wales Museum of Western India, 1969.

Khandalavala, K., Chandra, M. and Chandra, P., *Miniature painting: a catalogue of the exhibition of the Sri Motichand Khajanchi collection held by the Lalit Kala Akademi*, New Delhi, Lalit Kala Akademi, 1960.

Khandalavala, K. and Mittal, J., 'The *Bhagavata* Mss from Palam and Osarda – a consideration in style', *Lalit Kala*, no.16, 1974, pp.28–32.

Kincaid, D., *British social life in India, 1608–1937*, London, G. Routledge & Sons, 1938; 2nd ed., 1973.

Koch, E., 'The influence of the Jesuit Mission on symbolic representations of the Mughal emperors', in Troll, C.W. (ed.), *Islam in India: studies and commentaries. Vol.I. The Akbar Mission and miscellaneous studies*, 1982, pp.14–29.

'Jahangir and the angels: recently discovered wall paintings under European influence in the Fort of Lahore', in Deppert, J. (ed.), *India and the West*, New Delhi, South Asian Institute, University of Heidelberg, 1983, pp.173–95.

*Shah Jahan and Orpheus: the pietre dure decoration and the Programme of the Throne in the Hall of Public Audiences at the Red Fort of Delhi*, Graz, Akademische Druck-u. Verlagsanstalt, 1988.

Kramrisch, S., *A survey of painting in the Deccan*, London, Indian Society, 1937.

*Unknown India: ritual art in tribe and village*, Philadelphia, Museum of Art, 1968.

*Painted delight*, Philadelphia, Museum of Art, 1985.

Krishnadasa, R., *Mughal miniatures*, Delhi, Lalit Kala Akademi, 1955.

'The pink enamelling of Banaras', *Chhavi: Golden Jubilee Volume*, Varanasi, Bharat Kala Bhavan, 1971, pp.327–34.

Kubiak, W. and Scanlon, G.T., *Fustat Expedition Final Report Vol. 2: Fustat-C*, The American Research Center in Egypt, Inc./Eisenbrauns, Winona Lake, 1989.

Kumar, P., 'Terracotta icons of Molela', in *Arts of Asia*, vol.13, no.1, 1983, pp.88–93.

Lach, D.F., *Asia in the making of Europe. Vol.II, book I: the visual arts*, Chicago, University of Chicago Press, 1970.

Lafont, J.M., *Regards français sur l'Inde de 1610 à 1849*, Paris, 1989.

Latif, M., *Bijoux moghols*, Brussels, Société Générale de Banque, 1982.

Latif, S.M., *Lahore: its history, architectural remains and antiquities*, Lahore, New Imperial Press, 1892.

Leach, L.Y., *Indian miniature paintings and drawings: the Cleveland Museum of Art catalog of oriental art. Part one*, Cleveland, Museum of Art, 1986.

Lee, S.E., *Rajput painting*, New York, Asia Society, 1960.

Lightbown, R.W., 'Oriental art and the Orient in late Renaissance and Baroque Italy', *Journal of the Warburg and Courtauld Institutes*, vol.XXXII, 1969, pp.228–79.

Liu, X., *Ancient India and ancient China trade and religious exchanges AD 1–600*, New Delhi, Oxford University Press, 1988.

Lockhart, L., *Nadir Shah: a critical study based mainly upon contemporary sources*, London, Luzac, 1938.

Loewe, M., 'Spices and silk: aspects of world trade in the first seven centuries of the Christian era', *Journal of the Royal Asiatic Society*, 1971, pp.166–79.

Losty, J.P, *The art of the book in India*, London, British Library, 1982.

Luillier-Lagaudiers, Le Sieur, *see* Symson, W.

Majumdar, R.C. (ed.), *The history and culture of the Indian people*, 11 vols, Bombay, Bharatiya Vidya Bhavan, 1951–69.

*An advanced history of India*, Madras, Macmillan of India, repr.1978.

Manrique, S., *Travels of Fray Sebastien Manrique, 1629–1643*, Luard, C.E. and Hosten, H. (trans.), 2 vols, London, Hakluyt Society, 1927.

Manucci, N., *Storia do Mogor or Mogul India, 1653–1708*, Irvine, W. (trans. and ed.), 4 vols, London, Indian Text Series, 1907–8.

*Marg*, Bombay, vol.XVI, no.2, March 1963 (special number on Deccani painting).

Marteau, G. and Vever, H., *Miniatures persanes exposées au Musée des Arts Decoratifs*, 2 vols, Paris, Bibliothèque d'Art et d'Archéologie, 1912.

Martin, F.R., *The miniature painting and painters of Persia, India and Turkey*, London, Bernard Quaritch, 1912.

Meen, V.B. and Tushingham, A.D., *Crown jewels of Iran*, Toronto, University of Toronto Press, 1968.

Meer Hassan Ali, Mrs, *Observations on the Mussulmans of India*, Crooke, W. (ed.), Karachi, Oxford University Press, 1978.

Melikian-Chirvani, A.S., 'L'école de Shiraz et les origines de la miniature Moghole', in Pinder-Wilson, R. (ed.), *Paintings from Islamic lands*, Oxford, Bruno Cassirer, 1969, pp.124–41.

*Metalwork from Iranian lands*, London, HMSO, 1982.

'Studies in Hindustani metalwork: on some Sultanate stirrups', in Adle, C. (ed.), *Art et Société dans le monde Iranien*, Paris, 1982.

'Islamic metalwork as a source on cultural history. Section II: The making of Islamic culture in India: the evidence

of metalwork', *Arts and the Islamic World*, vol.I, no.1, 1982–3, pp.36–44, 78–80.

Mendonça, Maria José de, *Embroidered quilts*, see Museu Nacional de Arte Antiga, 1978.

Michell, G., *The Islamic heritage of Bengal*, Paris, Unesco, Protection of the Cultural Heritage, Research Papers 1, 1984.

(ed.) *Islamic heritage of the Deccan*, Bombay, Marg Publications, 1986.

*Penguin guide to the monuments of India. Volume 1: Buddhist, Jain, Hindu*, London, Viking, 1989.

et al. (eds.), *In the Image of Man*, London, Arts Council of Great Britain, 1982.

Miller, J.I., *The spice trade of the Roman Empire, 29 BC to AD 641*, Oxford, Clarendon Press, 1969.

Mittal, J., 'Deccani painting: Golkonda and Hyderabad schools', in Sherwani, H.K. (ed.), *Dr. Ghulam Yazdani commemoration volume*, Hyderabad, 1966, pp.127–33.

Mitter, P., *Much maligned monsters. History of European reactions to Indian art*, Oxford, Clarendon Press, 1977.

Mode, H. and Chandra, S., *Indian Folk Art*, New York, Alpine Fine Arts Collection, 1985.

Mohanty, B.C., *Brocade fabrics of India*, 2 vols, Ahmedabad, Calico Museum of Textiles, 1984.

Moreland, W.H. (ed.), *Relations of Golconda in the early seventeenth century*, London, Hakluyt Society, 1931.

Mukharji, T.N., *Art manufactures of India*, Calcutta, Superintendent of Government Printing, 1888.

Mukherjee, S.N., 'Caste, class and politics in Calcutta, 1813–38', in Leach, E.R. and Mukherjee, S.N. (eds.), *Elites in South Asia*, Cambridge, Cambridge University Press, 1970.

Murphy, V., 'Kashmir shawls', in Horsman Lanz, H. (ed.), *Kashmir shawls: woven art and cultural document*, London, Kyburg gallery, 1988, pp.4–9.

Murphy, V., and Crill, R., *Tie-dyed textiles of India: tradition and trade*, London, Victoria and Albert Museum, and Ahmedabad, Mapin Publishing, 1990.

Musea Nacional de Arte Antiga, *Embroidered quilts from the Musea Nacional de Arte Antigua, Lisboa, India, Portugal, China, 16th–18th century*, London and Lisbon, 1978.

Musée National des Arts Asiatiques Guimet, *Miniatures de l'Inde impériale. Les peintres de la cour d'Akbar (1556–1605)*, Paris, Musée Guimet, 1989.

Nabholtz-Kartaschoff, M.-L., *Golden sprays and scarlet flowers: traditional Indian textiles from the Museum of Ethnography Basel, Switzerland*, Kyoto, Shikosha Publishing, 1986.

Nadvi, S.S., 'Some Indian astrolabe-makers', *Islamic Culture*, vol.9, Hyderabad, October 1935, pp.621–31.

Nath, R., *History of Sultanate architecture*, New Delhi, Abhinav Publications, 1978.

Pal, P. (ed.), *Aspects of Indian Art*, Leiden, E.J.Brill, 1972.

*Romance of the Taj Mahal*, London, Thames and Hudson, 1989.

Patwardhan, P.R. (ed.), *Fort William correspondence 1773–6*, vol.VII, Calcutta.

Pearson, M.N., *Merchants and rulers in Gujerat: the response to the Portuguese in the 16th century*, Berkeley, 1976.

*The New Cambridge History of India: The Portuguese in India*,

Vol.I.1, Cambridge, Cambridge University Press, 1987.

*Periplus of the Erythraean Sea, The*, see Schoff, W.H. (trans.).

Pinder-Wilson, R.H., *Paintings from the Muslim courts of India*, London, British Museum/World of Islam Festival Publishing, 1976.

(ed.), *Paintings from Islamic Lands*, Oxford, Cassirer, 1969.

Pires, T., *The Suma Oriental of Tome Pires*, Cortesão, A. (trans.), 2 vols, London, Hakluyt Society, 1944; repr. 1980.

Pyrard de Laval, F., *The voyage of François Pyrard of Laval to the east Indies . . .*, Gray, A. (trans.), 2 vols, 1887–90.

Ravenshaw, J.H., *Gaur: its ruins and inscriptions*, London, Kegan Paul, 1878.

Rawson, P.S., *The Indian sword*, Copenhagen, The Danish Arms and Armour Society, 1967.

Ray, H.P., *Monastery and guild: commerce under the Satavahanas*, Delhi, Oxford University Press, 1986.

'Early Maritime contacts between South and Southeast Asia', *Journal of Southeast Asian Studies*, vol.XX, no.1, 1989, pp.42–54.

Ray, P., 'Printmaking up to 1901: a social and technological history', in Paul, A. (ed.), *Woodcut prints of nineteenth century Calcutta*, Calcutta, Seagull Books, 1983, pp.80–107.

Regani, S., *Nizam-British relations 1724–1857*, Hyderabad, 1963.

Riboud, K. (ed.) *In quest of themes and skills: Asian textiles*, Bombay, Marg Publications, 1989.

Richards, D.S., *Islam and the trade of Asia: a colloquium*, Oxford, Cassirer, 1970.

Rivett-Carnac, Mrs, 'An afternoon's ramble in an Indian bazaar', *Journal of Indian Art and Industry*, vol.3, 1883, pp.6–7.

Rogers, A. and Beveridge, H. (trans. and eds.), *The Tuzuk-i-Jahangiri or Memoirs of Jahangir*, London, Royal Asiatic Society, 1909 (vol.I), 1914 (vol.II).

Rousselet, L., *India and its native princes*, London, Chapman and Hall, 1876.

Sainsbury, W.N. (ed.), 'The fine arts in India in the reign of James I', *The Fine Arts Quarterly Review*, vol.II, January-May 1864, pp.313–9.

Saksena, B.P., *History of Shahjahan of Dihli*, Ahmedabad, 1958.

Sarkar, Sir J., *History of Aurangzeb*, 4 vols, Calcutta, 1912; repr. Patna, Patna University, 1921, and Lahore, 1981.

*Studies in Mughal India*, Calcutta, 1919.

(trans.) *Maasir-i Alamgiri*, by Saqi M. Khan, Calcutta, 1947, repr. Lahore, Ever Green Press, 1981.

*Mughal administration*, rev. ed., Calcutta, 1952.

Schimmel, A. and Welch, S.C., *Anvari's divan: a pocket book for Akbar*, New York, Metropolitan Museum of Art, 1983.

Schoff, W.H. (trans.), *The Periplus of the Erythraean Sea*, New York, Longmans, 1912; repr. New Delhi, Oriental Books Reprint, 1974.

Seal, A., *The emergence of Indian nationalism*, Cambridge, Cambridge University Press, 1971.

'Imperialism and nationalism in India', in Johnston, G.

and Seal, A. (eds.), *Locality, province and nation*, Cambridge, Cambridge University Press, 1973, pp.1–27.

*Sëir Mutaqherin, The; or review of modern times; being an history of India, as far down as the year 1783 . . . . by Seid-Gholam-Hossein-Khan*, Nota-Manus (trans.), 4 vols, Calcutta, 1789; repr. Lahore, Sheik Mubarak Ali, 1975.

Sen, G., *Paintings from the Akbar Nama*, Singapore, Lustre Press, 1984.

Sewell, R., *A forgotten empire, (Vijayanagar)*, London, Swan Sonnenschein, 1900.

Shah, U.P., *More documents of Jaina paintings and Gujarati paintings of sixteenth and later centuries*, Ahmedabad, L.D. Institute of Indology, 1976.

    *Treasures of Jain Bhandaras*, Ahmedabad, L.D. Institute of Indology, 1978.

Sharar, A.H., *Lucknow: the last phase of an oriental culture*, London, Paul Elek, 1975.

Sharma, O.P., *Indian miniature painting*, Brussels, Bibliothèque Royale Albert Ier, 1974.

Sherwani, H.K., *The Bahmanis of the Deccan*, Hyderabad, n.d.

    *Muhammad Quli Qutb Shah*, Karachi, Pakistan Historical Society, 1962

    *History of the Qutb Shahi dynasty*, New Delhi, Munshiram Manoharlal, 1974.

Sherwani, H.K. and Joshi, P.M. (eds.), *History of medieval Deccan (1295–1724)*, Hyderabad, 1973.

Shiveshwarkar, L., *The pictures of the Chaurapanchasika*, New Delhi, National Museum, 1967.

Shyam, R., *The kingdom of Ahmadnagar*, New Delhi, Motilal Banarsidass, 1966.

Silverstein, J., *Woven winds: the art of textiles in India*, Stratford, Ontario, 1981.

Simsar, M.A. (trans. and ed.), *Tales of a parrot*, by Ziya ud-din Nakhshabi, Graz, Akademische Druck u. Verlagsanstalt, 1978.

Singh, C., *Textiles and costumes from the Maharaja Sawai Man Singh II Museum*, Jaipur, Maharaja Sawai Man Singh II Museum Trust, 1979.

Skelton, R.W., 'Murshidabad painting', *Marg*, vol.X, no.10, December 1956, pp.10–22.

    'The Nimat nama: a landmark in Malwa painting', *Marg*, vol.XII, no.3, June 1959, pp.44–50.

    *Indian miniatures from the XVth to the XIXth centuries*, Venice, Neri Pozza Editore, 1961.

    'The Shah Jahan cup', *Victoria and Albert Museum Bulletin*, vol.II, no.3, July 1966, pp.109–10, fig.8.

    'A decorative motif in Mughal art', in Pal, P. (ed.), *Aspects of Indian art*, Leiden, E.J. Brill, 1972, pp.147–52.

    'The relations between the Chinese and Indian jade carving traditions', in Watson, W. (ed.), *The westward influence of the Chinese arts from the 14th to the 18th century*, Colloquies on Art and Archaeology in Asia, no.3, London, University of London, 1972, pp.98–110.

    'Early Golconda painting', in Härtel, H. and Moeller, V. (eds.), *Indologen-Tagung 1971*, Wiesbaden, 1973, pp.182–95.

    *Rajasthani temple hangings of the Krishna cult*, New York, The American Federation of Arts, 1976.

    'Indian painting of the Mughal period', in Robinson, B.W. (ed.), *Islamic painting and the arts of the book in the Keir Collection*, London, Faber and Faber Ltd., 1976, pp.231–74.

    'The Indian collections: 1798–1978', *The Burlington Magazine*, vol.CXX, no.902, May 1978, pp.297–304.

    'Shaykh Phul and the origins of Bundi painting', *Chhavi-2*, Varanasi, Bharat Kala Bhavan, 1981, pp.123–9.

Skelton, R. and Francis, M. (eds.), *Arts of Bengal: the heritage of Bangladesh and Eastern India*, London, Whitechapel Art Gallery, 1979.

Skelton, R. *et al.*, *The Indian heritage: court life and arts under Mughal rule*, London, Victoria and Albert Museum and Herbert Press, 1982.

Skelton, R., *et al.* (eds.), *Facets of Indian Art*, London, Victoria and Albert Museum, 1986.

Smart, E.S., 'A preliminary report on a group of important Mughal textiles', *The Textile Museum Journal*, Washington, 1986, pp. 5–23.

Somers Cocks, A., *The Victoria and Albert Museum: the making of the collection*, Leicester, Windward, 1980.

    *Princely magnificence: Court jewels of the Renaissance 1500–1630*, London, Victoria and Albert Museum, 1980.

Sonday, M. and Kajitani, N., 'A type of Mughal sash', *Textile Museum Journal*, vol.III, no.1, December 1970, pp.45–54.

    'A second type of Mughal sash', *Textile Museum Journal*, vol.III, no.2, December 1971, pp.6–12.

Soustiel, J. and David, M.C., *Miniatures de l'Inde, 2*, Paris, J.Soustiel, 1973.

Spear, [T.G.] P., *The nabobs*, London, Oxford University Press, 1932; repr. 1963.

Spink, M. (ed.), *Islamic jewellery*, London, Spink and Son, 1986.

Spink & Son Ltd., *Islamic and Hindu jewellery*, London, 1988.

Spuhler, F., *Islamic carpets and textiles in the Keir collection*, London, Faber & Faber, 1978.

Standford, J.K., *Ladies in the sun: the memsahib's India, 1709–1860*, London, Gallery Press, 1962.

Staude, W., 'Contribution à l'étude de Basawan', *Revue des Arts Asiatiques*, vol.8, no.1, 1933–4, pp.1–18.

    'Les artistes de la cour d'Akbar et les illustrations du Dastan-i Amir Hamzah', *Arts Asiatiques*, vol.2, no.1, 1955, pp.47–65.

Stchoukine, I., *Les miniatures indiennes au Musée du Louvre*, Paris, Musée du Louvre, 1929.

Steele, F.A., 'Phulkari work in the Punjab', *Journal of Indian Art*, vol.II, no.24, London, 1888.

Stern, S.M., 'Ramisht of Siraf, a merchant millionaire of the twelfth century', *Journal of the Royal Asiatic Society*, 1967, pp.10–14.

Stewart, Major, C. (trans.), *The Tezkereh al Vakiat, or private memoirs of the Moghul Emperor Humayun by Jouher*, Santiago de Compostela, Sunsil Gupta, 1832; new ed. Delhi, Idarah-i-Ababiyat-i, 1972.

    *La peinture indienne à l'époque des grands Moghols*, Paris, Librairie Ernest Leraix, 1929.

Stronge, S., 'Mughal jewellery', *Jewellery Studies*, vol.I, 1983–4, pp.49–53, pls.IIB-III.

*Bidri ware: inlaid metalwork from India*, London, Victoria and Albert Museum, 1985.

'Jewels for the Mughal court', *The V&A Album 5*, London, Victoria and Albert Museum, 1986, pp.308–17.

Stronge, S., Harle, J. and Smith, N., *A Golden Treasury: jewellery from the Indian subcontinent*, London, Victoria and Albert Museum, and Ahmedabad, Mapin Publishing, 1987.

Tavernier, J.-B., *Travels in India (1676)*, Ball, V. (trans.), 2nd ed., London, Macmillan, 1925.

Taylor, J., *The textile manufactures of Dacca*, London, John Mortimer, 1851.

Thapar, R., *A History of India*, vol.I, Harmondsworth, Penguin Books, 1966.

Tibbetts, G.R., *Arab navigation in the Indian Ocean before the coming of the Portuguese*, London, Royal Asiatic Society, 1971.

Tillotson, G.H.R., *The Rajput palaces*, New Haven and London, Yale University Press, 1987.

Titley, N., *Miniatures from Persian manuscripts: a catalogue and subject index of paintings from Persia, India and Turkey in the British Library and British Museum*, London, British Museum Publications, 1977.

*Persian miniature painting*, London, British Library, 1983.

Tod, J., *Annals and antiquities of Rajasthan*, Crooke, W. (ed.), 3 vols., London, 1920; repr. Delhi, Motilal Banarsidass, 1971.

Topsfield, A., 'Sāhibdīn's Gita-Govinda illustrations', *Chhavi-2*, Varanasi, Bharat Kala Bhavan, 1981, pp.231–8.

*Paintings from Rajasthan in the National Gallery of Victoria*, Melbourne, National Gallery of Victoria, 1980.

*Indian Court Painting*, London, HMSO, 1984.

'Udaipur paintings of the Raslila', *Art Bulletin of Victoria*, no.28, 1988, pp.54–70.

*The City Palace Museum, Udaipur. Paintings of Mewar Court Life*, Ahmedabad, Mapin, 1990.

Turner, P., *Roman Coins from India*, London, Institute of Archaeology and Royal Numismatic Society, 1989.

Veenendaal, J., *Furniture from Indonesia, Sri Lanka and India during the Dutch period*, Delft, Volkenkundig Museum Nusantara, 1985.

Vogel, J.P., *Tile mosaics of the Lahore Fort*, Marshall, Sir J. (ed.), Calcutta, Archaeological Survey of India, vol.41.

Wainwright, C., 'Only the true black blood . . .', *Furniture History*, vol.XXI, 1985, pp.250–5.

Warmington, E.H., *The commerce between the Roman Empire and India*, Cambridge, Cambridge University Press, 1928.

Watt, G., *Indian art at Delhi 1903*, Calcutta, Superintendent of Government Printing, 1903.

*The commercial products of India*, London, John Murray, 1908.

Welch, S.C., *The art of Mughal India*, New York, The Asia Society, 1963.

*A flower from every meadow*, New York, The Asia Society, 1973.

*Room for wonder: Indian painting during the British period 1760–1880*, New York, The Asia Society, 1978.

*India. Art and Culture 1300–1900*, New York, Metropolitan Museum of Art, 1985; repr. Ahmedabad, Mapin Publishing, 1989.

Welch, S.C. and Beach, M.C., *Gods, thrones and peacocks*, New York, The Asia Society, 1965.

Welch, S.C. *et al.*, *The Emperor's album: images of Mughal India*, New York, Metropolitan Museum of Art, 1987.

Wellescz, E., *Akbar's religious thought reflected in Mogul painting*, London, Allen and Unwin, 1952.

Wheeler, R.E.M, *et al.*, 'Arikamedu: on Indo-Roman trading centres on the east coast of India', *Ancient India*, vol.II, 1946–7.

Whitechapel Art Gallery, *Woven air: the muslin and kantha tradition of Bangladesh*, London, 1988.

Wiet, G., 'Une famille de fabricants d'astrolobes', *Bulletin de l'Institut Français d'Archéologie Orientale*, XXXVI, Cairo, 1936.

Wilkinson, J.V.S., *The Lights of Canopus*, London, Studio, 1929.

Wilkinson, T., *Two monsoons*, London, Duckworth, 1976.

Wilkinson, W.R.T., *Indian colonial silver: European silversmiths in India (1790–1860) and their marks*, Argent Press, London, 1973.

*The makers of Indian colonial silver: a register of European goldsmiths, silversmiths, jewellers, watchmakers and clockmakers in India and their marks 1760–1860*, London, published by author, 1987.

Wink, A., '*Al-Hind*: India and Indonesia in the Islamic world economy c.700–1800 AD', in Marshall, P.J. (ed.), *India and Indonesia during the Ancien Régime*, Leiden, E.J.Brill, 1989, pp.33–72.

Worswick, C., *Princely India: photographs by Raja Deen Dayal (1884–1910)*, New York, Pennwick/Agrinde, 1980.

Worswick, C. and Embree, A., *The last empire: photography in British India, 1855–1911*, New York, Aperture, 1976.

Yazdani, G., *Bidar, its history and monuments*, London, Oxford University Press, 1947.

*The early history of the Deccan*, 2 vols, London, Oxford University Press, 1960.

Yule, H. and Burnell, A.C., *Hobson-Jobson: a glossary of Anglo-Indian colloquial words and phrases*, London, John Murray, 1886; repr. 1903 and 1968.

Zebrowski, M., 'Decorative arts of the Mughal period', in Gray, B. (ed.) *The arts of India*, London, Phaidon, 1981, pp. 177–89.

'Bidri: metalware from the Islamic courts of India', *Art East*, no.1, 1982, pp.26–9.

*Deccani painting*, London, Sotheby Publications, 1983.

'The Indian ewer', in R.Skelton, *et al.* (eds.), *Facets of Indian Art*, London, Victoria and Albert Museum, 1986, pp.253–9.

# Index

Bold figures indicate illustration number